UNSEEN

UNSEEN

UNPUBLISHED BLACK HISTORY

FROM *THE NEW YORK TIMES* PHOTO ARCHIVES

DARCY EVELEIGH, DANA CANEDY, DAMIEN CAVE AND RACHEL L. SWARNS

BLACK DOG
& LEVENTHAL
PUBLISHERS
NEW YORK

UNSEEN
Unpublished Black History from *The New York Times* Photo Archives

Copyright © 2017 by The New York Times Company

Cover design by Amanda Kain
Cover copyright © 2017 by Hachette Book Group, Inc.

Black Dog & Leventhal Publishers
Hachette Book Group
1290 Avenue of the Americas
New York, NY 10104
www.hachettebookgroup.com
www.blackdogandleventhal.com

First Edition: October 2017

Black Dog & Leventhal Publishers is an imprint of Hachette Books, a division of Hachette Book Group. The Black Dog & Leventhal Publishers name and logo are trademarks of Hachette Book Group, Inc.

The publisher is not responsible for websites (or their content) that are not owned by the publisher. The Hachette Speakers Bureau provides a wide range of authors for speaking events. To find out more, go to www.HachetteSpeakersBureau.com or call (866) 376-6591.

Additional photo credits information is on page 298.

Print book interior design by Elizabeth Van Itallie

LCCN: 2017944944

ISBNs: 978-0-316-55296-7 (hardcover), 978-0-316-55297-4 (ebook)

Printed in the U.S.A.

Q-T

10 9 8 7 6 5 4 3 2 1

TO FORMER *NEW YORK TIMES*
PHOTO EDITOR
JOHN GODFREY MORRIS,
WHO SAID, "GO BACK AND RE-EDIT
EVERYTHING."

INTRODUCTION

BY RACHEL L. SWARNS

Each photograph on these pages will take you back: To the charred wreckage of Malcolm X's house in Queens, just hours after it was bombed. To a packed church in Greenwood, Mississippi, where Medgar Evers inspired African-Americans to dream of a day when their votes would count. To Lena Horne's elegant penthouse on the Upper West Side of Manhattan. To a city sidewalk where schoolgirls jumped rope, while the writer Zora Neale Hurston cheered them on, behind the scenes.

These stunning images from black history, drawn from old negatives, have long been buried in the musty envelopes and crowded bins of *The New York Times* archives. Unseen and unpublished for decades, they are gathered together in this rare collection for the very first time.

Our photographers for *The Times* captured these scenes, and many, many more. They snapped pictures of pioneers in Hollywood and hip-hop and sports; prominent figures, such as James Baldwin, Thurgood Marshall and the Reverend Dr. Martin Luther King Jr.; and ordinary people, savoring the joys of everyday life.

They illuminate stories that were never told in the newspaper and others that have been mostly forgotten. Yet as you look at these images and read the stories behind them, you may find yourself wondering, as we did: How did they languish unseen for so long?

Were the photographs—or the people in them—not deemed newsworthy enough? Did they not arrive in time for publication? Were they pushed aside by words at an institution long known as the Gray Lady, or by the biases of editors, whether intentional or unintentional?

The reality is that all these factors probably contributed.

As journalists, we strive for objectivity and impartiality as we question and portray the world around us. Yet we rarely turn the lens on ourselves. At a time when concerns about the persistence of the racial divide simmer across the country, it is worth considering how we as an institution have depicted African-Americans in our pages and, at times, erased them from view.

The New York Times is known today as a leader in photography, with a team of staffers and freelancers who bring vivid pictures to our readers from war zones in Afghanistan and the Middle East, elementary schools in Harlem and county fairs during hotly contested presidential campaigns. The newspaper has won nine Pulitzer Prizes for photography, seven of them in the 2000s.

But we have not always valued images so highly.

HOW DID THESE PHOTOGRAPHS LANGUISH UNSEEN FOR SO LONG?

For most of the twentieth century, *The Times* had only a small staff of photographers—the first was hired sometime after 1910—and nearly all of them were based in New York City. As a result, most staff photographs depicted local events, though *The Times* also bought pictures from freelancers and studios in other parts of the country and overseas. (*The Times*'s picture agency, Wide World News Photo Service, which had staff members in London, Berlin and elsewhere, was sold to The Associated Press in 1941.)

In those early days, we put a premium on words, not pictures, which meant that many photographs that were taken were never published.

It's likely, however, that some holes in coverage reflected the biases of some editors at *The Times*, which has long been known as the newspaper of record, who determined what was newsworthy and what was not, at a time when black people were marginalized in society and in the media.

After months of searching through our archives, we could not find a single staff photograph of the scholar W.E.B. Du Bois or Romare Bearden, one of the country's pre-eminent artists, or of Richard Wright, the influential author of *Native Son* and *Black Boy*. (*The Times* did publish a handful of photographs of these men taken by freelancers, friends or private studios.)

Sarah Lewis, an assistant professor of History of Art, Architecture and African-American studies at Harvard University, said this is no surprise, given the nation's long history of demeaning and ignoring the visual narratives of black people.

In the nineteenth century, when photography was born, scientists used photographs to support racist theories of white superiority. The camera became "an instrument of denigration," Lewis said, as pictures of slaves were taken to try to prove that blacks were a separate and subhuman species.

At the same time, though, black photographers were using their cameras to depict what the white world so often failed to see: the beauty in their communities. Frederick Douglass and Du Bois believed that African-Americans could harness the power of the new technology to capture the dignity and accomplishments of black people and document events that would otherwise go unrecorded.

Douglass, the runaway slave, abolitionist and statesman, argued that "the moral and social influence of pictures" was even more important in shaping national culture than "the making of its laws."

Pointedly challenging the notion of black inferiority, Du Bois displayed photographs of black businessmen, craftsmen, homeowners, clergymen, university students, musicians, laborers and well-dressed men, women and children of all hues at the Paris Exposition in 1900. He noted that the "Negro faces" he presented at that world fair "hardly square with conventional American ideas."

"It was important to create a new vision," said Deborah Willis, who chairs the Department of Photography and Imaging at New York University's Tisch School of the Arts, of Du Bois's efforts.

"It was about power," said Willis, who has written about Du Bois and the Paris Exposition. "Images are both empowering and disempowering."

That holds true, even in modern times, as concerns remain about media outlets that continue to view communities of color primarily through the lens of criminality and social dysfunction. One photograph in this book brings that point home: It depicts black demonstrators protesting outside *The New York Times* in 1971, complaining that the newspaper was more interested in reporting on "black violence" than on "black productivity."

But this extraordinary trove of rediscovered images reveals that our photographers captured far more than that.

They were witnesses to history, capturing the bullet holes in the Chicago apartment where Fred Hampton, the Black Panther leader, was killed by the police; the hopeful faces of two children—one black and one white—in an integrated classroom in New Jersey; and a rare image of Martin Luther King Jr. during a visit to New York City.

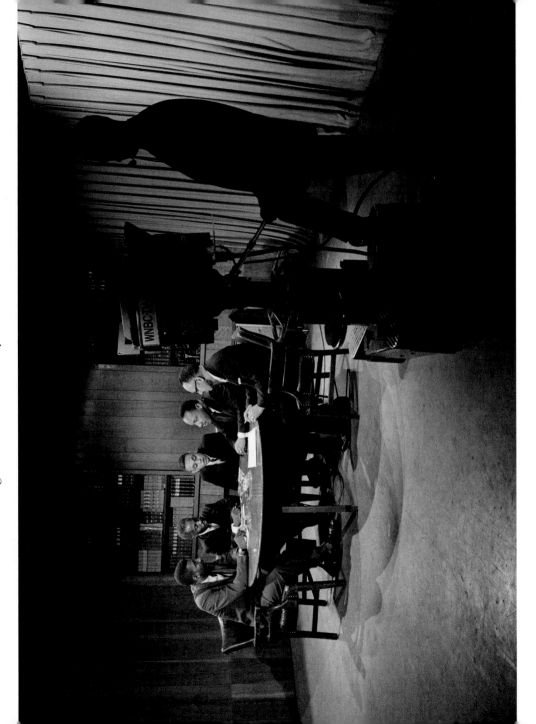

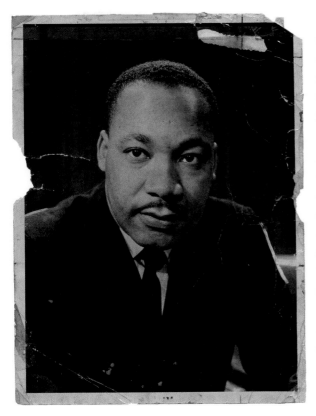

Consider the close-up of King and what it reveals about what we know and think we know about how images are made and edited. The photograph has appeared many times over the past fifty years, as date-stamps on the back of the print clearly show, and it looks as if it might have been taken during a formal sitting.

That was not the case. It was instead taken on June 30, 1963, as King participated in a roundtable that was broadcast on NBC, a period of relative calm in an otherwise tumultuous day when black protesters hurled eggs at King as he arrived at a church in Harlem. Earlier, he had criticized black nationalists, saying that those who called for a separate black state were "wrong." Some believed that those remarks inspired the attack that night.

Our photographer, who went uncredited, captured images of the NBC discussion, and an editor later cropped one of them to create the close-up of King that is now so familiar—and so disconnected from the turbulent events of that day.

Many of the other photographs, and their stories, are equally intriguing. But the collection, featuring both photographs and stories that were part of an online Black History Month project at *The Times* in 2016, and dozens of new images never published until now, is far from comprehensive.

Our archive is vast. It contains ten million prints—roughly half of which are believed to have been taken by staff photographers—and more than 300,000 sacks of negatives. The filing was sometimes idiosyncratic, so additional images may still be unearthed.

The photographs that have already emerged offer revealing glimpses of historic moments and a glorious array of people who are at times joyful, heartbroken, outraged, purposeful and, finally, visible.

Sarah Lewis says there is "an aspect of redemption" to this kind of work. As journalists, we view it as simply doing what we should always strive to do: bringing diverse faces, voices and stories to our readers, in all of their fullness and complexity.

UNSEEN

PROTESTERS AT
THE TIMES

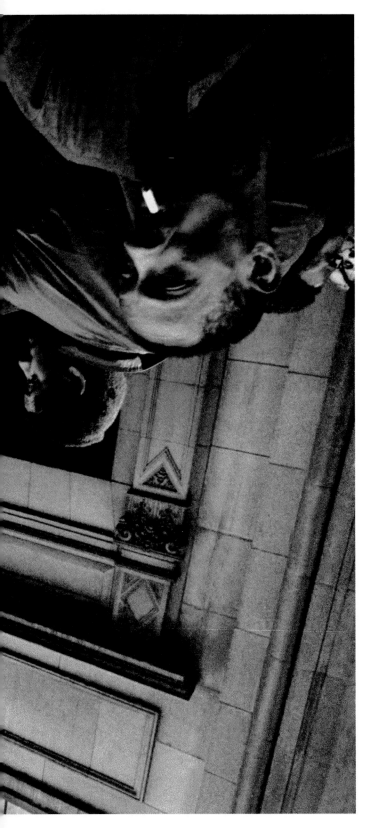

One would have to look closely at the protest photo-
graphs to tell that the scenes were from another era.
There were no selfies or videos being shot, of course.
And perhaps the hairstyles and dated eyeglasses
might give away the time period. Yet the photo-
graphs of protesters taking their outrage to *The Times*
(and to the streets, in 1971) are eerily familiar.

It was early May that year when *The New York
Times* became a part of the protest story. Dozens of
supporters of a group called the National Economic
Growth and Reconstruction Organization (NEGRO)
demonstrated outside the paper's headquarters to op-
pose the lack of coverage that week of a fire depart-
ment order to close a factory and job-training center
in Harlem operated by NEGRO.

The Times published a story on the demonstration
without running a photograph, though Ernie Sisto
shot a number of dramatic ones, shown here.

The fire department had ordered the factory
vacated due to what it described as "extremely
hazardous conditions" due to the lack of an
adequate stairway for the 250 people working in
there, the story of the protest said. In response,
the organization temporarily installed a mobile
staircase such as was used to board an airplane and
the order was rescinded.

The organization was given three weeks to build
a permanent staircase.

On the day of the protest, the organization's
president, Thomas W. Matthew, a neurosurgeon,
stood atop a car in front of *The Times* building and
criticized its coverage of NEGRO. He told the as-
sembled supporters that the newspaper was more
interested in reporting on black violence than on
black productivity.

Matthew had founded the group to support black
empowerment programs. He had gained notori-
ety the previous year when he and members of his

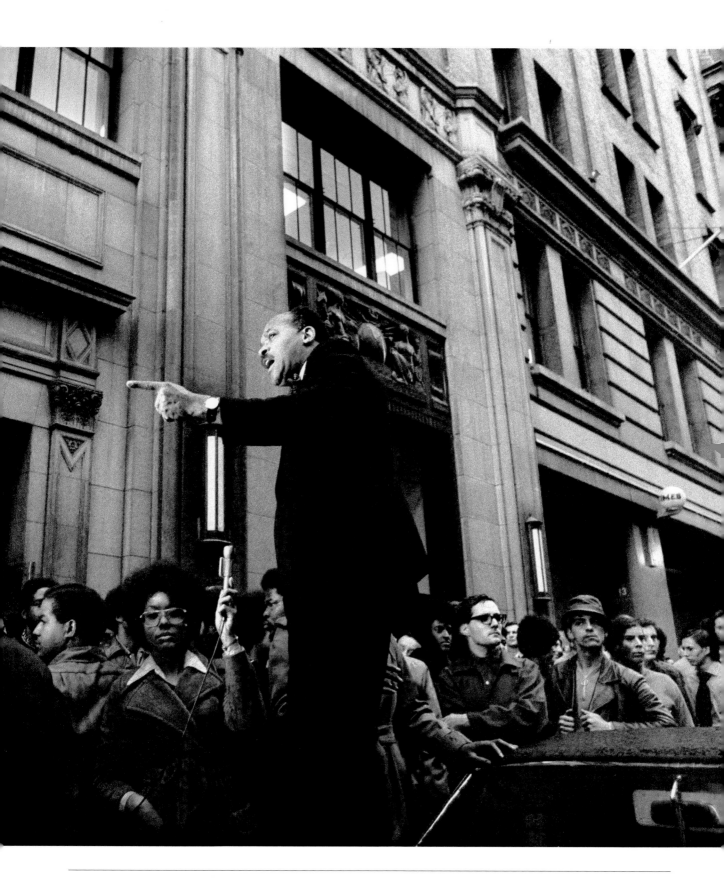

organization were given authority to take over Ellis Island for two weeks to set up a drug rehabilitation facility.

Regarding the group's complaints against *The Times*, Matthew eventually met with officials from the newspaper and recounted to his group that the meeting had been productive and that the editors had agreed to do more positive reporting on black accomplishments. The newspaper had also agreed to take part in a media study of self-help efforts in the black community.

A *Times* spokesman said at the time that Matthew was told that the news department believed that its coverage of NEGRO had been fair but that the paper would take his concerns under consideration. *The Times* stressed that it would not be intimidated— but added that it would, however, be responsive to legitimate complaints.

—DANA CANEDY

BURNING A SYMBOL, ARRESTED ON A TECHNICALITY

Racial tensions sometimes explode into view—in Harlem in 1964, in Newark in 1967, with the Black Lives Matter movement in our own era. But there are also smaller moments that are often overlooked and then forgotten, even when they reveal the double standards of justice.

On May 16, 1967, the Reverend A. Kendall Smith was arrested for burning an object in City Hall Park in Manhattan—a Confederate flag. At the time, white protesters rallying against the Vietnam War could often be seen torching the American flag, in many cases, without facing arrest or other legal consequences. In Central Park just a few weeks earlier, thousands of protesters gathered for a demonstration that included setting Old Glory ablaze.

Smith, however, was arrested for burning a different flag, one long associated with white supremacy, even though there was no law prohibiting it, and, as the photo shows, little danger, leading to the odd technicality of an arrest for unpermitted burning of an object.

The Times's John Orris was there, along with a small crowd that included the

police, but the small story the paper published did not include a photograph.

It was a confusing scene. Smith, a minister from Harlem who was the chairman of a group called Harlem Citizens for Community Action, was wearing a white sheet cut like a poncho, his version of a Ku Klux Klan uniform, according to Orris's notes, which are still in *The Times*'s archives. His notes also said the sheet was commandeered from a nearby hotel.

The cause for outrage, however, was clear. Reverend Smith said he had burned the flag to protest the "Southern" treatment of black residents in New York City. Noting the thirteenth anniversary of the United States Supreme Court's decision on school desegregation, he said he wanted to protest New York's lack of compliance with it—an issue that still resonates today as the city continues to struggle with a lack of diversity in many of its public schools.

—DAMIEN CAVE

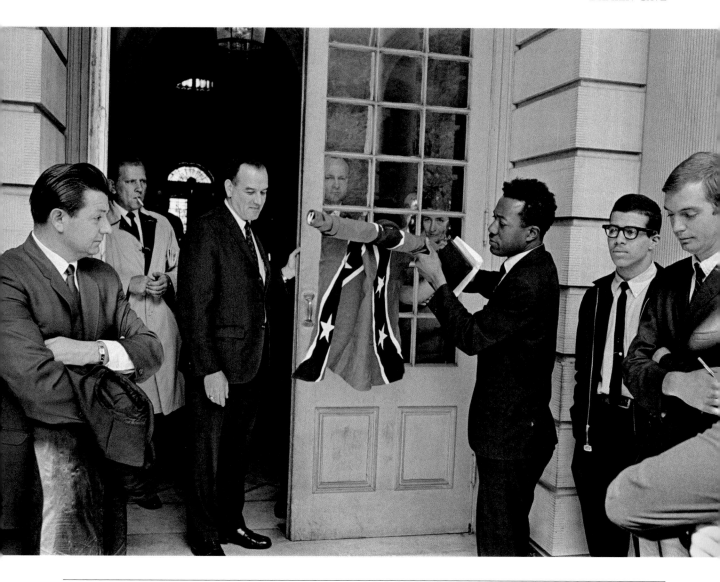

CLAUDE SITTON, REPORTER AND PHOTOGRAPHER

The copper-jacketed bullet tore through a civil rights worker's shoulder, stopping within an inch of his spine. The shotgun blast shattered the car windows of four voting rights activists and gouged the wall of a nearby home.

And a fire destroyed voter registration equipment and materials outside the city's voter registration headquarters, leaving the street strewn with rubble.

It was 1963 in Greenwood, Mississippi, a major battleground in the fight for civil rights, and white officials were playing down and ignoring a series of attacks intended to discourage thousands of African-Americans from registering to vote.

Claude Sitton, the renowned *New York Times* correspondent, shot photos and took meticulous notes, exposing the racial violence with his pen and with his lens.

Sitton is best known for his words. But the typewritten letters that he sent, along with his film, to John Dugan, a *Times* photo editor, reveal that he was also determined to capture history with his camera.

He carried a Leica, according to one of his sons, and wrote about light and shadows and underexposed frames. He lamented the gloom inside a crowded black church and the time constraints he faced as he scrambled to report the news and illustrate it at the same time.

"I didn't have very much time," Sitton wrote apologetically, "and will try to give you a better selection the next time I offer something."

Yet there is power in Sitton's plain-spoken letters and in the black-and-white images he captured on Tri-X film in March 1963. Shown together here, they offer a firsthand look at life on the front lines of the civil rights movement.

In one frame, Robert P. Moses, the field secretary of the Student Nonviolent Coordinating Committee, clipboard in hand, pointed to the holes left by the

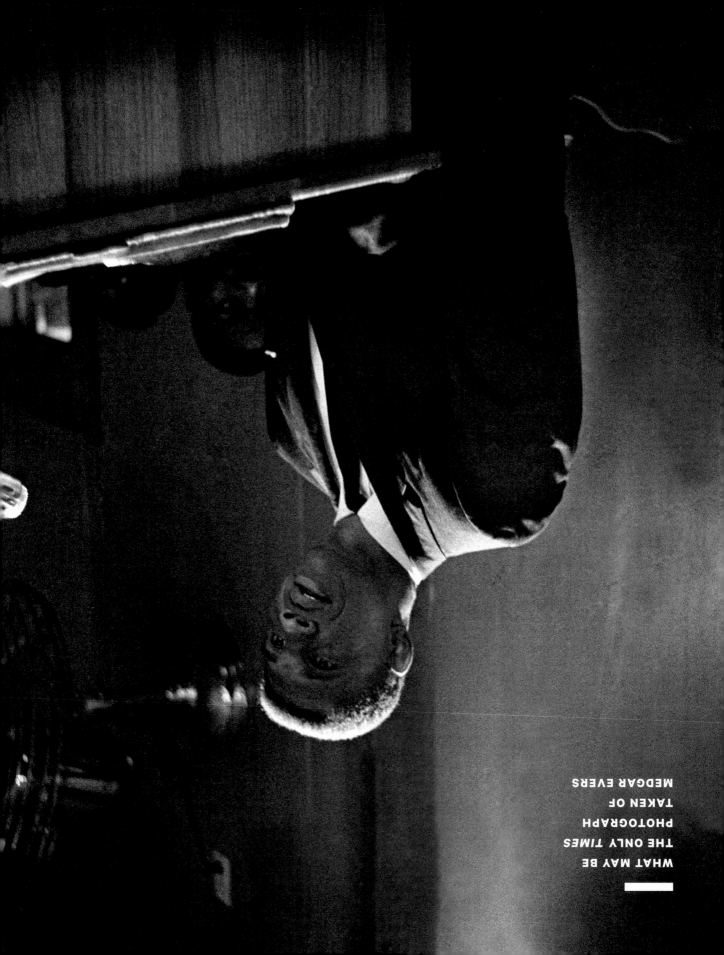

WHAT MAY BE
THE ONLY TIMES
PHOTOGRAPH
TAKEN OF
MEDGAR EVERS

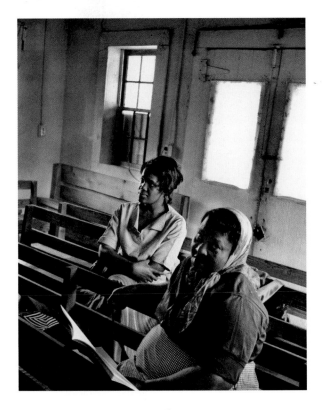

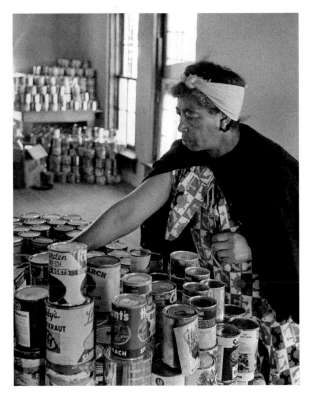

shotgun blast in the wall of a weathered home. In another, the charred detritus of the fire—set by a person or persons unknown—littered the street outside the old voting headquarters.

Medgar Evers, the state field secretary of the N.A.A.C.P., addressed a packed voter registration rally at the local African Methodist Episcopal Church in what may well be the only *Times* photograph taken of Evers.

In another series of images, black women took their seats in a citizenship training school intended to train volunteers to help register black voters, and another woman stacked cans of food in the Sunday school room of a local church. The food was collected in Chicago for hungry black farm workers in Greenwood, who had been denied federal food assistance by white county officials in retaliation for their voter registration efforts.

African-Americans accounted for sixty-one percent of the county's population. Yet only 1.9 percent of blacks of voting age were registered, compared with 95.5 percent of whites. The Justice Department, contending that whites were disenfranchising blacks with discriminatory voting laws, filed suit.

Justice Department officials also sought a federal court order to prevent the city and county from denying blacks the right to protest, after the police unleashed a German shepherd dog on peaceful marchers and jailed voting rights activists.

It was the first time that federal officials had taken such a step, Sitton noted in his article about Greenwood, which was published in April 1963. (Only three of the many photographs that he took during his time there were published.)

But with every step forward, it seemed, there were several steps back. Two months later, on June 12, 1963, an assassin shot and killed Evers in front of his home in Jackson, Mississippi.

That afternoon, hundreds of African-Americans took to the streets in protest. And Claude Sitton was there with his pen, his notebook and his camera.

—RACHEL L. SWARNS

Mr. Dugan:

John:

 You might get a couple of usable prints off this roll to
illustrate the Greenwood, Miss., VOTE story, which National is
holding for the first big paper. It's undeveloped Tri-X. The
exposure on Frames 1-6 should be okay but 7-11 may be underexposed
because they were shot inside a room with only natural light from
windows. Further, the subjects are very dark-skinned. XXXXXXX As
I told you, I didn't have very much time and will try to give you
a better selection the next time I offer something.

FRAMES 1 & 2: Robert P. Moses, chief of the Negro voter registration
campaign in the Mississippi Delta points to holes XXXXXXX gouged into
the side of a home in Greenwood by a shotgun blast. The charge of
buckshot passed through the two front windows of an automobile
occupied by four Negro voter registration workers before striking
the home, which is directly across the street from the XXXXX voting
drive headquarters in Greenwood. All were cut slightly by flying glass.

FRAMES 3 & 4: "I'm a man who has always been a race-pride Negro,"
says Cleveland Jordan (center), a 59-year-old part-time farm worker
of Greenwood. "I've been registered for 15 years and my first
voting was form Mr. Roosevelt. Jordan is shown talking with Robert
P. Moses, head of the Negro voter registration campaign in the
Mississippi Delta, in front of campaign headquarters in Greenwood.
Man on left stopped to listen and asked a newsman if he could help
him obtain a birth certificate.

FRAMES 5 XXXX : Hollis Watkins XXXX, a Student Nonviolent Coordinating
Committee field secretary from McComb, Miss., works in the Negro
voter registration headquarters in Greenwood. He is one of more
than twenty persons brought into the area to assist in the campaign
after four major civil rights organizations declared LeFlore County
"a testing ground for X democracy."

FRAME 6: A clerical worker in the voter registration headquarters
in Greenwood.

FRAMES 7 thru 11: Scenes from a Citizenship Training School being
conducted in Greenwood as part of the voter registration campaign
by Miss Annell Ponder of Atlanta, field supervisor for citizenship
education for the Southern Christian Leadership Conference. (She
is the young woman with long hair dressed in open-necked blouse. The
Older Negroes are being trained as teachers who will then set up
citizenship classes for prospective Negro XXXX registrants.)

 Sitton

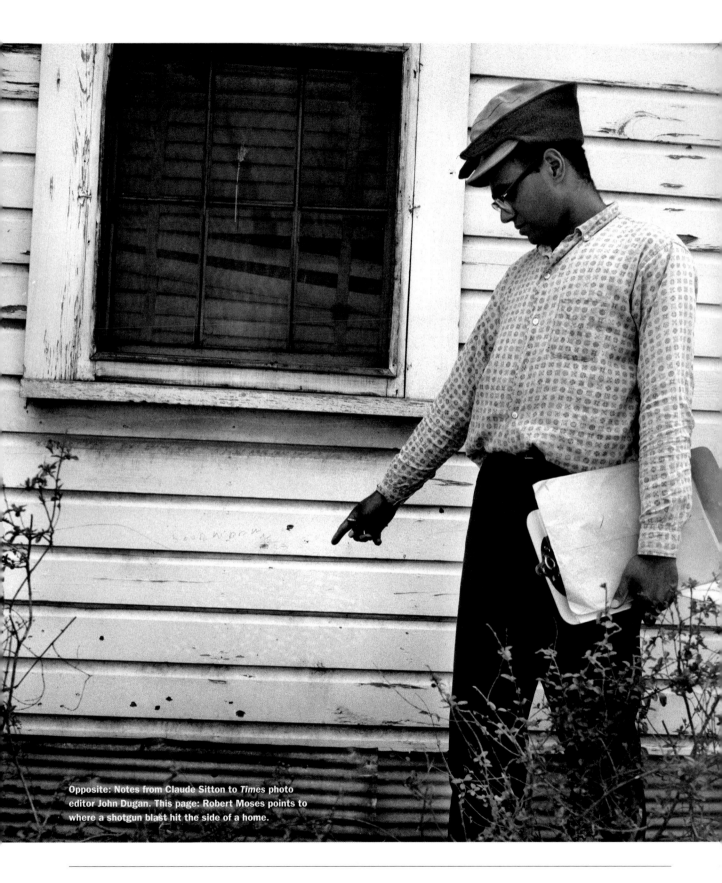

Opposite: Notes from Claude Sitton to *Times* photo editor John Dugan. This page: Robert Moses points to where a shotgun blast hit the side of a home.

KING OF THE RING:
LARRY HOLMES IN A
DIFFERENT ROLE

During his seven-year reign as a heavyweight boxing champion, Larry Holmes often put on a show, defeating the likes of Earnie Shavers, Ken Norton—for the World Boxing Council title in September 1978—and the ultimate showman, Muhammad Ali.

In June 1979, Holmes took his talents to Broadway, joining the actor Danny Aiello for a once-in-a-lifetime sparring session inside a small ring atop the stage of the Helen Hayes Theatre, where Aiello was starring in a play entitled *Knockout.*

Holmes, then preparing for his W.B.C. title defense against the unheralded Mike Weaver, was making his Broadway debut as a way of helping to promote the fight, which was drawing little interest from television networks.

Aiello also welcomed the publicity stunt as a way to boost ticket sales for *Knockout,* which had been sagging since it opened two months earlier.

During the sparring session, Aiello pretended that a hard right hand from Holmes had caught him squarely on his chin and went crashing to the canvas. Many in the audience gasped until Aiello hopped back on his feet, assuring everyone that he was never really hurt.

"I look back at that day as one of the top highlights of my career," said Holmes, who retained the W.B.C. title until 1983, when he relinquished it to become champion of the newly formed International Boxing Federation.

"In fact, I would place that day third on my list of greatest career moments," he added. "I rank it right behind beating Ken Norton for the title and defeating Gerry Coouey a few years later."

When his sparring with Aiello was done, Holmes draped a white towel around his neck and began talking to audience members. That photograph—taken

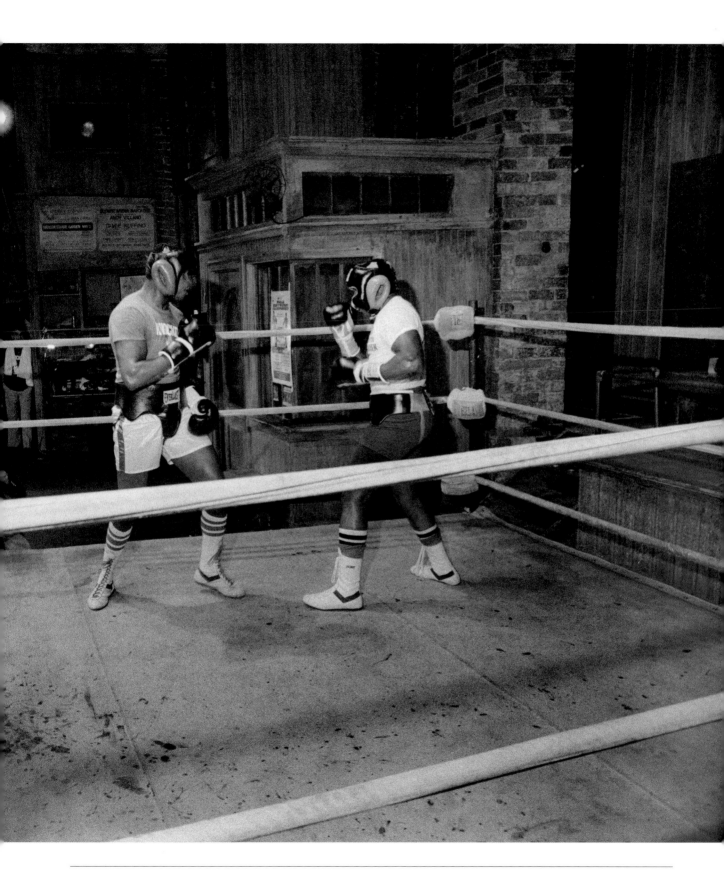

by Marilynn K. Yee of *The Times*—was never published, though Holmes wished it had been.

"A lot of people, especially some New York sportswriters, didn't like me, even though they really didn't know me," he said. "Maybe if they had seen that photo of me having a pleasant talk with the audience about the kind of discipline it takes to become a champion, then maybe those writers, and their readers, would have looked at me in a more friendly and positive light."

Aiello, who said that Holmes's appearance that day "gave ten more months of life to our struggling production before it was finally canceled," agreed that the photo of Holmes might have enhanced his public persona.

"Larry put on such a great performance that day," the actor recalled. "His wonderful personality was on full display, and so was his generosity, as he took the time not just to talk to the audience, but to promote both his fight and our theatrical production, and it would have been nice for people to see some of that interaction."

—VINCENT MALLOZZI

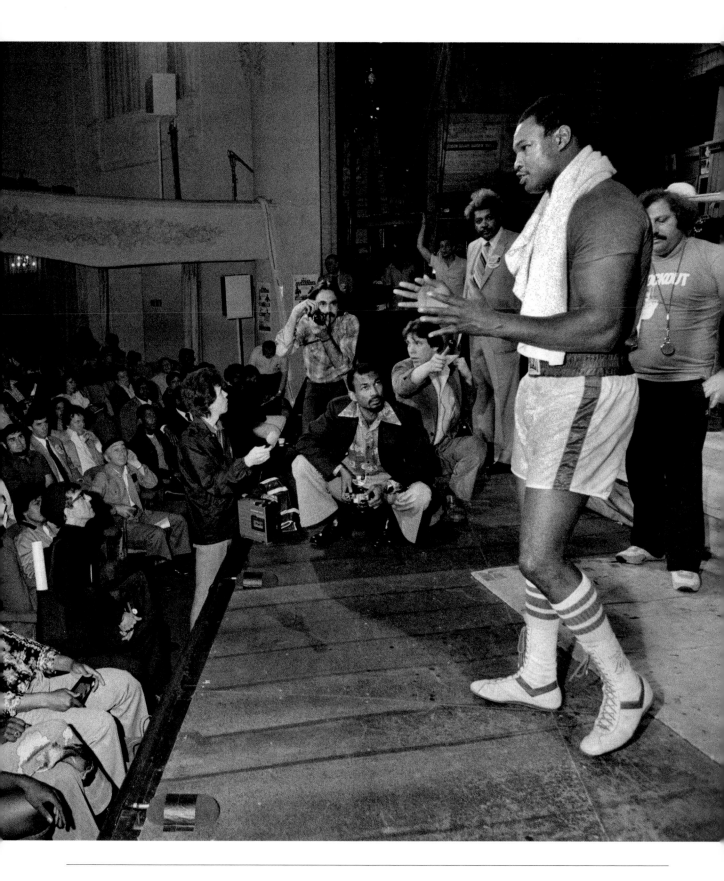

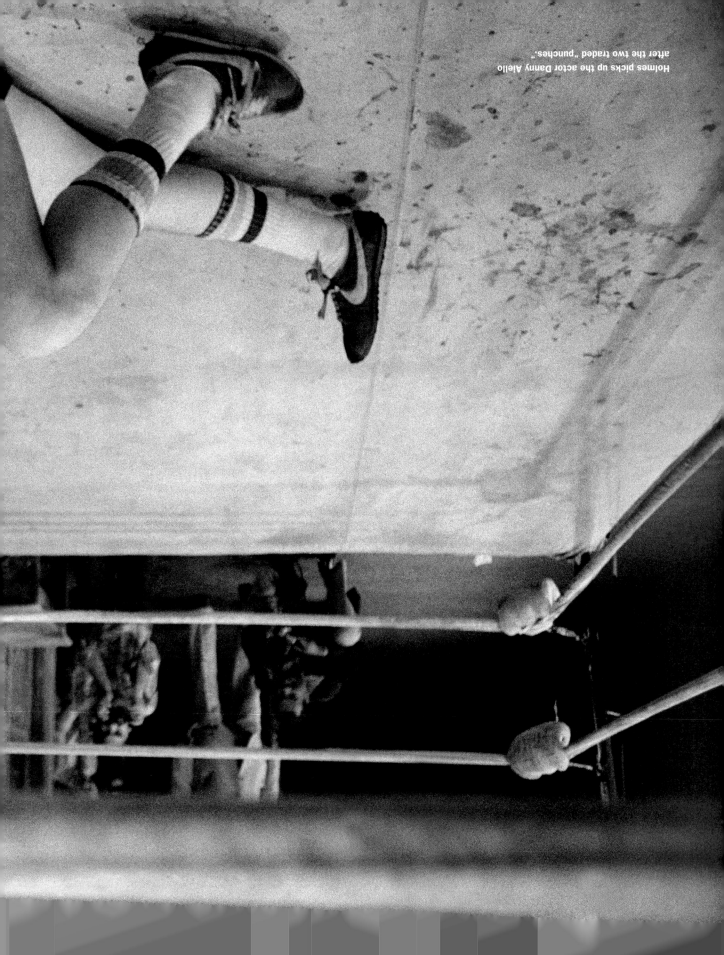

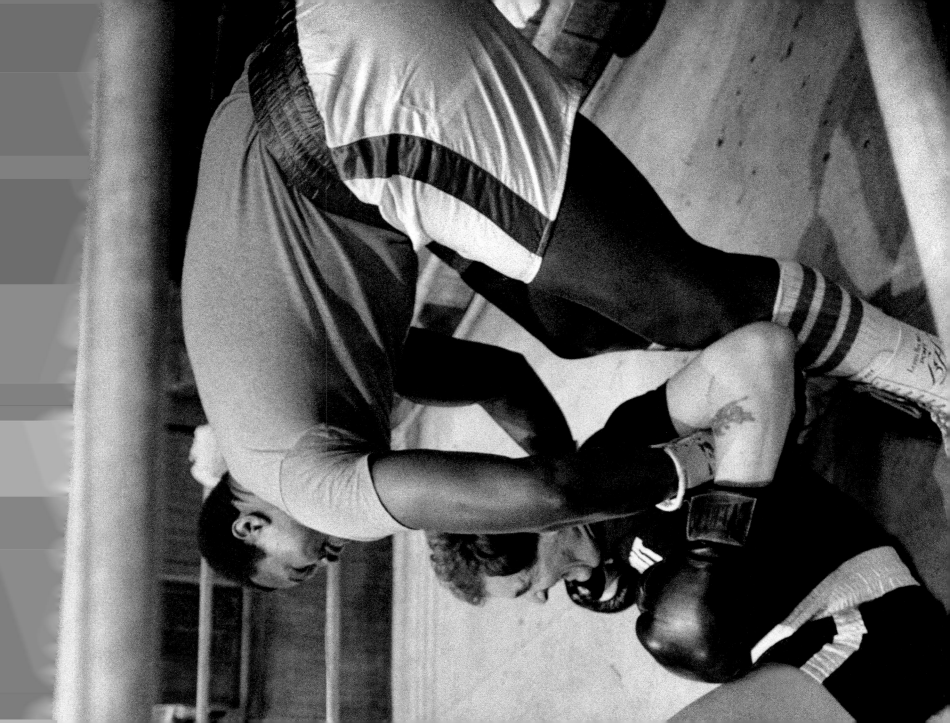

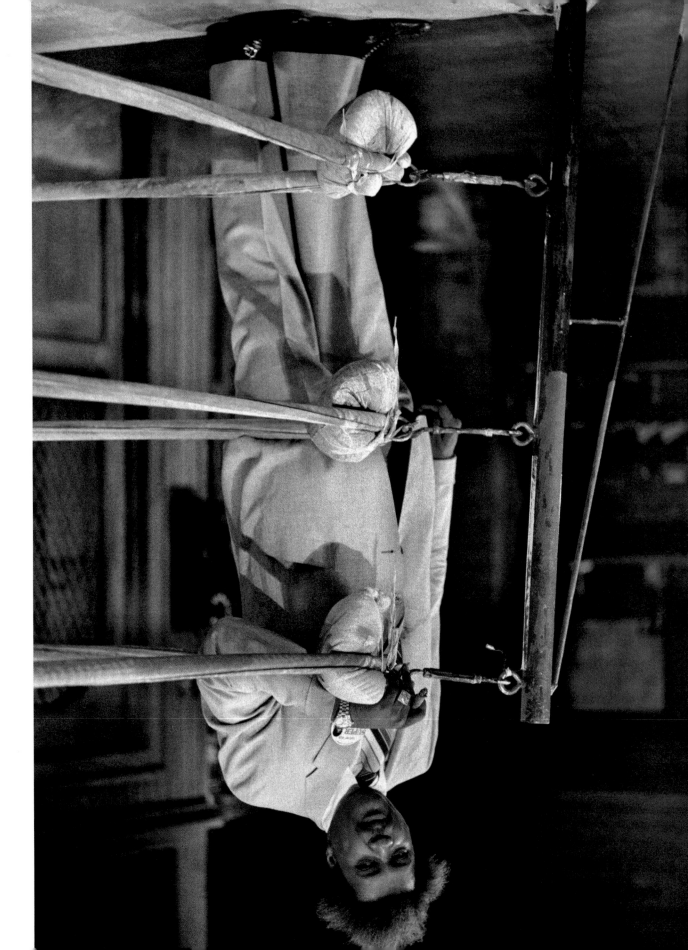

DON KING GOES QUIET

The boxing promoter Don King was never at a loss for words. Presiding over press conferences the way a ringmaster presides over a circus, he fueled controversy—and ticket sales—while putting together multimillion-dollar bouts for a stable of marquee heavyweights that he promoted, including Muhammad Ali, Joe Frazier, George Foreman, Larry Holmes and Mike Tyson.

But in this photo from June 7, 1979, which was taken by Marilynn K. Yee of *The Times* on the very same day she captured Holmes sparring with the actor Danny Aiello and later chatting with their audience at the Helen Hayes Theatre, King appears to have nary a thing to discuss. Dressed in a gray suit, his trademark hairstyle standing at attention, he leans quietly against the ropes in a corner of a small ring that was part of the set used in the play *Knockout*, which starred Aiello.

"What's great about that picture is that it might be the only one ever taken of Don with his mouth shut," Holmes said, laughing.

Indeed, it was a rare subdued look for King, who by then had already orchestrated boxing's two most historic events. "The Rumble in the Jungle" in Kinshasa, Zaire, 1974, pitted Foreman, the undefeated world heavyweight champion, against Ali, the former champion who was now challenging for the title. And "The Thrilla in Manila," the third and final match between Ali and Frazier, in Cubao, Quezon, the Philippines, was fought in 1975 for the heavyweight championship of the world.

Ali won both fights, beating Foreman by knockout just before the end of the eighth round to regain the heavyweight title, and Frazier the following year by technical knockout just before the start of the fifteenth round.

In 2006, *Forbes* estimated that King had promoted some 600 title fights and generated a net worth of $350 million over his storied career.

"In my book, Don King is the greatest promoter that ever lived," Holmes said. "He brought big money into the game of boxing, and set up so many must-see fights with all of the big-bangers he represented."

King, now in his mid-eighties, is a controversial figure who has been sued by a number of fighters. "I had a few problems with him myself," said Holmes.

But, he added, "No matter what anyone said about him, he was the promoter everyone wanted to do business with, because everyone knew he was going to get them the biggest payday."

—Vincent Mallozzi

HE WAS THE PROMOTER EVERYONE WANTED TO DO BUSINESS WITH

MARTINA ARROYO'S STAR RISES AT THE MET

The distinguished American soprano Martina Arroyo, now 80, sang her last performance at the Metropolitan Opera nearly thirty years ago.

But in this previously unpublished Sam Falk photo of her backstage in 1965, during her run as the formidable heroine Elizabeth of Valois in Verdi's *Don Carlo*, she looks aptly regal and in character, yet a little amazed: a young New York artist on the brink of what became a major Met career.

It started slowly.

Born in Harlem, the daughter of a Puerto Rican father and an African-American mother, Arroyo made her debut in 1961 in a small role, the Celestial Voice in *Don Carlo*. During the 1961–62 season, she proved a trouper at the company by singing various supporting roles in Wagner's *Ring* cycle, including the Third Norn, Woglinde the Rhinemaiden and Ortlinde the Valkyrie.

After a three-year absence, her Met breakthrough came in February 1965, when she sang her first *Aida*. That October in *Don Carlo* she stepped way up from the Celestial Voice to Elizabeth of Valois.

Her performances came just ten years, almost exactly, after Marian Anderson broke the color barrier at the Met in 1955, singing Ulrica in Verdi's *Ballo in Maschera*. In 1961, Leontyne Price, another pioneering black artist, made a high-visibility, high-pressured Met debut as Verdi's Leonora and quickly became a company star.

Arroyo had worked her way into the ranks more slowly, drawing less initial attention to her talent, which makes it especially wonderful to see this lovely and historic photo unearthed for all to see.

In all, she would sing some 200 performances at the Met. Today, Arroyo still contributes to opera by running the Martina Arroyo Foundation, which presents young singers in thoroughly prepared and staged productions of central repertory works. She remains an inspiring role model to emerging artists.

—ANTHONY TOMMASINI

IN ALL, SHE WOULD SING SOME 200 PERFORMANCES AT THE MET

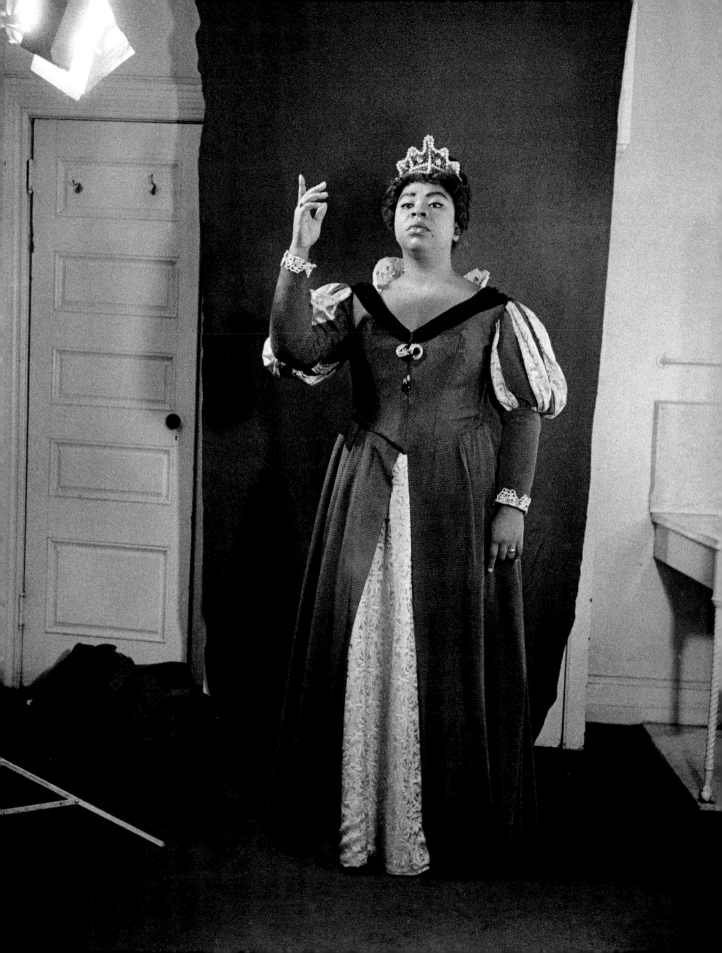

OPENING OF A MUSLIM SCHOOL AND MOSQUE

Such pristine style: white skirts and blouses, white head coverings. Such urban surroundings: the cracked sidewalk, the metal gates.

It was a juxtaposition that, while imperfect,

revealed both the heart of New York and the heart of Tyrone Dukes. He was a *Times* staff photographer for just a few years, from 1974 to 1979, and he made his mark with a mix of spot news and style photography (he shot the Aretha Franklin image that appears elsewhere in this book)—interests that can both be found in this outtake from a shoot in 1970 at the

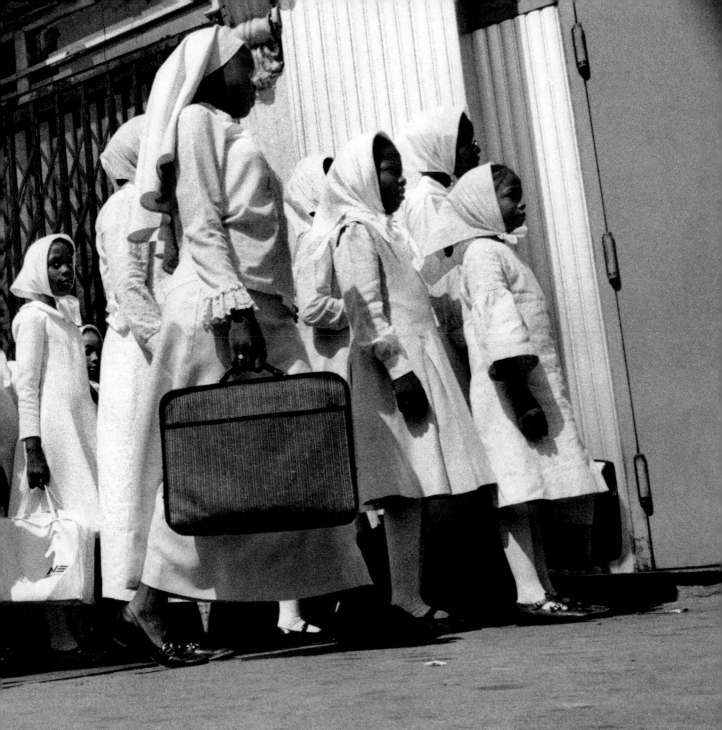

Harlem mosque that replaced one that had burned down following the assassination of Malcolm X.

When Dukes took this photograph, he was not yet twenty-five; at thirty-seven, he died of a liver ailment. And in between he found a way to make a mark with an eye for patterns and style, on any assignment.

While the image here was not used, the photographs that *The Times* published included shots of the building's exterior and activities in the classroom—and signs with messages of uplift, including one that said "Fashion, black man. Produce. Create. Earth first. More jobs for self."

—DAMIEN CAVE

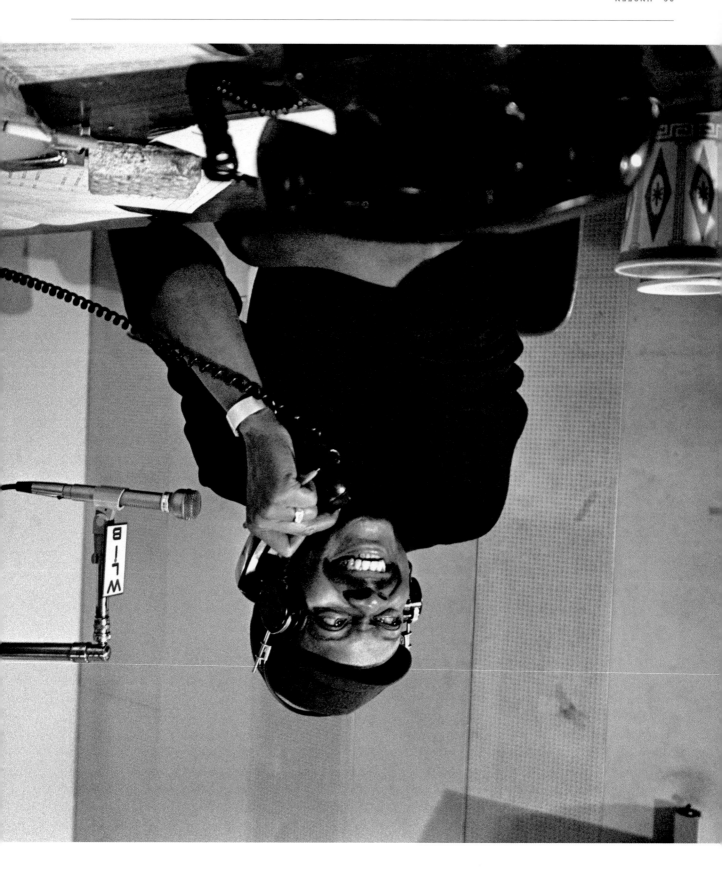

EDDIE O'JAY, DISPENSER OF SOUL MUSIC AND WISE WORDS

"Every morning, with a jazz organ grooving in the background, Eddie O'Jay's gravelly voice woke up New York with good gruff humor." So wrote Nelson George in his long-running column on black music in *Billboard*.

Like thousands of other fans, George felt O'Jay fulfilled the greatest roles of a disc jockey—as taste-maker, raconteur and community connector. Appropriately, the jovial photo of O'Jay shot in November 1968 by Eddie Hausner of *The Times* (but never published in the paper) shows him conversing by phone with a listener on his beloved program, *The Funk Show*. A mix of music, opinion and wisdom, *Funk* ran for years on New York's storied black radio station, WLIB.

While O'Jay first began D.J.'ing in 1949, he didn't become a force in black radio until the mid-fifties with a show on Cleveland's WABQ. He modeled his style on that of Al Benson, whom he had heard spinning records in Chicago. "He wasn't pretending to be white," O'Jay said of Benson in an interview with George for his book *The Death of Rhythm and Blues*. "A lot of jocks tried to sound white. I could never do that. You knew right away when you heard me that I was black. It was just a natural thing."

O'Jay's frank style made a deep impression on a soon-to-be-important group of young Ohio-based singers. That trio not only hired him as their manager in the early days, they adapted his last name: The O'Jays went on to record such iconic hits as "Back Stabbers," "For the Love of Money" and "I Love Music."

In 1961, D.J. O'Jay took his talents to Buffalo's WUFO, where he worked alongside other soon-to-be-iconic black spinners such as Frankie Crocker and Gary Bledsoe. New York talk show host and D.J. Imhotep Gary Byrd, who grew up in Buffalo, cited O'Jay as the first black voice he heard on the radio. "He hit that town like a tornado," Byrd later said.

O'Jay had the same effect at New York's WLIB. "Eddie was a master," said Frankie Crocker at a memorial service for O'Jay, who died in April 1998. "He's the reason I went into radio."

Held at St. Peter's Church in Manhattan, the service drew stars such as Sarah Dash of Labelle, politician Percy Sutton and the Reverend Calvin Butts, who delivered the eulogy. In his speech, Butts recalled O'Jay's signature lines: "Don't lose your head. You need your head. Your brain is in it."

"He influenced my life with his sayings and the music he played," Butts said.

—Jim Farber

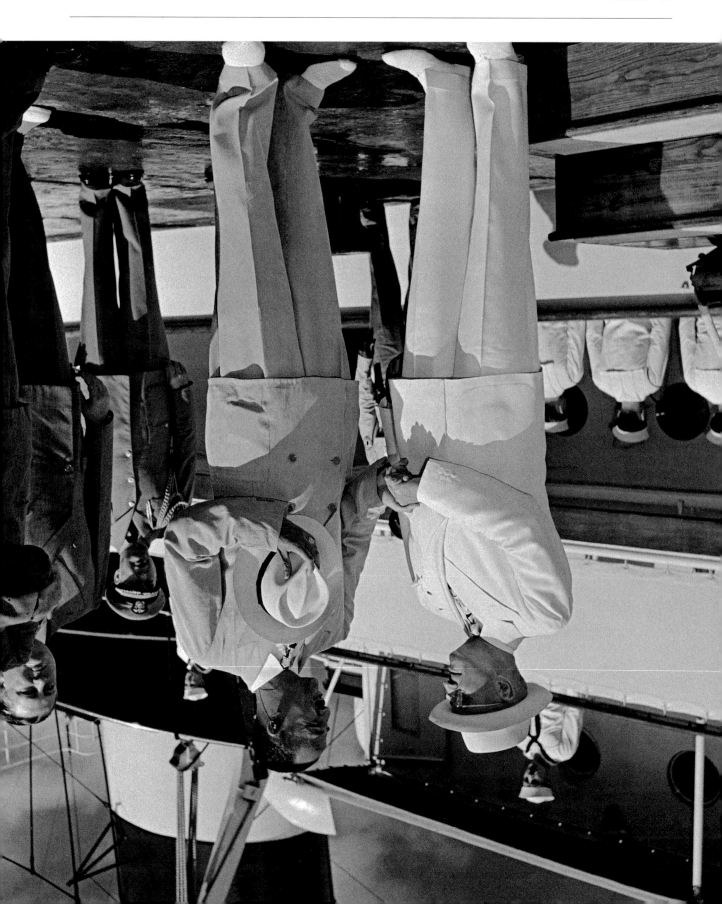

WILLIAM H. HASTIE MEETS TRUMAN

When President Harry Truman arrived in the Virgin Islands in February 1948, he was greeted as a "champion of human rights"—in part because of his role in elevating the man whose hand he is shaking here. William H. Hastie was the first black governor of the islands, and he was appointed by Truman.

Hastie was originally from Nashville. But after graduating from Amherst College and Harvard Law School, he served in the Virgin Islands as a federal district judge from 1937 to 1939. During World War II, he was a civilian aide to Henry L. Stimson, the Secretary of War, but resigned in 1943 over what he described as obvious discrimination within the Army Air Forces.

"The simple fact is," he said, "that the air command does not want Negro pilots flying in and out of various fields, eating, sleeping and mingling with other personnel, as a service pilot must do in carrying out his various missions."

His appointment as governor seemed to suggest that Truman did not hold his activism against him. But it's interesting to note that the photograph by George Tames that was published with *The Times*'s story about the president's visit showed the two men standing side by side—but not shaking hands.

—DAMIEN CAVE

SAMMY DAVIS JR. LEADS THE PACK

The image comes from a 1967 concert at Madison Square Garden hosted by a group fighting defamation against American Italians: they rejected the term Italian-American because they said they were American first.

That article mentioned Sammy Davis Jr. only in passing. We never published a photograph of the show. But Michelle V. Agins, a Times staff photographer who knew Davis, recalled that he and the Chairman of the Board, Frank Sinatra, later struggled to get along. At one point, Sinatra failed to appear for an African-American cause dear to Davis. A lightly edited version of Damien Cave's conversation can be found here.

Q. So when you look at this image, what comes to mind?

Well, that must have been when they were getting along—he's in front, leading the Chairman!

The people I know, over at Patsy's, the restaurant, said they were fighting so bad in the late '70s that when the Chairman was coming there, Sammy, he'd go in another door because he didn't want to run into Frank; if one knew the other was there, they'd leave.

At that time of this picture by William E. Sauro, he felt like he was a brother to him.

But once when the Chairman was supposed to meet him in Chicago back in '82 for a fund-raiser to help children of color in the music industry—with instruments and stuff like that—the Chairman didn't show up. That's when I met Sammy. He said he was really upset because, he said, "This guy, he's like my brother, and he's letting me down." That was the quote he used. I remember. He was reserved in his disappointment, but his face spoke.

There was a closeness and kinship for them. When I see that picture, I think of them back then, when they were brothers, when they were boys.

Q. But what happened? Did Sammy play without Frank?

In Chicago, he still did that show by himself.

It was a group founded by Ben Branch—you know, the guy who was with Martin Luther King when he looked down and said, hey, I really want you to play "Precious Lord"—that's Ben.

Q. That was right before King was shot and killed. And Sinatra never showed up in Chicago?

Nah, his people kept saying, "Oh, he's coming, he's coming." But it didn't happen.

Q. What was your own rapport with Sammy like?

I used to make fun of him—for being so little. I was friends with his manager.

Q. Did he talk like he sang?

Talking, he had that Rat Pack voice. He was totally a dude. But when he sang, his voice was amazing. It could tumble buildings. All of that came out of him. All of it.

—DAMIEN CAVE

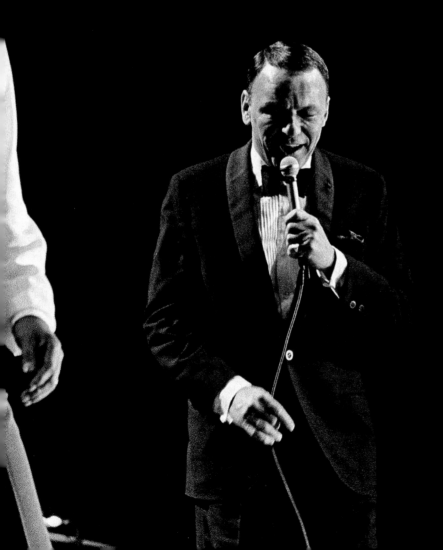

DOMESTIC PEACE CORPS HELPING SENIORS

When *The Times* presents images of public service confronting struggle, we attempt to forge a connection: We pick who you will see and hear based on import, yes, but sometimes that's woven in with what's most likely to make people care.

Often, that means we show children—and that's probably why you've never seen this image from a senior citizen program at Harlem's Salvation Army headquarters. It was shot by Eddie Hausner for a front-page story on July 2, 1963, about a pilot program for a "Domestic Peace Corps." There were twenty-seven volunteers dispatched to Harlem that summer to work in a number of different roles—in hospitals, schools, churches and senior centers—but the two photos we published showed volunteers interacting with children.

They were strong images—one in a classroom, the other showing a young volunteer interviewing families about sending children from large families to a summer camp. But this unpublished image also showed an element of the program that the others did not; it showed partnership.

Many of the volunteers, the story said, "were drawn from Negro colleges in the South" and in all of the assignments, the volunteers worked alongside professionals to provide help in understaffed agencies. In this case, that meant two Peace Corps women, Bessie Wright of Benedict College in South Carolina smiling in the foreground, and Mary Leach of New York City singing in the background, were singing along with Eva Jessye on the piano. Jessye was the group's chairwoman, or "chairlady" as Hausner wrote in his notes that made their way to *The Times* morgue.

At its core, the program—which led to the creation of a national service program called Volunteers in Service to America or VISTA in 1964, as part of Lyndon B. Johnson's War on Poverty—was less about charity and handouts than about bolstering and supporting the work of those already there. That was then, and it still continues to be a model for assistance that all too often ends up overlooked or forgotten. Just like this photo, unearthed from our archives.

—Damien Cave

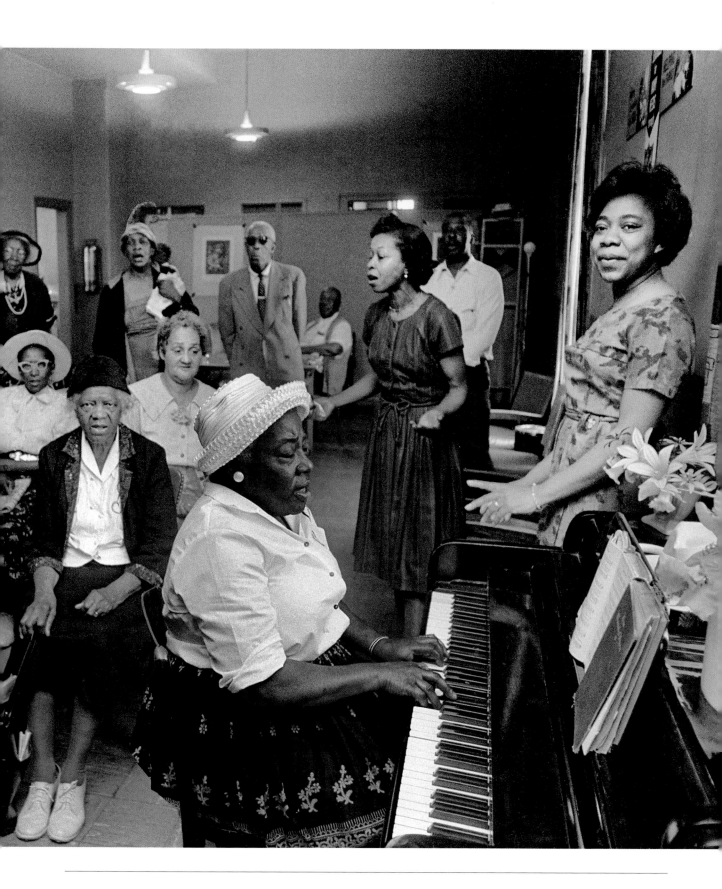

CHARLES EVERS FOR MAYOR

Tuesday, May 13, 1969, Charles Evers won the Democratic primary for mayor of Fayette, a "drowsy little town" in the southwest corner of Mississippi, as *The New York Times* described it, noting that his triumph marked "a significant achievement" in the "citadel of white supremacy" that was then the Magnolia State.

Significant indeed. The victory of Charles Evers, who was then forty-six and would be unopposed in the June 3 general election, seems in retrospect to have been one of those "before and after" moments in history, as these photographs, taken by Don Hogan Charles of *The Times*, make clear.

The photographer spent several days with the

**MOST IMPOR-
TANT, BLACK
PEOPLE ARE
STANDING IN
LINE WITH WHITE
PEOPLE TO VOTE**

Evers campaign, taking hundreds of pictures as primary day drew near, on voting day itself and immediately afterward. We see Evers in thankful contemplation in church at the far left the morning after. His younger brother, Medgar, a civil rights leader slain by a white supremacist five years earlier, must be in his thoughts.

We see pictures of the Evers campaign headquarters and of stores and homes. We see Charles Evers exhorting a crowd of supporters in a church. Most important, black people are standing in line with white people to vote. Charles Evers casts a ballot for himself. And after the polls close, the votes are counted, with lawyers from the Department of Justice looking on.

Such scenes, such events, had been scarcely imaginable in the Mississippi of the recent past. The victory of Charles Evers, and the triumphs of several other black office-seekers in Mississippi that year, were brought about in part by the Civil Rights

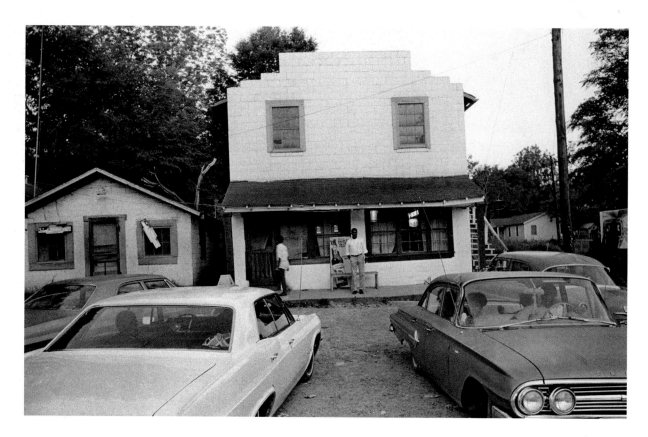

Act of 1964 and the Voting Rights Act of 1965, which allowed for federal supervision of elections in areas with a history of discrimination. They were also achieved by the patient, decades-long efforts of the National Association for the Advancement of Colored People. Charles Evers was for a time its field secretary in Mississippi, having taken over from his martyred brother.

Charles Evers was reelected mayor of Fayette in 1973, after running unsuccessfully for Mississippi governor in 1972. He was mayor until 1981, and again from 1985 to 1989. He also ran unsuccessfully for the United States Senate in 1978. A

Top left: Charles Evers in church the morning after the election. Bottom left: Campaign workers and journalists outside Evers Headquarters. Above: Downtown Fayette, Mississippi.

political pragmatist as well as an idealist, he was at various times a Democrat, an independent and a Republican and an adviser to presidents of both major parties. Ever his own man, Evers endorsed Donald Trump for president, with the hope that he would bring jobs to Mississippi.

That would not be completely out of character. Ninety-four years old as this is written, Charles Evers has always been quick to express his love for his country and his state, which he helped to change. As a black voter put it on the eve of that primary in 1969, "No matter what happens tomorrow, Mississippi will never be the same as it was yesterday."

—DAVID STOUT

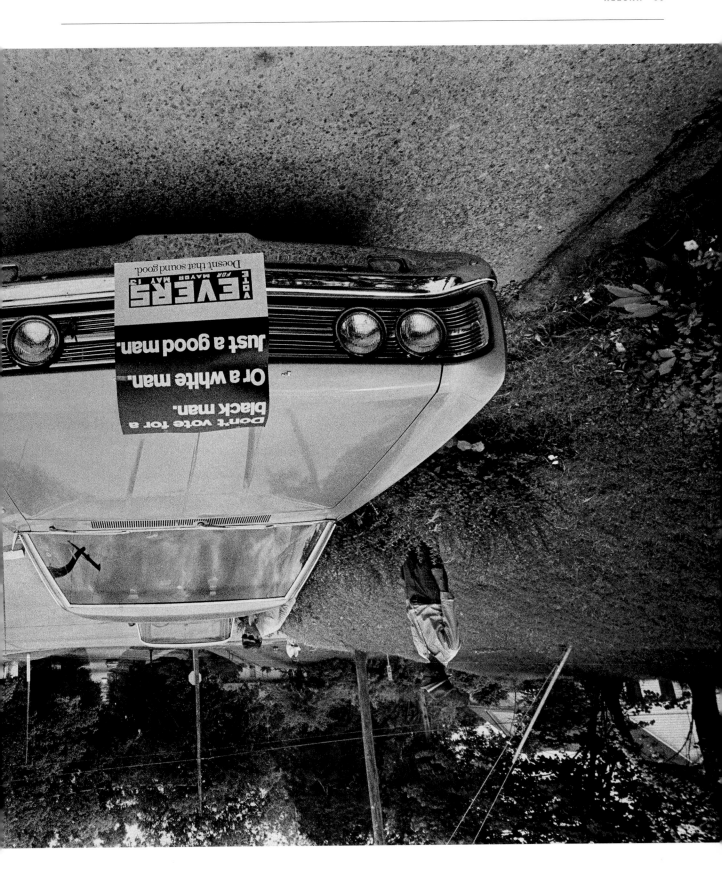

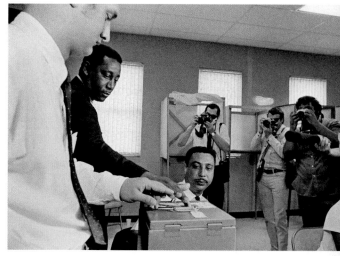

Left: An Evers Campaign poster. Top: Charles Evers casts his vote. Above: Tallies of the paper ballots being counted by polling administators at Fayette City Hall.

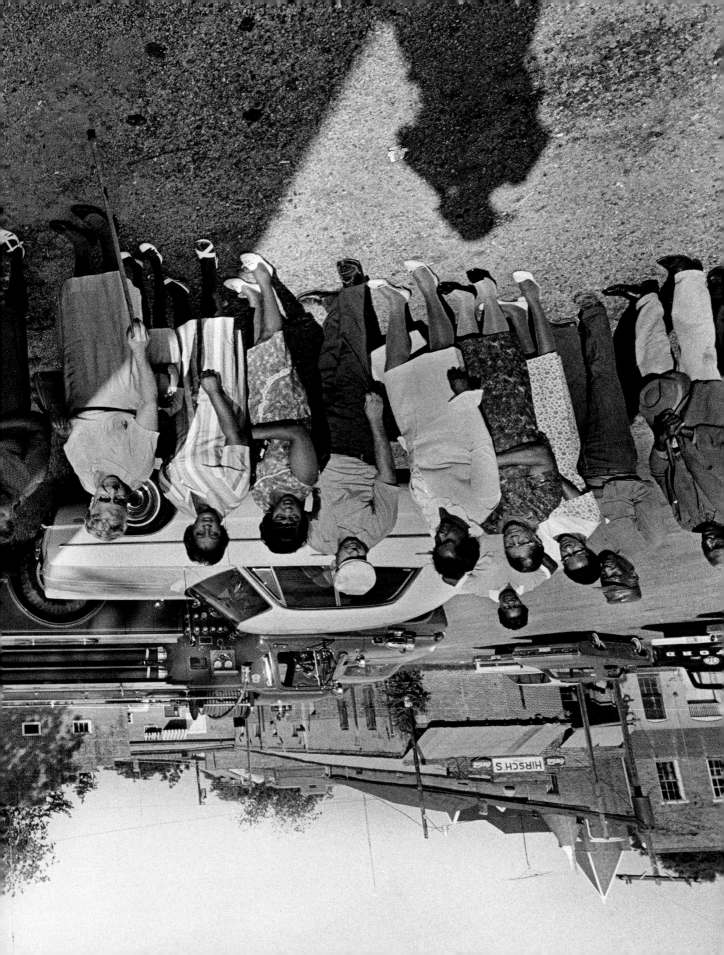

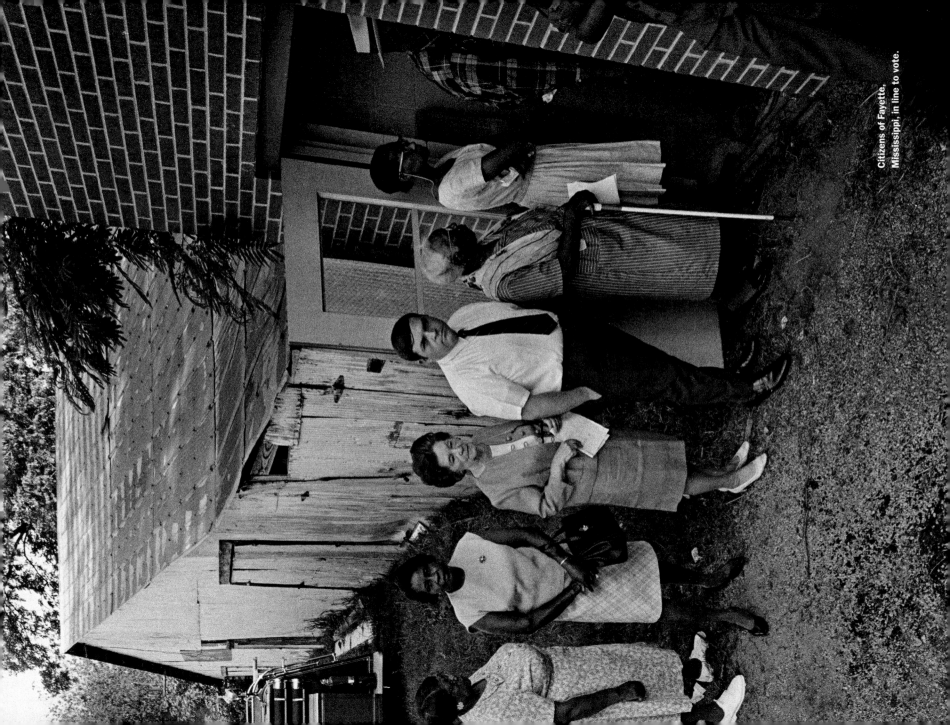

Citizens of Fayette, Mississippi, in line to vote.

SOUTHERN POLITICS AS USUAL

They ran businesses, school boards and newspapers. They were prominent planters and well-known politicians. They were genteel and respectable and, in the eyes of their white peers, eminently reasonable.

But these influential men and women also espoused virulently racist views. They were among the thousands of members of the powerful citizens' councils who banded together to defend segregation and white supremacy across the South.

By the time this photo was taken in Jackson, Mississippi, on November 13, 1963, the councils had been up and running for nearly a decade, using their political clout and connections to help pass legislation that favored segregation, to intimidate black voters and civil rights workers and to preach the gospel of racial integrity in the media.

The unnamed woman depicted in this photo, an employee of the council in Jackson, stood behind a table adorned with Confederate flags. She was selling bumper stickers and copies of the book *The Cult of Equality: A Study of the Race Problem* by Stuart O. Landry, which compared blacks to apes and described them as weak in the face of hardship and misfortune.

The council distributed this book and others like it to white high schools around the state.

"Negroes do not face difficulties or adversity with courage or determination," Landry wrote. "They slink away rather than meet the issue."

The councils burnished their image with positive coverage from supporters in the media and with the help of local leaders like the mayors of Jackson and Greenwood, who were also loyal members.

Officially, council members publicly deplored the violence of the Ku Klux Klan, but many quietly condoned its brutal tactics. And as this became increasingly evident, some correspondents, like Claude Sitton of *The New York Times*, began to abandon the polite language that many newspapers had used to describe the groups.

Sitton took this photo and several others for a story about Southern politics, which was never published.

But in his published articles, Sitton did not mince words, describing the councils as "racist" and "militantly segregationist."

—Rachel L. Swarns

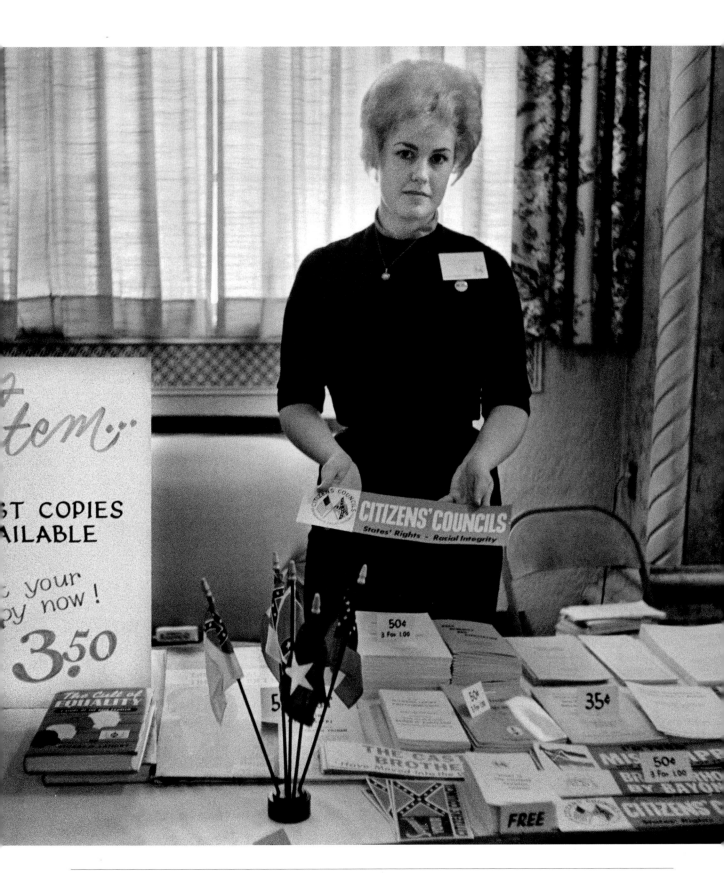

RALPH J. BUNCHE, SCHOLAR AND DIPLOMAT

On October 19, 1949, *New York Times* photographer Neal Boenzi captured the handshake between an influential American diplomat and India's first prime minister, Jawaharlal Nehru.

Only the prime minister's face would appear in the newspaper the following morning.

Left out of the published photographs was Ralph J. Bunche, the black scholar and diplomat who headed the United Nations division responsible for helping to guide colonial territories to statehood. He was a behind-the-scenes man, a foreign policy expert who rarely stood squarely in the spotlight.

In less than a year, though, all of that would change. In September 1950, Bunche became the first African-American to win the Nobel Peace Prize, edging out Nehru, who was also under consideration.

Bunche had negotiated the 1949 peace accord between the new state of Israel and its Arab neighbors, a diplomatic coup that brought peace for a time to a troubled region.

Soft-spoken and unflappable, Ralph Bunche mixed easily with foreign leaders. But he disliked the limelight. His first inclination when he learned of the Nobel award?

He wanted to give it back.

"Peace-making at the U.N. was not done for prizes," said Bunche, who had earned his doctorate in government and international relations from Harvard University. His boss, Trygve Lie, the secretary-general of the United Nations and a Norwegian, had to persuade him to accept the award.

Just a few months earlier, Bunche had considered and declined the offer of a prestigious government post, assistant secretary of state, which would have required him to move his family to Washington. He knew that none of the accolades he had received could change the painful realities of life in a segregated city. Even as one of the world's most famous diplomats, Bunche would still have had to endure the indignities of Jim Crow in the nation's capital.

So when he met with President Truman, he declined the position.

"It is extremely difficult for a Negro to maintain even a semblance of dignity in Washington," Bunche said. "At every turn, he's confronted with places he can't go because of his color."

But racism bubbled up everywhere, even in the North.

In 1959, nearly a decade after he won the Nobel Peace Prize, Bunche and his son were refused membership in the West Side Tennis Club in Forest Hills, Queens.

By then, as a senior official at the United Nations, he was responsible for the organization's program on peaceful uses of atomic energy and had organized and directed the neutral troops that kept the peace after the British-French-Israeli invasion of Suez.

Bunche, who would spend more than two decades at the United Nations, ultimately received an apology from officials at the tennis club, but declined their belated offer of membership.

His frustration with the slow pace of racial progress prompted him to march with Martin Luther King Jr. and to participate in other civil rights protests in the 1960s.

"I've been the token Negro," he said, "for too many years."

—Rachel L. Swarns

RALPH ELLISON, INTENSE MAN OF LETTERS, AT EASE

Ralph Ellison burned with intensity when he wrote and when he spoke. But here he is, photographed by Keith Meyers of *The Times*, strolling the streets of New York in July 1986, at ease, almost disappearing into his surroundings. Though this is Ellison in an entirely different context, a certain famous line from his most famous novel comes to mind: "I am an invisible man. I am a man of substance, of flesh and bone, fiber and liquids—and I might even be said to possess a mind. I am invisible, understand, simply because people refuse to see me."

When this image was shot, Ellison had just published *Going to the Territory*, a collection of essays that included deep explorations of William Faulkner, Duke Ellington and Ellison's friend Richard Wright. He was already a celebrated writer, and the only criticism that *The Times* lobbed at him in its review was that the book's essays had already been published and so there was nothing new—because obviously we all wanted more.

"The reader is impressed and delighted by the integrity of Mr. Ellison's vision," wrote John Edgar Wideman in his review. "His voice is assured, calm, wise."

In an interview with *The Times*'s Brent Staples, Ellison said he was still working on another novel, but that the essays came together more easily.

"These pieces were not conceived of as a collection," the seventy-two-year-old author said. "They were written as they were called for, and they may have some thematic continuity of which I am not aware."

If that sounds more easy-breezy that you might expect from Ellison, that's in part why this image in particular is so striking: here we have a man of great intensity seemingly at peace, in part it seems, because he had been spending time outside of New York, in the Berkshires. "This time of year I'm usually there," he told *The Times*, "where only the foxes and woodchucks interrupt me."

—Damien Cave

A CELEBRATED WRITER IN A DIFFERENT CONTEXT

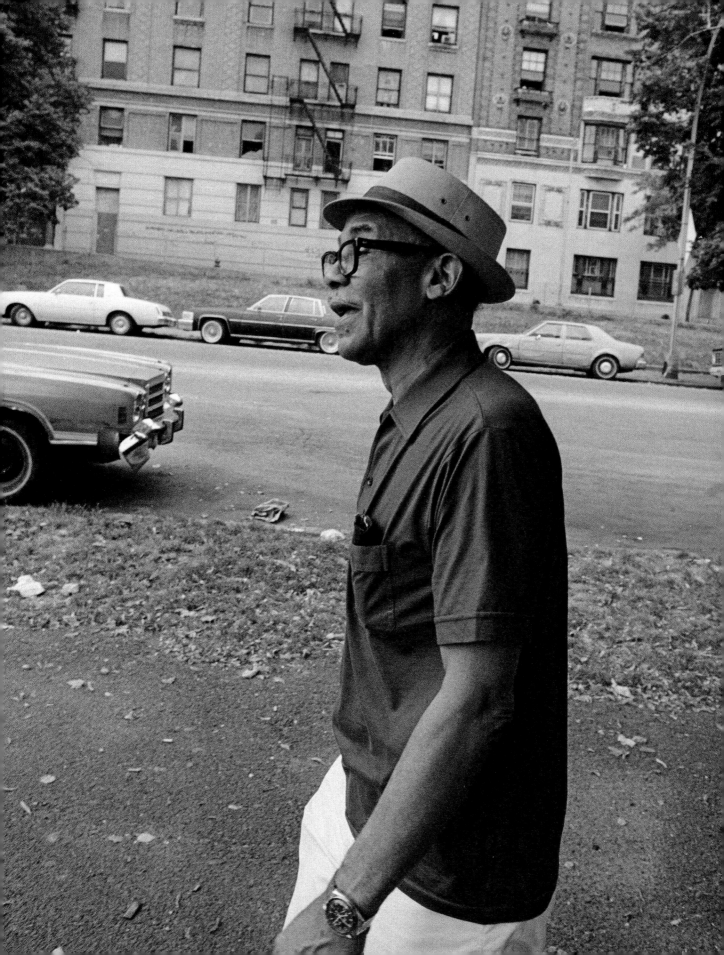

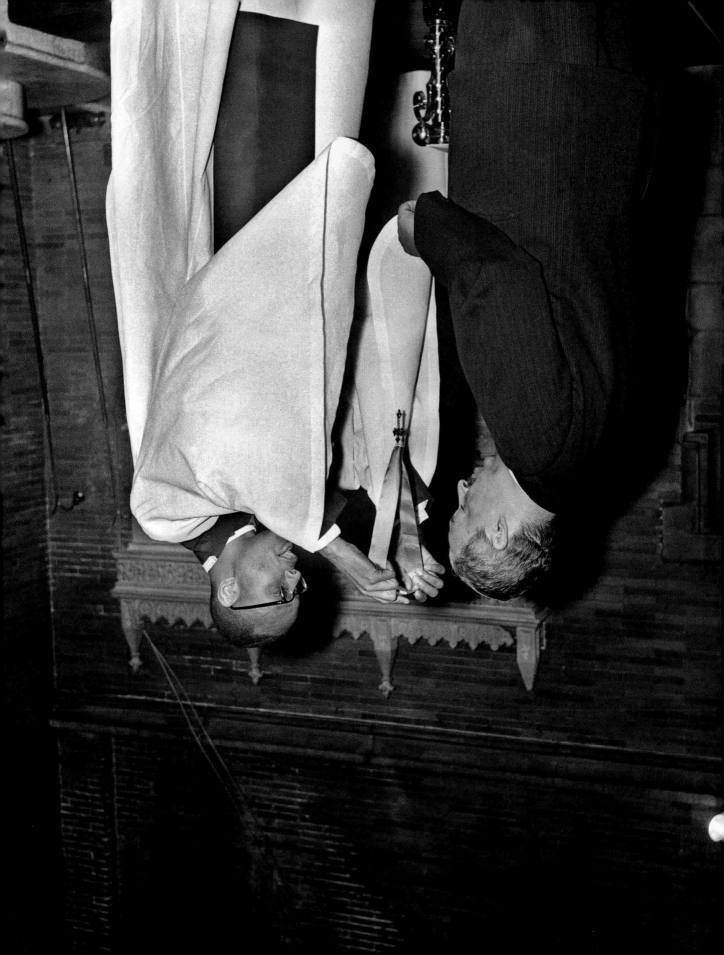

SPIRITUAL STRENGTH FOR THURGOOD MARSHALL

Thurgood Marshall was a lawyer of heroic imagination, who led the team that brought school desegregation to the Supreme Court, winning an end to separate but equal. In 1967, he became the country's first black Supreme Court justice.

But five years before that, on the Sunday after Thanksgiving in 1962, he made his way to St. Philip's Protestant Episcopal Church in Harlem, where he was a vestryman, and bowed his head to receive the St. Philip's Rector's Award from the Reverend M. Moran Weston.

To outsiders, perhaps, it was a minor accolade for Marshall, then a federal appeals court judge. It went unmentioned in his lengthy *Times* obituary. But the quiet humility he displays here in a photograph reveals just how much his faith, and church, provided him with spiritual strength.

Our article the next day only hinted at that. We ran a photograph of Marshall behind the pulpit and wrote that he had urged his neighbors to "make Harlem the kind of place that people will want to come to." The article went on to quote him telling them: "We can complain, we should complain, and we shall continue to complain. But we must feel the responsibility first ourselves."

It was a strong message. By a strong man. Showing the judge in eyes-closed, pious prayer in this photo by Patrick Burns probably didn't fit with the coverage. Now, though, the photograph conjures up another message, delivered by President Barack Obama in 2015 after the church shootings in Charleston, South Carolina, when he described the deeper meaning of the black church in American life. Over centuries, black churches have been "our beating heart," he said. "The place where our dignity as a people is inviolate."

—Damien Cave

DIZZY DOES A GOOD TURN
FOR ANOTHER JAZZ LUMINARY

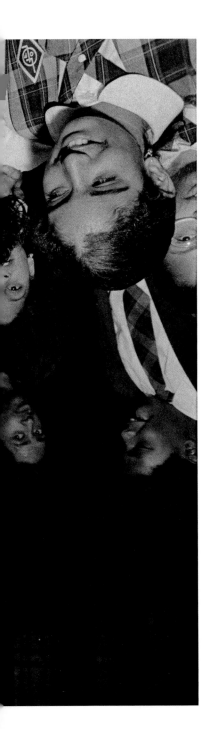

The trumpeter Dizzy Gillespie was an inventor of bebop, a pioneer of Latin jazz and a renowned jazz ambassador. But when he visited Our Lady of Lourdes School in Harlem in mid-December 1983, he was carrying the mantle of a lesser-known jazz luminary: the late Mary Lou Williams.

He was there to speak with students and to recruit youngsters for the Mary Lou Williams Children's Jazz Chorus. That Friday night he delivered a benefit concert at Our Lady of Lourdes Church, with proceeds benefiting the Mary Lou Williams Foundation.

The Harlem-based photographer Don Hogan Charles was on hand for Gillespie's visit, and *The Times* ran an article previewing the concert, though it didn't use this irresistible image.

Williams had died two years earlier, leaving behind one of the most widely arcing legacies in jazz. She'd toured the Midwest with vaudeville acts as a teenager, written and arranged for Duke Ellington and Benny Goodman, and eventually embraced the bristling, Manhattanite sounds of bebop, which she integrated into her own earthy, swinging style.

The Times jazz critic John S. Wilson wrote in Williams's obituary that she "ranked with the greatest of jazz musicians." And she was more than a top-flight musician. She turned her Harlem apartment into a meeting ground and sanctum for jazz's greats.

"It was the easiest thing to stop by Mary Lou's house, because if she was there, the door was open," said the bassist Buster Williams (no relation), who played with her for over a decade. "Guys would come to her house and work things out, ideas that they had. And then this stuff would find itself on the bandstand at Minton's or Birdland or all the clubs."

In the 1950s Williams went through a religious awakening, converting to Catholicism and temporarily retiring from music. She often spent full days praying and meditating at Our Lady of Lourdes. But she continued to serve the music scene, starting the Bel Canto Foundation to provide funds and other forms of support to ailing musicians. She financed it by opening two thrift stores.

When she returned to the piano a few years later, she dedicated herself to writing liturgical music—including three lengthy masses, one of them commissioned by the Vatican—and to passing on her knowledge to younger musicians.

On his visit to Our Lady of Lourdes in 1983, Gillespie was furthering that work. Together with Carmen Lundy, a younger vocalist, he sought students for a choir that would perform Williams's masses and uphold the mission of the Mary Lou Williams Foundation, which she had established just before her death, along with Father Peter O'Brien, a Jesuit priest.

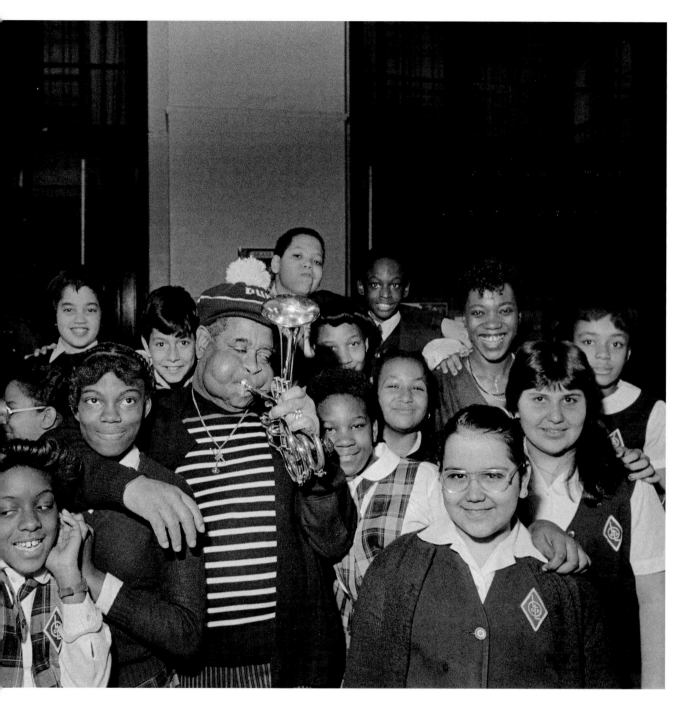

"Mary Lou wanted young people to know and come to love jazz," Carmen
Lundy said. "Father O'Brien asked me to go into Our Lady of Lourdes, and I had
to hand-pick the voices. I literally went around and listened to each child sing.
And that's how we created the first Mary Lou Williams chorus."

—GIOVANNI RUSSONELLO

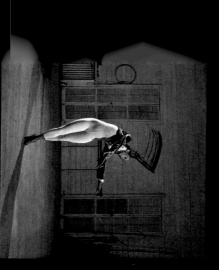
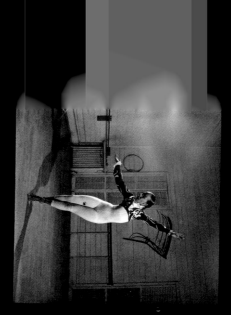
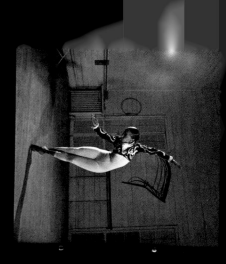
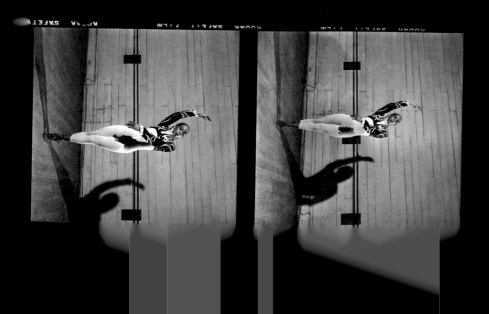
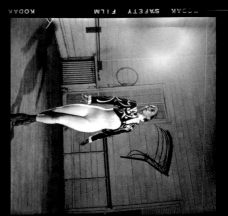
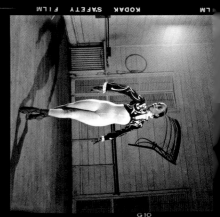

7E

KODAK SAFETY FILM KODAK SAFETY FILM KODAK SAFETY FILM KODAK SAFETY FILM

9 G10

JANET COLLINS BLAZES A TRAIL AT THE MET OPERA

Janet Collins was a pioneering black ballerina in a world that welcomed only white dancers. She began her dance career in Los Angeles, and in 1932, at the age of fifteen, she was asked to join the Ballet Russe de Monte Carlo. Her acceptance to the company came with conditions. She was told she could join only if she performed in white face. She flatly refused.

Eventually, Collins made her way to New York City and danced on Broadway. Her East Coast debut in 1949 at the Lexington Avenue Y was met by rave reviews by *New York Times* dance critic John Martin, who called her "the most exciting young dancer who flashed across the current scene in a long time." Her dreams were bigger than Broadway, and in 1951 she auditioned for the Metropolitan Opera. After watching her dance, director Zachary Solov was convinced he'd found his newest star. He approached Met Opera director Rudolf Bing with trepidation, telling him he had found the perfect ballerina. "But," he added, "she's black." All Bing asked was, "But can she dance?" The reply from Zolov: "Yes! She's magic!"

Collins thus became the first black artist to perform at the Metropolitan Opera. Her appearance in Giuseppe Verdi's *Aida* came nearly four years before Marian Anderson made it to the Met stage.

The images here were taken by *Times* photographer Sam Falk for a 1955 preview of modern works called *American Dance* at the ANTA Theatre (now the August Wilson Theatre) in Manhattan.

It appears that Falk had little time with Collins, snapping just eight frames as she performed her solo for his camera. A small, one-column image of frame number six ran with a photo-heavy presentation in *The Times* that featured other dancers, including Martha Graham, Daniel Nagrin, Valerie Bettis, John Butler and Anna Halprin.

These images show a rare opportunity that *The Times* had to see Collins in an intimate setting. An extensive search through the paper's picture archives showed her either on stage in performance or in portraiture distributed by the Metropolitan Opera.

Even though Janet Collins, who died in 2003, broke barriers, it is obvious that critics found it hard to look beyond race in her performances. In his review of *American Dance*, which appeared several weeks after these photos were taken, John Martin criticized her as "a bit night-clubby" in presentation and said she does not compare with her tried-and-true "Negro Spirituals."

—DARCY EVELEIGH

CRITICS FOUND IT HARD TO LOOK BEYOND RACE IN HER PERFORMANCES

MALCOLM X'S CLOSE CALL IN QUEENS

Malcolm X was sleeping when firebombs crashed through his living room windows shortly before three in the morning. Jolted awake by the explosions, he rushed his wife, Betty Shabazz, and four young daughters out into the cold before fire engulfed their modest brick house in East Elmhurst, Queens.

We published an article about the attack on February 15, 1965, and paired it with a photograph taken by a news agency that captured Malcolm X stepping out of his car, in front of his house. What our readers did not know was that one of our own photographers, Don Hogan Charles, had walked through the house, shooting powerful pictures of the damage.

This stark image of the shattered windows, singed walls and sooty debris offers a glimpse of the private life of a man who spent much of his time in the public eye. Malcolm X gave speeches in Manhattan, Detroit and other cities around the country and overseas. But he came home to Queens.

The two-bedroom house at 23-11 97th Street, which was owned by the Nation of Islam, had a small living room, a dining room, a bathroom, a kitchen and a former utility room, where Malcolm X's five-month-old daughter slept in a crib. Few of the family's possessions survived the blaze. Malcolm X, who told our reporter that he had been receiving daily threats, escaped that firebombing unscathed. He was assassinated one week later.

—Rachel L. Swarns

FEW OF THE FAMILY'S POSSESSIONS SURVIVED THE BLAZE

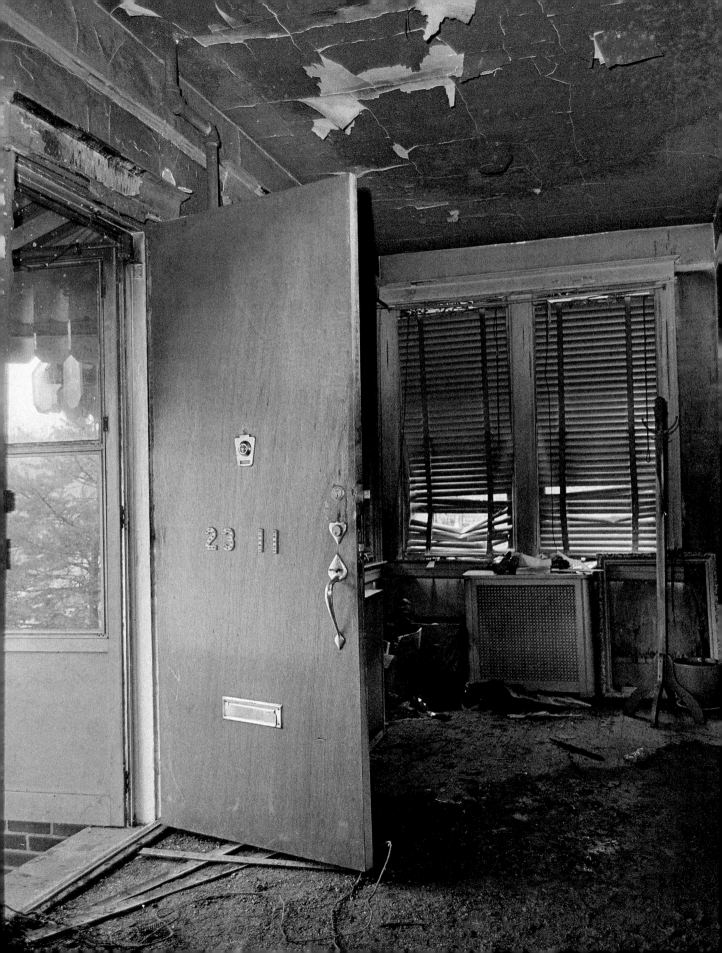

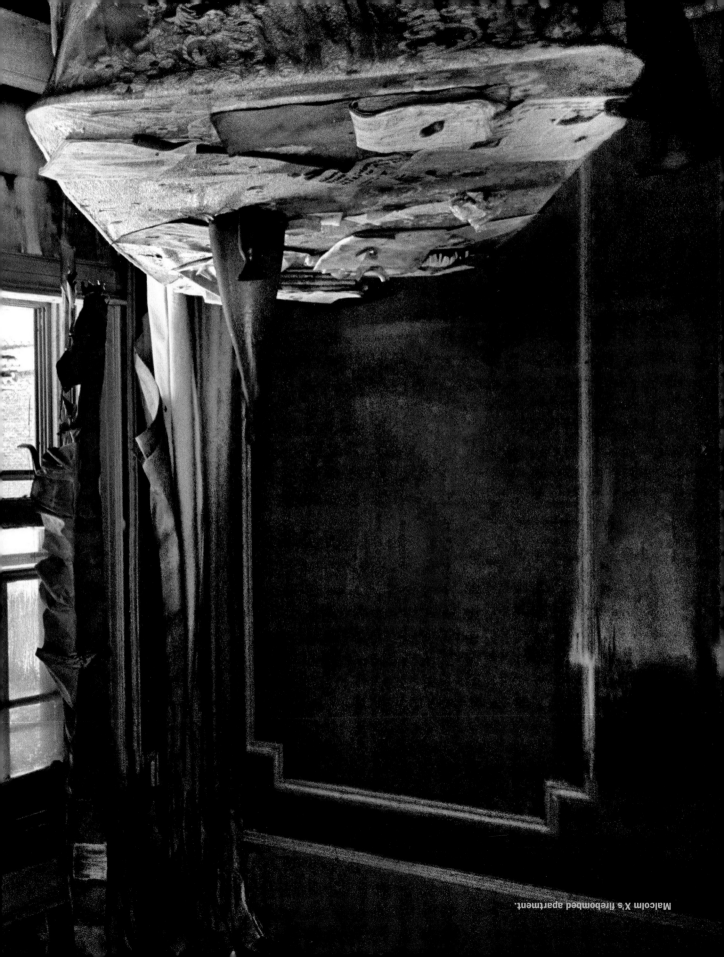

Malcolm X's firebombed apartment.

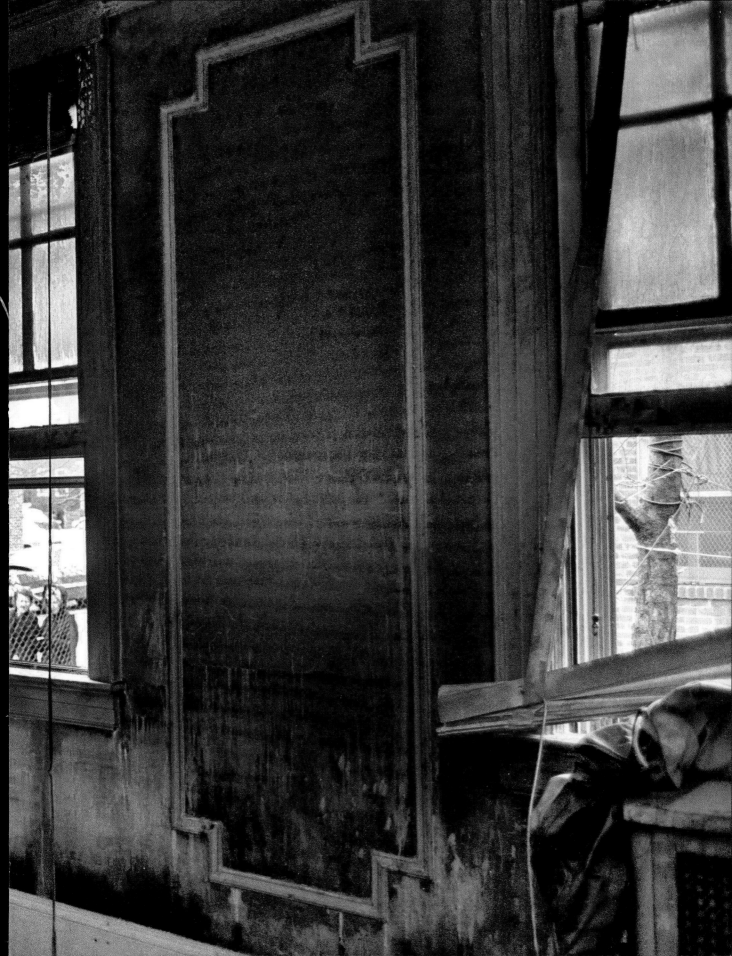

SAYING FAREWELL TO MALCOLM X

The white police officers in this photo by Don Hogan Charles looked suitably solemn as the body of Black Nationalist and minister Malcolm X was wheeled into the Unity Funeral Home in Harlem. Outside the building, a line of black mourners that snaked down the street waited to pay their respects to the controversial fallen leader.

Malcolm's body lay in a bronze casket as an estimated 2,000 people visited the funeral home during the first day of the public viewing.

The funeral home required a constant and heavy police presence, as it endured a bomb threat that was later determined to be false, threats of firebombing and the high emotions of Malcolm's distraught followers. Hundreds of police reinforcements were sent to Harlem. Police kept visitors behind a barrier, inspected flower arrangements and detained a man outside the funeral home who was carrying a rifle under his coat.

The threat of violence had been hovering for months.

One week after his home was firebombed, Malcolm was assassinated on February 21, 1965, at the Audubon Ballroom in Manhattan as he began a weekly address to hundreds of followers from his Organization of Afro-American Unity. As he was starting his remarks, two men in the audience began arguing to distract his bodyguards, authorities would soon determine. Two other men later determined to be Black Muslims rushed the stage and shot and killed him. Malcolm, once a rising star in the Nation of Islam, had split from the group and its leader, Elijah Muhammad, over philosophical differences.

Just days before he was killed, which prompted the outpouring of mourning, Malcolm said that he "lived like a man who was already dead."

—DANA CANEDY

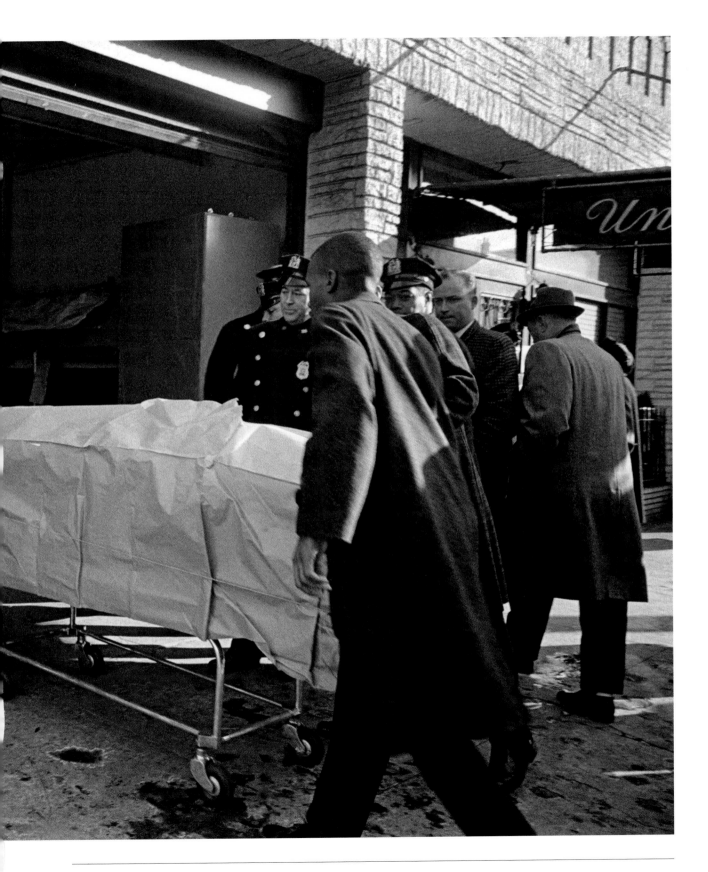

MUHAMMAD ALI RETURNS

He was one of the most compelling athletes of the twentieth century, but by September 24, 1970, it had been more than three years since Muhammad Ali had been able to do what he did best: playfully boast and then skillfully box. On that day, however, Ali traveled to the offices of the New York State Athletic Commission to apply for a boxing license. It was one more milepost on his path back to the ring; Ali had not boxed since March 22, 1967, when he stopped Zora Folley in seven rounds to defend his heavyweight title. The win had given him a 29–0 record. He was the man who called himself "the Greatest," who could "float like a butterfly and sting like a bee."—whose career had come to resemble one long, sustained exclamation point.

A month later, however, against the backdrop of the Vietnam War, Ali refused

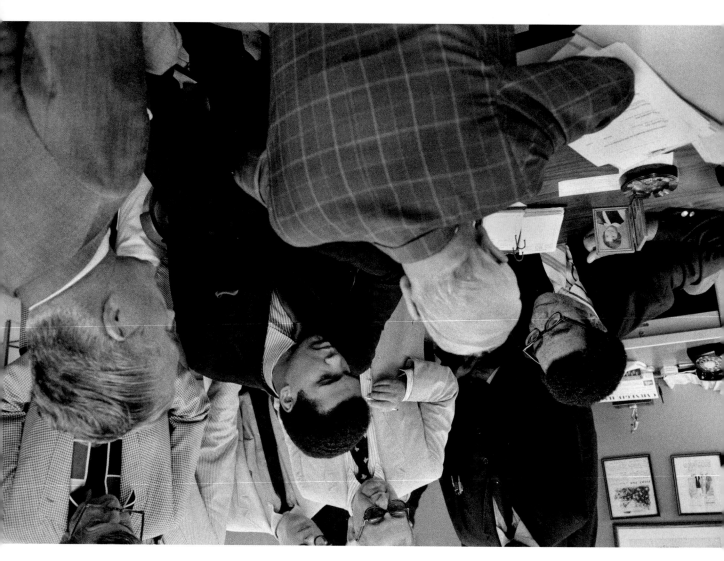

induction into the United States military, citing religious grounds as a member of the Muslim faith. He was immediately stripped of his title, and his boxing licenses in New York and other states were tossed aside, too.

More punishment awaited. In June of that year, Ali was convicted of violating federal law in declining to be drafted and was sentenced to five years in prison and fined $10,000, the maximum penalties for the offense.

As the appeal of his conviction wound its way through the courts, Ali made numerous public appearances, sometimes speaking at universities. But he did not box. No state would allow him to do so.

Only in 1970 did things begin to shift. That August, Atlanta—with no state athletic commission in Georgia to stand in the way—granted Ali a boxing license. And the following month, Judge Walter R. Mansfield of United States District Court ruled that New York's athletic commission had violated Ali's rights by barring him from fighting.

Dozens of other people convicted of crimes had been licensed to fight in New York, Mansfield noted. So why not Ali?

Armed with Judge Mansfield's ruling, Ali showed up at the commission's offices in Manhattan ten days later, seeking reinstatement as a boxer. *The Times* was there and published a modest article, describing Ali as notably subdued and disinclined to do any boasting. "All that's behind me now," Ali was quoted as saying.

The article appeared on the bottom of an inside page of the Sports section, without the picture of Ali that Carl T. Gossett Jr. took that day, showing him sitting at a table, in suit and tie, as he filled out commission paperwork.

The next month, in Atlanta, Ali made his return to the ring and beat Jerry Quarry in a fight that was stopped after three rounds. Two months later, his boxing license in New York restored, Ali beat Oscar Bonavena in a 15-round bout at Madison Square Garden.

That set the stage for what was called the Fight of the Century: the March 1971 bout at the Garden between Ali and Joe Frazier, who was also undefeated. At that point, Ali was back to being Ali, producing a poem for the fight that concluded, "This might shock and amaze ya, but I'm gonna destroy Joe Frazier."

He didn't. Frazier knocked Ali down in the 15th, and final, round, and won a unanimous decision. But three months later, Ali came back with a victory of his own: an 8–0 United States Supreme Court ruling that overturned his draft conviction.

Other epic moments in Ali's career awaited: the Rumble in the Jungle in which he dethroned George Foreman, the brutal Thrilla in Manila in which he barely bested Frazier. And by the time his career was over in 1981, he had fought six times in New York with the license that had been taken away and then given back.

—JAY SCHREIBER

HIS CAREER HAD COME TO RESEMBLE ONE LONG, SUSTAINED EXCLAMATION POINT

THE BLUE NOTES, BEFORE THE
CURTAIN WENT UP

Chester Higgins Jr.'s 1976 shot of Harold Melvin & the Blue Notes at the Apollo
Theater captures a time of tension and transition. Both the group and the theater
were going through a difficult period. The Blue Notes had recently lost their bari-
tone lead singer, Teddy Pendergrass, who bolted to start a solo career. The Apollo
faced uncertainty, too, with diminishing audiences and finances amid the troubled
New York of the mid-1970s.

That April, in an attempt to reassert its historic value and to publicize its on-
going relevance, the famed Harlem venue assembled a number of all-star perform-
ers for a two-day taping session, from which six ninety-minute television specials
were culled and shown as *The Apollo Presents*.

In an interview with *The New York Times*, the chairman of the company that
produced the shows, David Salzman, said the idea was "to convey the magic and
excitement that is uniquely associated with the Apollo." At the same time, the
theater's owner, Robert Schiffman, admitted to the paper that the Apollo could
no longer afford the level of talent being featured in the specials, which included
vintage musicians such as Cab Calloway, the Copasetics and Count Basie, as well
as hot younger acts such as LaBelle, Ashford and Simpson and the Blue Notes.

Higgins had a connection that helped him get his Blue Notes shot. In the late
'60s and early '70s, he had been the production photographer for *Soul!*, a pivotal
public television series about black arts and politics directed by Stan Lathan, who
was directing the Apollo specials. "I knew my way around a TV studio camera
and I knew that director's style," Higgins recalled.

Backstage at the Apollo, he shot the Blue Notes huddled around a TV camera
when its light was off, capturing a fascinating variety of perspectives and expres-
sions. Singer Jerry Cummings appears at the front of the photo with an anticipa-
tory look, flanked by a mirrored image of him. Behind Cummings, at the far right
of the image, David Ebo looks off warily while, on the other side of the television
camera, Harold Melvin seems lost in his own thoughts. The intimate gaze of
Higgins's camera shows us the wide variety of feelings experienced by performers
just before they take the stage. Yet no images appeared with the article *The Times*
published originally about the Apollo specials.

Harold Melvin started his storied group in the '60s. They peaked in the early
to mid-'70s with such "Philly Soul" hits as the aching "If You Don't Know
Me by Now," the barreling "Bad Luck" and the politically charged "Wake Up
Everybody." Melvin died of heart-related issues in 1997, at age fifty-seven.

—JIM FARBER

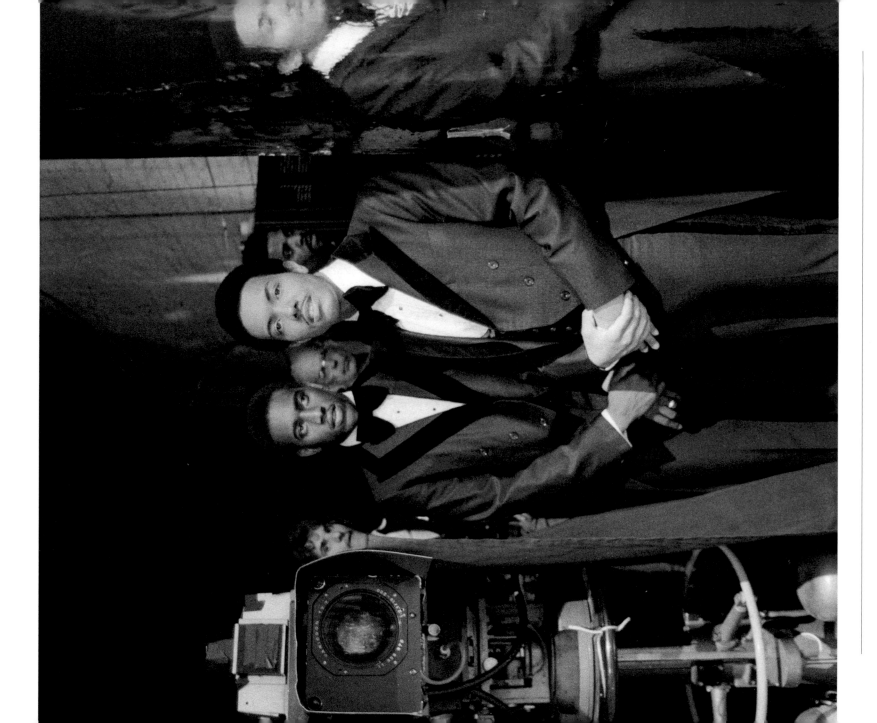

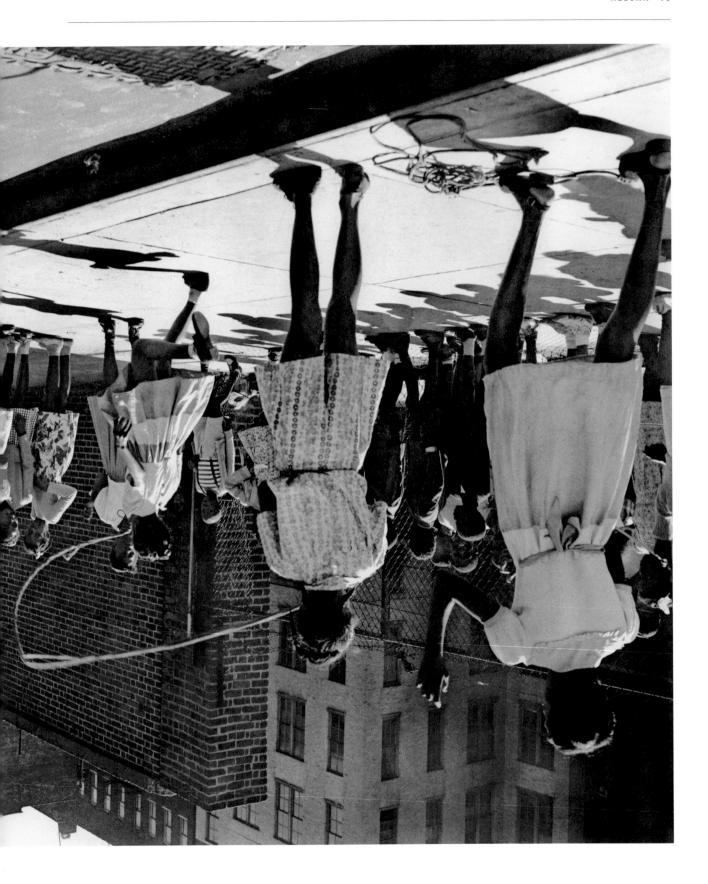

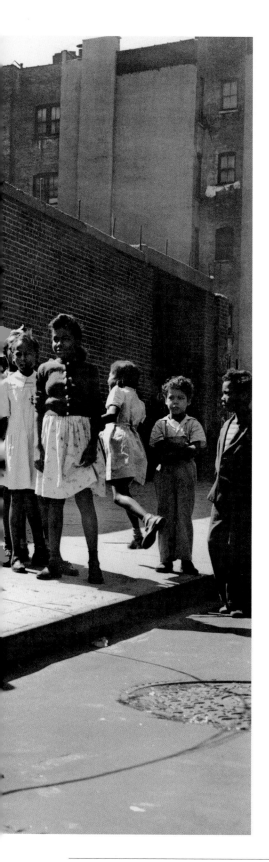

BEHIND THE SCENES, A HARLEM LEGEND

It is one of the oldest photographs in our series: a sidewalk scene in Harlem from 1946. A girl skips rope amid a crowd of children on a lazy summer afternoon. But what is most striking is the woman who was not captured by the camera's lens.

That woman was Zora Neale Hurston, the novelist and folklorist known as the Queen of the Harlem Renaissance, and she was helping to organize outdoor activities for the children. She had joined forces with a group of women who were trying to combat juvenile delinquency in the community, showing the world that black people were willing and able "to do things for themselves," she said.

This was nine years after Hurston published her masterwork, the novel *Their Eyes Were Watching God*, and nearly fourteen years before she would die in poverty and obscurity.

In 1946, Hurston was still well known, notable enough that *The New York Times* wrote about her efforts in Harlem. She had been criticized by some of her contemporaries, who said she caricatured blacks with works that focused on folk culture and the lives of rural people instead of on racial discrimination and social protest.

But Hurston dismissed those critics as a "sobbing school of Negrohood" and urged them to reconsider their rejection of rural African-American culture. "Who knows," she wrote, "what fabulous cities of artistic concept lie within the mind and language of some humble Negro boy or girl who has never heard of Ibsen?"

Maybe that's what drew her to work with underprivileged children. Hurston certainly knew a bit about hard times. Her mother died when she was young, and after that, she said, she was "passed around the family like a bad penny."

This photograph, by an unidentified *Times* staffer, never appeared in the newspaper; it was shot for an article about the program in Harlem and Hurston that ran on page fourteen without an image. But in the faces of those children, Zora Neale Hurston may well have seen something of herself.

—Rachel L. Swarns

THOMAS JOHNSON IN VIETNAM

No colored water fountains or food lines. No difference in weapons. Death did not discriminate during war.

These photographs from the Vietnam War suggest that soldiers serving in the United States Army were Americans first. They fought, ate, slept and died together, black and white alike. Survival meant depending on each other as much as on their training.

That is not to say that African-American soldiers serving in the war were entirely immune to racial injustice. In a *New York Times* dispatch from Saigon, correspondent Thomas A. Johnson wrote, "It is true that a vast majority of Negroes are lower-ranking enlisted men, and that the proportion of Negroes to whites in rifle platoons and elite units are far greater than the overall proportion in the Armed Forces here. These facts are reflected in the higher Negro death rate."

HE WAS THE FIRST BLACK REPORTER ON A MAJOR METROPOLITAN DAILY NEWSPAPER TO SERVE AS A FOREIGN CORRESPONDENT

The first black reporter on a major metropolitan daily newspaper to serve as a foreign correspondent, Johnson reported that the conflict also provided opportunities for black soldiers that they otherwise might not have had.

"It is also true," he wrote, "for a number of reasons, including a lack of opportunity at home, that the Negro reenlistment rate is three times greater than whites in the Army, and that the Negro career soldier is an integral figure at all levels and in all facets of the military structure."

Johnson joined *The New York Times* in February 1966 and was at the time the only black reporter on staff. He covered civil rights issues and urban unrest and also reported extensively on African American soldiers in Vietnam, spending weeks on the ground detailing daily life and frustrations of war. He took thousands of photographs while doing so, including those shown here, shot in Hue and Phu Yen Province in March and April of 1968.

Some of his reporting and photography became a series, "The Negro in Vietnam," which received a great deal of attention, and *The Times* promoted it with an ad campaign and a special booklet issue.

—DANA CANEDY

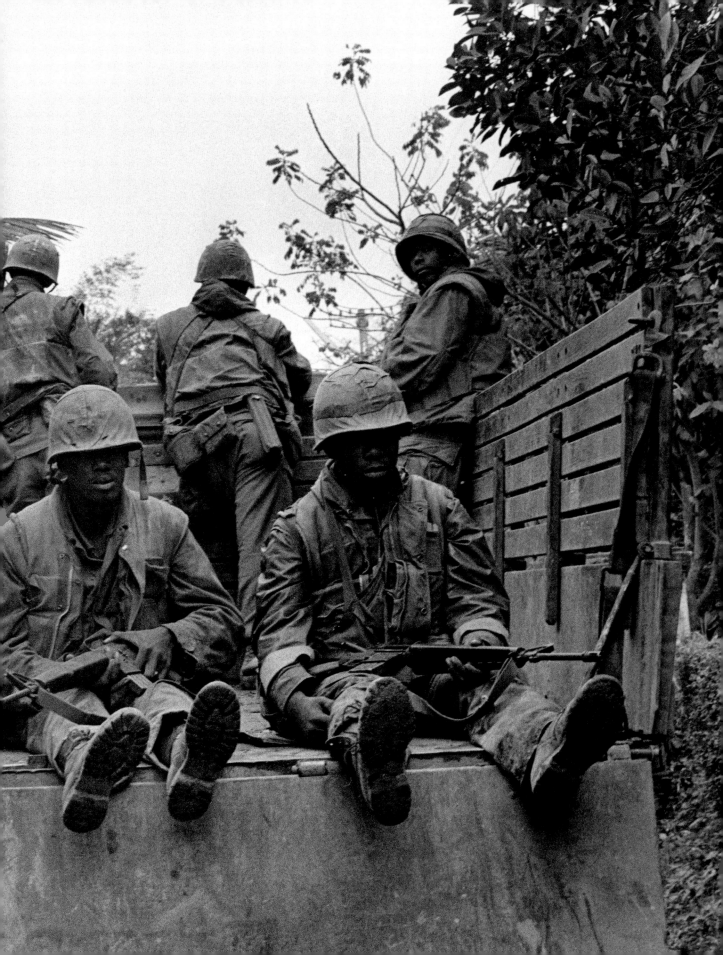

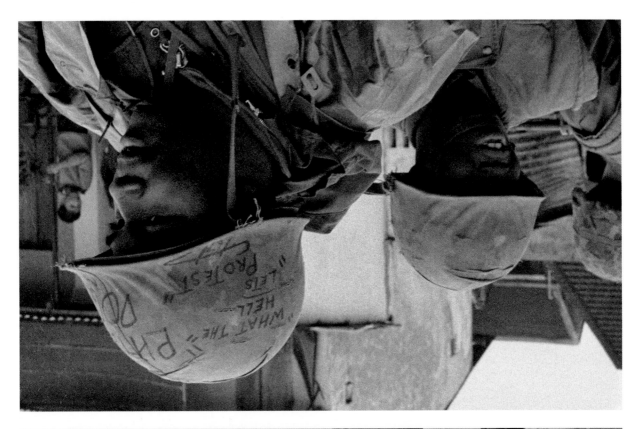

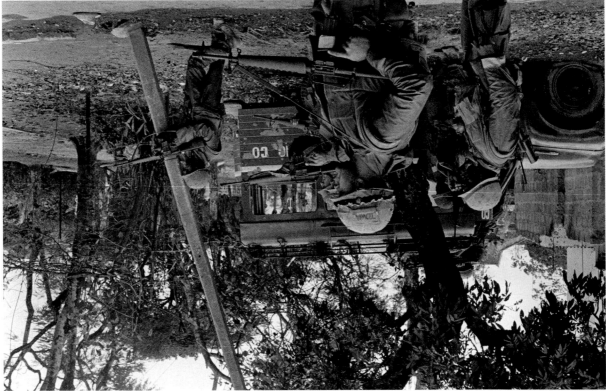

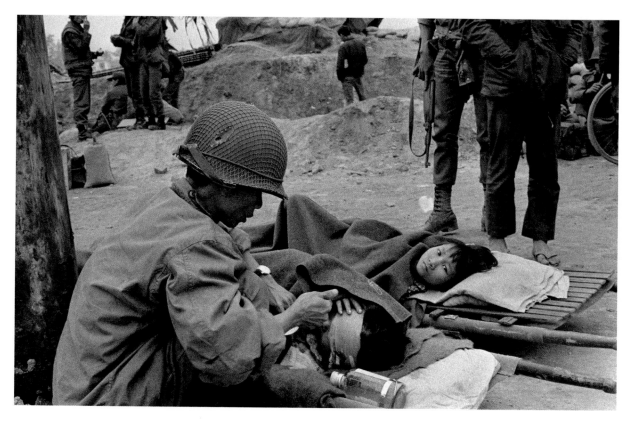

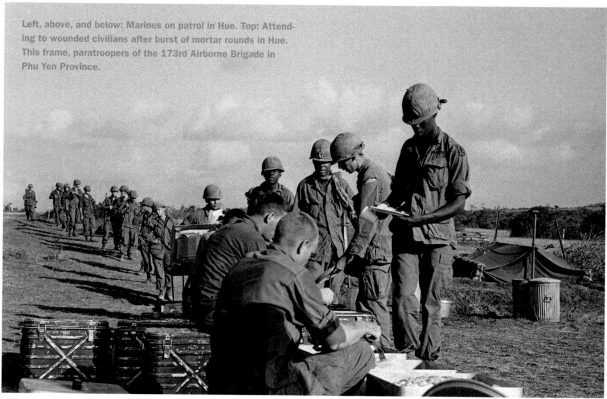

Left, above, and below: Marines on patrol in Hue. Top: Attending to wounded civilians after burst of mortar rounds in Hue. This frame, paratroopers of the 173rd Airborne Brigade in Phu Yen Province.

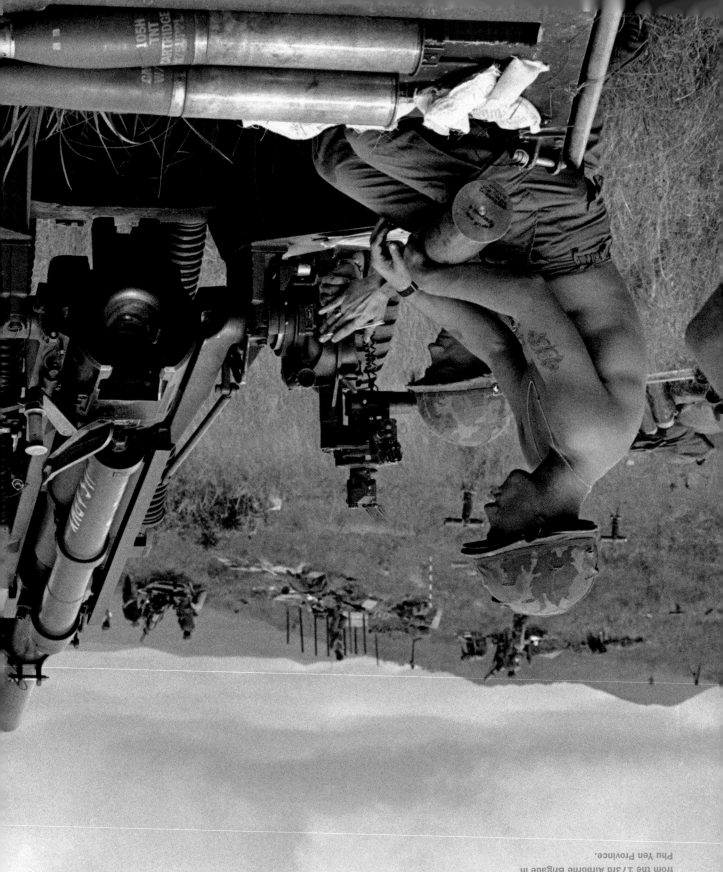

United States Army Paratroopers
from the 173rd Airborne Brigade in
Phu Yen Province.

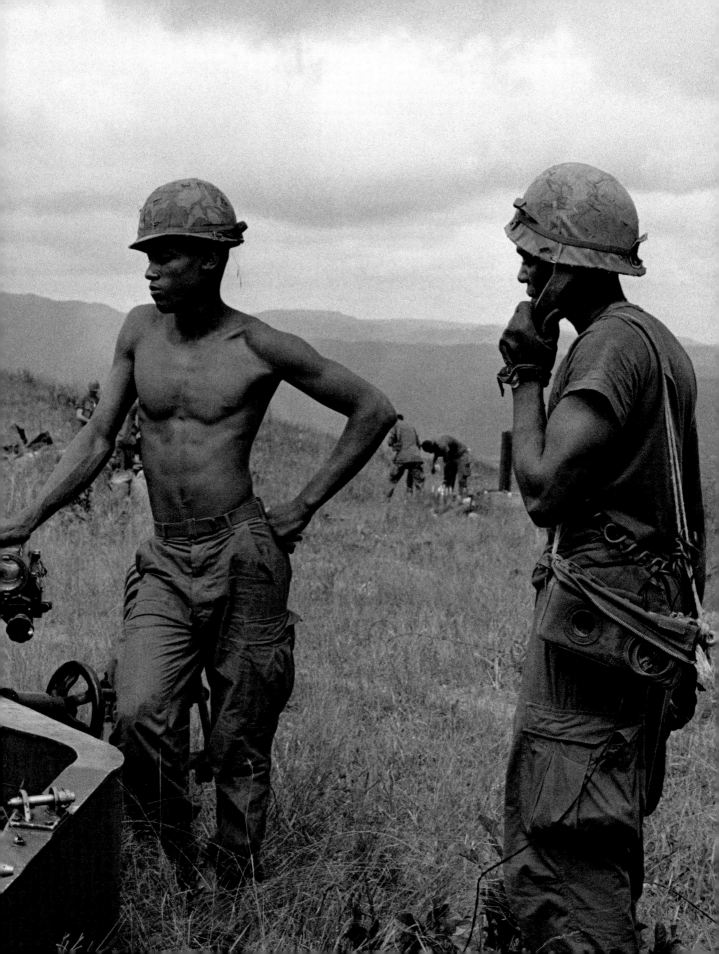

Marines with children in Hue.

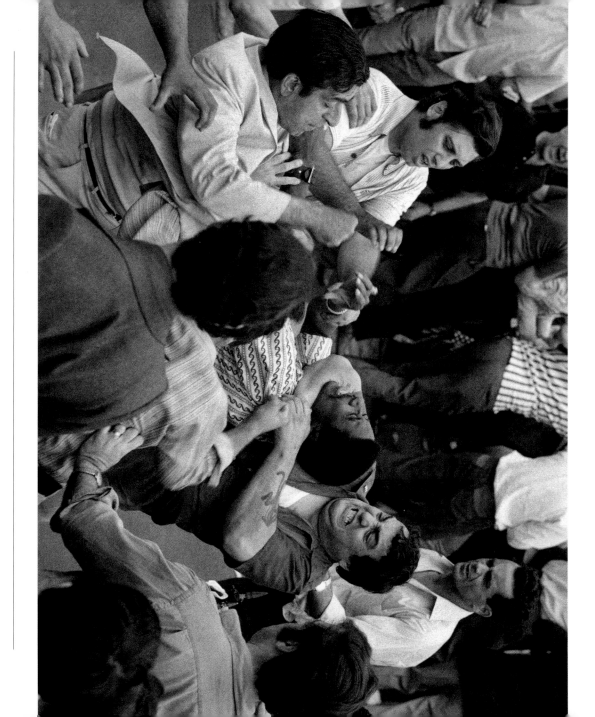

A MOB BOSS, GUNSHOTS AND RACIAL VIOLENCE

On June 28, 1971, Joseph A. Colombo Sr., the Brooklyn Mafia boss, was shot in the head and critically wounded at Columbus Circle as an Italian-American civil rights rally was about to begin.

The crowd reacted immediately "with confusion, sorrow, anger, rage and violence directed at Negroes in the crowd, because, as the radio told them and they told each other, Colombo had been shot by a black man," The Times reported.

The gunman was killed, and our front-page article the next day showed a wounded Colombo, but the black man in the image here—unpublished until now—was simply a bystander. Librado Romero, a retired Times staff photographer who took the photo, said he

lost track of the man and never found out what had happened to him, but he described the scene as a frenzy of "ugly, ugly anger."

His recollection of that moment, found below, has been condensed and lightly edited. Colombo remained alive, though paralyzed, until 1978.

William E. Sauro is the other photographer from *The Times* who was there. We were assigned to go up and cover Colombo speaking, so we walked up from Times Square, and we stopped for coffee because we were early. And then when we were approaching the scene at Columbus Circle, we heard the shots ring out.

We rushed up. We were kicking ourselves for not being there when it actually happened. We were very upset about that.

But Bill, by way of a side anecdote, said, "It's a good thing we stopped." He always maintained that it was my suggestion that we stop, and he always used to say that I had saved his life because he knew Colombo, and he said, "I undoubtedly would have been talking to him, and I probably would have gotten shot as well."

But at any rate, when we got there, I think we photographed the shooter's corpse being put into an ambulance, or maybe he was still alive.

And then these skirmishes started happening all around us. I think what I did was get up on a lamppost so I could have a better view of everything; I think that's where that picture was shot from.

I've seen it time and time again: when people are at odds, and then their anger rises to the point where they become violent toward one another.

When the Colombo thing happened, in terms of racial tension, it wasn't at its peak, but it was still around. There was certainly tension—anything could trigger off a riot or a small one.

With Colombo, it all happened very quickly. It was all within 10 to 15 minutes.

There is a part of you that simply wishes it wasn't happening. However, it's not your place as a journalist to partake unless someone's life is being threatened and you could possibly do something about it. That's the exception. For the most part, you're just bearing witness: You're the eyes for the public to be able to realize what's happened.

With this photo, that guy was alone and surrounded, and what he was trying to say or do, I just don't know.

I don't remember what happened after that.

THERE IS A PART OF YOU THAT SIMPLY WISHES IT WASN'T HAPPENING

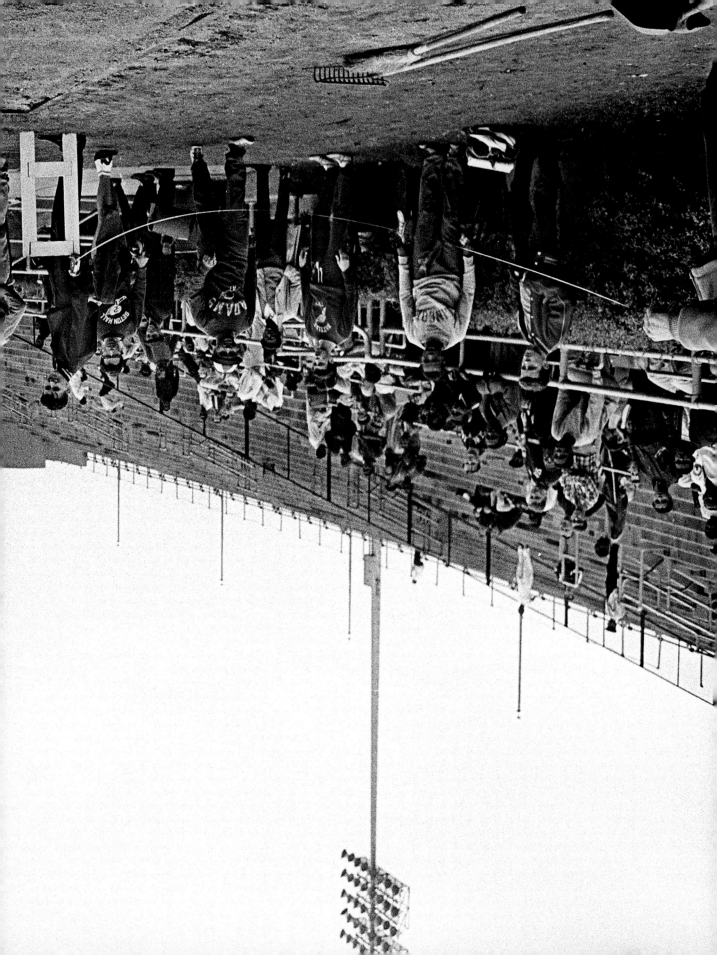

BOB BEAMON JUMPING LONG

Bob Beamon set a national record in the triple jump two weeks before this photograph was taken. It was 1965, he was still in high school, and he was competing again, this time on Randall's Island, where he just missed another record in the broad jump.

The photograph that *The Times* published showed him in the foreground, with only the crowd watching. What was lost? Check out the faces of his young competitors, staring with awe and interest, in this picture by Meyer Liebowitz. That's the gaze that would go on to become a much bigger part of Beamon's story.

In 1968, Beamon shattered the world record for the long jump at the Olympics in Mexico City, flying so far for so long, that it took extra time—several long excruciating minutes—for the judges to conclude that his jump measured twenty-nine feet two inches, which beat what was then the world record by a full foot and six and three-quarters inches.

Those who witnessed it called it "the leap of the century." His Olympic record still stands.

—Damien Cave

A YOUNG JESSE JACKSON RALLIES FOR JOBS

The Reverend Jesse L. Jackson was only twenty-seven on September 22, 1969, when he led a rally of 4,000 people in Chicago, calling for an end to discrimination in the construction trades. An unpublished photo of the event, by Gary Settle of The Times, *is shown here. In an interview with Damien Cave, which has been condensed, Jackson described what he remembered from that day.*

We wanted to demand that if they were going to build where we live, we should have the trade skills to build. If there were public contracts, we should have the right to have a part of those contracts.

The police were there to protect them from us; we should have been protected from them.

We were just fighting regular racial segregation, except it was segregation in the unions—as it was in the schools, as it was in the police and fire departments. It was as hostile as anything we faced in the South, maybe even more so.

As for me, well, I'm still here. My fire for justice and inclusiveness is as strong now as it was then. Today it is facing those police in Ferguson, those police who still think they have the right to kill us; or in Flint, it's the right to poison the water. We're still fighting these barriers to equality and justice.

It's not understood. The same people who call us lazy lock us out of trade unions. We've had to fight to get the right skills to work. Many young men are hopeless and jobless—they don't have the same trade skills their white counterparts had.

In the fight to rebuild where we live, there are countless jobs. There are probably more jobs than people. People ask how can you police poverty. You can't police poverty. But you can develop people where you live so there's less need for police.

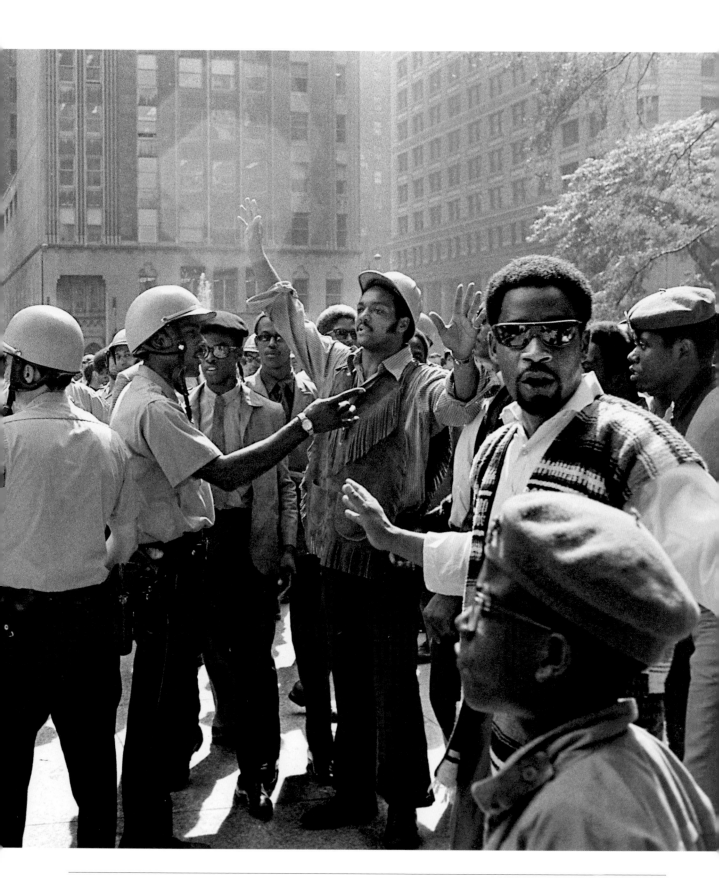

ARETHA FRANKLIN, QUEEN OF THE APOLLO

The marquee at the Apollo, that billboard of black stardom, simply said it all: "She's home. Aretha Franklin."

It was June 1971. After a year of struggling with canceled concerts and rumors of a nervous breakdown, the Queen of Soul was at the apex of her powers. She had a band behind her, King Curtis and the Kingpins, that Jerry Wexler, her producer at Atlantic, described as "locked and loaded." She had just recorded a live album in San Francisco, wowing a hippie crowd with her complete command of the stage, bouncing through soul new and old, along with Simon and Garfunkel's "Bridge over Troubled Waters."

Harlem was ready for her, too. The lines left many disappointed. *Billboard* magazine described her appearance as "the natural woman in a natural setting."

But *The Times* went one better, with a journalist who got it: C. Gerald Fraser.

Gerry Fraser was one of only two black reporters on the staff when he was hired by *The Times*—a Boston-born son of Jamaican and Guyanese immigrants who pushed his way into journalism after many rejections, including one that involved being mistaken for a janitor when he applied for a job at *The Boston Globe*.

What a loss it would have been if he had given up. His probing coverage of black prisoners, including those in the 1971 Attica rebellion, is perhaps what he is best remembered for (he died in 2015 at the age of ninety), but the Apollo concert he described, and the way he described it, are both marvelous:

"Inside, the thousands of black people who saw and heard Franklin were more than an audience. They were part of a black interaction—they came not only to see and hear 'Lady Soul,' 'Soul Sister No. 1,' 'The Queen of Soul' and all those other labels she bears, but also to participate with her in an exultation of their blackness."

The article went on to quote a fan who said Franklin "has the genius of combining all forms of black culture into music," and an Apollo employee who said her show was "the most overwhelming thing we have ever had in this theater."

All of which makes the Tyrone Dukes photograph here so fascinating. Who is the reporter holding the microphone off to the right of Franklin? Is it Fraser?

Franklin's spokesman showed her the image and told me she did not recall who was in her dressing room that night. But just look at her response—that glare! You can feel her longing for the interview to be over, to just *end* already.

What we've got here is the reality of journalism as practiced out of view: Franklin, at twenty nine, was already an iconoclast who had no time for suffering fools or long-winded questions, and just out of the frame, with the other reporters, was Fraser, a pioneer in his own right, just trying to get something fresh to punctuate the amazing moment he experienced only minutes earlier.

A great quote from the star would have risen to the top of the article. But what did she give him? A little bit about her music ("a mixture of blues and pop and a little jazz and a little funk here and there, you know, something like that") and not much else. Fraser described the after-show interview, deep into the article. She was hungry. She said she had some "chicken and dumplings to get back to."

Even as Aretha Franklin created history, it seems, she saw fit to let others explain it. "I'm not really a talker," she told the newsmen (yes, all men) that night.

So Fraser, a total pro, turned to Roberta Flack, another soul singer, outside the dressing room. She was the one he let have the final phrase about why Aretha Franklin's music connected so strongly with the Apollo audience.

That, too, was wise. "Sincerity, you know, truth and honesty," she said. "I think that's probably the thing."

—DAMIEN CAVE

SITTON AND THE SIT-IN

Times correspondent Claude Sitton tended to be invisible, his sensitivity and talent visible only through his reporting and writing, and the occasional photograph he sent back to New York. This one, though, reveals more. Look closely in the upper right of the image and you'll make out a man in a hat—that's him, captured in the reflection of a window through which he shot a photograph of three young black women who were part of an ongoing protest in Atlanta in 1961.

It's a beautiful mistake not only because it captures a corner of Sitton, but also because it reveals the sometimes odd nature of reporting, the way we observe, peer in, almost intrude—but usually manage not to significantly alter the scene we aim to document. Claude Sitton was a master observer and measurer of mood, and this photograph in many ways complements the story that he was working on when he snapped it.

It was a lengthy piece that ran on page one describing the sense of concern that many people in Atlanta felt as black student demonstrations reached into their eleventh month. On one hand, the protests had become the norm; the casual looks on the women's faces here—and their distance from white patrons—reveals just how common this kind of scene had become.

And yet, Sitton's presence alone hints at the comments and fears heard and felt outside. It seemed to many as if violence was on its way, whether in Atlanta or elsewhere, and it was clear that forces opposing integration were not finished fighting.

"How would you like it if your little girl came back home ravished from a forced racially integrated school?" said one of the leaders of a group resisting integration. When he said, "The national government is the enemy of the people," Sitton noted in his story, the audience shouted, "Yes! Yes!"

—Damien Cave

ELSTON HOWARD, YANKEE MAINSTAY

The New York Yankees of the 1950s and early 1960s made it tough on everyone else. They won nine World Series in a span of fourteen years with rosters stuffed with stars who were on their way to baseball's Hall of Fame.

But when it came to putting players of color in the club's famous pinstripes, the Yankees were a lot closer to last place than to first.

Most of the sixteen teams that then made up the major leagues had already broken the color barrier by the time the Yankees—either because they were being cautious or biased, or both—finally put Elston Howard on the opening-day roster for the 1955 season.

Howard was from St. Louis, a high school star in three sports who turned down offers of college scholarships to sign with the Kansas City Monarchs of the Negro leagues in 1948. Three years earlier, Jackie Robinson had played a season for the Monarchs before beginning his journey to the Brooklyn Dodgers and American history. Howard's journey was less dramatic, but no less determined.

After three seasons with the Monarchs and two in the United States Army, Howard signed with the Yankees. He was an outfielder, but by the time the Yankees called him up to the majors, he had become a catcher, too.

And from that first season in 1955, when he hit .290 in 271 at-bats, he became a reliable member of the Yankees' lineup—someone who could play right field or left, catcher or even first base. And could hit.

In 1957, he was named to the American League All-Star Team, the first of nine consecutive selections. In 1958, he was a World Series hero as the Yankees rallied from a three-games-to-one deficit to beat the Milwaukee Braves and regain the world championship. In 1960, he took over the majority of the catching duties from Yogi Berra, who by then was thirty-five.

And in 1961, the year that two of Howard's teammates, Roger Maris and Mickey Mantle, staged their epic pursuit of Babe Ruth's single-season mark of sixty home runs, Howard put up dazzling numbers, too: 111 games behind the plate, a .348 batting average and twenty-one home runs.

That fall, the Yankees took on the Cincinnati Reds in the Series. Howard homered in the first game and caught the fifth, when the Yankees clinched the title in Cincinnati. The account of the victory in the next day's editions of *The New York Times* included a picture of Howard, his catching mask still on, embracing pitcher Bud Daley after the last out.

The main photo, though, was of the two managers—the Yankees' Ralph Houk, looking joyous, and the Reds' Fred Hutchinson, looking somber—as Hutchinson awkwardly congratulated Houk in the locker room.

When the Yankees arrived home the following day at Penn Station, champions of baseball for the third time in four years, *The Times* was there to greet them, but no story appeared about the welcome home. Nor did *The Times* choose to use a picture that its photographer, Arthur Brower, took of Howard and his wife, Arlene, as they left the train.

In it, Howard, with a suitcase in his left hand, had a jaunty Reds hat on his head in a sly display of humor. Arlene held a Yankees World Series pennant.

A year later, the Howards would celebrate again as the Yankees beat the San Francisco Giants in seven games to win still another Series. And in 1963, Howard was named the American League's most valuable player.

Howard had one more strong season left, in 1964, and then his offensive numbers began to fade, as they often do for catchers who are climbing past their mid-thirties. His last season was 1968, as a part-time player with the Boston Red Sox.

He became a coach for the Yankees and then an administrative assistant for the team, but death claimed him early, as it did with Robinson. He was

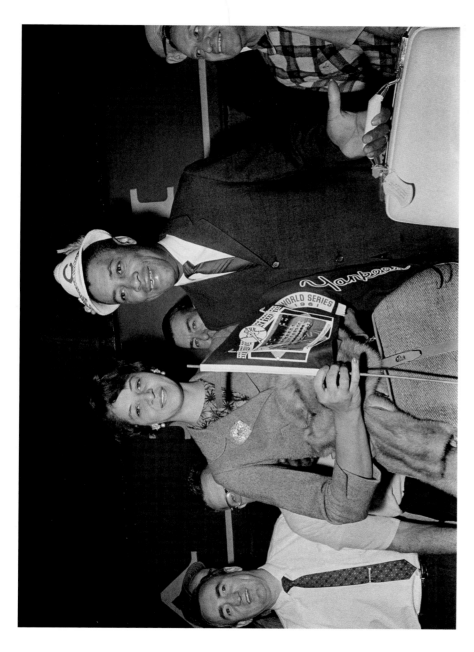

only fifty-one when he died of a heart ailment in December 1980.

Two months later, George Vecsey wrote a "Sports of the Times" column about the man who had integrated the Yankees. He interviewed Arlene Howard, who talked at length about what it was like to be married to someone who had to deal with the pressure of being the first black player on the team.

"There were times when Elston would come home angry—people never knew that—and I felt the brunt," she told Vecsey. "I had to be wife, mother and psychiatrist sometimes, but I wanted to be."

She recalled their experiences at spring training in St. Petersburg when for years the Howards had to find their own accommodations away from the team hotel. "We had friends, and we always managed to rent houses, but I was angry nonetheless," she said. "Elston was angry, too, but his nature was such that he put his anger into competing."

And there were sweeter memories, too. "Travel was by train, you always had Monday off, you played day games, you could plan your evenings," she said. "Every Sunday night, we'd go into the city knowing we had Monday off. It was a marvelous family era."

Accompanying the column was a picture of Elston and Arlene Howard. It was a nice photo, but not as eye-catching as the one that never ran twenty years before.

—JAY SCHREIBER

BENNY CARTER, A JAZZ LEGEND WHO MADE IT SEEM SO EASY

Jazz, the most American of music, is inextricably linked to the history of race in this country, with a lineage stretching from western Africa to slavery and through the blues and ragtime.

When the saxophonist, arranger and composer Benny Carter started performing in the 1920s, black musicians often played in jazz clubs where they could not sit in the audience because of the color of their skin. By the 1930s and '40s, as big band swing music became wildly popular, white bandleaders got much of the attention and money for a genre that was created and developed by African-Americans.

Carter's arrangements for his own band—as well as for Fletcher Henderson, Chick Webb, Benny Goodman, Glenn Miller and Count Basie—greatly influenced the direction of swing. Though he never reached the level of fame of some of his contemporaries, Carter recorded in eight different decades and was widely respected by his peers. One of the first black arrangers to break the color barrier in television, he composed for *The Mod Squad*, *Bob Hope Presents the Chrysler Theatre*, *Ironside* and other shows. He also arranged music for Billie Holiday, Ella Fitzgerald, Sarah Vaughan and Ray Charles.

I was a freelance photographer for *The New York Times* trying my best to impress my editors and land a full-time staff job when I photographed Carter on May 20, 1988. He was playing at a Greenwich Village club called Carlos 1. It was a time when many of the legendary figures in jazz were still with us, and I tried my best to photograph as many of them as possible, among them Cab Calloway, Ornette Coleman and Miles Davis.

Even at eighty years of age, Benny Carter did not disappoint. (He continued to play for almost another decade, and died in 2003.) His arrangements and improvisations were complicated, detailed and packed with ideas. Yet, as he played his sax, he made it all seem easy. And he generously afforded extended solos to his band members: pianist Richard Wyands, bassist Lisle Atkinson and drummer Al Harewood.

As he sat silently listening to his bandmates, I made a picture of him holding his saxophone. I remember thinking about the power of his presence even when he wasn't playing.

Jazz has rarely gotten much attention in mass media since the 1960s. In *The Times*, it is most often relegated to the back of the culture section behind classical music, opera and pop. Even though the review of Carter's performance in *The Times* was brief, there was no room for a photograph. As a freelancer, I was always disappointed when my photos didn't run, but this was one I could live with because I had spent a set in the presence of one of America's music greats.

—JAMES ESTRIN

I REMEMBER THINKING ABOUT THE POWER OF HIS PRESENCE EVEN WHEN HE WASN'T PLAYING

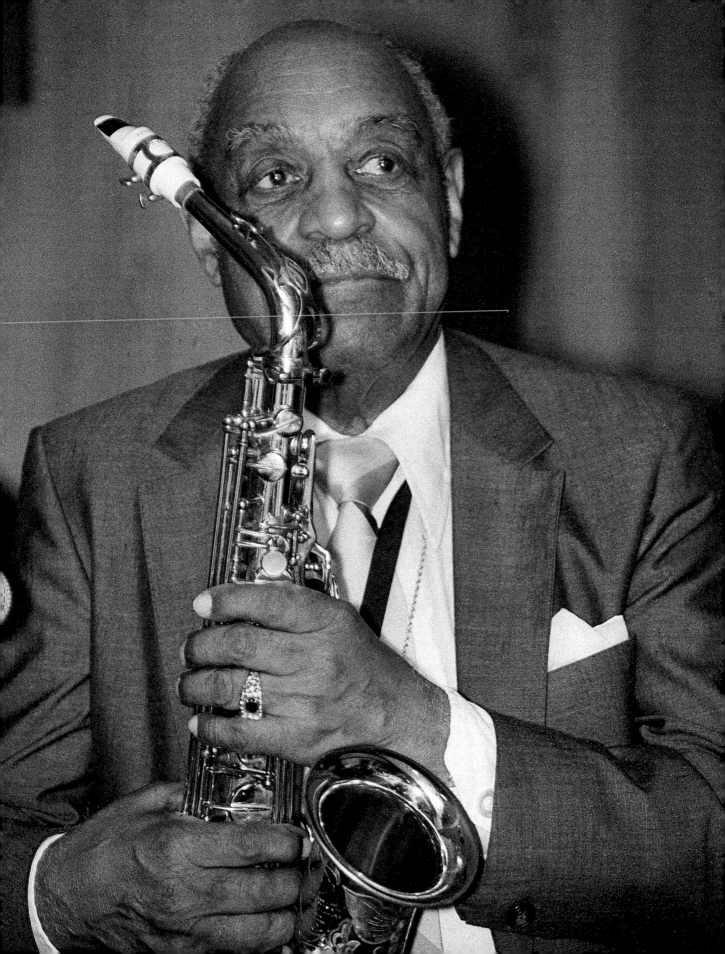

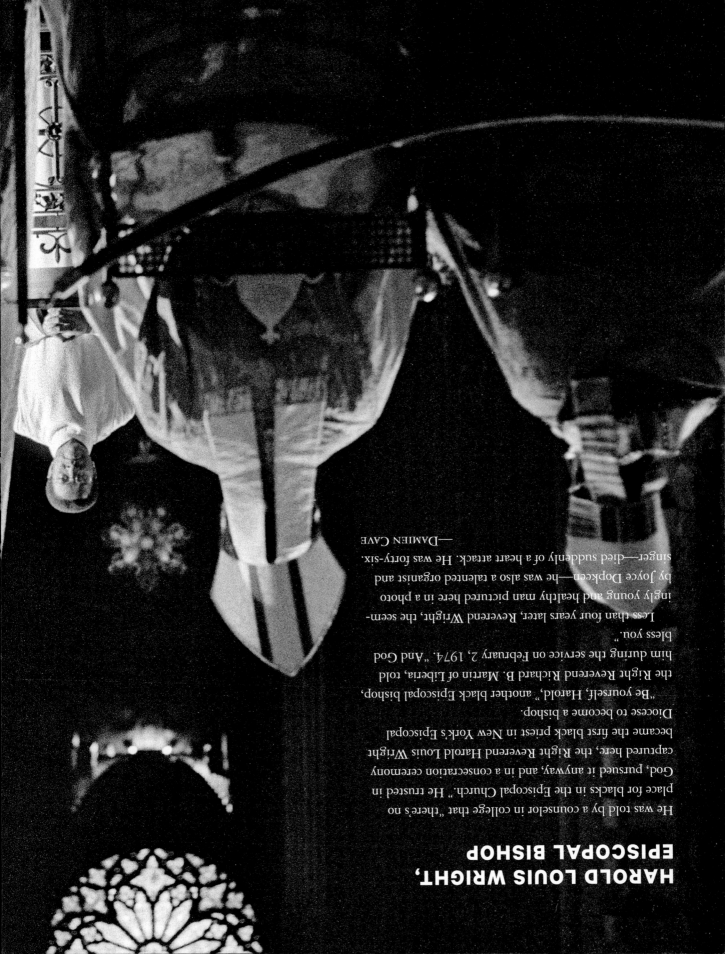

HAROLD LOUIS WRIGHT, EPISCOPAL BISHOP

He was told by a counselor in college that "there's no place for blacks in the Episcopal Church." He trusted in God, pursued it anyway, and in a consecration ceremony captured here, the Right Reverend Harold Louis Wright became the first black priest in New York's Episcopal Diocese to become a bishop.

"Be yourself, Harold," another black Episcopal bishop, the Right Reverend Richard B. Martin of Liberia, told him during the service on February 2, 1974. "And God bless you."

Less than four years later, Reverend Wright, the seemingly young and healthy man pictured here in a photo by Joyce Dopkeen—he was also a talented organist and singer—died suddenly of a heart attack. He was forty-six.

—DAMIEN CAVE

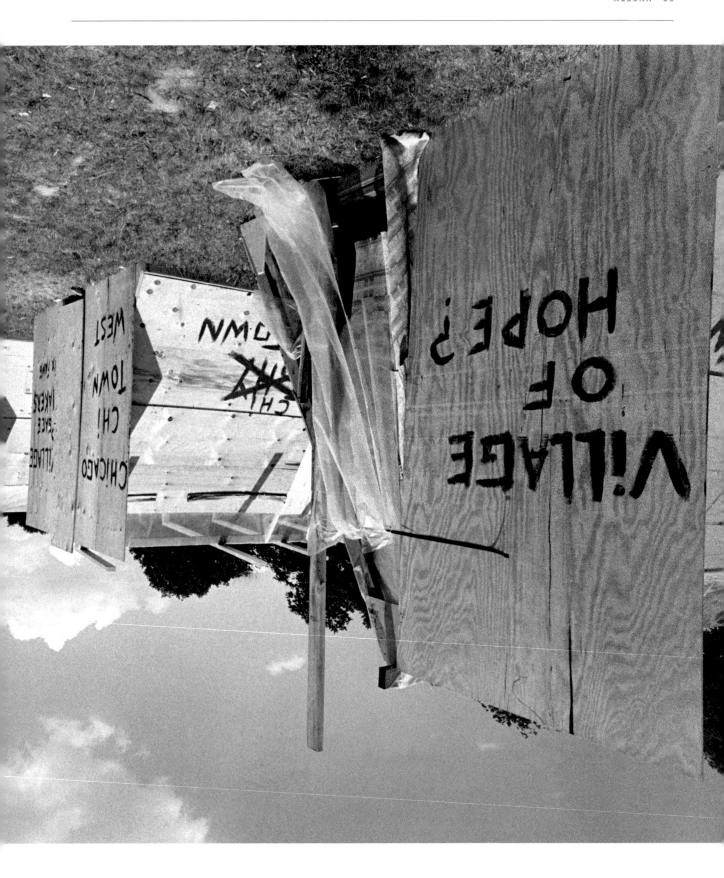

BATTLING POVERTY AT RESURRECTION CITY

Reverend Dr. Martin Luther King Jr. often described poverty and prejudice as related enemies, and in the last few months of his life, he called publicly for a national demonstration by the poor that would "confront the power structure massively."

The Poor People's Campaign was an effort to do just that, not just with a march but rather with an extended occupation of the National Mall in Washington. Organized by King and the Southern Christian Leadership Conference (SCLC)—and led by Ralph Abernathy in the wake of King's assassination—the campaign brought around 3,000 people from all over the country to a bit of land that would soon be drenched by rains, and filled with wooden shanties and varied attempts at utopian do-it-yourself collectivism.

They called it Resurrection City—in reality, it was fifteen acres near the Reflecting Pool.

The first demonstrators arrived on May 12, 1968, on buses from Mississippi. An architect designed rudimentary tents and wooden structures for temporary residents, and then came a city hall, a general store, a health clinic and a handful of celebrity visitors, including Sidney Poitier, Marlon Brando and Barbra Streisand.

The Times assigned Faith Berry, an African-American author, to visit the camp near the end of its six-week run. George Tames, a staff photographer in Washington, took hundreds of photos. A handful of them ran with Berry's article, which explored the camp's struggle to cohere as an ad-hoc society of people of different races with varied demands and overwhelming needs.

The published photos generally captured the messy end of the camp. Resurrection City's failures—from theft to illness and racial conflict—dominated the coverage of the time.

Calvin Trillin, writing in *The New Yorker* that

summer, captured it best when he wrote: "The poor in Resurrection City have come to Washington to show that the poor in America are sick, dirty, disorganized and powerless—and they are criticized daily for being sick, dirty, disorganized and powerless."

The images shown here present an alternative, and more well-rounded, portrait.

First, there's an image capturing one of the camp's many speakers. A camp's public address system was used to announce everything from campsite meetings and emergencies to long-distance phone calls, but it was also the place where Abernathy and others sought to rally residents, and remind them of the cause.

The other images show life in the camp at its most calm, humane and mundane—two women chatting inside a tent, a bit of barbering, and some of the homes and home-made messages intended to define the camp on its own terms.

These photographs do not show simple success, nor failure. They are less pretty than powerful, as a testament to idealism and its challenges—like a backdrop to the urge to gather and make demands, wherever and whenever needed.

—Damien Cave

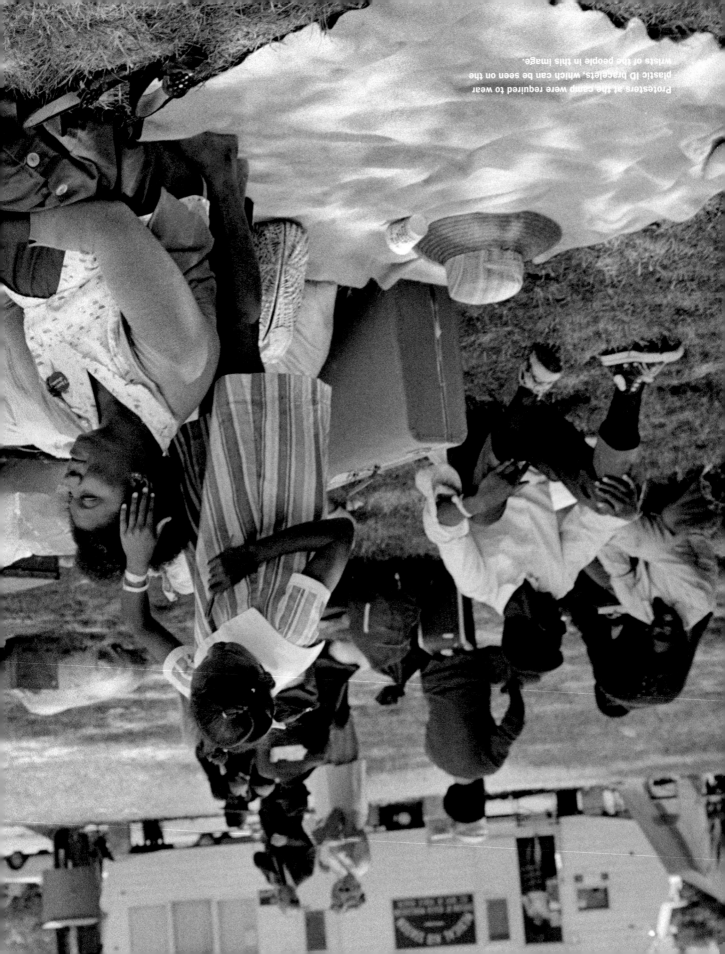

Protesters at the camp were required to wear plastic ID bracelets, which can be seen on the wrists of the people in this image.

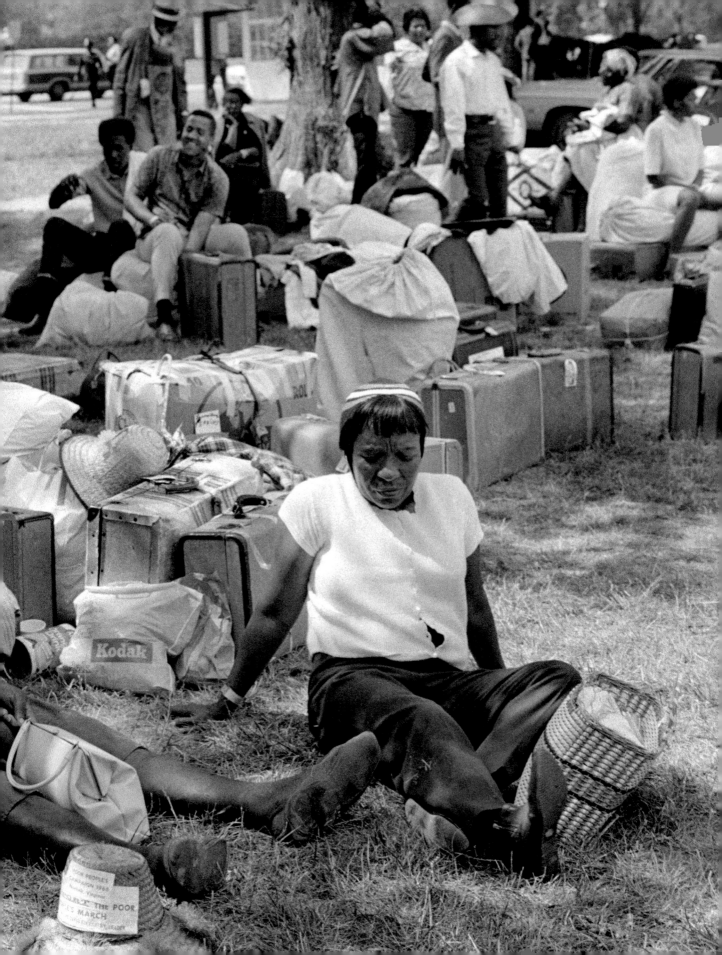

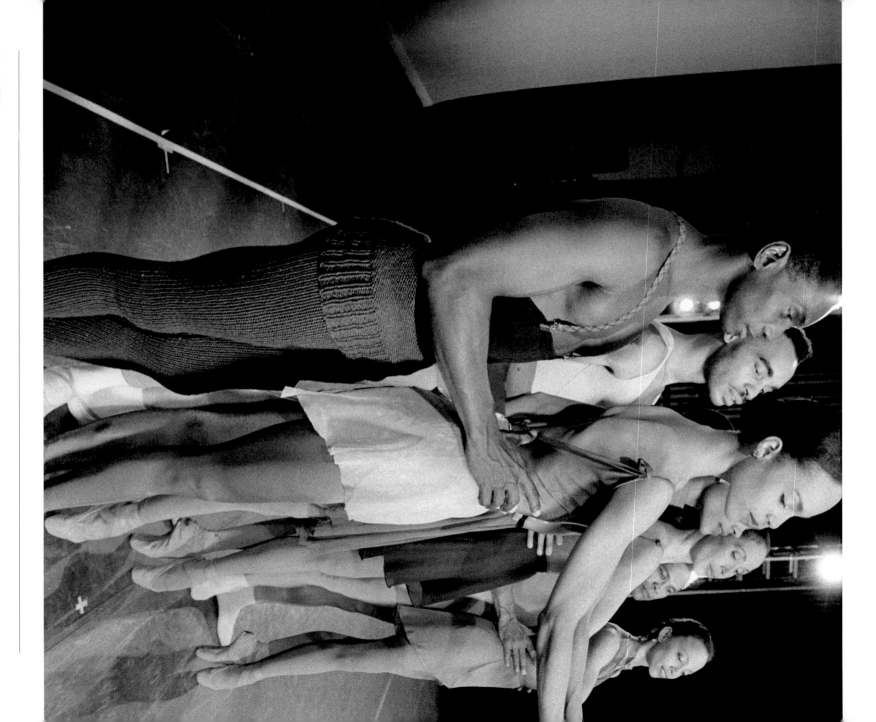

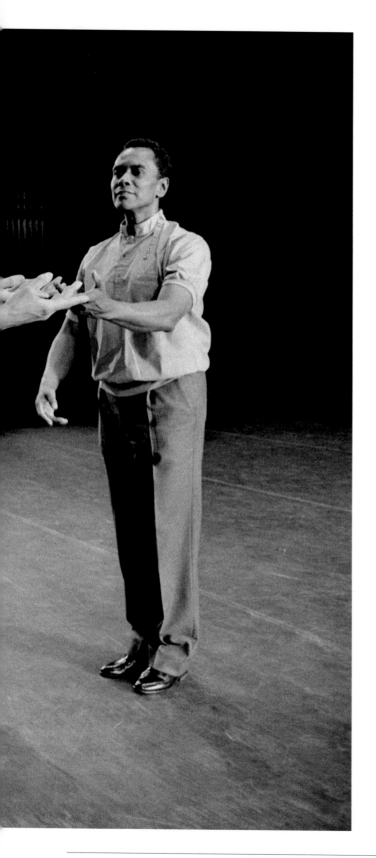

ARTHUR MITCHELL, DANCING THROUGH BARRIERS

In March 1993, I photographed Arthur A. Mitchell, the legendary African-American dancer, choreographer and co-founder of the Dance Theatre of Harlem, surrounded by his principal dancers rehearsing *Creole Giselle*, a classical ballet set on a Louisiana plantation.

I was struck by Mitchell's charisma and his wide smile, but when he tapped his toe, counting out the rhythm or emphasizing a word or a motion, there was this bone-chilling sound that defines the rigidity, the perfectionism and the focus that the grueling world of classical ballet demands.

MITCHELL AND BALANCHINE TRANSFORMED BALLET IN THIS COUNTRY

During the photo shoot, Mitchell pushed me around like I was one of his dancers. Mostly we did what he wanted, and he knew what he wanted. Once or twice he yielded to my requests, but not for long. The photograph to the left is all his design—and it is beautiful.

Feeling bruised nonetheless, I complained that he seemed more than a little Draconian and charming at the same time. Jennifer Dunning, a *Times* dance critic, told me she appreciated that tough approach. "Thankfully he is that way," she said, "because we got to see some great ballets, which we never would have seen."

Dancing through barriers, of course, is a theme that rages through Mitchell's life. Born in 1934, he grew up poor in Harlem, supporting his mother and siblings shining shoes and mopping floors. "I took over running the family when my father left," he often said. "I was twelve."

Trained as a tap dancer, he switched to ballet at a time when classical ballet companies did not hire black dancers and when television refused to show

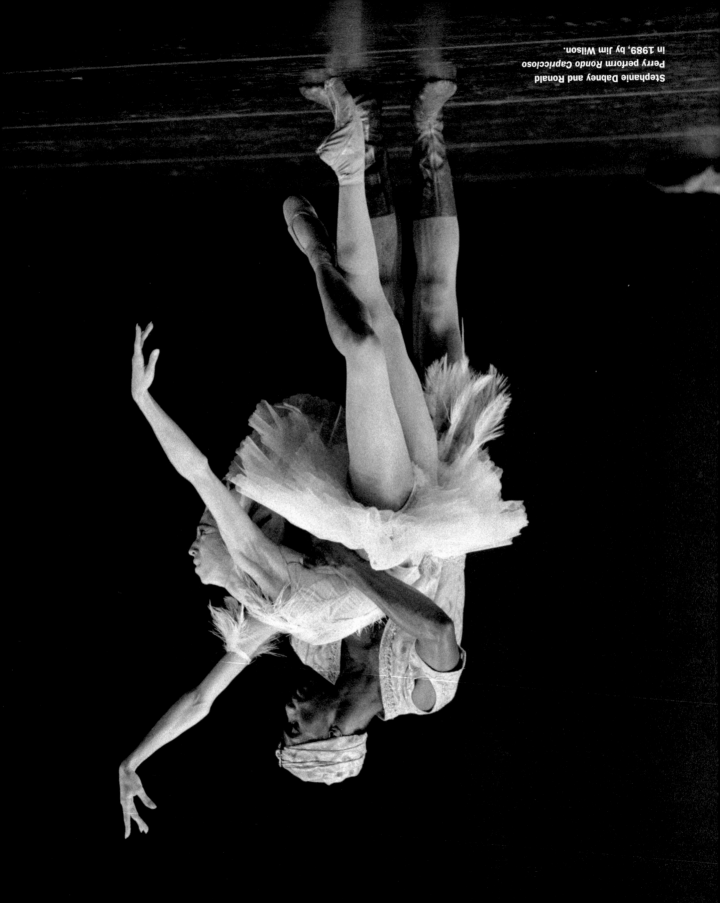

Stephanie Dabney and Ronald
Perry perform Rondo Capriccioso
in 1989, by Jim Wilson.

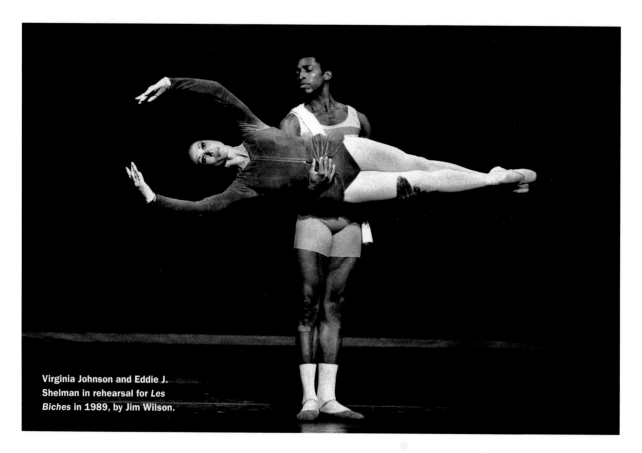

Virginia Johnson and Eddie J. Shelman in rehearsal for *Les Biches* in 1989, by Jim Wilson.

black and white dancers together. When Mitchell was accepted at School for American Ballet, parents complained that they didn't want their daughters dancing with an African-American. George Balanchine responded that they should take them out of the school.

In 1955, Mitchell became the first black dancer selected by Balanchine to star with an all-white New York City Ballet.

I was dancing the Fourth Movement in *Western Symphony* with Tanaquil Le Clercq," Mitchell remembered, "and some bald guy sitting right behind the conductor jumped up and he said, 'Oh my God, they've got a nigger in the company.' The people in the audience at City Center just went crazy, shouting and screaming. In the end we got a standing ovation."

In broader terms, Mitchell and Balanchine transformed ballet in this country into an American art

and Black American art. In 1969, Mitchell founded his Harlem company, with a school and community program, and it continues to thrive. "Through hard work and developing technique and a repertoire that was universal, and using American energy and attack," he said, "we brought visibility to African-American dancers in classical ballet, utilizing what they did best, their sense of rhythm and sense of freedom, coupled with the technique of classical dance."

Mitchell, who is now the artistic director emeritus at the Dance Theatre of Harlem, offered a bit of guidance to the young.

"Remember, the arts ignite the mind, and they give you the possibility to dream and to hope," he told me. "If you find space in this story—tell people what is key—using the arts to instill hope."

—SUZANNE DeChillo

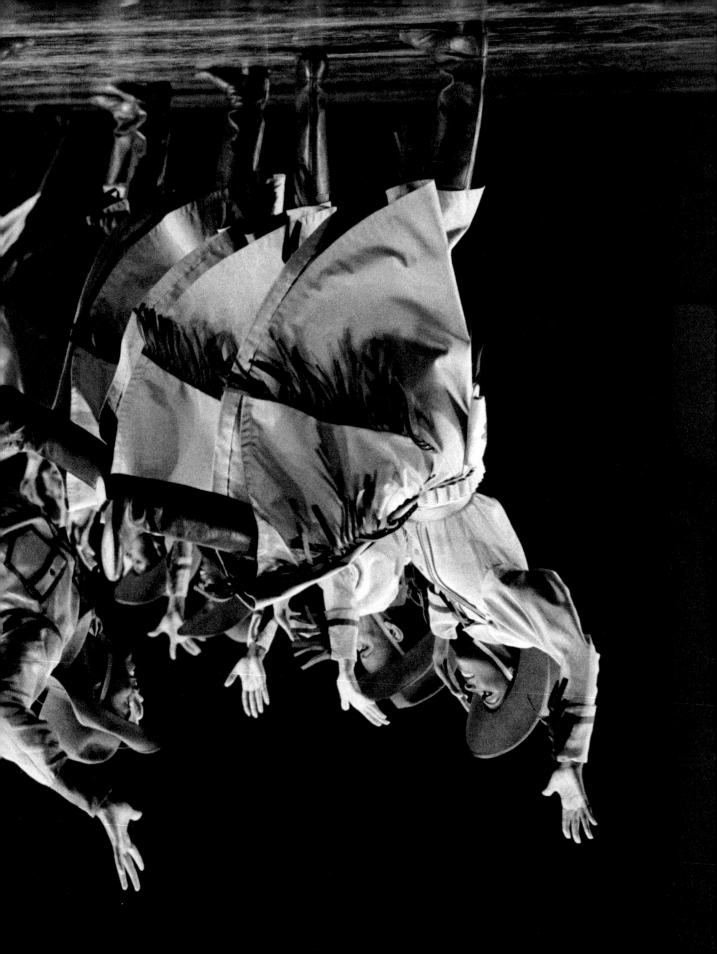

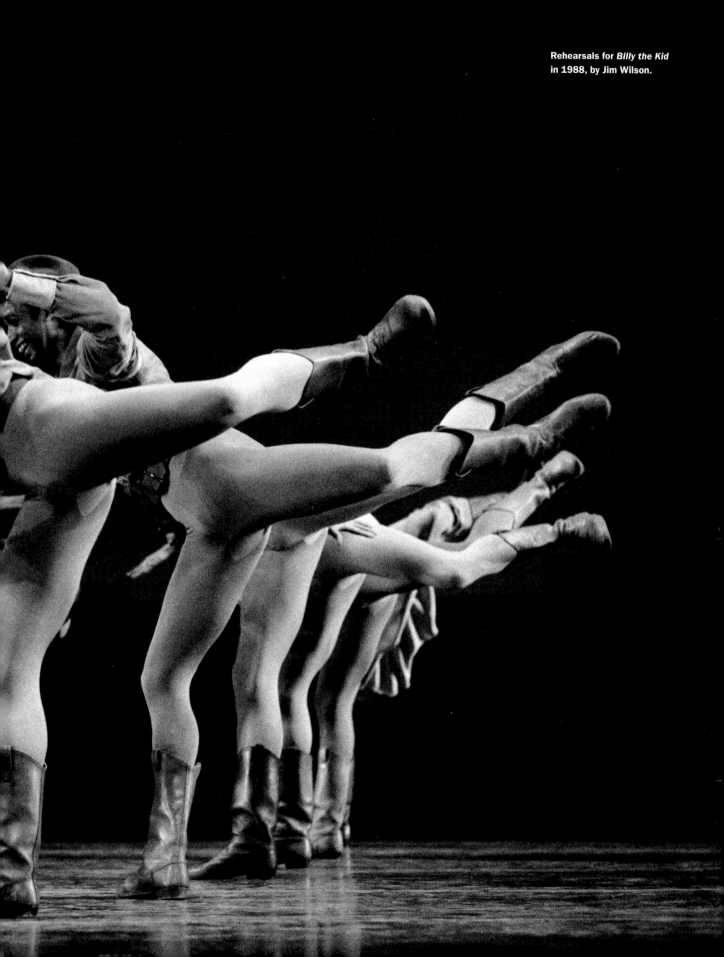

THE QUIET COURAGE OF ROSA PARKS

It is impossible to know what she might have been thinking that March day in 1956 outside the Montgomery County courthouse. The prim woman in the photograph, gripping her handbag with white-gloved hands, wore a neat overcoat and an uneasy expression behind her wire-rimmed eyeglasses.

Was she about to step to the microphones to speak, or had she just stepped away from them? Was she trying to ignore the television cameras capturing her appearance for all to see? Who was the white man trying to guide her along, or the black man with a seemingly supportive hand lightly touching her back?

There was no caption information to identify the woman as Rosa Parks in the unpublished image by George Tames found in a sack of negatives in our

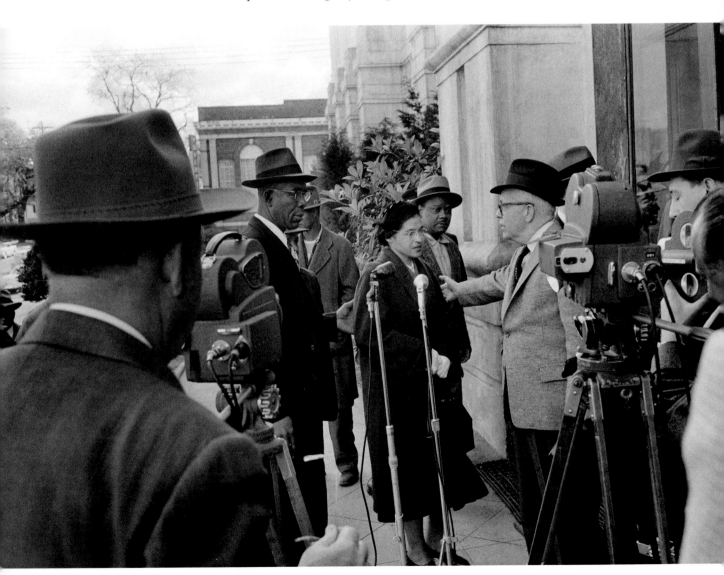

archives, and no mention of the men surrounding her outside the courthouse that day.

It is only in the context of history that the significance of the photo, deeply descriptive without words, comes into sharper focus. Parks was at the courthouse for the trial of Martin Luther King Jr., who was charged with violating an anti-boycott law. The boycott at issue followed her arrest on December 1, 1955, for refusing to give up her seat to a white man on a crowded city bus.

That act of civil defiance by Parks, a forty-two-year-old seamstress heading home at the end of her shift in the tailoring department of the Montgomery Fair department store, helped galvanize the yearlong boycott of the city's bus system. It was a bold decision by a strong yet weary woman—and a spark that ignited the civil rights movement.

At the courthouse that day, though, Parks was not the story. It was the account of King's trial for an illegal act of civil disobedience—the boycott—that became the focus of our article, which ran without a photo, on page twenty on March 22, 1956.

The trial was an important moment. It would elevate King, a twenty-seven-year-old charismatic preacher from Georgia, to the iconic leader of the movement.

But as for the woman at the courthouse entrance that day, our first photograph of Parks was a news agency picture of her being fingerprinted after her arrest that ran on the front page. Including that image, her picture appeared in our pages only four times in the first twenty-five years after her arrest.

Eventually, her name and likeness would become a national symbol of courage, and she would be forever known as the Mother of the Civil Rights Movement.

In February 2013, on what would have been Parks's one hundredth birthday, the United States Postal Service provided its own memorable portrait, issuing a commemorative stamp in her honor. That image shows her at roughly the age she was in the photograph here, but with a look of steely determination.

Later that month, Parks, who died in 2005 at the age of ninety-two, was immortalized as the first black woman to be honored with a life-size statue in the National Statuary Hall of the Capitol. That sculpture places her on a pedestal, seated as if on a bus, looking straight ahead into the future.

"This morning, we celebrate a seamstress, slight of stature but mighty in courage," President Obama said at the dedication ceremony. "Rosa Parks held no elected office. She possessed no fortune; lived her life far from the formal seats of power. And yet today, she takes her rightful place among those who've shaped this nation's course."

—DANA CANEDY

AT THE COURTHOUSE THAT DAY, PARKS WAS NOT THE STORY

SHIRLEY CHISHOLM, POLITICAL PIONEER AND CENSUS TAKER

She had already surprised everyone by becoming the first black woman in Congress after an upset victory in 1968. Then Shirley Chisholm signed up for work as a census taker in Brooklyn, where she represented a range of struggling neighborhoods.

It was a thankless task; many of the "enumerators" for the 1970 census quit because so many poor black and Hispanic residents refused to answer questions or even open the door.

Their distrust in government ran deep, *The Times* reported, with some fearing that giving up their personal information would lead to genocide.

Chisholm, a daughter of immigrants from Barbados who studied American history with the zeal of a woman determined to shape it, understood such sentiments. She also embodied what was needed to bring those New Yorkers into the fold. It wasn't pontificating. It wasn't condescending, or scolding; it required the same charm and resolve she showed first as an educator, then as a politician.

"I do not see myself as a lawmaker, an innovator in the field of legislation," she wrote in her 1970 autobiography, *Unbought and Unbossed*. "America has the laws and the material resources it takes to insure justice for all its people. What it lacks is the heart, the humanity, the Christian love that it would take."

Our census article that ran on August 1, 1970, relegated Chisholm's role to a footnote, a single line in a lengthy story told from cities across the country.

As a result, this photograph by Meyer Liebowitz of her looking resolute and formal, with her census bag and buttoned-up dress, was never published.

The distrust she aimed to combat back then in poor minority neighborhoods has not disappeared from the census process. Blacks and Hispanics still tend to be undercounted.

Chisholm, though, went on to appear in our pages more frequently: when she confronted congressional leaders over various issues; when she ran a long-shot campaign for president in 1972; when she announced her plans in 1977 to marry Arthur Hardwick, whom she met while serving in the New York State Assembly; when she died in 2005 at the age of eighty.

But even though she was a groundbreaker who served seven terms in Congress, she never commanded the level of attention that other civil rights leaders from that era did. Perhaps it was because she was a woman; she often said she had faced more discrimination because of her gender than because of her race. Or perhaps she never would have wanted all that celebrity anyway.

"That I am a national figure because I was the first person in 192 years to be at once a congressman, black and a woman proves, I would think, that our society is not yet either just or free," she wrote in her autobiography.

Putting it more simply in her later years, she said she did not want to be remembered as the first black woman to be elected to Congress, or to run for president, but rather as a black woman who "dared to be herself."

—Damien Cave

PAUL ROBESON COMES HOME

He stepped off the British Overseas Airways jet in New York City on December 22, 1963. After five years of self-imposed exile, Paul Robeson had finally come home.

But he was far from the triumphant singer and actor who had dominated the stage in the United States and in Europe.

A gray overcoat enveloped his once imposing frame, which had been battered by illness. Doctors stood by, ready to tend to him. He was sixty-five years old. And his long years as a political activist—a vocal leader who was blacklisted for his views—had taken their toll.

The reporters and well-wishers at Idlewild Airport in Queens didn't know it, but he would soon retreat from public life.

The son of a slave, Robeson was an American Renaissance man. A gifted

athlete, actor, singer and speaker, he also held a law degree from Columbia University. But it was in the theater that he found international acclaim.

He was one of the first African-Americans to hold major roles in predominantly white productions, and he received rapturous receptions for his performances in *Emperor Jones*, *Porgy and Bess* and *Othello*. He starred in 11 Hollywood films, including *Show Boat*, *Jericho* and *Proud Valley*.

George Jean Nathan, the noted drama critic, described Robeson as "one of the most thoroughly eloquent, impressive and convincing actors" he had ever come upon.

But Paul Robeson earned the ire of American officials and producers when he began to use his public platform to speak out against oppression in the United States and around the world.

His political activism on behalf of the colonized in Africa and India—and his open admiration of the Soviet Union—left him beloved in some quarters and despised in others.

"The artist must elect to fight for freedom or slavery," Robeson said. "I have made my choice."

For that, he would pay a heavy price.

Deemed a subversive and a Communist, Robeson watched as his commercial bookings dried up in the United States. Concert halls refused to host him. Rioters in Peekskill, New York, prevented a performance in 1949, smashing the stage and attacking his fans.

In 1950, the State Department stifled his career further when it made it impossible for him to perform overseas. The department canceled his passport when Robeson refused to sign an oath swearing that he was not a Communist.

By 1952, his income had plummeted to $6,000 from $100,000 in 1947.

Robeson sued the State Department. And in 1958, the Supreme Court ruled in a related case that Congress had not authorized the department to withhold passports based on an applicant's "beliefs and association."

Robeson was given a passport that year and departed for London, where celebrations for his sixtieth birthday were held around the world. But by then, he was well past his prime. In 1961, he fell ill. He spent time in an East German hospital before finally returning home.

At the airport in Queens, Robeson smiled quietly as he walked on the tarmac with his wife, Eslanda, keeping his famous baritone mostly under wraps. He hugged his son, Paul Jr., in a photograph that appeared in *The New York Times*. None of the other photographs that Allyn Baum took that day, including the one here, were published.

Robeson broke his silence only when reporters asked whether he planned to take part in the civil rights protests boiling across the country.

"Yes," he said. "I've been part of it all my life."

—Rachel L. Swarns

THE ARTIST MUST ELECT TO FIGHT FOR FREEDOM OR SLAVERY

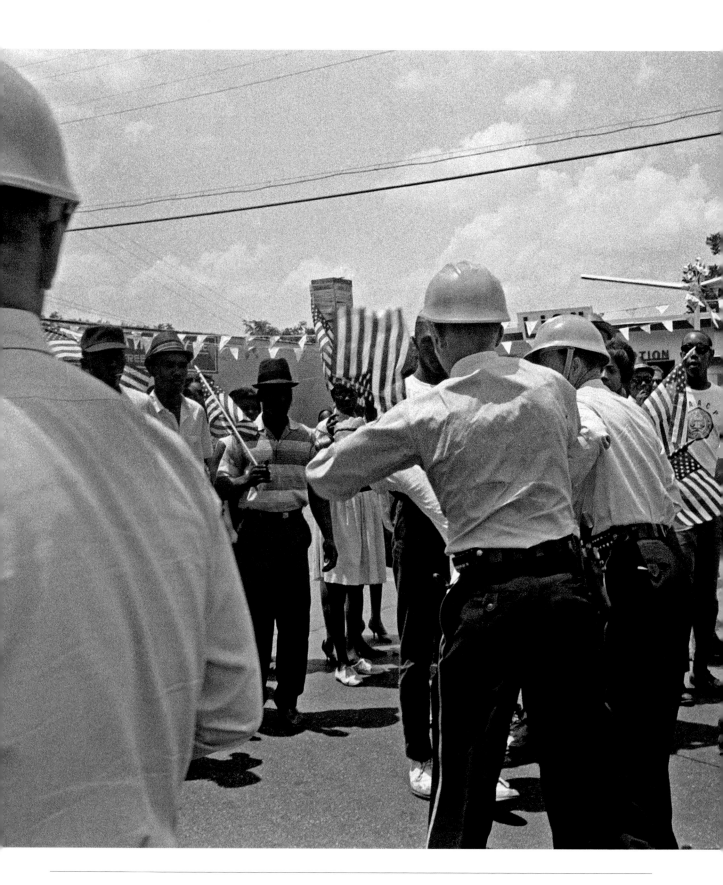

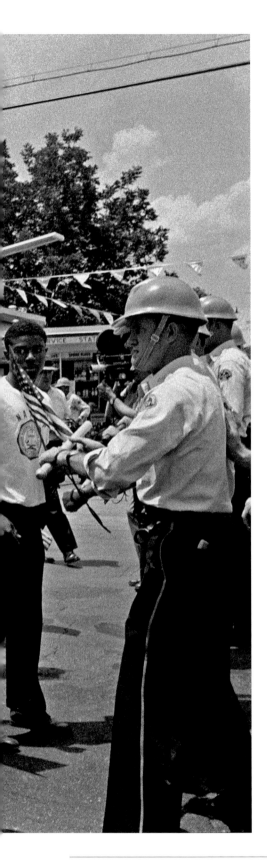

ON THE DAY MEDGAR EVERS WAS KILLED

The sniper fired his shot from a high-powered rifle, hitting Medgar Evers, the civil rights leader, as he walked from his car to his home after midnight in Jackson, Mississippi.

Within an hour, he was dead.

It was June 12, 1963, and by that afternoon, as word of the assassination spread, hundreds of black protesters in Jackson started marching—straight into a wall of white police officers.

Many of the marchers carried American flags. The officers carried clubs and automatic rifles.

Claude Sitton snapped this photograph just as the authorities seemed poised to lunge into the peaceful crowd. The officers would strike a girl in the face with a club that afternoon and wrestle a middle-aged woman to the ground as they took 145 people into custody.

Why didn't Sitton capture the rough arrests on film?

Perhaps he was too busy taking notes. He was not a photographer. He was a reporter, one of the most prominent chroniclers of the civil rights movement, and his article about Evers's death and the protests that followed would land on the front page of *The New York Times*. (His article, published on June 13, 1963, ran with two close-up photos taken by news agencies, one of Evers and one of his wife, Myrlie Evers.)

By then, Sitton, the great-grandson of a slave owner, had spent about five years crisscrossing the South as he reported on court cases and demonstrations, church burnings and assassinations. He was so well known that civil rights workers carried his phone number in case they got into trouble.

Later, as national editor of *The Times*, he instituted a rule that required his staff reporters to cover the Reverend Dr. Martin Luther King Jr. wherever he went. That's why Earl Caldwell, a *Times* correspondent, was in Memphis when King was assassinated in 1968.

—RACHEL L. SWARNS

ENDURING THE UNSPEAKABLE WITH DIGNITY AND DRY EYES

"There are to be no tears; we're going to act with dignity."

Thus did Myrlie Evers steel herself and her three children that Wednesday, June 19, 1963, as they watched Myrlie's assassinated husband, Medgar Evers, lowered into the earth at Arlington National Cemetery, where he was entitled to rest because of his Army combat service in Europe during World War II.

Dry eyes were important "so those who wished him dead would not see weakness," Myrlie recalled more than a half century later. So her eyes were dry, mostly, behind dark glasses, even though her grief was so deep she remembers hardly anything else about that day, not even the weather. (It was sunny and warm, with temperatures reaching the mid-eighties.)

Medgar Wiley Evers knew he was in constant peril; he had endured threats and slurs the previous eight years as the Mississippi field secretary of the National Association for the Advancement of Colored People. His wife worked with him, organizing civil rights demonstrations and voter registration drives.

Early on the morning of June 12, 1963, Medgar Evers was shot dead in the driveway of his home in Jackson by a white supremacist named Byron De La Beckwith.

This photograph of Myrlie Evers, widowed when she was just thirty, was taken by George Tames of *The New York Times*. She is shown comforting her son Darrell, who is partly obscured by a soldier. The photo was never published. The editors had chosen to run a wire service article the previous day about the arrival of Medgar Evers's coffin at Washington's Union Station on Monday, June 17. The article was accompanied by a wire service photo of the procession to a funeral home in the capital.

Not that *The Times* gave short shrift to the martyrdom of Medgar Evers. His assassination was the lead story on June 13. An editorial that day called the murder a "maniacal act of racist depravity" that would surely advance the prospects for strong civil rights legislation.

On the evening of Tuesday, June 11, President John F. Kennedy had addressed the nation on television, declaring that legislation was essential, yet not sufficient. What was needed, the president said, was a collective examination of conscience, and not just in the old Confederacy: "We are confronted primarily with a moral issue. It is as old as the scriptures and is as clear as the American Constitution. The heart of the question is whether all Americans are to be afforded equal rights and equal opportunities, whether we are going to treat our fellow Americans as we want to be treated."

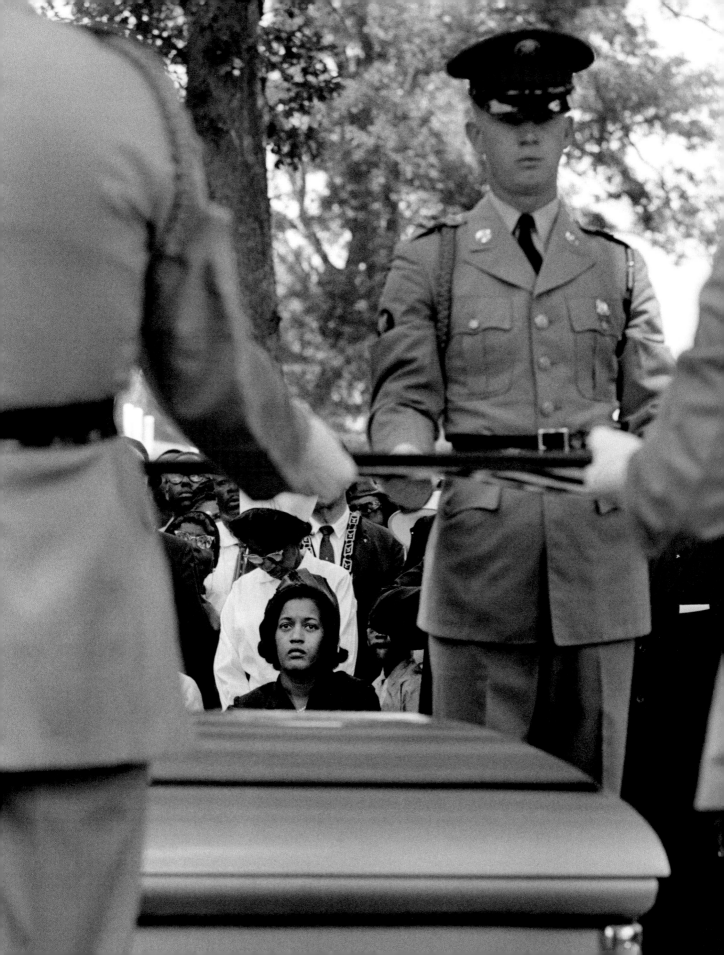

Just hours before Kennedy spoke, Governor George C. Wallace of Alabama had yielded to a federal court order and the presence of National Guardsmen and allowed two black students to enter the University of Alabama. Thus, the governor's inaugural pledge of the previous January, "segregation now, segregation tomorrow, segregation forever," had endured for less than six months.

Myrlie Evers and her children, Reena, Darrell and Van, watched Kennedy's speech that evening of June 11. Myrlie recalls that she expected her husband to quiz Reena, who was eight, and Darrell, a little older, about the speech when he got home from a meeting. (Van was only three.)

Just after midnight, Medgar Evers pulled into his driveway. Moments later, there was a shot and he lay dying. Reena ran to him and looked into his face and said, "Please, Daddy, get up." But he couldn't. He was dead at thirty-seven.

The murder should have been easy to solve: a rifle found in a honeysuckle

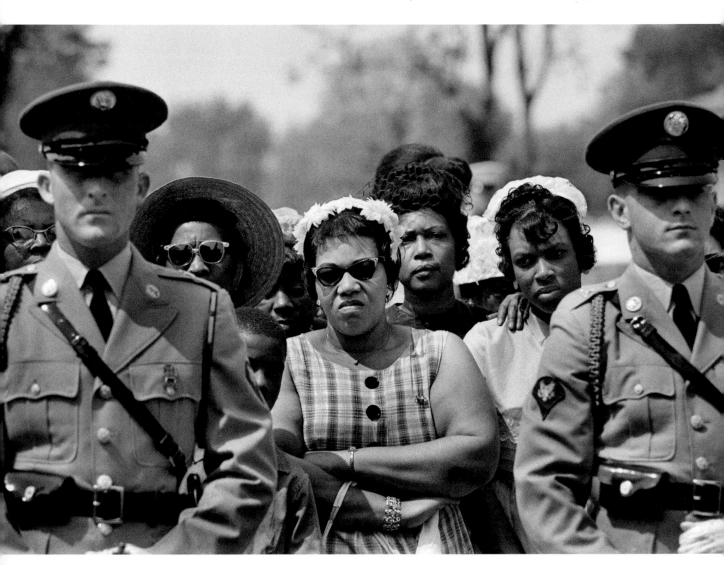

thicket near the scene was traced to Beckwith, and his fingerprints were found on the weapon's telescopic sight. But all-white juries refused to convict him in two Mississippi trials in the 1960s.

Around that time, Myrlie Evers moved her family to Claremont, California, where she earned a degree in sociology. She continued to campaign for civil rights, serving for a time as head of the N.A.A.C.P. board, the first woman to hold that post. She also became active in Democratic Party politics and worked in advertising.

And she continued to lobby for yet another trial of Beckwith. A new generation of prosecutors, prompted in part by a new generation of journalists who probed injustices from Mississippi's racist past, brought him to trial again in early 1994. By this time, he had served several years in a Louisiana prison for illegally transporting dynamite to New Orleans, where prosecutors believe he hoped to blow up the home of a leader of the Anti-Defamation League of B'nai B'rith.

In the Louisiana prison, Beckwith had boasted of killing Medgar Evers, just as he had bragged years earlier among his Ku Klux Klan friends. A Louisiana prison guard testified to what he had heard Beckwith saying. The guard's testimony and the evidence from the previous trials were enough to persuade a jury of eight black people and four whites, and Beckwith was sentenced to life in prison for murder. Some people in the courtroom thought Beckwith, who wore a Confederate flag on his lapel during the trial, looked dazed as the verdict was read, as though not sure where he was. He was in a new Mississippi.

Like the man he killed, Beckwith, who detested Jews, Catholics, and immigrants as well as black people, served his country honorably in World War II, as a Marine in the Pacific, where he was wounded. But he apparently had a different vision of what his country should be, right up to January 21, 2001, when he died at the age of eighty.

Darrell Evers, who was not quite ten when his father was killed, became an artist and died in 2001, age forty-seven, in Burbank, California. Van Evers is a commercial photographer in Pasadena.

In 1976, Myrlie Evers married Walter Williams, another civil rights activist. He died in 1995. In her eighties, Myrlie Evers-Williams, as she is now known, divides her time between California and Mississippi, where her daughter, Reena Evers-Everette, is executive director of the Jackson-based Medgar and Myrlie Evers Institute, which campaigns for social and economic justice.

But can she really feel comfortable in Mississippi, considering all that happened there? Silly question: "It's home."

—DAVID STOUT

DRY EYES WERE IMPORTANT SO THOSE WHO WISHED HIM DEAD WOULD NOT SEE WEAKNESS

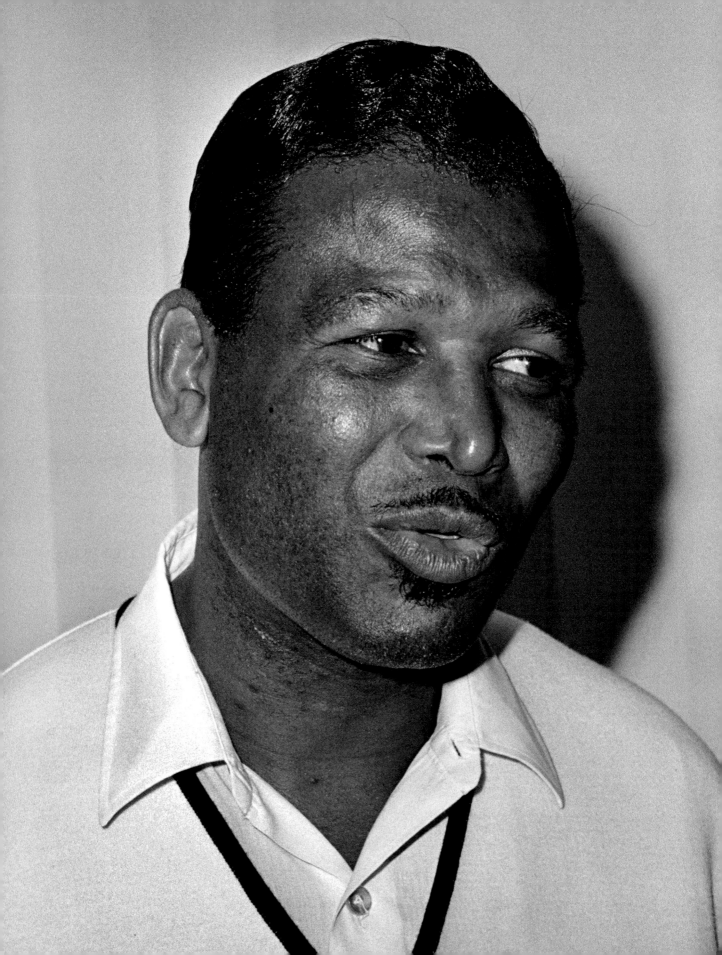

SUGAR RAY ROBINSON, A FIGHTER WITH STYLE

Sugar Ray Robinson was a five-time world middleweight champion whom many believe to be the greatest boxer in history. With his artistry and knockout power, Robinson, who was also a welterweight champion, inspired the description "pound for pound the best," a phrase coined to transcend the various weight divisions.

In the 1984 book *The 100 Greatest Boxers of All Time*, Robinson was ranked number one by Bert Sugar, then the editor of *The Ring* magazine.

"Robinson could deliver a knockout blow going backwards," Sugar wrote.

Muhammad Ali was inspired by Robinson's "matador" style, and Sugar Ray was his inspiration in dethroning Sonny Liston as the heavyweight champion in 1964. Ali had asked Robinson to be his manager.

From 1940 to 1965, Robinson recorded 175 victories against 19 defeats. (By comparison, today's biggest names rarely fight more than twice a year.) He registered 110 knockouts, but was never knocked out himself. As an amateur he was undefeated, going 85–0.

He was as flashy out of the ring as he was in it. Robinson was handsome, as this photograph, taken by Patrick A. Burns in June 1969 when Robinson spoke in New York on behalf of the President's Council on Physical Fitness, clearly shows. And he was stylish, owning Sugar Ray's, a bar and restaurant that was a focal point in the Harlem scene, and driving a pink Cadillac convertible. He traveled with an entourage that included a valet, barber, family members and George Gainford, who trained him throughout his career.

It was well known that Robinson liked to help family and friends, and he expressed no regrets for going through the piles of money he made. But his lavish spending came at a cost—he was forced to fight well past his prime.

What a prime it was. Some of his most memorable bouts—there were six in all, two of them in one month—were against Jake LaMotta, known as the Raging Bull, including a ten-round decision against Robinson in 1943. Robinson earned the middleweight crown in 1951 by stopping LaMotta in the thirteenth round. Robinson called LaMotta "the toughest guy I ever fought."

Ray Robinson died in 1989 at the age of sixty-seven.

—EARL WILSON

HE WAS AS FLASHY OUT OF THE RING AS HE WAS IN IT

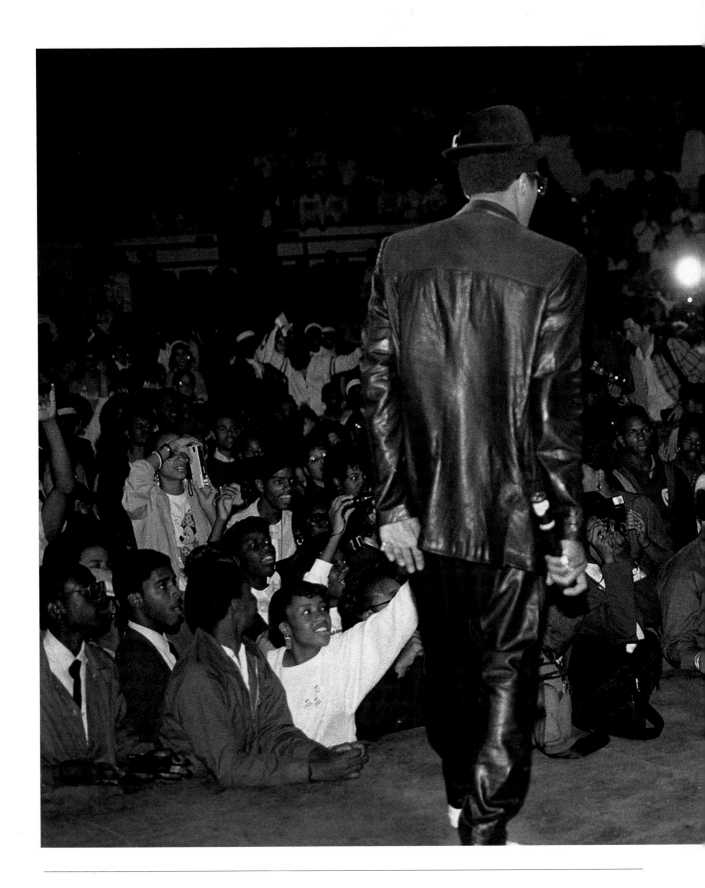

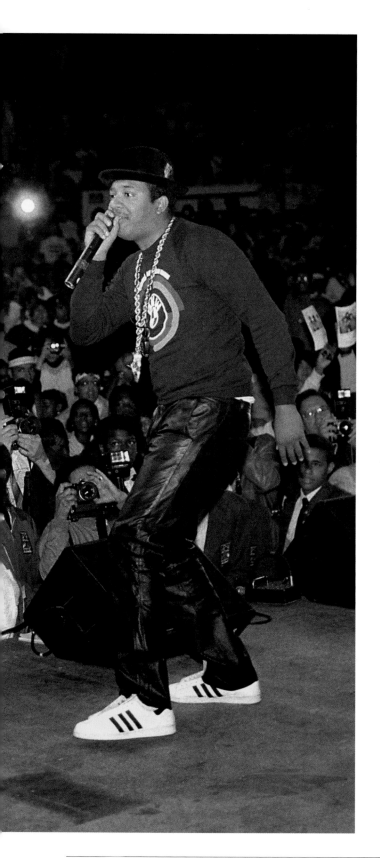

RUN-DMC'S "CRY FOR JUSTICE"

Chester Higgins Jr. describes covering Run-DMC at Madison Square Garden in 1986 for a benefit concert against crack cocaine. We never published photographs from the show or wrote about the performance.

Arriving to photograph this new group Run-DMC, I had mixed feelings. The music was slamming. The wordplay structure was mesmerizing, delivered as a diatribe that delineated the injustices experienced by this generation of young black people living in a society that held them in contempt. It resonated as a cry for justice giving voice to frustrations. The music's relentless tempo, driving earnestness and poetic structure had become a new creation with its own energy that spoke to these young people, but I found some of the lyrics horrifying, especially the use of the word "nigger."

Growing up in the South, I felt the sting of this derogatory word; to embrace it in a song smacked of self-hate.

But at the same time, it was clear these entertainers connected with the youth of their generation. The audience loved them, and I realized how powerful and totally off the radar the new music called rap had become.

BRAND-NEW NATIONAL GUARDSMEN

They were not even out of their civilian clothes yet, but these newly enlisted soldiers in the New Jersey National Guard were ready to serve. In this photograph from 1967, Sergeant Frank Robinson instructed the recruits in the proper presentation of arms at the Jersey City Armory. The men were the newest members of the 1st Battalion, 113th Infantry of the 50th Armored Division, known as the Jersey Boys because of the blue uniforms the state militia wore in pre-Revolutionary times.

The men had been permitted to join the Guard as a result of a program that then-Governor Richard J. Hughes requested to increase its number of black troops. The Army had approved the request, which called for increasing the state Guard by five percent, and reaching the goal with all black enlistees. The program was a response to complaints during rioting in Newark that summer that the white guardsmen called in to keep order had needlessly fired on black businesses and homes. Before the riots, there were only eight black men among the 743 in the battalion.

The reasons for joining the Guard varied among the black recruits. Some did so out of patriotism, others in hopes of avoiding the draft and being sent into combat in Vietnam.

"Any time doors open, Negroes have the responsibility to walk through, otherwise the doors may slam and never open again," one of the recruits, nineteen-year-old Matthew Rivers (at rear in the photo), said to *The Times* the summer he joined the battalion. The other recruits that Sergeant Robinson was leading in the photo by Robert Walker were, from front, Ernest Stallings, Alex Watson, Edward Williams and Ed Grice.

—Dana Canedy

KEY PLAYERS
IN THE CAPITAL

They look so different, the suit-clad man with the jaunty stride and his much taller companion, wearing the flared pants that were in fashion when this photograph was taken, on October 7, 1971. In fact, they had much in common. They both stood tall in the early days of the civil rights movement, and they both helped to shape the future of the District of Columbia as it began to govern itself in the early 1970s, after two centuries of control by Congress.

The shorter man is the Reverend Walter E. Fauntroy, pastor of the New Bethel Baptist Church in Washington. The man talking to him is Marion S. Barry Jr., a community activist who would climb to the summit of local politics, be toppled in disgrace, then rise to the top again, in one of the most remarkable comebacks in the history of urban politics.

On this sunny Thursday, *New York Times* photographer George Tames has captured Barry and Fauntroy as they tour a poor neighborhood. Barry is just weeks away from being elected to the District's school board, whose members will immediately elect him board president.

Barry and Fauntroy worked with the Reverend Dr. Martin Luther King Jr. In the early 1960s, Barry was an organizer of the Student Nonviolent Coordinating Committee, and its first national chairman. Around that time, Fauntroy became director of the Washington Bureau of the Southern Christian Leadership Conference. He helped to organize the 1963 March on Washington, immortalized by King's "I have a dream" speech.

Seven years after the picture was taken, Barry was elected Washington's mayor. He was elected three more times, once after serving a prison term for cocaine possession arising from a sting in which he was caught in a hotel with a woman not his wife. (He was married four times.) After leaving City Hall, he was elected to the City Council, representing a hard-pressed district until his death in 2014 at age seventy-eight.

His admirers saw Barry as a Robin Hood who empowered black people and helped the city of Washington free itself from near-colonial rule. His detractors saw him as a shameless rogue who sullied the District's image by his personal conduct and used the city payroll as an employment agency for his cronies. It could be argued that he was both.

**HIS ADMIRERS
SAW MARION
BARRY AS A
ROBIN HOOD**

Walter Fauntroy served as the District's first delegate to the House of Representatives for two decades, resigning his seat in 1990 to make an unsuccessful run for mayor while Barry was embroiled in legal troubles. While in the House, he was a founder of the Congressional Black Caucus, serving as its chairman from 1981 to 1983.

Recent years have not been kind to Fauntroy. He retired from his pastoral position in 2009, fell into debt, was accused of writing a bad check and left the country in 2012. For several years, he traveled in the Middle East, his behavior growing more bizarre as he slept in hostels and on park benches and sent e-mails to acquaintances railing against imaginary conspiracies.

He returned to the United States in 2016 and now, at eighty-four, is living in relative obscurity.

—David Stout

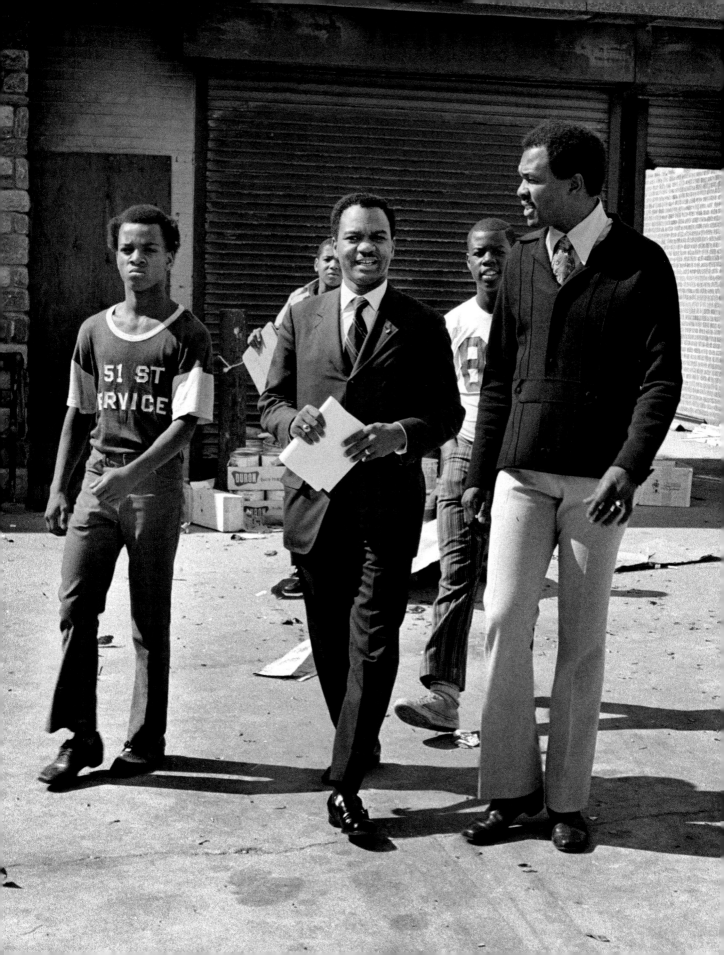

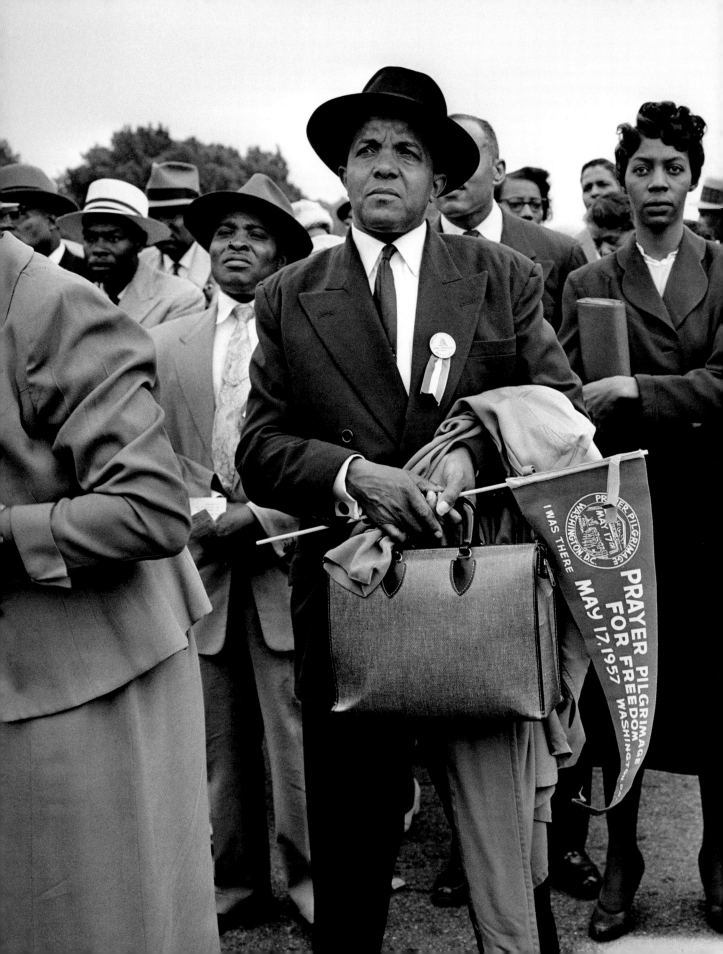

A PILGRIMAGE FOR EQUAL RIGHTS

Thousands came, from 30 states, to the Prayer Pilgrimage for Freedom at the Lincoln Memorial in Washington on May 17, 1957. They wanted immediate action on civil rights issues and to look back and forward on the third anniversary of *Brown v. Board of Education*.

In a speech to the crowd that day, Martin Luther King Jr. described that landmark Supreme Court decision as "a joyous daybreak to end the long night of enforced segregation."

But even then, it was clear that segregation in schools would outlast its historic defeat in the courts, in part because efforts to put the ruling in effect were weak or nonexistent.

"The Supreme Court's decision is not self-enforcing," said an article in *The New York Times Magazine* a few weeks after the pilgrimage, "and instead of spelling the end of an era of civil-rights litigation, it has marked the beginning of a new and even more bitter phase."

The photograph here, by George Tames, seemed to capture perfectly the mood of the time: No one in the picture looks satisfied or triumphant. But our article that day relied only on words. No photographs were included.

—Damien Cave

FRANKIE CROCKER: NO HOLE IN HIS SOUL

"Good evening, New York. This is the show that's bound to put more dips in your hips, more cut in your strut, and more glide in your slide. If you don't dig it, you know you've got a hole in your soul, and you don't eat chicken on Sunday."

This was the rap of legendary DJ Frankie Crocker, "often imitated, never duplicated." The words, no doubt, are burned in the memory of many who lived in New York in the 1970s. It didn't matter if you were black or white, young or old. Anyone who listened to music and owned a pair of roller skates knew the man (and his show) and loved it.

This photograph was taken by *Times* photographer Eddie Hausner in November 1968. He spent the afternoon with Crocker at WWRL in Woodside, Queens. According to his notes from the day, Crocker spun records while interjecting sexy prose over soul. He blasted a French horn and stood up for most of the show. He was also in charge of his own engineering.

The image wasn't published, and there were no articles in *The New York Times* mentioning this show or Crocker's involvement with the station.

"Tall, tan, young, and fly. Any time you want me baby, reach up for me, I'm your guy. Just as good to ya as it is for ya. You get so much with the Frankie Crocker touch. After all, how can you lose with the stuff I use?"

Crocker began his career in Buffalo at the soul powerhouse, WUFO. He moved to New York City in 1965 but was best known for his time at Manhattan's WBLS in the 1970s. He was a master of ceremonies at the Apollo Theater and was one of the first VJs on VH1. He also appeared in several Hollywood movies.

"Turn out the light and hold me tight, Frankie says it's just got to be all right. Closer than white on rice. Closer than coals on ice. Closer than the collar on a dog. Closer than a ham on a country hog."

Frankie "Hollywood" Crocker, the "Chief Rocker," died in 2000 at the age of 63.

"Sock it to me, Momma!"

My roller skates no longer fit.

—DARCY EVELEIGH

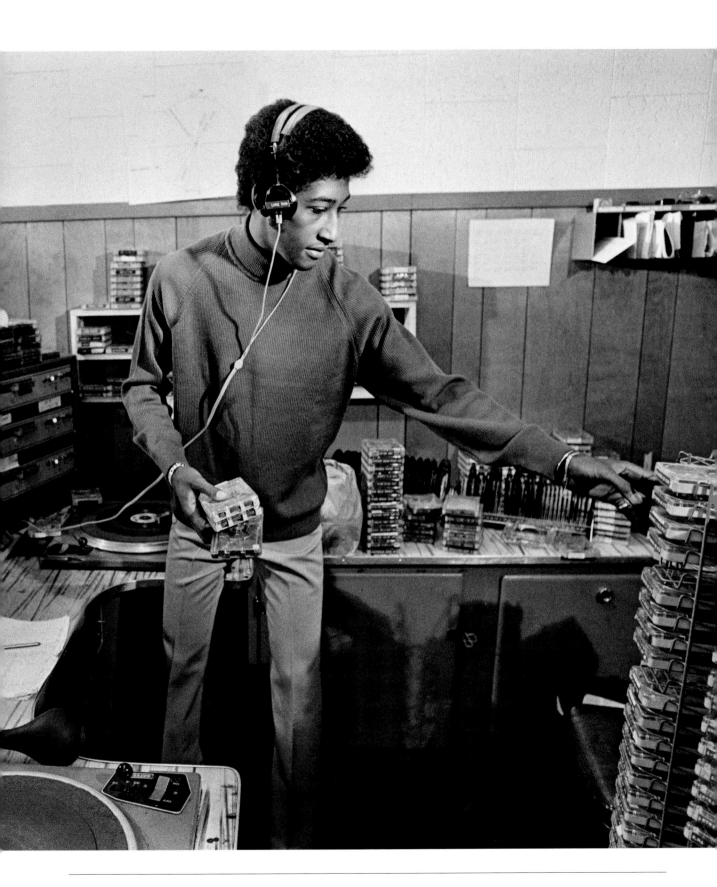

AN ISSUE TOO FRAUGHT TO INCLUDE NAMES

There is no more eloquent description of the fraught attitudes of the 1960s toward interracial relations than the words that appeared in an article in *The Times* on November 22, 1964, under the headline "Race, Sex and the Supreme Court."

"Over the last decade, the legal foundations of racial discrimination in this country have been washed away in the Supreme Court," reporter Anthony Lewis

wrote. "One after another, state and local laws drawing lines between human beings on the basis of their color have been found in conflict with the Fourteenth Amendment's promise of the equal protection of the laws. Only one area in the law of race relations has escaped this judicial scrutiny, and that is the most sensitive of all—sex."

Lewis's words described a nation wrestling with its racial future. *The Times* story appeared as the Supreme Court was about to take up a case challenging a Florida law against interracial cohabitation. The case, as Lewis described it, "threatens to stir again the deepest Southern racial fears."

Earl and Marion Miller represented those fears, in life as well as in the article.

Likely in an abundance of caution for their safety, that article, along with another photograph that appeared of Marion Miller serving her husband a meal, did not mention their names or tell their story.

This is who they were:

Earl Miller, now deceased, was an artist from Chicago whose wife was a Jewish real estate agent who emigrated from Germany with her family at the age of five. He was a member of the Spiral, a collective of thirteen artists formed by Romare Bearden that also included Jacob Lawrence. The couple met at a Manhattan nightclub, according to their daughter, Pringl, one of two Miller children—the other was a son, Hugh. The 1964 *Times* article did not include this touching photograph by Sam Falk of them looking adoringly at baby Pringl in a stroller from a park bench.

The envelope of negatives of the photographs of the Millers included an unusual handwritten message that instructed, "Under no circumstances, are prints of these negs to be given out or sold—to anyone." And the picture of the Millers that was published with the story only identified the couple as "A Negro painter and his wife at home in New York."

The note in the file and the vague description of the Millers that accompanied the photograph in the story hint at the risk they were taking in allowing themselves to be the faces of change.

Whether they embraced it or not, the Millers, who later divorced, and others like them who dared to love each other in those racially charged times, were leaders of a cause that forced their fellow citizens to confront one of the last standing laws of legal segregation.

—DANA CANEDY

BROWNSVILLE'S STRUGGLE

Brownsville's reputation as an urban failure began at least as far back as the 1940s with a popular novel, *The Amboy Dukes*, about a rough and tumble gang of hooligans in this area in the middle of Brooklyn. But what really defined it was what followed: white flight and fires and property abandonment, creating the urban wasteland captured here in this photo by Barton Silverman from 1972.

Just a few years earlier, *The Times* reported, only four percent of the apartments in Brownsville were considered up to standard. Success was harder to find than vermin. One woman told a reporter that her daughter was calling "Here kitty, here kitty" to a rat the size of a cat.

"If there is a hell," said Vincent Negron, director of the Good Shepherd Mission Center, in that same article from March 7, 1968, "many people in Brownsville will take it in stride."

These days it's hard to imagine any section of Brooklyn so bereft and empty, but Brownsville's demise came at a tough time, when federal, state and local government seized on empty lots and concentrated poverty in overlooked areas that tended to be black and Latino. So even today in Brownsville, housing projects still dominate. In fact, no area of the country has a higher concentration of public housing.

As a result, Brownsville's rates of poverty are still among the highest in New York City.

Even as it has improved in many ways, including its outward appearance—Amboy Street today has trees and newer buildings and far more energy—the area continues to be associated with trouble. Instead of the Amboy Dukes, it is now better known as the place that produced one of the world's meanest, most feared brawlers: Mike Tyson.

"I grew up in the streets," he said, in an interview with *The Times* in 1997, soon after biting the ear of Evander Holyfield. "I fought my way out."

—DAMIEN CAVE

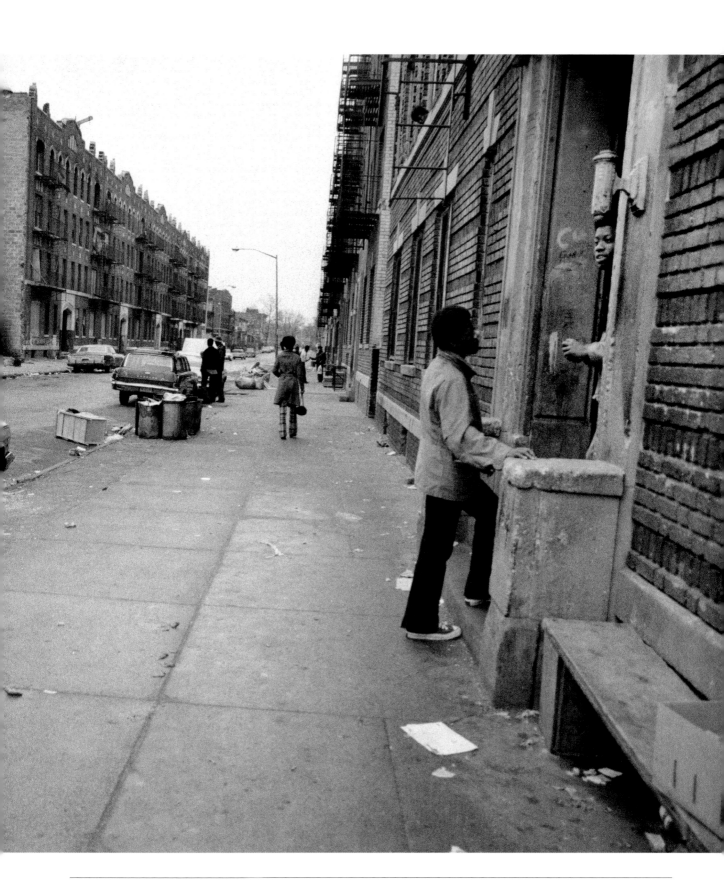

ANDREW YOUNG'S WARM WELCOME AT THE UNITED NATIONS

When Andrew Young Jr., a former mayor of Atlanta who helped draft the Civil Rights Act of 1964 and the Voting Rights Act of 1965, saw this photo, he said he knew immediately where and when it was taken because of one thing: what he was wearing.

"I knew it was the U.N. because I had that fancy suit," he said. "There were

some black tailors up in Harlem who, when I was appointed, they called me up—they said, 'You've never had anybody, have you?' I said, 'Look, I've been working for Martin Luther King for $6,000 a year; I buy clothes right off the rack at the discount store.' They said, 'Well, we want to make you a suit.' And that's the suit they made me."

It was the first tailored suit Young ever owned, and he wore it on his first day of work as the United States ambassador to the United Nations in January 1977. Chester Higgins Jr. captured him upon arrival, where he was met by hundreds of people in the lobby who were waiting for Kurt Waldheim, the Austrian diplomat who was then secretary-general. Instead the crowd of journalists and U.N. supporters cheered loudly for Young and rushed to greet him.

Young was the first African-American ambassador to the U.N.—at a time when the sheen, significance and optimism of the institution had yet to wear off. His presence mattered.

"The U.N. is a very friendly place if you show everybody just a minimal amount of respect," he said. "I never had a bad experience."

He did, however, end up with quite a few stories. It was a social place, he said, and so he attended every country's national day event for at least a few minutes, before sneaking out through the U.N. kitchen.

He helped negotiate a sensitive deal involving oil in Angola, with leaders whom he stayed in touch with for decades. He played tennis with the Russian ambassador regularly, which he's convinced helped American diplomacy. And there was even a time when the entire Chinese delegation, new to the U.N. at the time, ended up at the Waldorf Astoria, where Young and his wife lived, for a meal carried in by Young's mother-in-law all the way from Alabama.

"She brought fresh corn from her garden, black-eyed peas, cabbage—she had ribs smoked and put in a freezer chest," Young recalled. "She brought a whole Georgia dinner to the Waldorf. And she even went down to the Waldorf kitchen to cook it."

What started with this image—which shows a gaggle of people whom Young could not identify then or now—carried him through into a period of international diplomacy that he said he would never forget.

"There were people there, from the beginning," he said, "who really cared about what I was doing."

—DAMIEN CAVE

SHE BROUGHT A WHOLE GEORGIA DINNER TO THE WALDORF

JAMES VAN DER ZEE: "THE HIGHEST TIME AND THE LOWEST TIME"

For sixty years, James Van Der Zee chronicled his beloved Harlem, taking pictures of celebrations big and small and making portraits of everyone from celebrities to cabbies.

Today he is acknowledged as the foremost chronicler of the community that was the heart of Black America.

While it is easy to now see why his breathtaking body of work was so significant, he in fact spent much of his prodigious career unknown to the art world. That changed in 1969, when his photos were featured in *Harlem on My Mind*, the groundbreaking show at New York's Metropolitan Museum of Art. Yet a few weeks after that milestone, Van Der Zee, then eighty-three, and his wife were evicted from the Harlem brownstone where they lived and he worked. Apart from the photos that were safely in the exhibition, city marshals hauled off some 20 boxes of his negatives and prints.

"It is the highest time and the lowest time," he told *New York Times* reporter Robert M. Smith in an article published on April 8, 1969.

That dilemma could just as easily apply to the options for illustrating the story. The paper used a photo by Donal F. Holway that shows Van Der Zee looking forlorn and disheveled—gazing away from the camera—seated amid scraps littering his studio floor. Not used was another photo that Don Hogan Charles of *The Times* had taken three months earlier that showed him looking straight at the viewer as he stood proudly by his camera, the instrument that brought him fame.

While Van Der Zee may have possessed a singular talent, his predicament was one shared by more than a few cultural icons in African-American and Latino communities. Working steadily, and perhaps unheralded, they enter their later years facing financial and personal difficulties. The question becomes, how best to portray them.

Here's a more recent example: In 2013, I learned that Jesús "Papoleto" Meléndez, a founder of the Nuyorican school of poetry that emerged from the Lower East Side in the 1970s, was about to be evicted from his apartment. He was forthright about his situation. "I don't want people to pity me," he told me. "I'm not looking for a handout. I want a job."

I visited his fifth-floor walkup in East Harlem, which was cluttered with books, computer gear, file cabinets and pretty much anything else you could imagine. I photographed him as he sat stone-faced at his desk, with the messy, dimly-lit apartment as a backdrop. After I put away my cameras, we chatted. He mentioned a volume of poetry he had written in the 1960s, and got up to retrieve it, a sheaf of onionskin paper he had bound in soft brown leather.

The moment he began reciting a poem, his whole demeanor changed: His face brightened, his body swayed to the rhythm of his words, which he underscored with sweeping gestures of his arm. He was not so much a man transformed, as he was what he was: a poet. Frantic, I grabbed the first camera I could from my bag, leaned back and took about ten frames.

Which picture did I use? The one at his desk described his predicament, yet it also defined him in a way he would not want. The picture of him reciting, bathed in soft light, showed who and what he was, a poet possessed by words. I chose that one.

Van Der Zee's later years were marked by both fame and financial worry, getting by on public assistance and charity. When he died in 1983, he was in the middle of a lawsuit he had filed to regain his archives from the Studio Museum of Harlem. Some other articles about him showed him seated inside his studio before he was evicted or walking with a cane. He was shown, again, as man diminished.

Unseen and unused was the majestic portrait Charles had taken of him.

—DAVID GONZALEZ

NEW YORK GRIEVES FOR MARTIN LUTHER KING JR.

It looked like the civil rights movement had poured into the streets of Manhattan, and in a way it had. Masses of people packed onto Seventh Avenue for as far as the eye could see. But they were not there for a parade or a protest. It was instead a sorrowful moment of mourning for thousands of people in New York City as they streamed out of buildings to share in their grief on the day of Reverend Dr. Martin Luther King Jr.'s funeral.

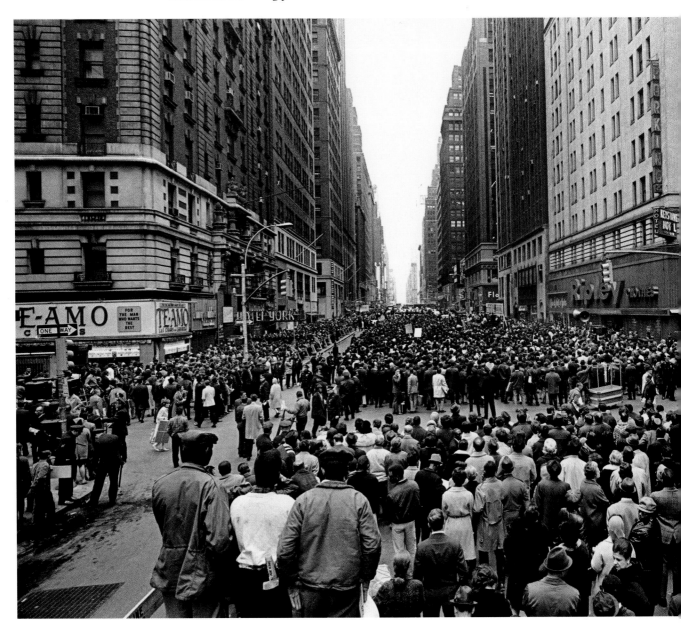

Work came to a halt and students stopped their studies in New York, as they did in cities, towns and even rural outposts across the country on April 9, 1968.

In New York City, nearly 200 diplomats and United Nations staff members gathered for a memorial service for King at the Church Center for the United Nations at United Nations Plaza. Ordinary people packed church pews. People in cars pulled over to listen to the funeral on the radio.

Blacks, as well as whites and others who had been moved by the movement King led, paid their respects by gathering in private and in public to reflect on the life of a man who had changed a nation. There was a concert in Central Park, marches on the Lower East Side and vigils throughout Harlem.

"It was a day that shifted its mood several times," according to a story in *The Times* that ran with several photographs that day, though none showing the large crowds gathered in the streets, as this picture by William E. Sauro clearly does. "Beginning with a Sabbath-like hush in the morning, it built up to a holiday bustle in afternoon, spurred by a bright blue sky and a golden sun, and then settled into what seemed to be an emotional release and weariness by nightfall."

As in many other places in the country, New York City did its best to accommodate the mourners. Schoolchildren were given the day off, the New York Stock Exchange was closed for the first time in honor of a private citizen, and most large retail stores stayed closed until after the 2 p.m. funeral.

Archbishop Terence Cooke offered a memorial mass at St. Patrick's Cathedral that evening, after returning from King's funeral in Atlanta.

Governor Nelson Rockefeller chartered a plane to take one hundred people to the funeral. Mostly a multicultural contingent of local public officials, religious figures and other dignitaries, the group included Mayor John Lindsay, Manhattan Borough President Percy E. Sutton and State Attorney General Louis J. Lefkowitz. Meanwhile, people crammed on chartered buses for the long ride to Atlanta, or met in local homes and watering holes throughout the boroughs, consoling each other wherever and however they could.

—Dana Canedy

ELEANOR HOLMES NORTON, EVER A CHAMPION FOR WOMEN

Two decades before she was elected the District of Columbia's delegate to the House of Representatives, Eleanor Holmes Norton was New York City's Human Rights Commissioner, having been named to that post by Mayor John V. Lindsay in 1970. Here she is on September 21 of that year, having a face-to-face exchange with the mayor in this photograph taken by Neal Boenzi of *The New York Times*.

A spokesman for Norton, who was elected to the House by the people of Washington, DC, in 1990, said she does not recall the details of the exchange. But there's little doubt the conversation concerned civil rights in general and women's rights in particular, issues of keen interest to Norton then as now. The photo was taken on the opening day of a week-long series of hearings by the New York City Commission on Human Rights in Manhattan on the status of women, but not published.

Lindsay said it was "nothing less than tragic" that women endured discrimination in workplaces across the country. But he said more than a quarter of New

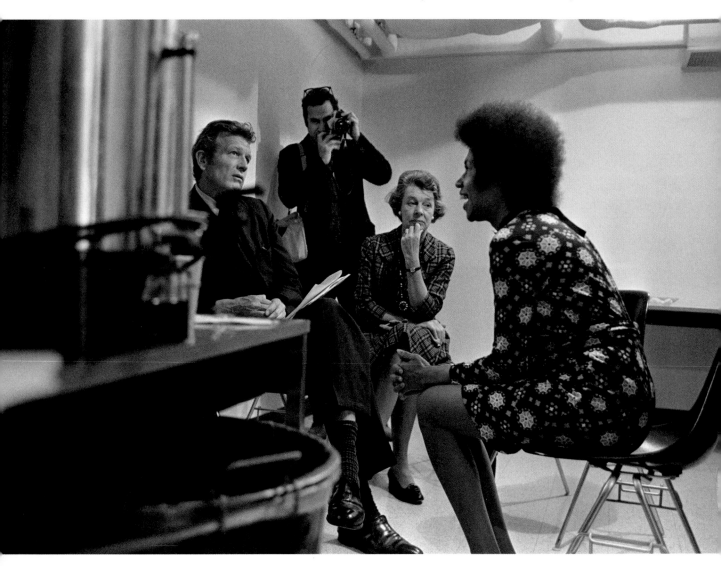

York City employees earning $10,000 a year or more (signifying membership in the middle class back then) were women, making the city's government a much fairer employer than most American companies or, for that matter, other cities. Indeed, a former head of the Women's Bureau of the United States Department of Labor said Lindsay was right.

All of which pleased Eleanor Holmes Norton not a bit. "The city government is reaping the benefits of job discrimination in private industry all over the country," she said in an interview during the hearings. "Many educated women regard New York as a mecca, but they come here and find just as much prejudice against them as elsewhere, and so inevitably they turn to government as the only alternative."

Sitting between Lindsay and Norton is Eleanor Clark French, who was born into Philadelphia's Main Line society and spent most of her adult life in New York. She was active in civic affairs, a delegate to five Democratic national conventions, and vice chairwoman of the New York State Democratic Committee from 1957 to 1960. (Earlier, she was for several years the women's news editor of *The Times*.)

Most interestingly, in 1964 she tried unsuccessfully to unseat the Republican congressman who represented the "Silk Stocking" district on Manhattan's East Side. The incumbent was a tall, debonair man from a decidedly upper-middle-class background, a fellow named . . . John Lindsay. (Eleanor French died in 1990 at the age of eighty-one.)

When this photograph was taken in 1970, Lindsay was undergoing a political metamorphosis. Elected mayor as a Republican in 1965, he lost his party's nomination in 1969. So he ran as a Liberal fusion candidate and won a second term. He ran briefly for president in 1972 and for the United States Senate in 1980— both times as a Democrat—before fading into political obscurity.

Eleanor Holmes Norton, who had worked for the American Civil Liberties Union, served in the New York City post until 1977, when she joined the administration of President Jimmy Carter as head of the Equal Employment Opportunity Commission. She teaches law at Georgetown University and turned eighty on June 13, 2017.

Can a single moment frozen in time tell us about the people whose images were captured? In this case, perhaps yes. Shortly after Lindsay died at age seventy-nine in 2000, the political journalist Richard Reeves, who knew him, said that despite his easy smile Lindsay was actually "a cool and distant man," not much given to passion. So he appears here.

But "passion" is a word that has been used often in describing Eleanor Holmes Norton. Her image in the photo reflects depth of feeling. So do some of her public remarks. In 2011, convinced that the city of Washington was being treated badly by lawmakers in both parties, she said, "It's time that the District of Columbia told the Congress to go straight to hell."

—DAVID STOUT

ROBERT C. WEAVER, AN URBAN PIONEER

In the early 1960s, President John F. Kennedy tried to create a Department of Urban Affairs that would pull together a number of agencies that had been dealing with housing since the New Deal. Congress refused to support the idea for years, until President Lyndon Johnson pushed through the creation of the Department of Housing and Urban Development, leading to the selection of the country's first black cabinet member: Robert C. Weaver.

In this photo by George Tames, Weaver seemed calm and collected as he accepted the appointment in 1966. He was the grandson of the first black person to graduate from Harvard with a degree in dentistry. At the moment of his appointment, he held more Harvard degrees—three, including a doctorate in economics, *The Times* noted—than anyone else in the Johnson administration's senior ranks.

As its first leader, he tried to push H.U.D. toward beauty and utility. He offered awards for design. He increased financing for small businesses displaced by renewal efforts, arguing, "You cannot have physical renewal without human renewal."

And throughout his life, in government and later in academia, he seemed to follow the advice he often gave others as a behind-the-scenes civil rights leader in the 1930s and 1940s: "Fight hard and legally," he said, "and don't blow your top."

—DAMIEN CAVE

CAPTURING THE LIONEL HAMPTON VIBE

Lionel Hampton, the jazz vibraphonist, had a great sense of music as a continuously transforming event: His body of work keeps you on alert in the intensified, energetic moment.

This picture, taken in 1985 by *Times* photographer Marilynn K. Yee, perfectly captures Hampton (with drumsticks), midbeat on drums, the instrument of his early career. He had just joined a New Orleans–style parade in New York, celebrating an art opening of jazz-related works at the Dyansen Gallery in SoHo. His smile suggests he's right at home, thrilled by the spontaneous spectacle.

But the march—which started at Columbus Circle, went east to 57th Street and Fifth Avenue, then restarted in SoHo near the gallery after the musicians took a bus downtown—didn't quite fit with our article, which previewed "a new and star-studded jazz festival" at South Street Seaport. So instead of this vibrant

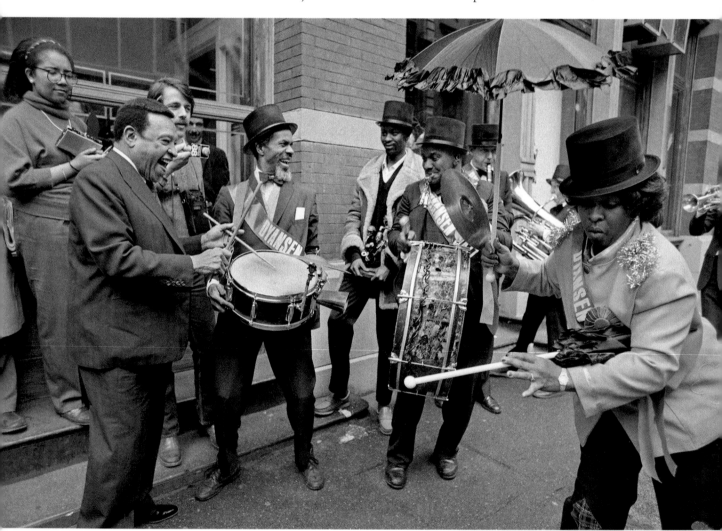

image with Hampton, who would be playing on the festival's first night, we ran a portrait of his face.

By that time, he had already come a long, long way. Born in 1908 in Louisville, Kentucky, he relocated with his mother to Birmingham, Alabama, later described by Martin Luther King Jr. as "probably the most thoroughly segregated city in the United States."

Hampton later moved to Kenosha, Wisconsin, and then to Chicago, and in the early days of his professional career he moved to Los Angeles to play drums in jazz bands, including Les Hite's. Louis Armstrong used the Hite band on a trip out West and persuaded Hampton to play vibraphone; he went on to become one of the pre-eminent soloists on the instrument.

During the late 1930s, Hampton was also a star in one of the first high-profile racially integrated bands, Benny Goodman's quartet, alongside Goodman, Teddy Wilson and Gene Krupa. Their records from back then remain powerful: impeccable, organized, propulsive.

RIGHT AT HOME, THRILLED BY THE SPONTANEOUS SPECTACLE

But there were private challenges. On tour, Hampton wrote, Goodman had to draw up a contract with promoters to ensure that Hampton and Wilson could stay in the same hotels as the rest of the band; he also had to hire people to escort the black musicians from hotel entrances to their rooms, so that—in Hampton's words—"we wouldn't be exposed to any unpleasantness."

And yet here was Hampton making some of the most generous and confident American music of the twentieth century. Some of what he did soon afterward, with his own bands, was rhythm and blues prefiguring rock 'n' roll; "Flying Home," in 1942, with a driving saxophone solo by Illinois Jacquet, became one of the great commercial breakthroughs made by a jazz musician. Hampton became an ambassador, bringing jazz far afield, and played "Flying Home" at Harry S. Truman's presidential inauguration in 1949, in a program with Lena Horne and the operatic soprano Dorothy Maynor.

And as Louis Armstrong did for him, Lionel Hampton helped elevate other important musicians in their early years, including Dinah Washington and Quincy Jones. He also lifted others in smaller ways, creating music scholarships at universities and helping to build low-income housing.

All that goodwill reverberated back to him in ways big and small. At the very least, it meant that a band of jazz marchers in 1985 could rely on him for unannounced percussion. It also meant that seventeen years later, he would be the one honored by another New Orleans–style parade held in New York, after his death. Wynton Marsalis and the Gully Low Jazz Band led a crowd of mourners and fans toward Riverside Church, where luminaries gathered for his funeral. The speakers included Illinois Jacquet; the Reverend Calvin O. Butts III; Representative Charles B. Rangel; and the former president George H. W. Bush.

—BEN RATLIFF

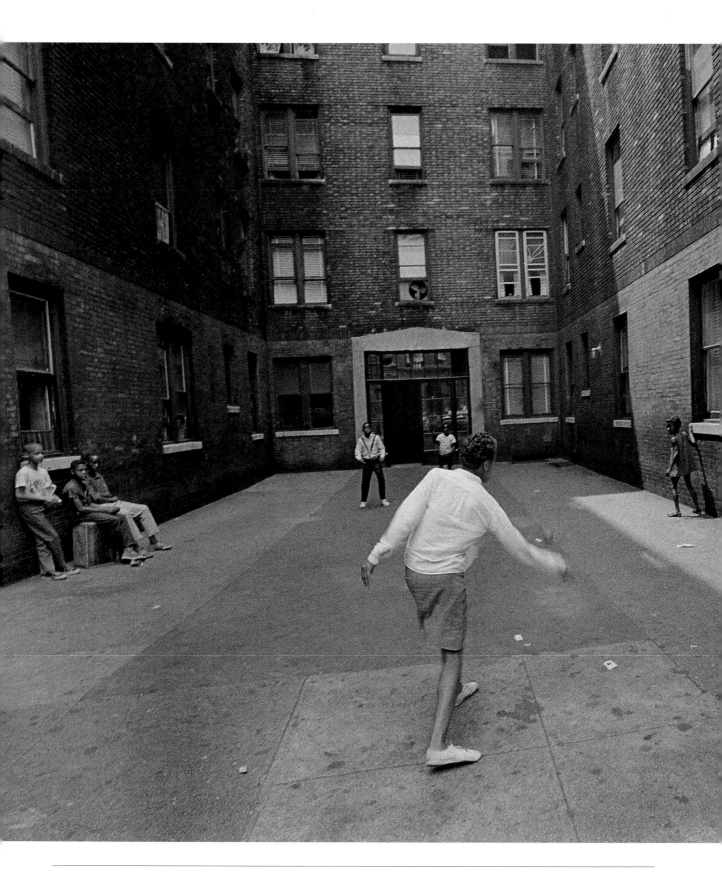

A game of handball takes place despite the rules of a local housing complex.

THE HARLEM OF DON HOGAN CHARLES

On August 8, 1966, *The New York Times* ran an article that said many Harlem residents wished more white people would visit to see for themselves their community's reality. The article, by McCandlish Phillips, detailed in an almost anthropological way the Harlem of 1966 to *Times* readers.

"A curtain of fear, about as forbidding as a wall of brick, has made the black ghetto almost psychologically impenetrable to the white man—at a time when many in the ghetto sense that it needs the white man to help it save itself from a kind of psychological secession from a white society," Phillips wrote.

The article went on to note that many "Negroes protest that white people see Harlem in caricature," but at the same time it stated—citing no authority—that thousands of children had shoes only for Sunday or none at all. Another *Times* finding was that "a surprising number" of residents preferred the word "black" to "Negro," and "some are turning to the study of African history and African dress."

As part of the usual newspaper process, Don Hogan Charles, then twenty-seven years old, was assigned to take the pictures—to spend a weekend documenting Harlem, where he lived.

Charles was the first black photographer hired by *The Times*. And the images he made reveal a Harlem much different from the one portrayed in the text. Four of his photos made it into print with that article, which had probably gone through several levels of editors, and the selected images are strong if somewhat predictable: One shows a scene outside a church; another shows men playing cards on the sidewalk.

But in the hundreds of other photographs that he shot, visible in the negatives of our archives, a fuller portrait of the neighborhood and his neighbors comes into view. The residents of Don Hogan Charles's Harlem are fully rounded people, not caricatures, symbols or subjects to be studied. He had less than two days to shoot this assignment, but his subjects share a dignity that was often missing from much reporting of the era.

Though *The Times* was both lauded and vilified for its reporting from the front lines of the civil rights struggles in the South, there were few black journalists in the industry during those years, beyond black news outlets. Major news media coverage of New York's black neighborhoods often resembled overseas "parachute journalism"—a quick visit, conversations with a few residents on the street, with a little seasoning from outside experts. In the following decades, many newspapers, including *The Times*, pushed along by lawsuits, added more black, Latino, Asian and female journalists.

Charles still lives in Harlem, but it is a neighborhood vastly different from the Harlem of the 1960s. Today many white people live in the neighborhood, real estate prices are soaring, and new galleries and restaurants are popping up daily. The area that was once forbidding enough to outsiders to merit a story about its realities is now one that longtime black residents worry about being able to afford.

—JAMES ESTRIN

Boarding a bus to Sunday services.

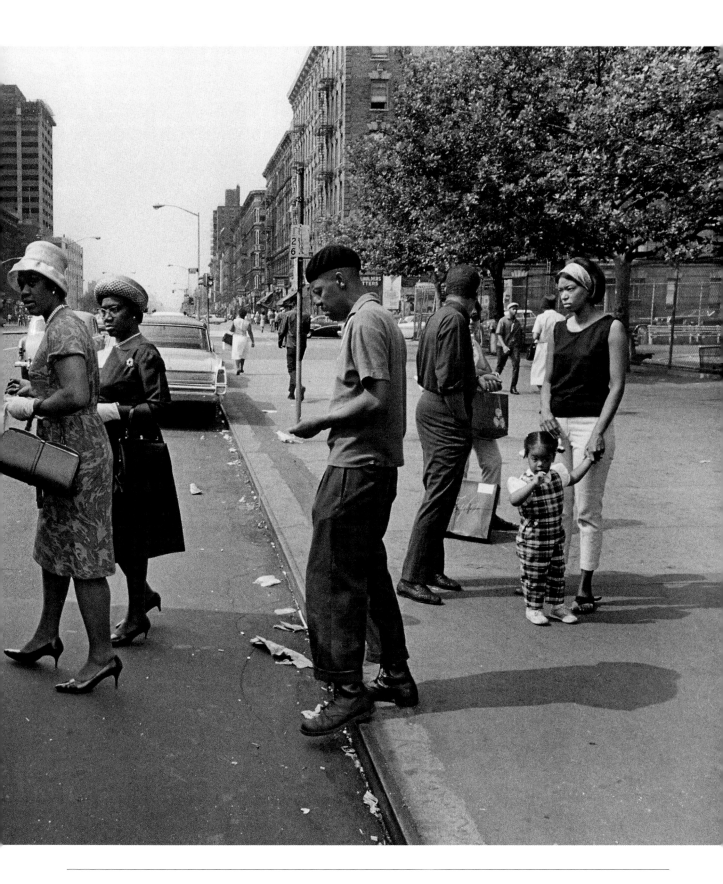

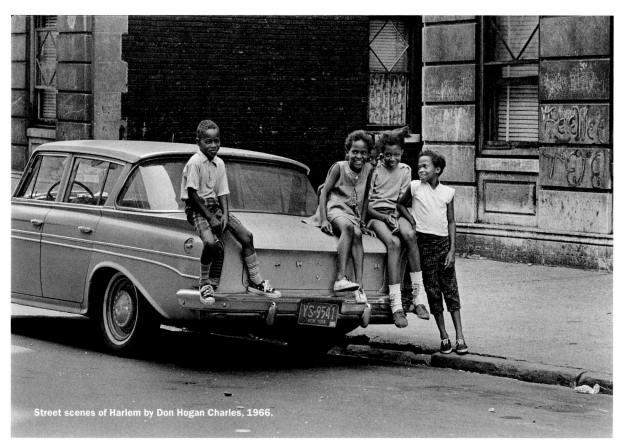

Street scenes of Harlem by Don Hogan Charles, 1966.

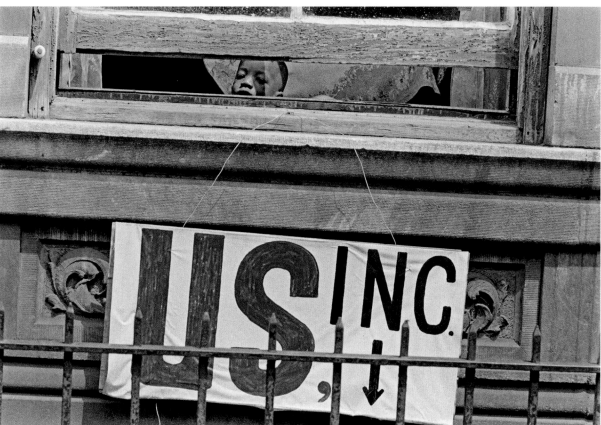

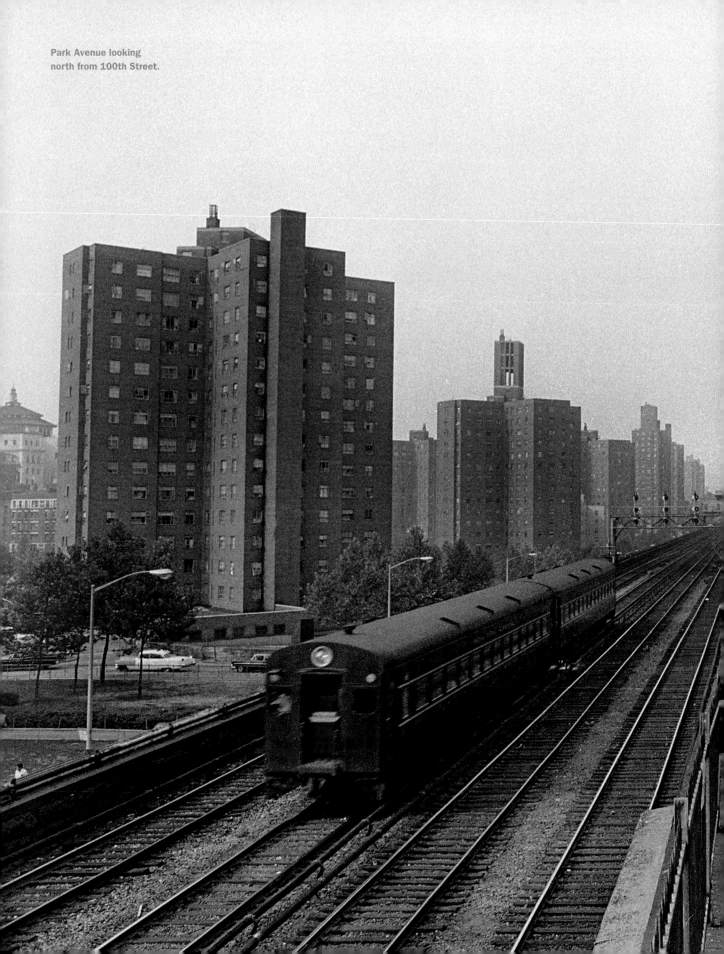

Park Avenue looking
north from 100th Street.

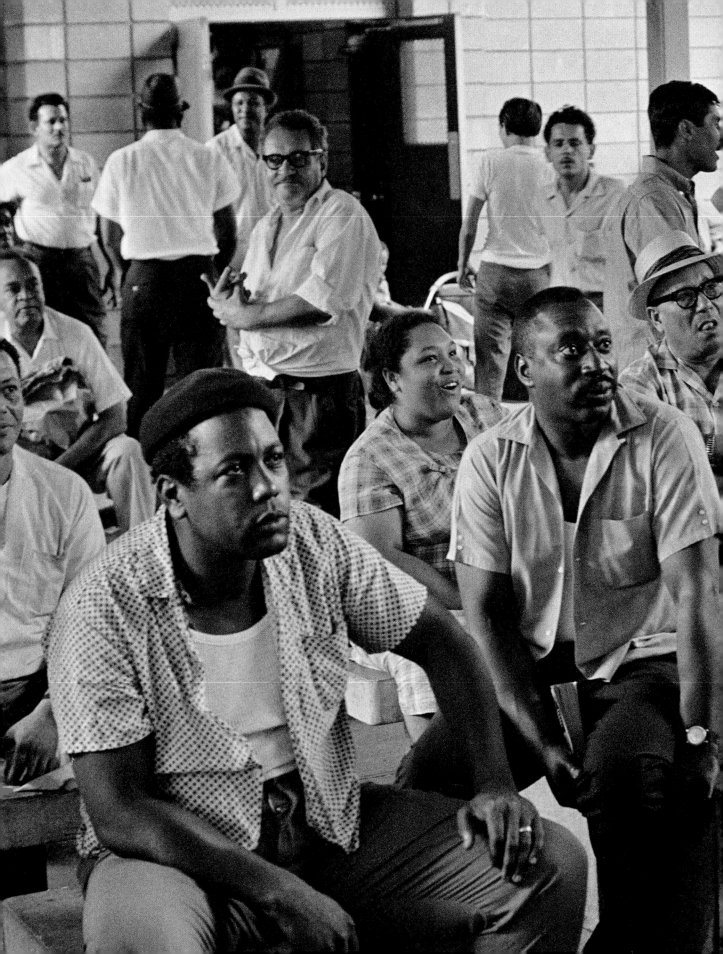

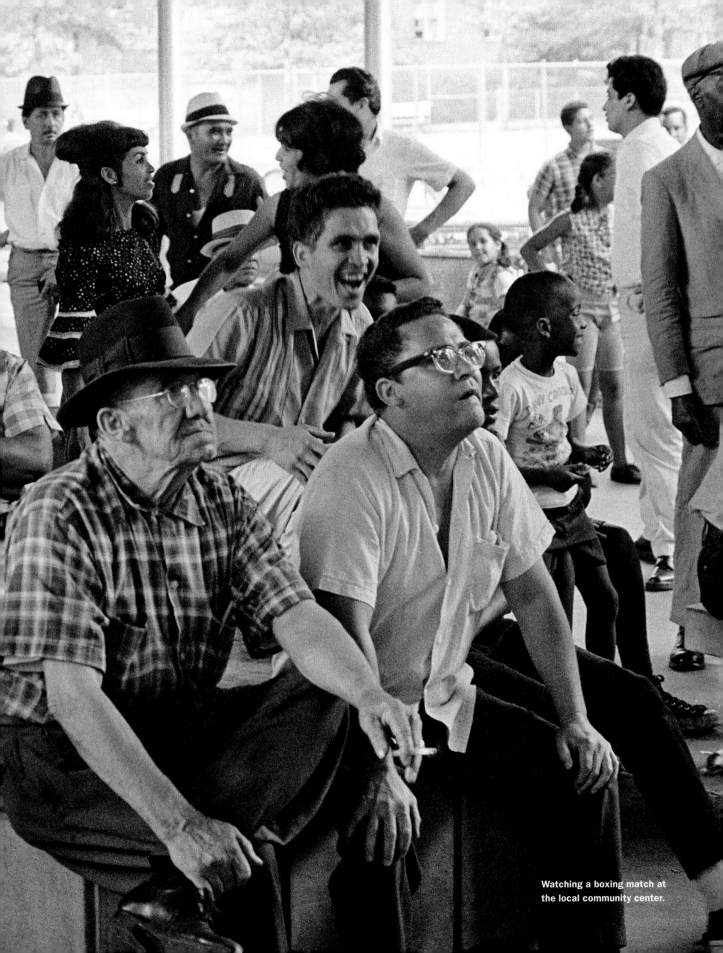

Watching a boxing match at the local community center.

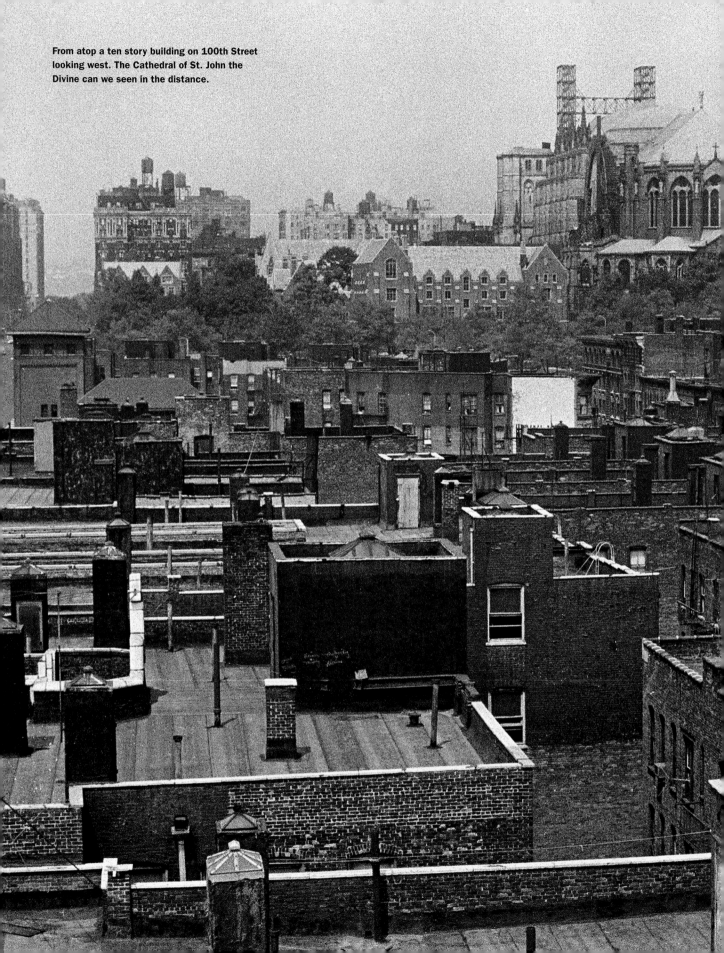

From atop a ten story building on 100th Street looking west. The Cathedral of St. John the Divine can we seen in the distance.

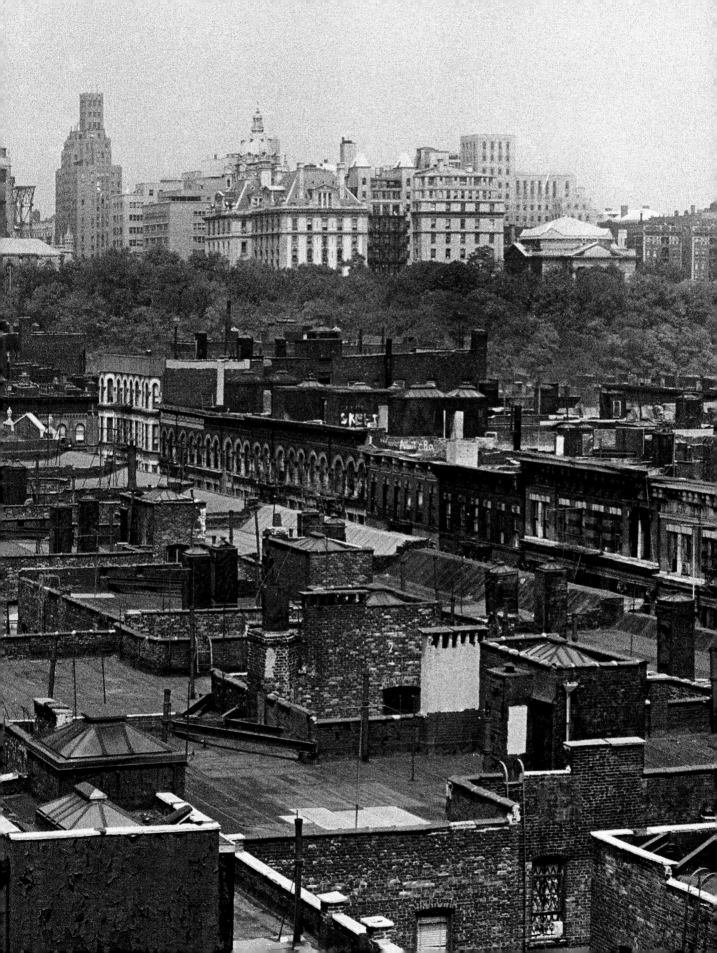

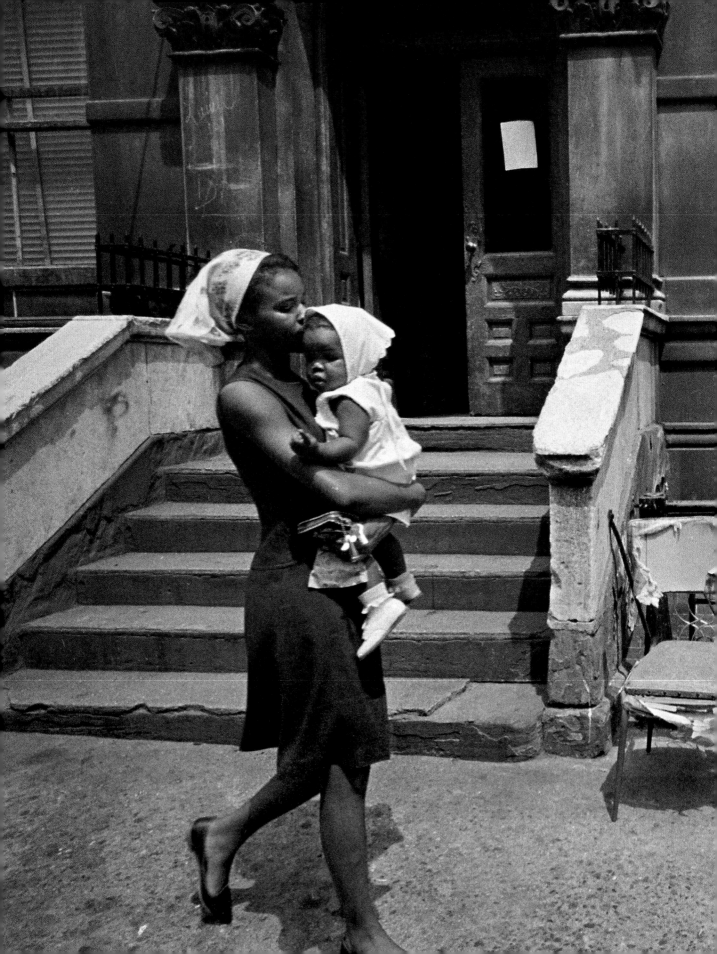

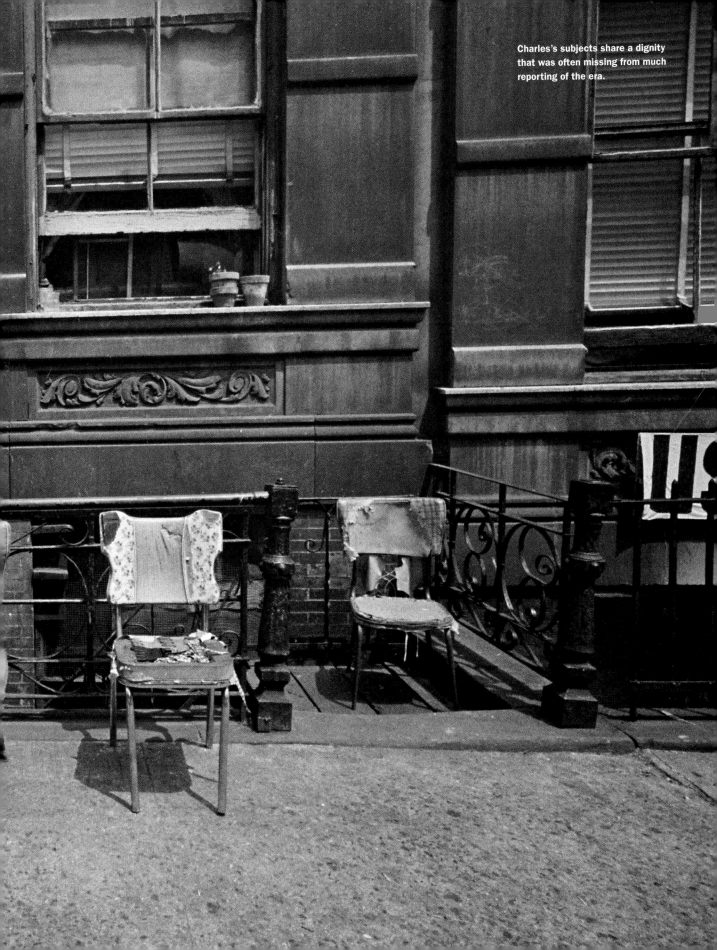

Charles's subjects share a dignity that was often missing from much reporting of the era.

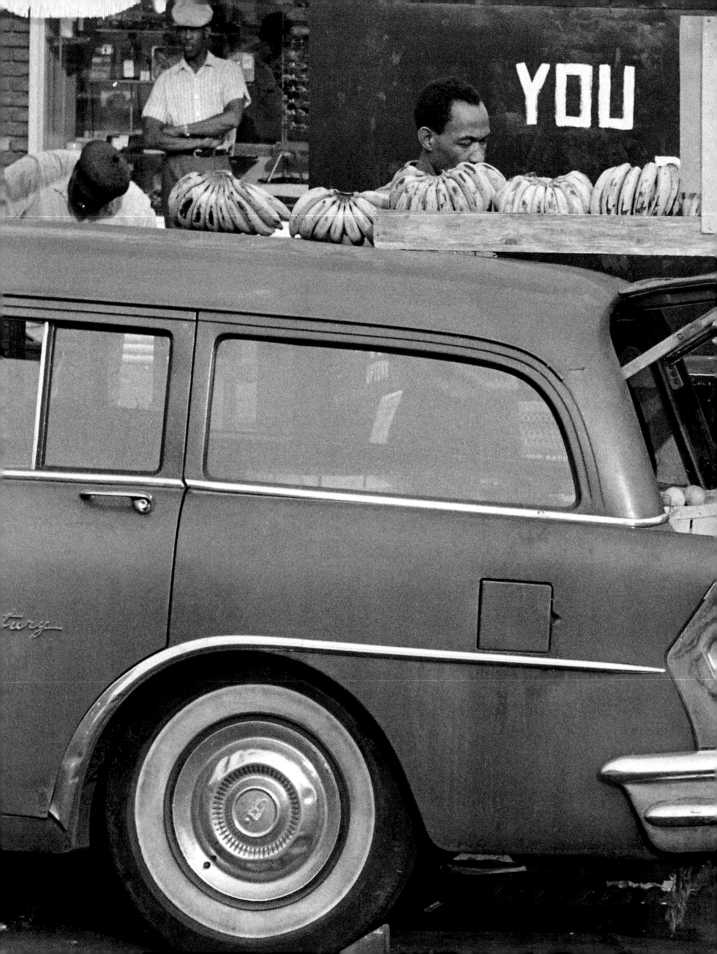

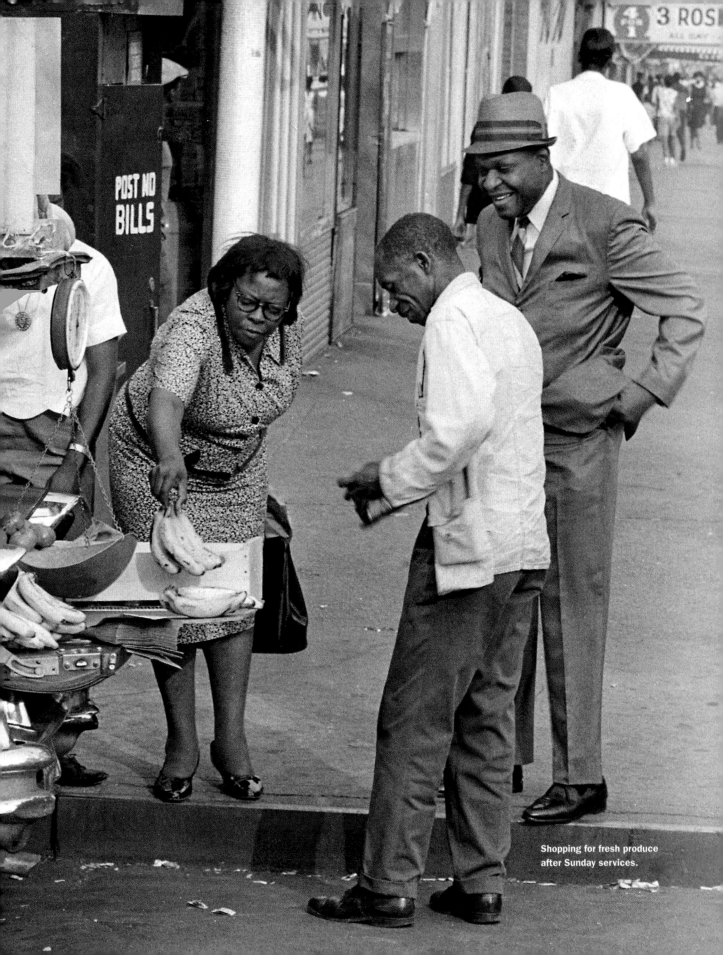

Shopping for fresh produce
after Sunday services.

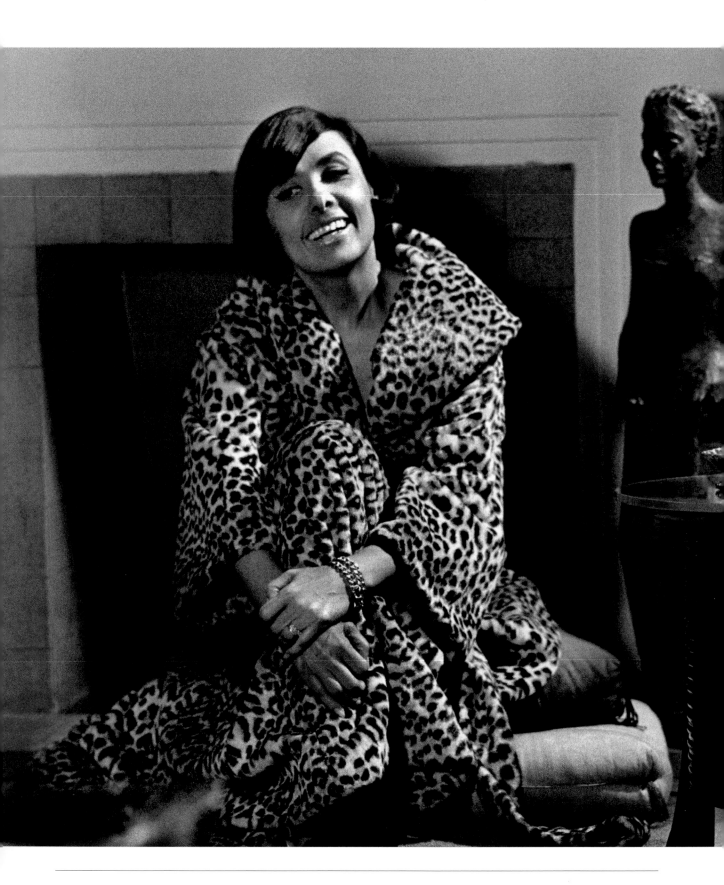

FOR LENA HORNE, A HOME AT LAST

She was one of the most famous performers in the country, a recording star, a Hollywood actress and a nightclub sensation.

But in the late 1950s, Lena Horne still struggled to find property owners in Manhattan who were willing to sell co-ops or condominiums to African-Americans, even very wealthy ones.

So how exactly did she snare the penthouse apartment, featured in this photograph, at 300 West End Avenue on Manhattan's Upper West Side? With the help of a good friend, Harry Belafonte.

Back in 1958, Belafonte, who was the first recording artist to sell more than a million LPs, was turned away from one Manhattan apartment after another. And he was furious. So he sent his publicist, who was white, to rent a four-bedroom apartment in the building at 300 West End Avenue. His publicist passed on the paperwork, and Belafonte signed the one-year lease in his own name.

Within hours of moving in, Belafonte said, the building's manager "became aware that he had a Negro as a tenant." The building's owner asked him to leave. Belafonte refused.

Instead, he bought the building, using dummy real estate companies to cloak his identity. Some tenants who had been renting there bought their apartments and some of Belafonte's friends moved in, too. "Lena Horne got the penthouse," said Belafonte, who described the real estate deal in his memoir, *My Song: A Memoir of Art, Race and Defiance.*

By December 17, 1964, when this photograph was taken by our photographer, Sam Falk, Horne and her husband, Lennie Hayton, a white composer and conductor, were comfortably settled in. She was hanging Christmas decorations that day as she prepared for the debut of her television show, *Lena.*

In the article that ran ten days later, accompanied by a different photograph, a close-up, she mentioned her difficulties in finding an apartment, but not the back story to where she had landed.

"Lennie and I lived in hotels for years while we were on the road," said Horne, who was forty-seven then. "And then we went through the hysteria of trying to find an apartment—all those stupid problems—and when we finally found a place that would admit both me and Lennie, we put our roots down."

—RACHEL L. SWARNS

YOUNG MEN OF THE "NATION"

My family was in the vanguard among the founding members of the Nation of Islam, a hybrid of black nationalism and Sunni Islam. They were and still are known among members of the "Nation" as the "pioneers." The main agent of spreading the faith was my grandfather Elijah Muhammad.

Muslims are not new arrivals in this country. But if you look at the discourse about Muslims in the current political and cultural spheres, you might have the

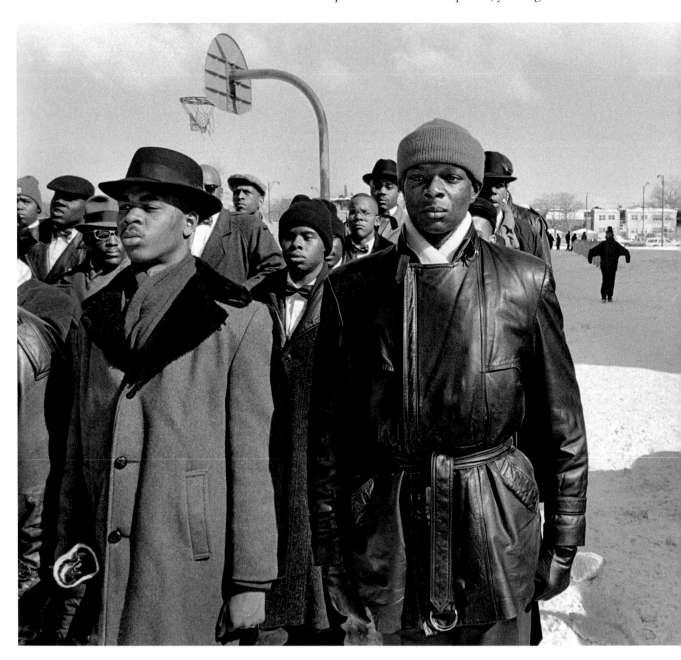

MUSLIMS ARE NOT NEW ARRIVALS IN THIS COUNTRY

impression that the religion of Islam is something new, and threatening. "We are all immigrants," is often repeated in this climate of ignorance and ethnic and racial hostilities.

According to academics, most Americans are ahistorical. We don't like to look back at what actions were taken to make this country, for better or worse, what it is today. Some of us are intoxicated with the myth of American exceptionalism, "The Shining City Upon a Hill." In that context, when I looked at this picture, I recalled how I felt when I worked with a *New York Times* team in 1993 to report on Muslims in America and spent time in familiar places that I had known growing up in Chicago.

The photograph, which did not appear in the paper, is of members of what is known as the Fruit of Islam, a wing of the Nation of Islam, when they went to a public housing project as a community outreach effort.

These young men's lives, like those of so many who joined the Nation of Islam before them, have been affected by an urgent need to dispel, after a legacy of slavery and institutional racism, the notion of them as pariahs who should be feared and quarantined in penal institutions, irredeemable wretches, as Frantz Fanon described them, existing on the margins of civilization.

Back then, as now, I would often see them on Harlem streets, dressed in their familiar suits and bow ties, selling the Nation of Islam journal. When I do, I often reflect on the conscious and subconscious impressions, and perhaps impact, they may have on other young men like themselves who are struggling to survive in this country. I think about what impact they might have had, or still could have, if the display of unity in this photograph had been a prelude to a deep commitment on the part of the "Nation," to stop the violence in the Woodlawn community and other Chicago neighborhoods, where death by gun violence has gone unabated for far too long. I don't feel that the burden of responsibility for curtailing what's happening in Chicago should be the Fruit of Islam's to bear—that's unfair and counterproductive and arguably racist. In my view, the enduring legacy of slavery and institutional racism is in large measure why some blacks choose criminal activities as a method of survival.

The Nation of Islam will endure, and we will continue to see these young men struggle lawfully, and unlawfully, to get by in a society that largely ignores or imposes a pernicious apathy toward them.

—OZIER MUHAMMAD

THE DAY TWO FORCES OF RESISTANCE MET IN CHICAGO

Times photographer Gary Settle knew it was a moment worth capturing when he spotted Rennie Davis and Fred Hampton standing together outside the federal courthouse during a break from the famous Chicago Eight trial.

It was September 1969, and the trial was a national spectacle. Eight activists faced an array of charges, including conspiracy and incitement to riot, for their involvement in the infamous protests at the Democratic National Convention the year before. The American Civil Liberties Union called it "probably the most important political trial in the history of the United States." (Five of the eight were eventually found guilty, but their convictions were reversed by an appeals court.)

Davis, one of the defendants, had been a founder of Students for a Democratic Society. And Hampton, twenty-one, was the precocious leader of the Illinois Black Panther Party and already known as one of the strongest voices in the struggle for black liberation.

Hampton was not on trial, but he came to support Bobby Seale, the Black Panthers' national chair, and to express solidarity with the other defendants.

Solidarity, in fact, was a guiding aim of Hampton's work. In just under a year with the Panthers, he had already brokered a peace agreement between Chicago's street gangs and united a range of grassroots groups in a "Rainbow Coalition"— including the Young Lords, a Puerto Rican nationalist organization, and the predominantly white Young Patriots.

The Reverend Jesse Jackson would later take up that term to describe his presidential campaign in 1984. "He was his own young force of resistance,"

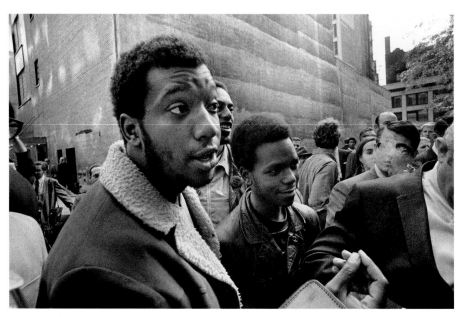

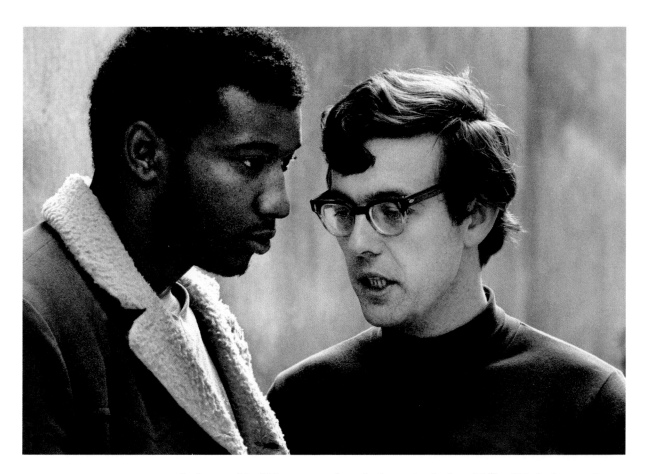

Jackson said of Hampton, whom he knew in the late 1960s. "He had maturity beyond his years."

Settle had been struck by Hampton's power earlier in 1969, when he heard him speak in Chicago's Grant Park. "He was articulate and he was forceful and he was passionate. He was kind of the Bernie Sanders of that time," Settle said. "I can see why the police and the F.B.I. would have thought he was a dangerous person, because they didn't understand a reasonable Black Panther standing up there, telling it like it was."

Indeed, just three months after Settle took his photograph, Hampton would be killed by police in a midnight raid on the Panthers' Chicago headquarters. He was twenty-one years old. Settle was out of town when the police attacked the headquarters, but he raced back to Chicago to capture photographs of the bullet-riddled house. Those photographs too proved historic, as investigations eventually revealed that the police had attacked without provocation.

Looking more recently at the picture of himself alongside Hampton, Rennie Davis remembered his counterpart as "an American hero that I had the good fortune to know and to meet and to care about. His story is not going to be forgotten."

—GIOVANNI RUSSONELLO

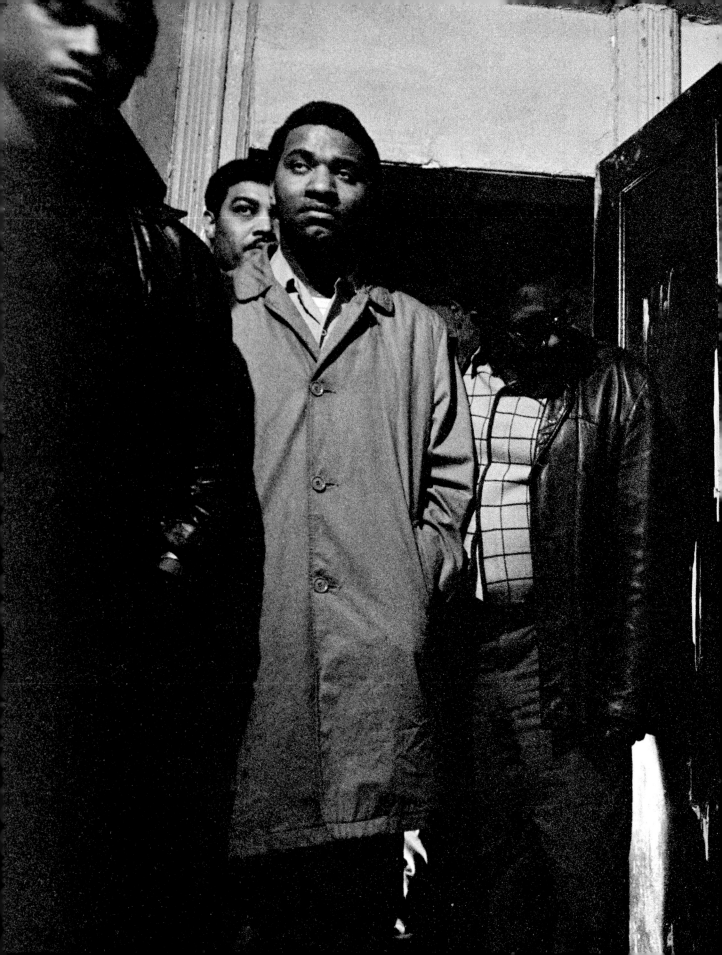

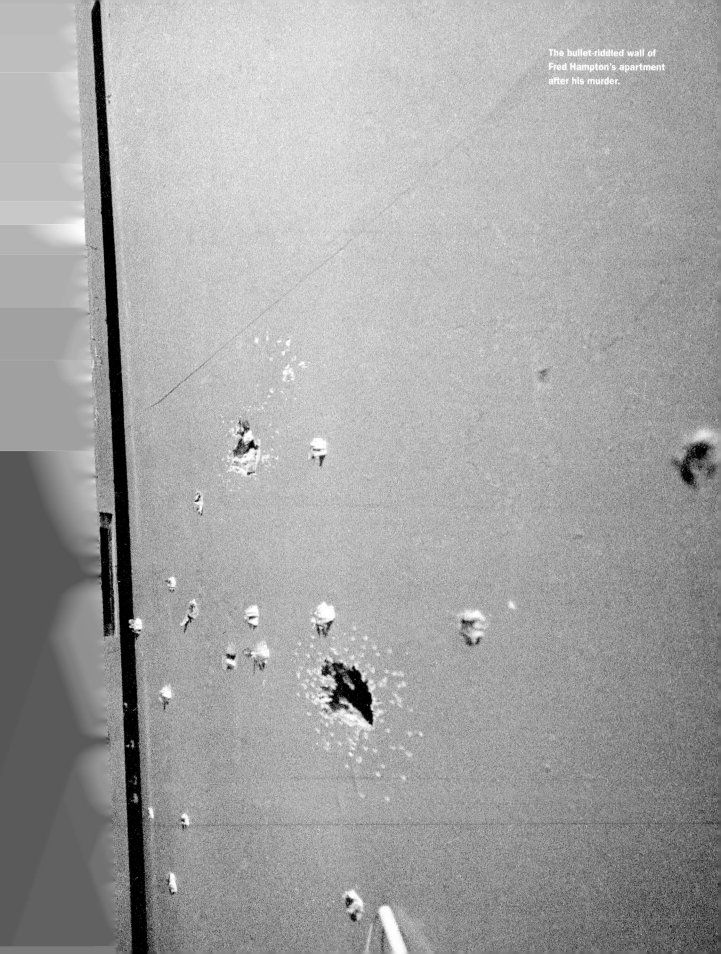

The bullet-riddled wall of
Fred Hampton's apartment
after his murder.

THE LESSONS OF ALBANY, GEORGIA

Members of the Student Nonviolent Coordinating Committee savor some downtime during a voter-registration drive in Albany, Georgia. Some of the S.N.C.C. members in this photograph, taken on Saturday, July 6, 1963, by Claude Sitton, who reported on the civil rights movement for *The New York Times*, have just been released from jail and are using the second floor of the clubhouse in the background as a barracks. They aren't welcome elsewhere around Albany, in the southwest corner of the Peach State.

Black people's resentment toward racial injustice around Albany had been building for years. It coalesced in the fall of 1961 as local civil rights advocates, the National Association for the Advancement of Colored People and S.N.C.C. formed the Albany Movement. The Reverend Dr. Martin Luther King Jr. and the Southern Christian Leadership Conference became involved.

As a formal entity, the Albany Movement sputtered out of existence in the summer of 1962, having apparently achieved little. It had been marked by internal dissension, and King lamented that the movement would have accomplished more by focusing on a single facet of segregation, like whites-only lunch counters or buses, instead of the entire Jim Crow way of life.

But King also said the lessons of the Albany Movement helped him and his allies plan strategy for campaigns in Birmingham, Alabama, and beyond. And the spirit of idealism that is evident in this picture lived on after the Albany Movement faded away. By 2017, Albany was a city of not quite 80,000 with an African-American mayor, Dorothy Hubbard, and several other black officials.

—DAVID STOUT

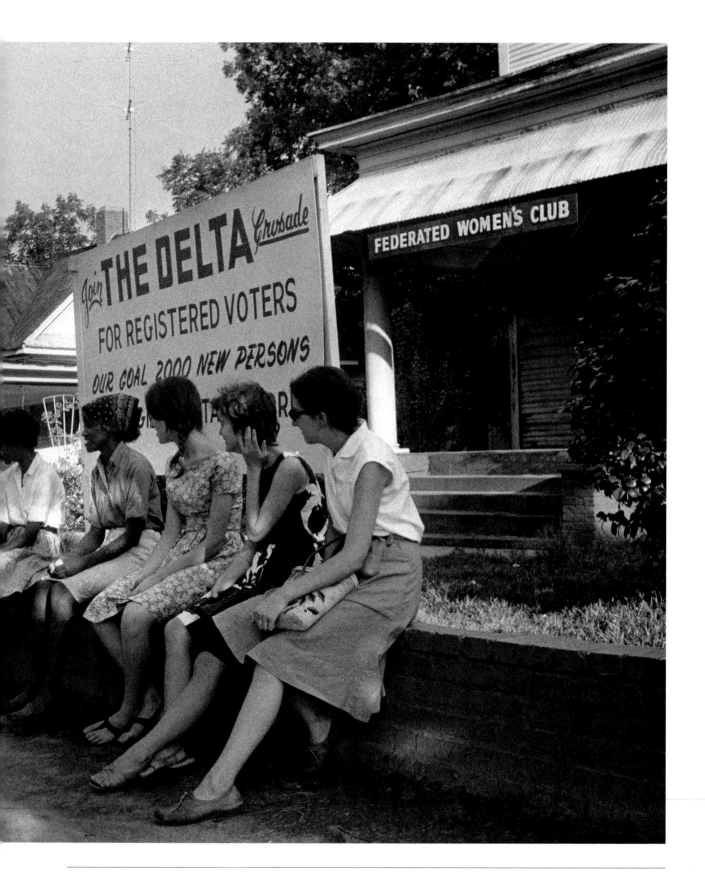

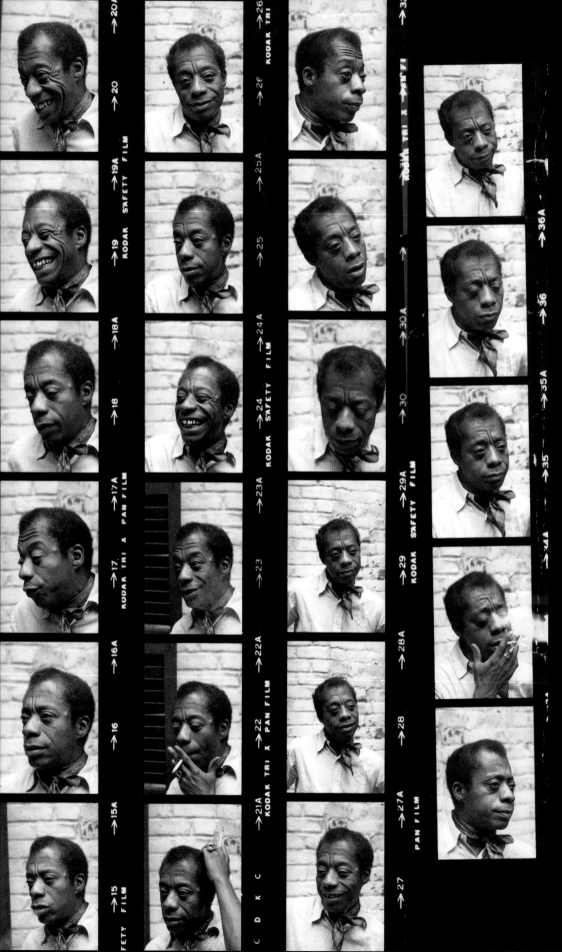

LOOKING AGAIN AT JAMES BALDWIN

He is pensive. Quizzical. Amused. Then, suddenly, there's that wide grin, that light-up-your-face laugh. That single shot of James Baldwin—Frame 19, at left—landed on the culture pages of *The New York Times* in 1972.

But our photographer Jack Manning took many, many more pictures that day. After more than four decades, we are finally publishing some of the most interesting outtakes.

The sheet includes twenty-three frames of Baldwin in an apartment on the Upper West Side of Manhattan as the writer and expatriate spent some time in New York on his way home to France after a fund-raising trip for the activist Angela Davis.

Baldwin was discussing his new collection of essays, *No Name in the Street*; his disillusionment with the civil rights movement; his writer's block; and the illness that kept him bedridden for months with what he said his "friends thought was hepatitis, but with something I thought was psychological."

The wide-ranging interview appeared in an article published on June 26, 1972.

But what captures us today in these close-ups is his face, the wide eyes, the lined forehead, the mouth frozen midsentence, the cigarette caught between his fingers, the evocative expressions that shift from frame to frame.

For years, Baldwin felt uncomfortable with his looks. His stepfather made fun of him when he was growing up, ridiculing his "frog eyes" and calling him the ugliest boy he had ever seen. Baldwin internalized that view of himself: "I had absolutely no reason to doubt him," he wrote in 1976 in his book-length essay, *The Devil Finds Work*.

"This judgment," Baldwin continued, "was to have a decidedly terrifying effect on my life."

Over time, he learned that not everyone shared that view. Baldwin electrified readers in the 1950s and '60s with a searing series of books and essays on race in America, including *Go Tell It on the Mountain*, *Notes of a Native Son*, *Nobody Knows My Name* and *The Fire Next Time*. People knew him not as the man with "frog eyes," but as a writer of passion and power.

BALDWIN FELT UNCOMFORTABLE WITH HIS LOOKS FOR YEARS

Henry Louis Gates Jr., the Harvard professor, was 14 when he came across *Notes of a Native Son*. It was the first time he had ever read a book by a black writer, "the first time I had heard a voice capturing the terrible exhilaration and anxiety of being a person of African descent in this country," Gates wrote in an article about Baldwin's legacy for *The New Republic*.

Gates finally met Baldwin at his home in France in 1973, just a year or so after Manning shot these photographs for *The Times*.

"People said Baldwin was ugly; he himself said so," Gates wrote in 1992. "But he was not ugly to me. There are faces that we cannot see simply as faces because they are so familiar, so iconic, and his face was one of them."

—Rachel L. Swarns

DWIGHT GOODEN, ABOVE IT ALL

Dwight Gooden arrived on the scene in the spring of 1984, a tall, skinny, electrifying nineteen-year-old who threw ferocious fastballs and elegant curves and immediately made the New York Mets a team to contend with.

The mural arrived not long after.

It adorned the side of a building on West 42nd Street, not far from Times Square. It was ten stories tall, had a Nike logo in the top right corner and depicted a still very young Gooden in what was already a classic image——his right arm coiled behind his back as he prepared to unleash another unhittable pitch toward home plate.

In every respect, the mural was larger than life, but at that point so was Gooden. In his rookie season, he had won seventeen games and lost just nine, recorded three shutouts and seven complete games and had struck out a major-league-leading 276 batters in 218 innings.

Nicknamed "Doc," he was an absolute sensation, part of the Mets team that would win the World

Series two years later. And yet, when the mural first appeared—and it was hard to miss—*The New York Times* did not run a picture of it in its pages.

Barton Silverman, *The Times's* legendary sports photographer, attempted to rectify the situation. In mid-November 1984 he went to the roof of a nearby building and had Gooden pose for him, with the mural as a backdrop.

It was a clever idea, but the photograph never ran in *The Times*. Nor did the amusing and intriguing picture that fellow *Times* photographer Ruby Washington took of Silverman aiming his camera at Gooden.

Certainly many other images of Gooden did appear in the paper.

There were the ones from 1985, when he was almost unbeatable, winning twenty-four games and losing just four, and winning the Cy Young Award as the National League's best pitcher.

There were the ones from 1986, when he was not as intimidating as he was the year before, but still powerful as the Mets eventually became the champions of baseball.

And beginning in 1987, there were the ones of a troubled Gooden, dealing with the substance-abuse problems that would become part of the narrative of his life.

A picture of Gooden arriving at a treatment facility as the 1987 season was beginning was published in *The Times* and it was jarring.

He was released from the facility a month later, pitched reasonably well that season, and even better in 1988, when the Mets nearly made it back to the World Series. But from that point on, his career took on a staccato rhythm, good and not so good and sometimes disturbing, especially as he drew drug suspensions. By 1996, he was, remarkably, a member of the Yankees, the Mets' constant rivals. In the Bronx, Gooden did surprisingly well, pitching the first no-hitter of his career that year and earning his second World Series ring. Four years later, he won still one more ring with the Yankees, this time in a cameo role.

From there, however, came too many instances of erratic behavior, some of it again tied to drug use. In a court appearance in 2005 in Tampa, he looked harrowingly thin as he stood next to his mother. That picture, too, appeared in *The Times*.

In the years since, Gooden's life seems to have stabilized, at least at times. As for the mural, it remained on the side of the building for a decade, finally coming down in 1995. In its place Nike put a mural of Charles Oakley, a tough-minded, physical forward on the New York Knicks.

But for some fans in New York, memories of the Gooden mural still linger, a bittersweet testament to that brief moment of time when he was young and overpowering and seemingly headed for a Hall of Fame career.

When he stood ten stories high, for all to see.

—JAY SCHREIBER

A NEWARK AT WAR WITH ITSELF

In July 1967, Newark erupted with violence after rumors circulated that a black cabdriver had been beaten and killed by white police officers. He was actually alive—arrested and injured—but for many black residents, it was just another example of Newark's systemic problems with police abuse, racism and corruption.

After six days of unrest, 23 people were dead; 725 were injured.

We described the clashes between the National Guard and black residents with the language of war. One of the front-page headlines on July 15 read, "Negroes Battle with Guardsmen." Another declared, "Sniper Slays Policeman."

The main photo published that day showed National Guardsmen and police officers standing over black men facedown on the ground, with a caption that said the authorities were "searching for weapons and stolen merchandise."

The photo that was not published, here, by Neal Boenzi, shows a calmer scene that points to the wider trauma experienced by Newarkers who were not involved in the violence, but who watched their city burn and their neighbors bleed.

"Were the disturbances in Newark and other towns riots?" asked Clement A. Price, a historian and revered scholar of Newark, now deceased, in a 2007 essay. "Were they rebellions? Were they civil disorders?"

The questions linger. Robert Curvin, the civil rights leader in Newark who later worked for *The New York Times* and the Ford Foundation, told me in 2006 that he was still haunted by the experience of trying to keep the city calm, to no avail.

"Talking about it is one of the most traumatic and painful things in my life," said Curvin, who died last year. "The destruction of human life that I saw in those very short few days, I will never get over."

—DAMIEN CAVE

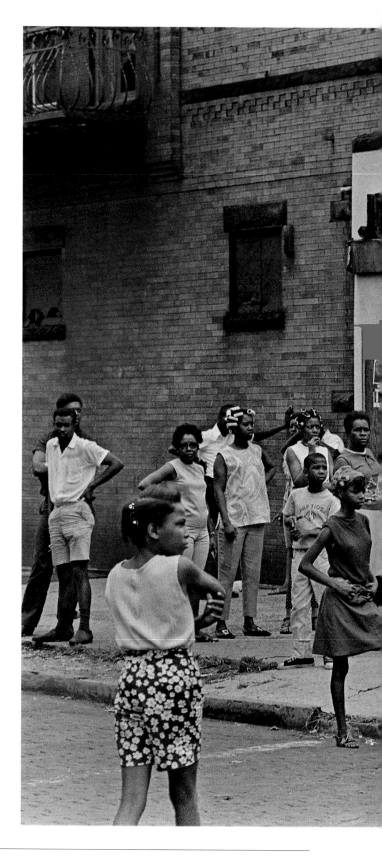

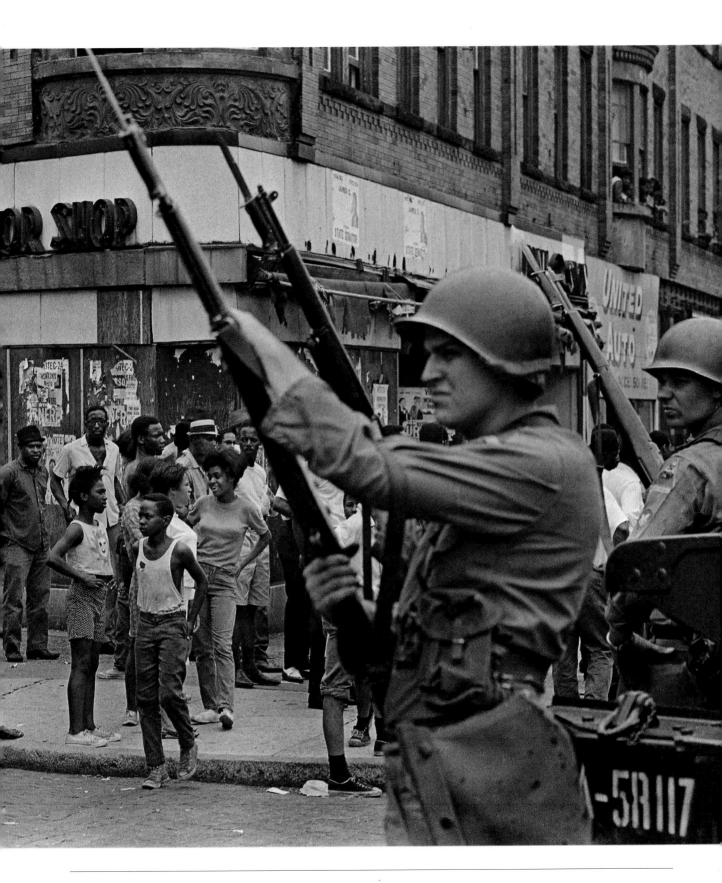

A HEARING IN MANHATTAN ON HARASSMENT IN MISSISSIPPI

In early 1965, President Lyndon B. Johnson has just been inaugurated after winning election to a full term in a landslide. Having helped to steer the Civil Rights Act of 1964 through Congress, he is envisioning a "Great Society" that will make life better for all Americans.

But things haven't changed in Mississippi. That's the message conveyed in this photograph, taken by Arthur Brower of *The New York Times* and not previously published, at a hearing in Manhattan on Thursday, February 11, 1965. Ten New York residents have come to recount how they were threatened and harassed by the police, sheriffs and white citizens during a civil rights campaign in the Magnolia State the previous summer.

Rita L. Schwerner is recalling how she and her husband, Michael Schwerner, were harassed during the voter registration drive they took part in before Michael and two other civil rights workers were slain by the Ku Klux Klan with the help of Mississippi lawmen in June 1964.

More specifically, the purpose of the hearing is to gather evidence of the denial of voting rights to black residents of Mississippi. The session is one of several convened across the country by attorneys for the Mississippi Freedom Democratic Party, which has just challenged the seating of Mississippi's five House members (all white men) in the new Congress on grounds that only a few black Mississippians had been able to vote.

Presiding is Paul O'Dwyer, Manhattan Democratic councilman at large, in the center. The other officials are Manhattan Democratic leader J. Raymond Jones, left, and Manhattan Republican councilman at large Richard S. Aldrich.

One witness is a lawyer who went to Mississippi to volunteer his services to civil rights workers, according to a *Times* account of the hearing. He tells the panel how he and several allies fled out the back door of a courthouse in Laurel, Mississippi, to escape a white mob. The lawyer, Edward Irving Koch, will become a New York City councilman, a member of Congress and finally a three-term mayor.

Ultimately, the five white men from Mississippi are seated in Congress, but the challenge to their election was not in vain. Evidence amassed at the Manhattan hearing and similar sessions helped to spur passage of the Voting Rights Act of 1965.

—DAVID STOUT

FOR MARIAN ANDERSON, A MEMORABLE CELEBRATION

Backstage after the performances, the joy was clearly visible in the faces of the two singers who'd come to Carnegie Hall on January 31, 1982, to honor Marian Anderson, a pathmaker who, decades before, blazed a trail they marched through. The first black opera singer to perform at Carnegie Hall, Anderson, looking, in the words of *Times* music critic Bernard Holland, "regal but a little frail," stood in her box before an enrapt audience who had come to help celebrate her eightieth birthday. What a party it was.

Negotiations to ensure the participation of Shirley Verrett and Grace Bumbry had taken more than a year. The performers stepped into the spotlight at what must have been personal highlight moments. Verrett sang arias from *Macbeth* and *Otello* by Verdi, Bumbry from *La Vestale* by Spontini and *Adriana Lecouvreur* by Cilea, and together they performed duets from Verdi's *Aida* and Donizetti's *Anna Bolena*, among others. The audience roared its approval with each passing selection. Anderson, in a moment of great pride and personal triumph, acknowledged the thunderous applause with waves and bows as Isaac Stern read congratulatory messages to her from President Ronald Reagan and New York mayor Edward Koch before the overflowing crowd.

WE FLOWED INTO THAT ROOM, ELBOWING EACH OTHER TO GET THE BEST POSITION

A small group of photographers crowded into a dressing room after the curtain calls to record the greetings between the divas. As a young, newly minted *New York Times* photographer, I was honored to be present at what I knew was a highly emotional and significant moment. We'd hoped that Carnegie would relent and allow us to photograph during the performances, but fearful of the jostling that would occur with a group of us in the auditorium, management restricted us to photographing Anderson's final bow and Stern's remarks, which ran in the paper, and then allowed us in to shoot the greeting among the trio of famous singers at concert's end, which did not.

We flowed into that room, elbowing each other to get the best position as the singers entered. They seemed genuinely pleased to be in such company. They greeted each other with huge smiles and what certainly seemed like much mutual respect and love. The warmth was clearly evident as the congratulatory words were exchanged by the performers.

—JIM WILSON

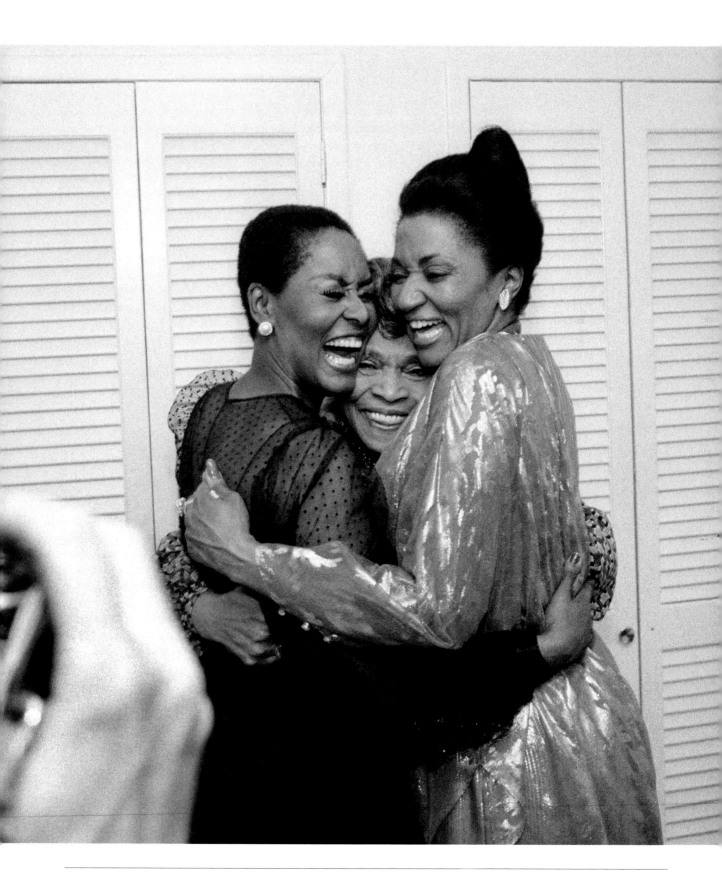

A NONVIOLENT MAN OF FAITH AND CERTAINTY

We will never know exactly when the Reverend Howard W. Thurman was photographed in his office at Howard University in Washington by George Tames of *The New York Times*, or why. This photograph, the oldest in the collection that forms this book, was never published, nor was there any article that might have provided a clue.

We do know, from the labeling on the negatives, that the photo was taken in 1943 or 1944, when Thurman was a professor of religion at Howard and dean of the university's Andrew Rankin Memorial Chapel, a center of campus religious and cultural life.

Thurman may be pointing to a passage in scripture. If so, that would explain his expression, which seems to convey faith and certainty. He was an early champion of a Christianity that would transcend racial and economic barriers and focus on the needs of the poor and downtrodden. On a trip to India in 1935, he met and was inspired by Mohandas K. Gandhi and never lost his belief in a nonviolent movement for human rights.

A grandson of slaves, Howard Washington Thurman was born in Daytona Beach, Florida, in 1899, worked as a janitor while attending Florida Baptist Academy, graduated from Morehouse College in Atlanta and was ordained a Baptist minister in 1925. After leaving Howard University, he was a co-founder with the Reverend Alfred Fisk of the Church for the Fellowship of All Peoples in San Francisco. Later, he became the first African-American appointed to a full-time faculty position at Boston University School of Theology.

Had he come of age in the time of television, Thurman, who died in 1981, might have been as famous as Martin Luther King Jr., for whom he was a mentor and, it is not too much to say, a soul mate.

"If a man knows precisely what he can do to you or what epithet he can hurl against you in order to make you lose your temper, your equilibrium, then he can always keep you under subjection," Thurman once said.

On another occasion, he observed, "During times of war, hatred becomes quite respectable, even though it has to masquerade often under the guise of patriotism."

—DAVID STOUT

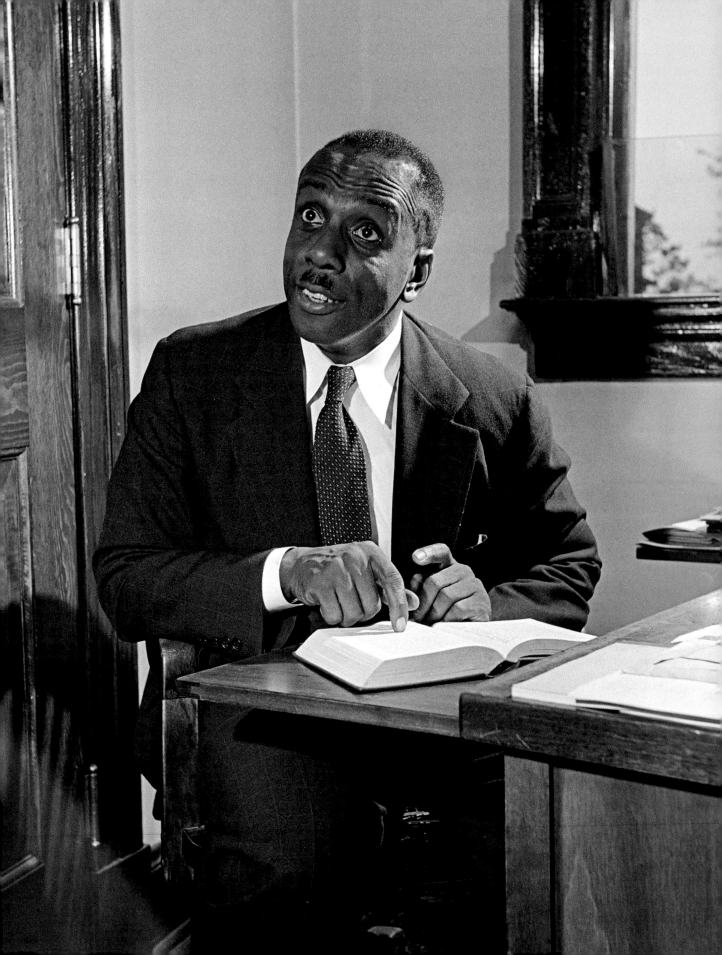

GWENDOLYN BROOKS, DELIVERING POETRY AND WISDOM

With her focused gaze and pile of books, the woman in this photo by Michael Evans from 1970 looks like a graduate student, preparing for exams. But in fact, it's a woman with much to teach—Gwendolyn Brooks, the Pulitzer-Prize-winning poet, preparing for a lecture at Yale University during a conference on "The Black Woman."

She was joined there by Maya Angelou; Shirley Graham Du Bois, the widow of W.E.B. Du Bois; and Sylvia Ardyn Boone, an African-American Studies lecturer at Yale, who said the conference grew from a course she was teaching, and her own desire to bring forward women who were "hard-headed, candid pioneers."

Brooks clearly qualified. In 1945, her first poetry anthology, *A Street in Bronzeville*, received glowing praise for its strength in recording the life of Chicago's South Side, prompting Richard Wright to praise her talent for capturing "the pathos of petty destinies, the whimper of the wounded, the tiny incidents that plague the lives of the desperately poor, and the problems of common prejudice."

She won the Pulitzer Prize in 1950, and quickly became a part of the black literary firmament. Over time, her focus evolved. Her work, while often still grounded in Chicago, began to reflect the politics of the 1960s, especially its emphasis on black power. She wrote poems about Malcolm X. She began to write, and teach, about how to merge art and politics.

After *In the Mecca*, a volume published in 1968 that began with a thirty-page poem that described a mother's search for a missing daughter in the Mecca, a horrific building that had once been a luxurious apartment house, Brooks left her mainstream publisher, Harper & Row, for Broadside Press, a small black-owned company in Detroit.

Her shift in direction and distribution may not have helped her career; her poetry never again gained quite as much acclaim, though she published more than a dozen books between the 1970s and her death in 2000. And yet, as can be seen in this photo, she tended to find fulfillment in other ways, engaging with other writers and sharing her writing and the work of other black women.

"All my life is not writing," she told one interviewer. "My greatest interest is being involved with young people."

—DAMIEN CAVE

FINDING SOUL FOOD, AND COMFORT, AT SYLVIA'S

Alexander Smalls is now an acclaimed restaurateur in his own right, but when he came to New York to sing opera in 1977, he told Damien Cave, he found sustenance and comfort at Sylvia's, the Harlem restaurant and fixture founded by Sylvia Woods in 1962. The photographs here by Jim Wilson of The Times, *were taken in 1983.*

For me, it was sort of like going to a big Southern enclave where the people were very much like Southern people I knew in the South.

Sylvia was the queen of all that in Harlem because she came from South Carolina and she created this environment for other Southern people to congregate and carry on. It was like that Sunday dinner after the church service, but it was in Sylvia's.

We would go up there, and it was a little edgy and sketchy and you kind of clutched yourself a little tighter because clearly the economic scenario there was much different from the Upper West Side or Lincoln Center. But it was also exciting. We were going to have fried chicken and candied yams and mingle and run into folks who made you feel like you were back home, south of the Mason-Dixon line.

That's what Sylvia's was like. It was a pilgrimage.

And Sylvia was there. And she greeted you. And seated you and sometimes gave you a hug. When I told her I was from South Carolina, I remember her taking me back in the kitchen, showing me how she made her ribs.

I was there eating one night, and Nina Simone came in and she and Sylvia had a little tussle, a little argument, because Nina never wanted to pay her bill.

You know Nina was one of those girls, like, "You know who I am?" And Sylvia was like, "Yes, and somebody's going to pay this bill, Nina, I'm tired of you."

I've been there many times with Cicely Tyson; with Ruby Dee and Ossie. This is the chorus of voices and images and impressions that wraps around me when I go there.

THAT'S WHAT SYLVIA'S WAS LIKE. IT WAS LIKE A PILGRIMAGE

These are people I knew personally, but I was introduced to them as a twenty-something-year-old from South Carolina who had come to New York to produce my operatic career, and they were as fascinated with me as I was with them. Baldwin! At Sylvia's! It was iconic.

That's what comes at me. You hear the roar of history, you know, a flash of civil rights and marches, Sylvia standing out front during a press conference and being revered and being seen as the mother of whatever the movement was, an anchor that anchors this great community. Adam Clayton Powell. That picture conjures up all of that for me.

A SCHOLAR AT EASE IN THE SUBURBS

By 1969, Kenneth B. Clark had appeared in *The New York Times* many times, but not like this: at ease, with a cigarette between his lips, as he relaxed with his family in the garden outside his comfortable suburban home in Hastings-on-Hudson, a predominantly white community.

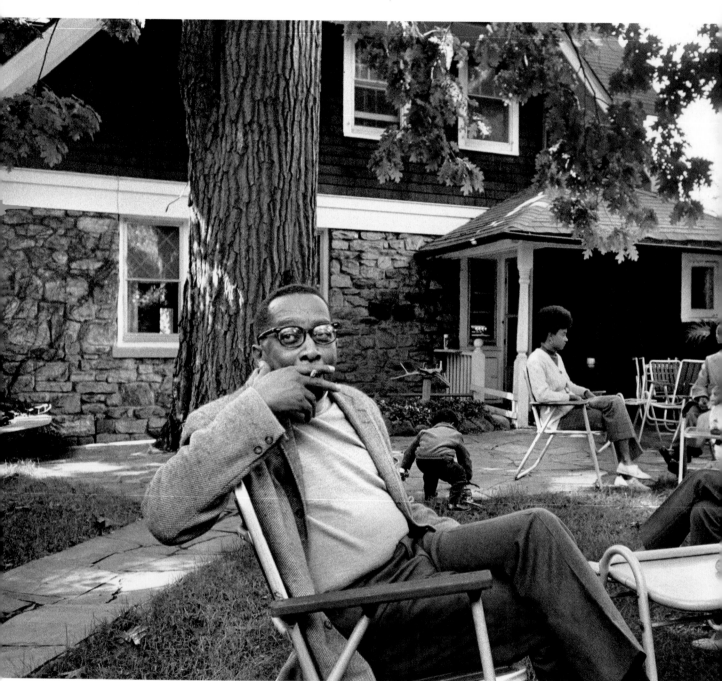

Clark was a prominent psychologist, scholar and educator. His pioneering research on the destructive effects of school segregation was invoked by the United States Supreme Court in its 1954 *Brown v. Board of Education* ruling, which deemed segregated schools unconstitutional.

He was the first black president of the American Psychological Association, the first African-American to earn a doctorate in psychology at Columbia University, the first to become a tenured instructor in the City College system of New York. As a national authority on integration, Clark was consulted by mayors, governors and members of Congress. It is no surprise that his photograph appeared in our pages.

But this image reflects a facet of his life that remained unexplored by *The Times* back then: how he incorporated his public vision of an integrated society into his personal life. In 1950, Clark moved his family from Manhattan to the predominantly white suburbs in Westchester County, decades before large numbers of African-Americans embarked on their suburban migration.

He did so for the same reason that many white professionals decamped from New York City: He wanted better schools for his children. The segregated schools in Harlem were still failing, he explained, despite his efforts to improve them. "My children have only one life," he said.

CLARK NEVER ABANDONED HIS FAITH IN THE POWER OF INTEGRATION

This photograph was intended to accompany an article about "middle-class Negroes in suburbia." The article never ran. But the picture, taken by Eddie Hausner on October 6, 1969, offers a fascinating glimpse of the noted psychologist, who was fifty-five at the time. The scene looks idyllic. And in some respects, Clark's suburban life was idyllic.

The renowned sculptor Jacques Lipchitz, who had a studio in the village, was a friend. Martin Luther King Jr. and James Baldwin were houseguests. Visitors described a home filled with books and African art. "A pleasant place, a pleasant suburb," said Clark, describing what first drew him to Hastings-on-Hudson.

But there was a flip side. His daughter, Kate Harris, who appears in this photo, later described feeling cut off and out of place among whites in the community who never fully accepted her. She said she was "good enough" to be named president of her class, but not good enough to be invited to the homes of her white friends for dinner.

Clark never abandoned his faith in the power of integration, despite his disappointment with the slow pace of change. He didn't give up on his Westchester suburb, either. In 2005, at the age of ninety, he died right here, at home.

—RACHEL L. SWARNS

DIONNE WARWICK AT EASE IN NEW JERSEY

Dionne Warwick never swayed from her humble New Jersey roots. No, instead the singer remained a proud Jersey girl even after she went on to international fame. Ever loyal to the place that was always home, Warwick beams in this photo that William E. Sauro took outside of her chic but modest three-bedroom brick home in Maplewood, New Jersey.

She grew up in nearby East Orange and, even after becoming a star, would keep the overflow from her massive wardrobe in her parents' house 10 blocks from hers.

The daughter of a chef, she grew up singing in the choir at the New Hope Baptist Church in Newark. She recorded her first single in 1962 in New York, "Don't Make Me Over," with songwriter-producers Burt Bacharach and Hal David, and went on to sing such other hits as "Walk On By" and "I Say a Little Prayer."

Dionne Warwick was also a fashion hit. Once voted "Best Dressed Singer" by the Paris Couturier Association, she even dressed fashionably at home. A 1968 *Times* article about her style said, "for just puttering around the house, she sometimes throws on a mink miniskirt, a ruffled blouse and black patent stretch boots." Still, she felt no need to go Hollywood.

In fact, in one of her hit songs, "Do You Know the Way to San Jose," she sang, "L.A. is a great big freeway . . . And all the stars that never were / are parking cars and pumping gas."

Warwick once said of Los Angeles in a *New York Times* interview, "I hate that place." She added, "It's a thousand miles to anywhere. They move too slow or too fast. I don't care for the pulse of the place. It doesn't happen for me."

Of course, her career took her all over the world, and she has lived in Brazil and spent time in Italy and other parts of Europe. Even so, she always returned home.

For a time, when her husband, Bill Elliott, was pursuing an acting career, Warwick found herself once again spending much more time than she cared to in Los Angeles.

"Because he's there, I'm in L.A. more now," she said in an interview in her den in New Jersey. "But I don't think I could ever leave New Jersey."

—DANA CANEDY

SHE EVEN DRESSED FASHIONABLY AT HOME

MAYORS GATHER TO SUPPORT
A MAYORAL RUN

It was a small but mighty fraternity.

During the summer of 1977, black mayors from across the country turned out for a reception to support and celebrate Percy E. Sutton's bid for mayor of New York City. Other influential black political leaders came as well, including Congressman Charles B. Rangel of New York.

In this photo by Marilynn K. Yee, the mayors mingled during the festivities, supporting a candidate hoping to join their ranks. They were, from left, Richard G. Hatcher of Gary, Indiana; Lommie Lane of Wilson City, Missouri; Riley Owens of Centreville, Illinois; Edith L. Greene, of Bolton, North Carolina; Rayner Smith of Woodmere, Ohio; Herman Daenteler, of Lincoln Heights, Ohio; Representative Rangel of Harlem; and Eddie O'Jay, assistant commissioner of community affairs.

Already a political superstar by the time he decided to enter the mayoral race, Sutton had risen from the Democratic clubhouses of Harlem to become the longest-serving Manhattan borough president and, for more than a decade, the highest-ranking black elected official in New York City, according to his obituary in *The New York Times*. He died on December 26, 2009, at the age of eighty-nine.

In his run for mayor, however, Sutton did not win, or even come close. He finished fifth in a seven-way Democratic primary, packed with formidable competitors, including Bella Abzug, a former United States Representative and leader of the women's movement; Mario Cuomo, then the Secretary of State for New York; and Representative Ed Koch, who won the nomination and the general election.

It would be another decade before New Yorkers would elect their first (and so far, only) black mayor, David Dinkins.

But Sutton, like many of his relatives, was used to being a pioneer. Born in San Antonio, Texas, he was a lawyer by training, and he came from a family of political and judicial leaders. One of his fourteen siblings was the first black elected official in San Antonio, as a member of the Texas House of Representatives. Another brother became a justice on the New York Supreme Court.

Sutton himself had a distinguished career that included serving as an intelligence officer with the Tuskegee Airmen, the famed all-black Air Force unit that flew missions in World War II. After his service, Sutton attended law school and then threw himself into the civil rights movement, representing more than 200 people arrested in protests in the South. He was also Malcolm X's lawyer.

Sutton, who had investments in the Apollo Theater and *The Amsterdam News*, became known as a father of Harlem and was a member of the "Gang of Four," a group of prominent politicians that included former New York Secretary of State Basil Paterson, Dinkins and Rangel.

Sutton, whose passion for civil rights was inherited from his father, was arrested as a Freedom Rider in Mississippi and Alabama in the 1960s. Still, he saw himself as a champion of gradual change. According to *The Times*'s obituary celebrating his life of accomplishment, he once described himself as "an evolutionist rather than a revolutionist."

—Dana Canedy

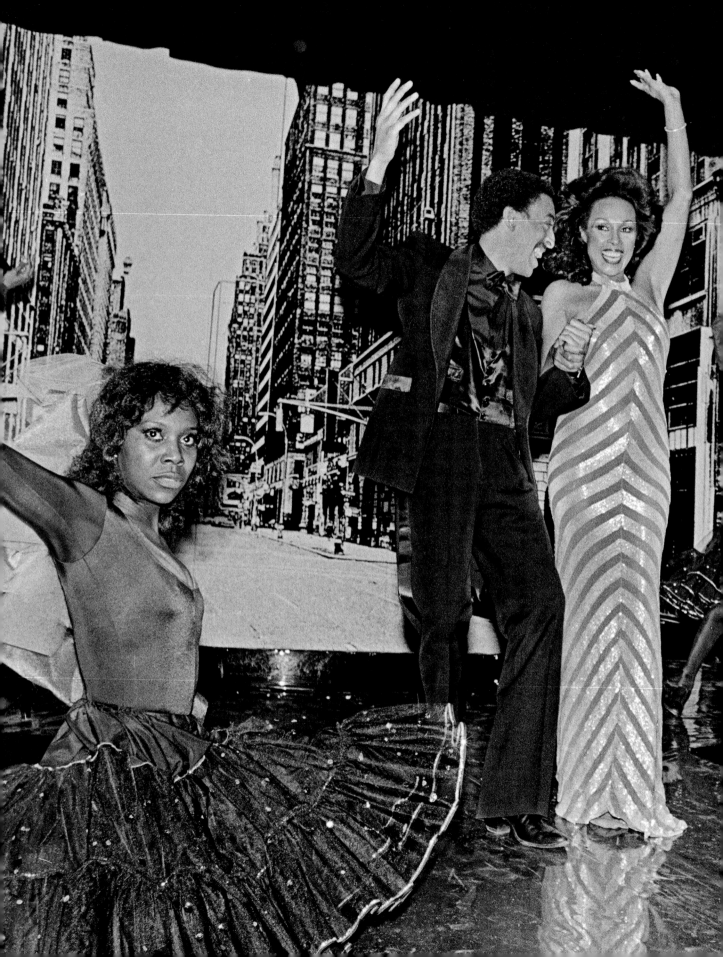

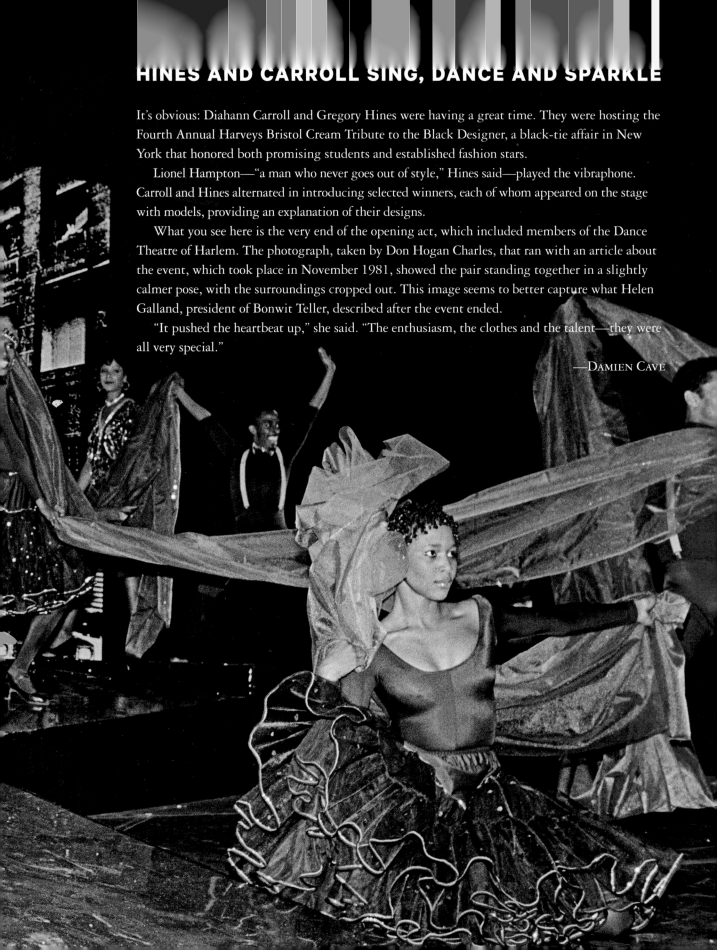

HINES AND CARROLL SING, DANCE AND SPARKLE

It's obvious: Diahann Carroll and Gregory Hines were having a great time. They were hosting the Fourth Annual Harveys Bristol Cream Tribute to the Black Designer, a black-tie affair in New York that honored both promising students and established fashion stars.

Lionel Hampton—"a man who never goes out of style," Hines said—played the vibraphone. Carroll and Hines alternated in introducing selected winners, each of whom appeared on the stage with models, providing an explanation of their designs.

What you see here is the very end of the opening act, which included members of the Dance Theatre of Harlem. The photograph, taken by Don Hogan Charles, that ran with an article about the event, which took place in November 1981, showed the pair standing together in a slightly calmer pose, with the surroundings cropped out. This image seems to better capture what Helen Galland, president of Bonwit Teller, described after the event ended.

"It pushed the heartbeat up," she said. "The enthusiasm, the clothes and the talent—they were all very special."

—Damien Cave

A RISING BLACK LEADER WHO PULLED OFF HIS OWN FAKE OBITUARY

It is impossible to know what Grady O'Cummings III might have represented to the group of youngsters he was holding court with in this photo taken in September 1963.

O'Cummings, who was photographed by Patrick A. Burns with the youngsters outside his office in Harlem, announced the next month that he would seek the Democratic nomination to run for president in 1964. He was one of the first African-Americans to run for president.

Certainly O'Cummings must have represented hope and possibility to the boys who had gathered around him that day.

Dedicated to economic and political empowerment for blacks, O'Cummings founded the National Civil Rights Party in 1963 to foster black enterprise and to appeal to liberal whites. He said at the time that the organization had 450 members, with branches in Chicago, Cleveland, and Philadelphia. The party designated him its presidential nominee days before he decided to run as a Democrat.

It will never be known where his ambitious political aspirations might have taken him. His dreams appeared to be cut short when it was reported that he had had a massive heart attack and died at home in November 1969, at just 36.

The New York Times ran an obituary about the unexpected death of the promising political novice who, sadly, was lost in his prime.

Or was he?

O'Cummings was not quite the determined political up-and-comer that he seemed. He had faked his death and was very much alive when he bamboozled *The Times* and *The Amsterdam News* into publishing his obituary.

In fact, this report might well also serve as the newspaper's long overdue correction. For it was only during the reporting for this article that *The Times* realized it had fallen for O'Cummings's hoax.

This is what actually happened.

Just four months after he sent in his obituary to *The Times*, O'Cummings reemerged at a news conference in Brooklyn, which went unnoticed by our paper. For an explanation of why he faked his death, O'Cummings said he had simply been trying to elude members of the Black Panthers, who he said had made death threats against him and his family, according to an article about the news conference in *The Amsterdam News*.

"I had to get out because I was trying to protect my family," the *News* quoted him as saying. He explained that he had fled to Buffalo, where he remained for months. "My wife, Winnie, was assaulted by four Black Panthers, and it made me very angry. I didn't go to the police because I am not an informer and didn't want to get involved."

The *News*'s account never explained why he had decided that the threat to his family had diminished enough in just four months for him to reemerge, and in such public and dramatic fashion.

Perhaps at least partly because he had misled the public, he never attained the political success he sought.

O'Cummings's presidential run had proved to be as short-lived as his faked death. In early March 1964, about five months after he was designated the presidential candidate of his National Civil Rights Party, he withdrew and said he would instead become his party's candidate for the seat held by Representative John J. Rooney, a Democrat, in Brooklyn's 14th Congressional district (as reported by *The Times* in a brief article).

Several decades later, *The Times* did mention O'Cummings and his candidacy for city council, in an article about the 1993 race. Even then, though, the newspaper did not correct the story of his death or run an editor's note about it.

A native of Grenville, South Carolina and a graduate of City College in New York, O'Cummings worked in public relations, and was publisher of *New York Speakout*, a weekly newspaper in Brooklyn, where he lived.

As for his death, it is never too late to set the record straight.

The Times can now report with the authority of having seen O'Cummings's death certificate stating that he died of natural causes on June 2, 1996, at the age of sixty-three.

It was twenty-seven years after his obituary appeared in *The Times. We* did not publish a second one.

—Dana Canedy

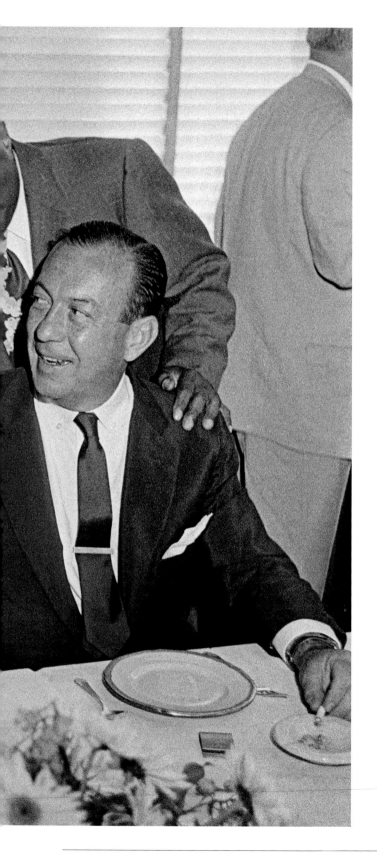

A TENNIS STAR LUNCHES WITH THE MAYOR

Long before Venus and Serena Williams graced the tennis court, Althea Gibson was the queen of tennis who resisted stereotypes and inspired others with her passion, focus, and zeal. She was an unlikely champion to some, but to others, she was simply a hardworking New Yorker who fought to reach the big time.

She was tall and wiry, at five foot eleven, but when asked in an interview to describe her style, Gibson gave it to us straight: "Aggressive, dynamic—and mean."

She doesn't look mean in this photo by Neal Boenzi, though, as she smiles with New York Mayor Robert F. Wagner and her parents in the summer of 1957. She had just won Wimbledon, becoming the first black player to do so. She was the top female tennis player in the world. And her hometown of New York City—where she'd broken the color line as the first black player to compete in the U.S. Open in 1950—was giving her a ticker-tape parade. Thousands of New Yorkers lined Broadway to cheer her success, and a meeting with the mayor was part of the festivities.

"If we had more wonderful people like you," Wagner told her, "the world would be a better place."

She was a product, first and foremost, of Harlem. Tennis became her sport when volunteers from the Police Athletic League happened to stop traffic on her block, West 143rd Street between Lenox and Seventh Avenues, and turn it into a paddle tennis court. She went on to gain support from a cadre of black tennis enthusiasts who were determined to break the color barriers of the sport and saw her as an undeniable star.

They and her neighbors were always her biggest fans, and when she made her way home after meeting Mayor Wagner, they did not disappoint. She was a global victor and a local girl made good, and there were hundreds of people waiting for her along with an array of streamers and signs hanging across the street that said "Welcome Home."

—DAMIEN CAVE

JAMES MEREDITH, THEN AND NOW

James Meredith earned a reputation as an independent, somewhat cantankerous man. Though he became an iconic figure in 1962 as the first African-American admitted to the University of Mississippi, he has never seemed comfortable in the civil rights pantheon.

Nor is he a man to climb into a time machine for a sentimental trip down Memory Lane, as he made clear in a telephone conversation about this photograph, which was taken by Eddie Hausner of *The New York Times* on August 20, 1966, as Meredith rode in Brooklyn with Dorothy Orr, executive director of Youth in Action, to promote voter registration.

When an interviewer suggested that perhaps Meredith had been nervous, riding in an open car only two months after being shot and wounded by a white supremacist ambusher in Mississippi, Meredith snorted and said, "You don't know the first thing about me! Do I look nervous in the picture?"

No, he looks relaxed and friendly on the tour through the Bedford-Stuyvesant neighborhood with James Miller, director of the voter registration drive, driving the lead vehicle in a thirty-car caravan. A *Times* account the next day, which did not include this photo, told how Meredith personally exhorted individuals to register. Encountering several men who were too young, Meredith made them promise to register when they were old enough.

▬▬▬

THE MORE THINGS CHANGE, THE MORE THEY REMAIN THE SAME

Dorothy Orr was active in the civil rights movement for decades and became a corporate vice president at the Equitable Life Assurance Society. She is believed to have been the first African-American woman to attain that status in the insurance industry. She died in 2015 at the age of ninety-five.

Meredith, who was approaching eighty-four when interviewed for this book, has sometimes confounded people. In 1967, he supported Governor Ross Barnett, the very man who had tried to bar him from Ole Miss, in his unsuccessful reelection bid. In 1991, Meredith backed the white nationalist David Duke in his campaign for Louisiana governor. He was for a time an adviser to arch-conservative Senator Jesse Helms of North Carolina.

Meredith has been lukewarm at best about any anniversary commemorations of his enrollment at Ole Miss, which touched off rioting that killed two people and was subdued by federal troops and National Guardsmen. Meredith endured isolation and harassment before graduating with a degree in political science; he then earned a law degree from Columbia University. The Mississippi campus where he was a pariah now has a statue honoring him.

When told how this book attempts to shed light on some lesser-known or

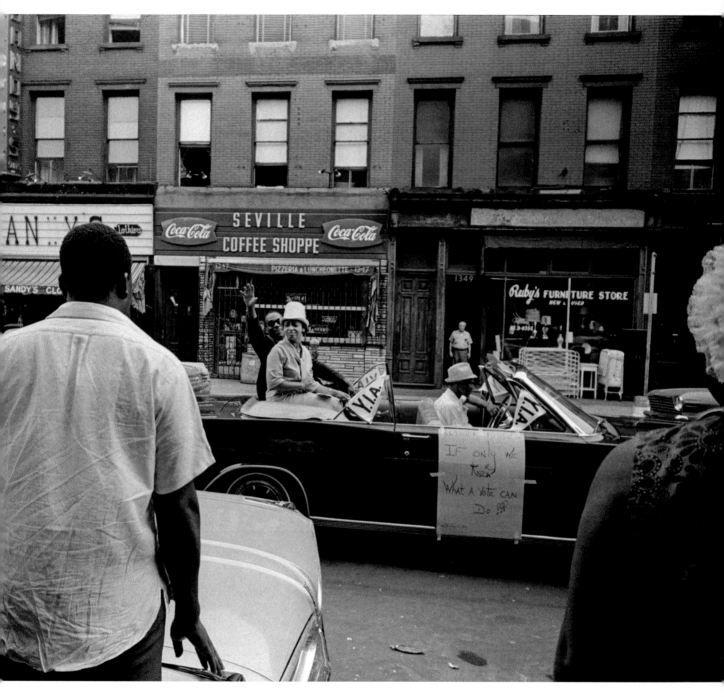

almost forgotten episodes of the civil rights era, Meredith said, "It's very much needed."

But he was unsentimental when asked to reflect on how Mississippi has evolved: "The more things change, the more they remain the same," he said. "That's truth and wisdom."

—David Stout

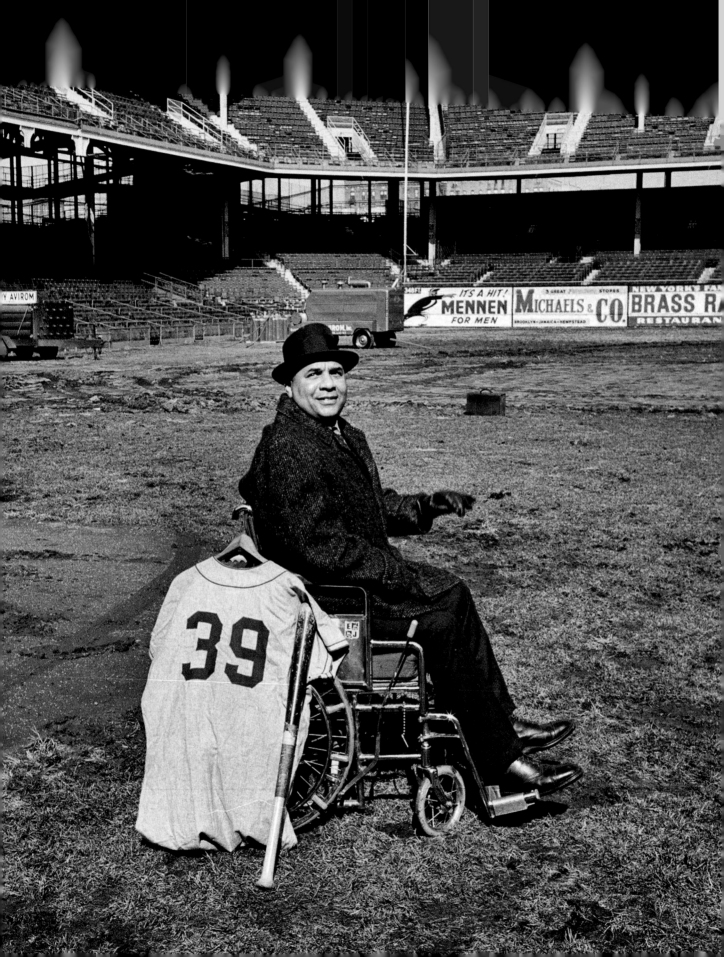

CATCHING ONE LAST GLIMPSE OF EBBETS FIELD

The wrecking ball had been painted white with red stitches, as if to soften its impact.

It was February 23, 1960, two and a half years after the Brooklyn Dodgers played their last game at Ebbets Field and the big metal ball had been summoned so it could be sent crashing into the ballpark and begin reducing it to rubble.

The Times reported that about 200 people had shown up to watch the demise of the colorful little stadium, which had been the home of the Dodgers for 44 years.

Among those present were several former Dodgers, including Roy Campanella, who had followed close behind Jackie Robinson in breaking down baseball's color barrier.

Campanella joined the Dodgers in 1948, one year after Robinson made his own major league debut. Over the next decade, Campanella arguably had as much of an impact on the Dodgers' fortunes as Robinson did. Short, stocky and powerful, he established himself as one of the great catchers in baseball history, being named the most valuable player in the National League three times.

By 1957, he was thirty-five and on the downside of his career, and he played in only 103 games, the fewest since his rookie season. But one of those games was on September 24, the last one the Dodgers, who were relocating to Los Angeles, would play at Ebbets Field. Campanella started the game and batted twice, and the Dodgers beat Pittsburgh, 2–0, although the victory was as empty as the stands were that night.

Four months later, Campanella's car skidded and struck a telephone pole while he was driving to his home on Long Island. The accident left him paralyzed from the shoulders down; his career was over.

So it was in a wheelchair, two years later, that he went out onto the field to watch Ebbets Field begin to fall. Michael Evans of *The Times* took a picture of Campanella as he sat alone on the field that day, his No. 39 uniform shirt and his bat propped against his chair.

Behind him were the left-field stands where so many of his home runs had landed. Still visible on the left-field wall were the faded advertisements from the days when Ebbets Field was alive and well: "Luckies Taste Better" read one ad for Lucky Strike cigarettes.

In every sense, the picture captured a memorable era forever gone, but *The Times* didn't publish it. Instead, two other pictures were used: one shot from on high inside Ebbets Field, focusing on the assembled crowd, and the other showing Carl Erskine, one of Campanella's old teammates, as he put his hand on the wrecking ball.

Campanella went on to work for the Los Angeles Dodgers in various roles, and in 1969 he became the second African-American player to be inducted into the Hall of Fame, joining Robinson, who was inducted seven years earlier.

Like Robinson, Campanella played for only one major league team, the Brooklyn Dodgers. Like Robinson, he played in only one home park, Ebbets Field. And on February 23, 1960, Campanella was there to say good-bye.

—JAY SCHREIBER

A ROUGH TRIP FOR A SYMBOL OF EQUALITY

There is perhaps no icon of American public schools more ubiquitous than the yellow school bus. The image of the black-and-yellow vehicles crisscrossing communities represented our investment in the futures of children and our determination to ensure that no matter how far away they lived from their school, we would get them there, and safely.

But after *Brown v. Board of Education*, the 1954 landmark ruling that struck down school segregation, this once beloved symbol of public schools suddenly became reviled, its cargo of children something to be feared.

This smiling little girl, posing for *Times* photographer Meyer Liebowitz in her Mary Janes and fur-collared coat for an article that ran in the October 22, 1963 edition of *The New York Times*, symbolized the worst racial fears of many white Americans—both above and below the Mason-Dixon Line.

She was waiting to board a bus that would carry her out of her segregated Harlem neighborhood to a better resourced school. While the article was published, the photograph was not.

With segregated schools now unconstitutional, and the civil rights movement in full force, it was no longer socially acceptable for white parents to say they did not want their children sitting in classrooms with black children—even though that was how they felt. So instead they latched on to the notion of busing as the culprit, saying that children were supposed to attend their neighborhood schools and it was unfair—in fact, unjust—to put them on long rides into other neighborhoods.

But with entrenched residential segregation caused by discrimination that was still legal at the time, busing was often the only means to ensure black children got the integration the Brown ruling had promised them.

White opposition to busing in New York City, and elsewhere, proved swift and sometimes violent. The images of angry white mobs marauding in Boston in reaction to court-ordered busing are seared into the American psyche. *The New York Times* and other new organizations gave these white protesters outsize attention, often characterizing busing as too radical and impractical, helping sway public sentiment against it and, as a result, wide-scale school integration itself.

Of course, children had been riding school buses long before they were used as a tool of integration. In 1950, seven million American children rode buses to school each day. And it's often forgotten that Linda Brown, the lead plaintiff in *Brown v. Board of Education*, sued after being bused past the nearest school, which was white, to a black school much farther away.

In reality, busing for integration was never widespread, and in the places

where it was implemented, it was largely done so peacefully. And all over the country, students continue to ride school buses each day, though almost never for integration.

The yellow school bus became the scapegoat for why efforts to integrate schools largely failed, when in truth, the failure was us.

—NIKOLE HANNAH-JONES

BABATUNDE OLATUNJI: "RHYTHM IS THE SOUL OF LIFE"

In the spring of 1968, *The Times* published a lengthy story about what it described as "a sweeping change taking place in Harlem that emphasizes blackness and African heritage."

The writer, Earl Caldwell, who is black, noted the appearance of long, brightly colored African robes. He quoted residents who said they would no longer identify as "negro," choosing black instead, and women who said they were done straightening their hair, giving them a sense of liberation from the pressure to appear white.

The photographs with the story, by Don Hogan Charles, showed a few clothing stores selling African dress; and a Yoruba religious service held at a place that had become a hub for African activity: the Olatunji Center for African Culture.

The story, focusing on the broader trend of black Americans reconnecting with Africa, did not dwell on anyone in particular, but the man in charge of the center, identified as Michael Olatunji, was, in fact, Babatunde Olatunji—the Nigerian drummer, bandleader and teacher who introduced African drumming to Bob Dylan and an entire generation of musicians who would forever see him as a powerful influence.

He's the one at the center of this previously unpublished photograph.

In 1968, when it was taken, Olatunji was already a well-known figure. His 1959 album, *Drums of Passion*, attracted interest not just from Dylan but also from Mickey Hart of the Grateful Dead, making Olatunji the most visible African musician in the United States. He had come to the United States on a scholarship to attend Morehouse College, with plans to become a diplomat. He ended up in New York, where he formed a musical ensemble that would become his full-time occupation.

His passion for sharing African music and culture led him to create the cultural center. He even convinced John Coltrane to support it, and until 1988, it offered music and dance lessons to hundreds of children like those seen here, drumming and dancing by Olatunji.

"Rhythm is the soul of life," went his personal credo. "The whole universe revolves in rhythm. Everything and every human action revolves in rhythm."

—Damien Cave

A NEW PASTOR IN HARLEM

When the Reverend Harold A. Salmon was installed as pastor of St. Charles Borromeo Roman Catholic Church in Harlem in September 1968, he was the first black priest to hold a pastorate in the New York Archdiocese. More than a thousand people filled the church and many more stood in the aisles to witness the ceremony of installation.

Salmon was named to head Harlem's largest parish by Archbishop Terence J. Cooke, who told the predominately black congregation that one of the prime needs of the archdiocese was "great understanding and unity," according to a *New York Times* story about Salmon's installation. Cooke, to Salmon's left in this picture, described him as "the right man in the right place at the right time."

In addition to his position as the parish pastor, Salmon was also named as the archbishop's vicar delegate for the area. In that role, he was responsible for planning and coordinating activities for seven parishes in Harlem.

The photograph here of Salmon's installation, by William E. Sauro of *The Times*, did not appear in the paper, but there was an article headlined "Soul Music Fills Harlem Church as Cooke Installs Negro Pastor," which included a description of music written by jazz pianist Eddie Bonnemere and played by his eight-piece band. In a short sermon, the thirty-eight-year-old pastor, garbed in bright red vestments, asked for "God's grace to accept what can't be changed but to have the courage to change what can be changed," according to *The Times* account.

The bulletin of St. Charles, a church that once barred African-Americans, hailed Salmon's appointment as the start of "a new era for black Roman Catholics."

The so-called cool priest, Harold Salmon was known to be outgoing, warm and athletic. He preached mutual support between the races, self-determination, education and adult leadership. He grew up in the Bronx, where he attended public school. He later attended Cathedral High School and College, where he played on the basketball teams, and went on to St. Joseph's Seminary and Georgetown University.

Less than a year after his installation, an article about Salmon appeared in the *Detroit Free Press*, lauding his leadership of St. Charles and citing rumors that he was a candidate for bishop. But in early 1970 the *Amsterdam News* in New York reported that he had taken a leave of absence and had been replaced; no cause was cited. He was later reported to have left the priesthood.

—DANA CANEDY

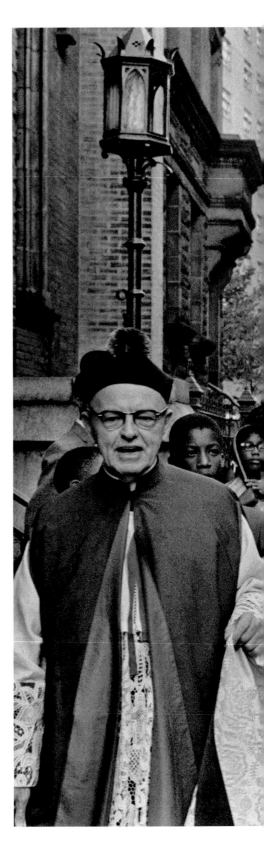

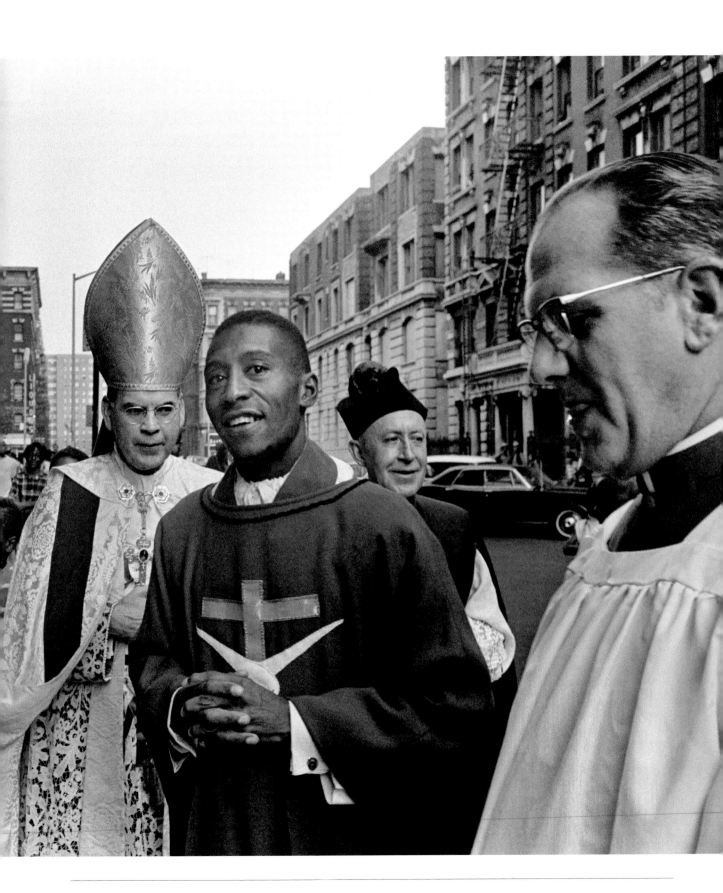

FOR TOMMY HUNT, SHOWTIME AT THE APOLLO

One of the Apollo's local fans got it almost right when she told *The Times*'s Earl Caldwell: "You get two shows at the Apollo. You get the show on the stage and the one in the audience."

In fact, there's a third performance that *Times* reporters and photographers often witnessed: the scene backstage. Check out Tommy Hunt here, gesticulating, arguing, singing—it's hard to tell exactly what he's doing, but he'd probably done it before. Hunt was an Apollo regular in the '60s, alongside Marvin Gaye, Ray Charles, Diana Ross, The Shirelles, The Supremes and many others. He was also one of soul music's earliest stars, joining The Flamingos in the '50s and singing what was then their biggest hit, "I Only Have Eyes for You."

In the photo here, it's the fall of 1967. Don Hogan Charles photographed Hunt for a story about Harlem and its struggle to draw large crowds to its nightspots in a time of rising crime and racial tension. It was the first and only mention that *The Times* provided for Hunt, whether by oversight or ignorance, but it fit a 1960s pattern in which many media outlets tended to show the black community through a lens of crime and its impact.

The Times did nonetheless allow for some nuance. The Apollo was held up as an exception, with nightly variety shows and full houses on weekends, and the photographs with the story showed Hunt onstage as members of the audience danced and pulled at him.

The backstage image never ran (probably because of the unidentified man with the closed eyes) but it seemed to capture Hunt, who was thirty-four at the time, in prime form, a star in his element.

Two years later, Hunt left New York and the Apollo. He made his way to England, where he scored several more hit singles as part of a music and dance movement called Northern Soul.

In an interview, he said he'd been stuck for years in a village called Knottingley, where it was often so cold that he was forced to wear "seventeen jackets." Looking at the photo of his younger self for the first time ever, he noted that he was quite a good-looking man back in the 1960s.

He suggested that even now he looks as good as he did in 1967, and sounds nearly the same. "I'm still in the business. I'm still as agile as I was then," he said. "I'm still doing it."

—DAMIEN CAVE

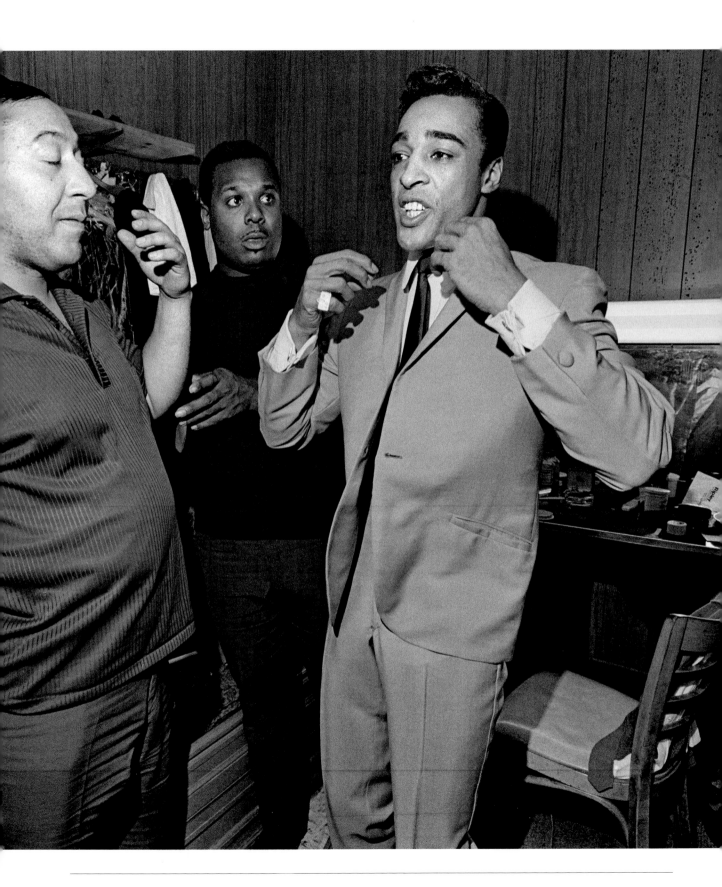

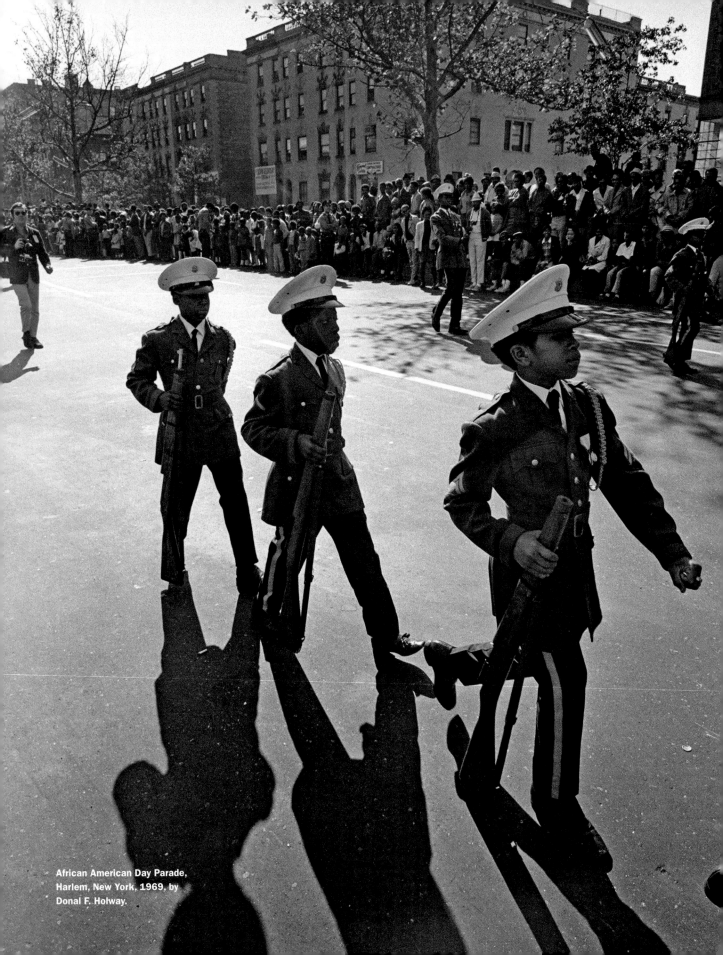

African American Day Parade,
Harlem, New York, 1969, by
Donal F. Holway.

PARADES SEEN AND UNSEEN

There are more unseen parade photos in *The Times* archives than anyone could imagine. Researching images for this book, we came across thousands—maybe tens of thousands—of photographs of parades for just about every ethnic holiday or group.

Only a small fraction of these—not including the images here, from a variety of African-American parades—were ever published. Why?

For starters, we did publish many parade photos, but they were usually the day after a holiday like Thanksgiving or the Fourth of July, when much of the reporting staff was off. The words were scarcer but there was still space to be filled, so the photos got in.

This issue of timing often defined the amount of space given to photography, and still does. Many smaller ethnic parades are held on Saturdays, when the deadlines for the big Sunday paper are earlier. So editors often use photos as "space holders" in the earlier editions, only to remove them to make room for the more substantial news stories filed later.

Like many picture editors over the years, we often arrive early on a Saturday morning and fill space with a "floater" while waiting for developments from Washington or other parts of the country.

It's impossible to know if one of the photos shown here played a similar role. Readers who now look through the electronic editions of *The Times* archives see only the final edition of that day's paper. The early editions were not digitized or preserved on microfilm.

So unless someone long ago actually cut one of these images out of the paper and saved it, there would be no way to ever access it again. It would be unseen and unrecorded—until now, of course.

—Darcy Eveleigh

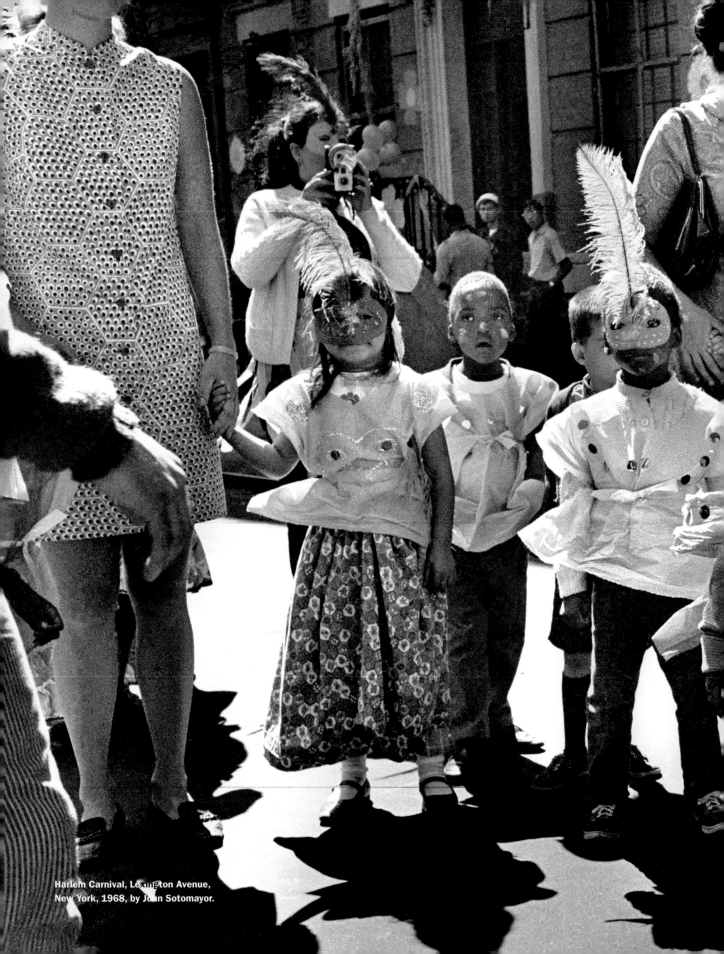

Harlem Carnival, Lexington Avenue, New York, 1968, by John Sotomayor.

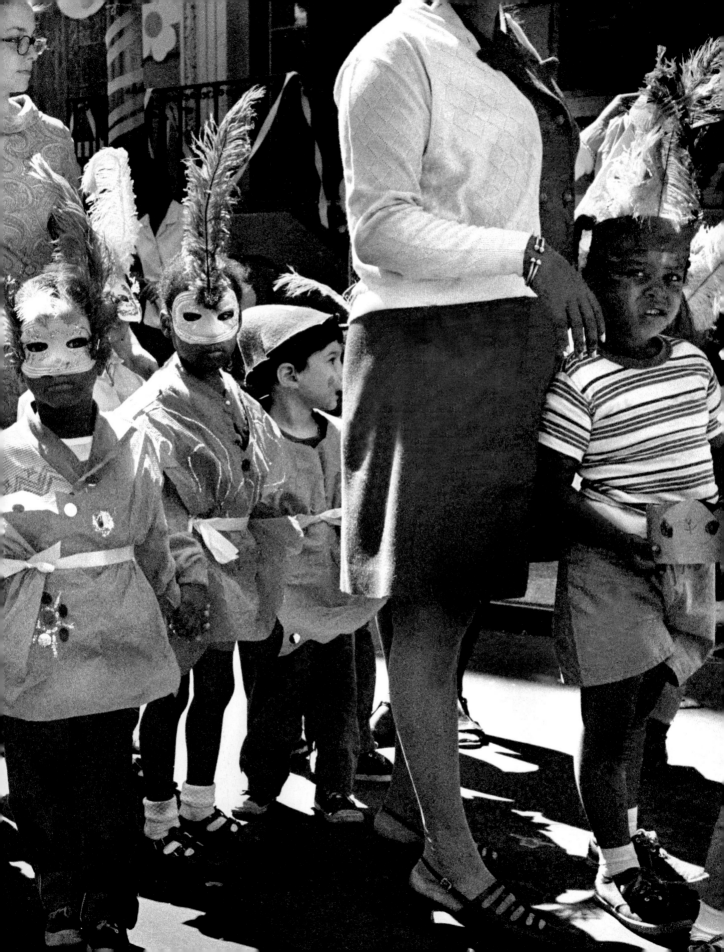

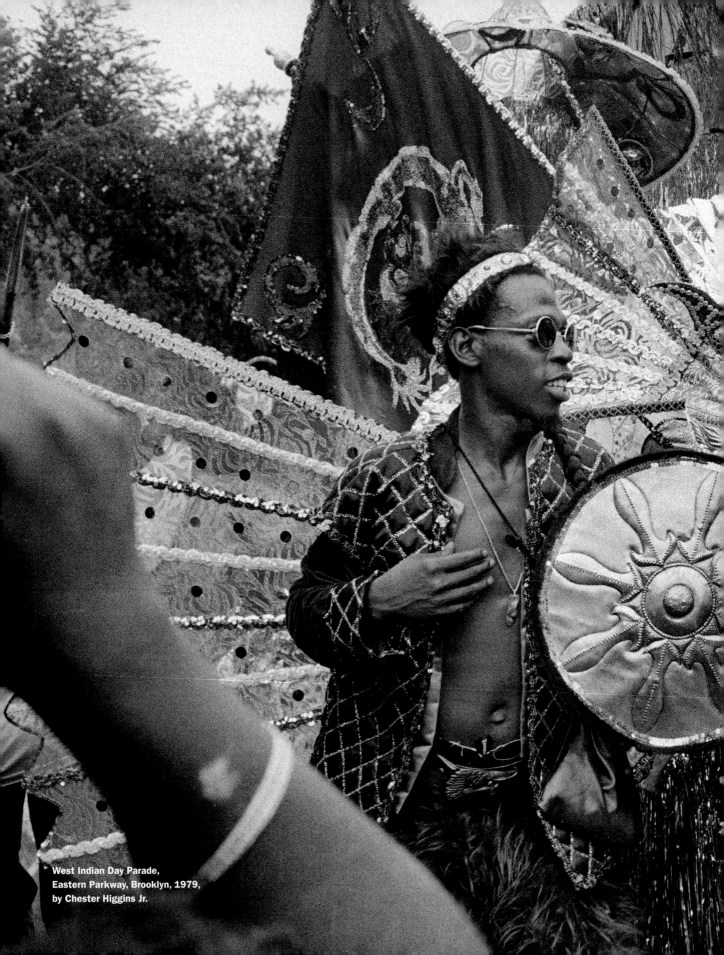

West Indian Day Parade,
Eastern Parkway, Brooklyn, 1979,
by Chester Higgins Jr.

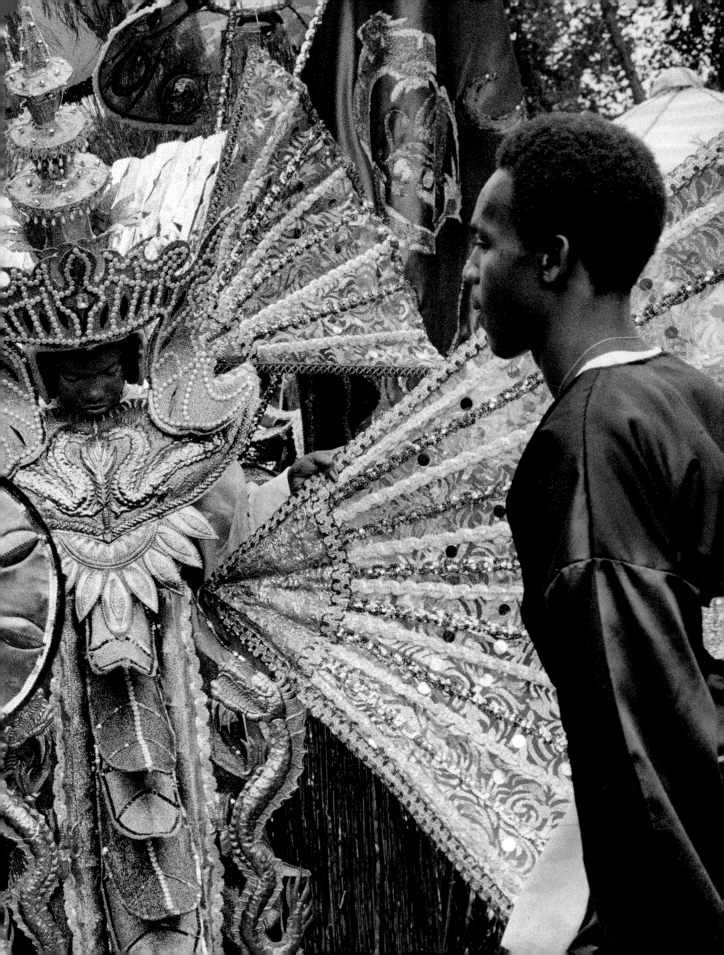

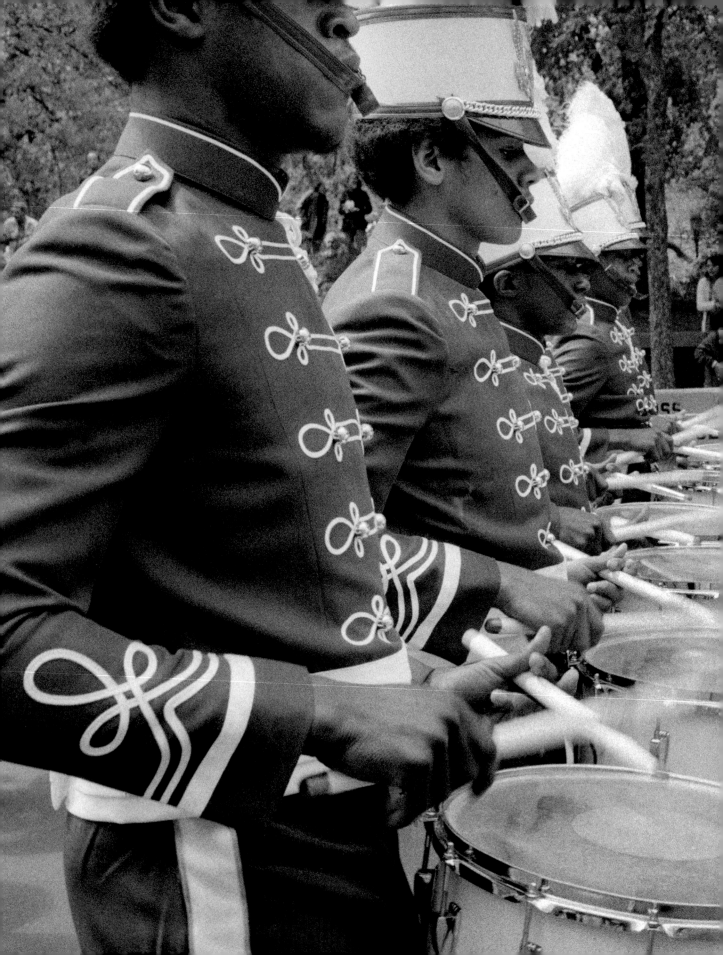

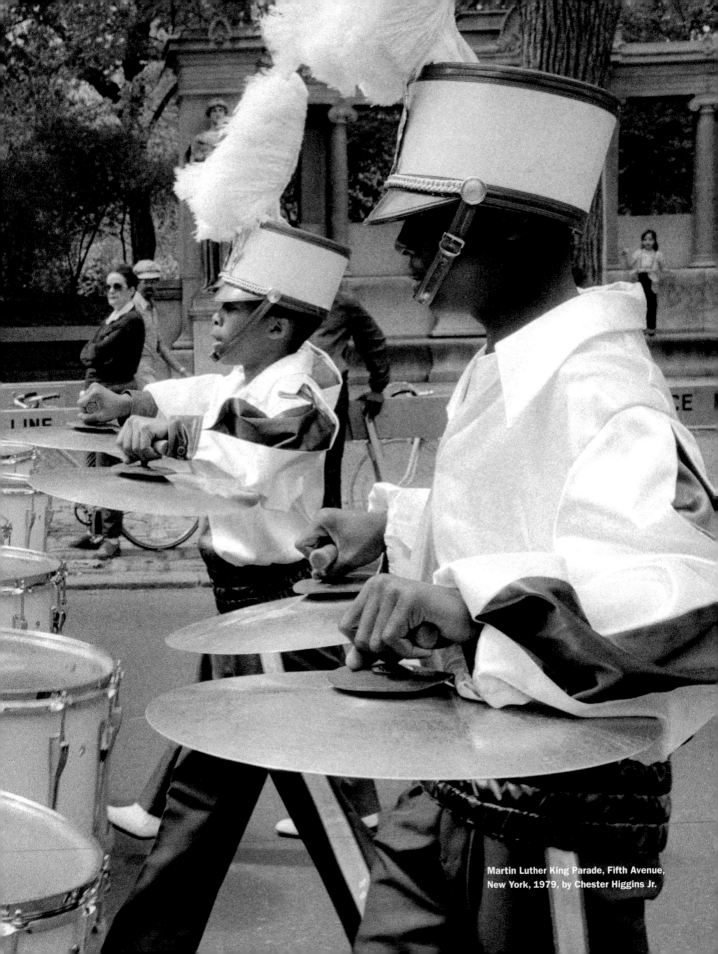

Martin Luther King Parade, Fifth Avenue, New York, 1979, by Chester Higgins Jr.

CARL B. STOKES, AMERICA'S FIRST BIG-CITY BLACK MAYOR

Carl B. Stokes was used to the word "first" accompanying his name. His most significant "first" came in 1967, when he was elected the first African-American mayor of a major city. His election as mayor of Cleveland put the city in the fore of racial progress. In this photo by George Tames, a beaming Stokes, center, greets residents shortly after taking office.

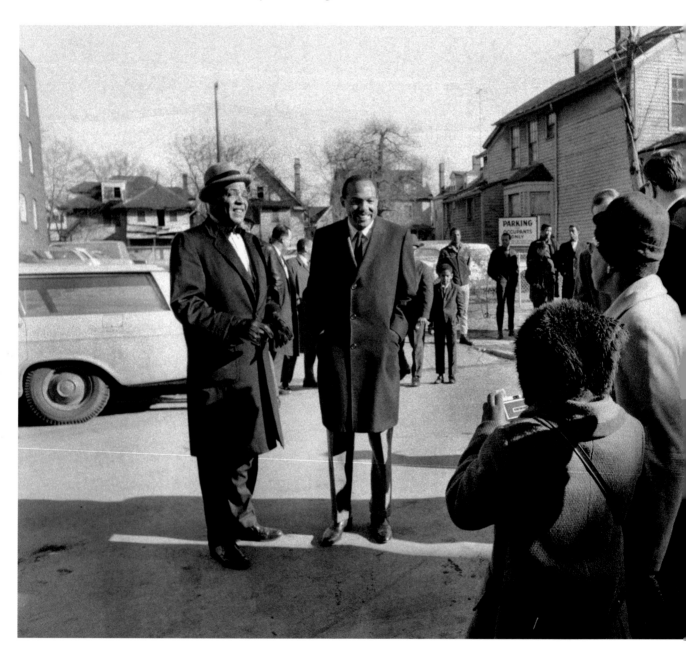

The great-grandson of a slave, Stokes defeated Seth C. Taft, the grandson of a president. Stokes, a Democratic moderate, won the election at a time when the population of Cleveland was two-thirds white. On the night of his election victory, the mayor-elect told a crowd of supporters that until that moment he had never fully known "the full meaning of the words 'God Bless America.'"

As a candidate, Stokes won over white voters with his work ethic and humor, saying in his autobiography, *Promises of Power*, "I went into every white home that would let me in there and every hall that would have me."

The mayor's tenure was defined in large measure by a critical event during the civil rights movement when a shootout during the summer of 1968 between a group of black men and the police resulted in the deaths of six black civilians and three white police officers. According to Stokes's obituary in *The Times*, when years later the former mayor spoke of what was known as the Glenville Riots, he described, with tears in his eyes, "the damn helplessness" he felt.

He wrote in his autobiography, "The aftermath of that night was to haunt and color every aspect of my administration."

HE WAS CREDITED WITH BRINGING BLACKS INTO CITY HALL JOBS AND ADVOCATING FOR POOR PEOPLE OF ALL RACES

And yet, during two two-year tenures, Mayor Stokes was credited with bringing blacks into City Hall jobs and advocating for poor people of all races, including expanding public housing.

Carl Burton Stokes was himself reared in public housing by a single mother who scraped by as a cleaning woman. His father, who was a laundry worker, died when Carl was just two years old. A high school dropout who served in the Army in World War II and later earned a high school diploma, Stokes went on to earn a bachelor's degree in law before attending Cleveland-Marshall College of Law. He was admitted to the bar in 1957.

As historically significant as Carl Stokes's eventual election was, his distinguished career also included serving in the Ohio legislature and as a municipal judge in Cleveland. He also had a career outside of politics.

After leaving office in Cleveland, he moved to New York City and in 1972 took a job at WNBC-TV and became the city's first black anchorman. Home was never far from his heart, however. Stokes returned to Cleveland in 1980, where he worked as a labor lawyer and then general counsel for the United Auto Workers, a union that had been among his earliest and strongest supporters as a mayor. He was a municipal judge in Cleveland from 1983 until 1994. In 1995, President Clinton appointed him the United States Ambassador to Seychelles. He was on a medical leave of absence from the post at the time of his death from cancer on April 3, 1996, at the age of sixty-eight.

—DANA CANEDY

BUCK LEONARD GETS THE NOD

It's been a long time coming, but here I am.

That's what Walter Fenner Leonard, known to baseball fans as Buck, seemed to be thinking in this photograph by Don Hogan Charles. He'd spent the 1930s and 1940s dominating the Negro leagues, hitting .300 or better and slamming quite a few home runs at the heart of the order for the Homestead Grays, along with Josh Gibson. But it took decades for his giant talents to be recognized. In this photo, shot for a story published on February 9, 1972, which ran with a far less interesting group of photographs that included a few other players, Leonard seems relieved and thrilled. And why not? He and Gibson were both finally being inducted into baseball's Hall of Fame, where they belonged.

—Damien Cave

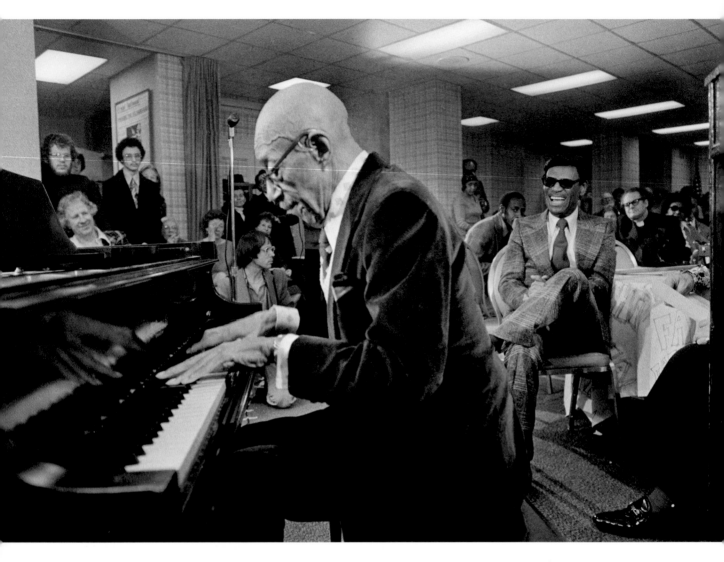

EUBIE AND "FATHA": A JAZZ DUO FOR THE AGES

Jazz greats and longtime friends Eubie Blake and Earl "Fatha" Hines jammed well into their twilight years, as you can see in this photograph from December 1975. It was shot during a party for Hines's seventieth birthday, at the Overseas Press Club, a jazz hall in New York, where he had served as honorary president.

In this photo by Chester Higgins Jr., of *The Times*, Hines, seated at right, in a dapper suit and sunglasses, looked on with glee as Blake, then ninety-two, played a tribute in honor of his lifelong friend. Some one hundred well-wishers, including big names in the jazz world, came out to celebrate the man known as the father of modern jazz piano.

Hines's passion for music had obvious influences. Born in Duquesne,

Pennsylvania, his mother played piano and organ and his father was a trumpeter. Hines began playing classical music at the age of nine, when he was already playing the trumpet.

During the 1920s, Hines collaborated with Louis Armstrong in a pioneering partnership that virtually redefined jazz piano. Hines described his own music as a "trumpet style" of piano playing.

"Hines played horn-like solo lines in octaves with his right hand and spurred them with chords from his left," said a *New York Times* article in April 1983 about his death of a heart attack at the age of seventy-seven. "He thus carved a place for the piano as a solo instrument outside the rhythm section and defined the roles of both hands for the next generations of jazz pianists."

Hines's collaboration with Armstrong produced such recordings as "West End Blues" and "Weather Bird." Hines later formed his own big band, which recorded his best-known composition, "Rosetta."

Blake, a composer and pianist, had a similarly substantial influence during a musical career that spanned most of a century. He helped to bring *Shuffle Along*, the first black musical comedy, to Broadway in 1921. But his greatest success came at the age of eighty-six, when he led a resurgence of the popularity of ragtime.

In a *Times* article on the occasion of Blake's ninetieth birthday, a reporter, McCandlish Phillips, reported that Blake, "who was robust as a rooster, stood through nearly all of a two-hour interview yesterday in his home on Stuyvesant Avenue in Brooklyn, danced through part of it, kept darting to the keyboard to illustrate a point and finished with a half-hour narrated concert in ragtime, pop, Broadway, classical and waltz tempos."

Eubie Blake was born in Baltimore, one of eleven children and the only one who survived past infancy. His father was a longshoreman who fought in the Union Army and his mother was a laundress who was deeply religious. He took up studying music after the manager of a store where his mother was shopping heard him pecking tunes on a piano and sent the piano to the family's home, over his mother's objections. The shopkeeper agreed to accept payment of just twenty-five cents a week. His mother had just one stipulation in agreeing to allow her son to take piano lessons—no "ungodly music" was to be played in their home.

Blake was awarded the Medal of Freedom at a ceremony at the White House in 1981 and made his last professional appearance the following year, a week before his ninety-ninth birthday. A year later there were celebratory performances of his music during a gala at the Shubert Theatre on Broadway for his hundredth birthday. Blake was suffering from pneumonia at the time and unable to attend, but he heard the performance on a phone. He also heard congratulations from President Reagan and Governor Cuomo.

Blake died five days later.

—Dana Canedy

THE MAN KNOWN AS THE FATHER OF MODERN JAZZ PIANO

A GREAT DAY FOR A RIDE

The notion that poor black communities are always looking for a handout—from the white and wealthy in particular—can be hard to shake in politics and in news coverage. Often overlooked are the efforts by people in these communities to contribute and try to improve their own lot and the fortunes of their children.

Or if those efforts are actually noticed, they rarely get treated very seriously. That's a bit of what happened here in the fall of 1970 when *The Times* did a feature story on the Community Riding School, an equestrian cooperative formed in Newark by a handful of black horse lovers who organized themselves to ride together and give free lessons to local children. One of the leaders of the group, Arthur Barrett, was nicknamed the Sundance Kid, which then led to this headline, which seemed aimed at making a white audience chuckle: "Sundance Kid and Friends Clop Through Newark's Black Slum."

A subject that might have received simple appreciation in its framing if it were a white man on a horse in Central Park took on a jokey tone with a black man in Newark's Central Ward.

The photograph that accompanied the article showed Barrett rearing the horse "to the pleasure of neighborhood youngsters," as the notes from photographer Eddie Hausner show. These outtakes go beyond tricks, showing the community and the community response. Instead of a circus feel, à la that headline, what you end up with is a sense of surprise, yes, but also a clear recognition of Barrett's passion and rigor. He's not smiling or laughing as he guides horses through traffic or various maneuvers; he's a man dedicated to his craft, for himself, for his horse, for his community.

—Damien Cave

PATRICIA R. HARRIS: DIPLOMAT, LAW SCHOOL DEAN AND CABINET MEMBER

Given the era, one might be forgiven for assuming that Patricia R. Harris, photographed in a smart dress and neat brooch enjoying cocktails with men in tuxedos aboard a luxury liner, was accompanying her husband to the black-tie affair. She was not.

In the photograph taken by *Times* photographer Larry C. Morris in December 1966, Harris was at the party of international diplomats as the United States Ambassador to Luxembourg and an alternate delegate to the United Nations. The first black woman to be named a diplomat, she was appointed to the post in 1965 by President Lyndon B. Johnson.

At the party, where the liner was docked along the Hudson River piers near West 44th Street, Harris was conferring with her counterpart from the Soviet Union, Nikolai Fedorenko. She was aboard the *Constitution*, one of 250 guests dining on champagne, caviar and pheasant. *The New York Times* story of the event named more than a dozen attendees from political and diplomatic circles, but made no mention of our ambassador to Luxembourg. Nor did the photo appear.

YOU DO NOT SEEM TO UNDERSTAND WHO I AM. I AM A BLACK WOMAN

The daughter of a Pullman car waiter, Harris was born Patricia Roberts in Mattoon, Illinois, and received a bachelor's degree at Howard University. She graduated first in her class of ninety-four from George Washington University's National Law Center in 1960. She then went to work for the Justice Department but later returned to Howard as a law professor, and in 1969 became the first black woman to be dean of a law school when she was named to the position at the university. Her husband, William B. Harris, was also an attorney.

Harris left Howard the following year and practiced corporate law until President Jimmy Carter selected her in 1977 as Secretary of Housing and Urban Development. It was another groundbreaking role, as she became the first African-American woman to hold a cabinet position.

In 1982, Harris made a brief foray into politics, running unsuccessfully for mayor of the District of Columbia against incumbent Marion S. Barry Jr. She had been considered the candidate for middle-class voters while Barry was regarded as the choice for poor blacks.

It was not the first time that her success made it necessary for Harris to defend herself against claims that she was out of touch with working-class blacks. At hearings before the United States Senate Committee on Banking, Housing and Urban Affairs in 1977 on her nomination as H.U.D. Secretary, she took issue with the suggestion that she might not defend the interests of the poor.

"I am one of them," she quickly replied. "You do not seem to understand who I am. I am a black woman, the daughter of a dining-car worker. I am a black woman who could not buy a house eight years ago in parts of the District of Columbia." The quote appeared in her obituary in *The Times*, following her death from cancer in 1985 at the age of sixty.

—DANA CANEDY

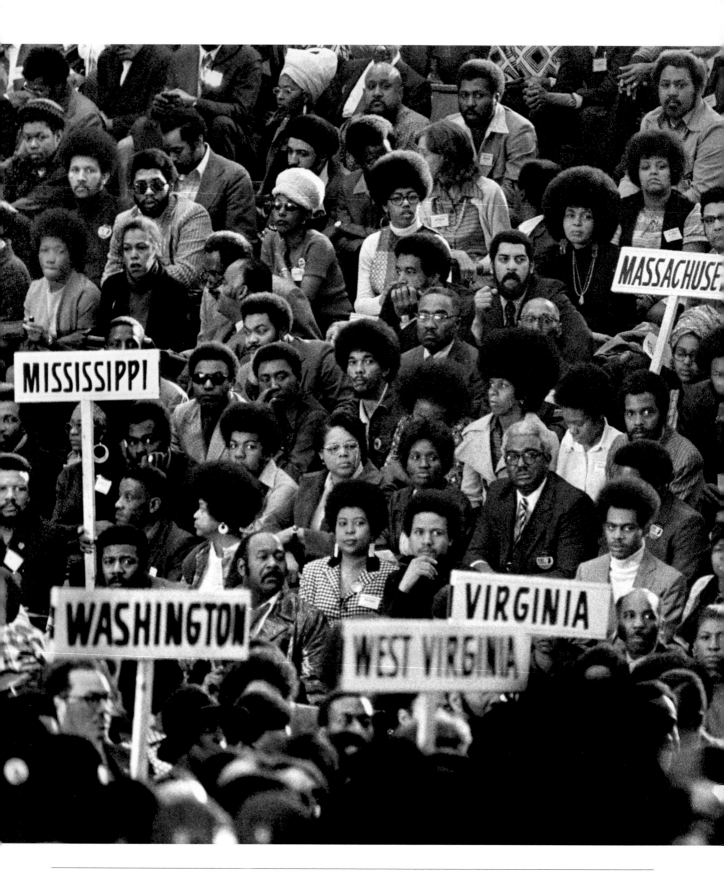

NATIONAL BLACK POLITICAL CONVENTION, 1972

It was a gathering whose purpose, creating political unity to empower black Americans to demand more national economic and social progress, could have been set in 2017.

This, though, was the National Black Political Convention of 1972. It was the first of its kind and it drew a Who's Who of Black America.

At a high school gymnasium in Gary, Indiana, speaker after speaker extolled the value of political activism and unity, urging those in attendance to keep the pressure on elected officials to hear their collective voice and call to action.

But the main call to action was for self-empowerment, as the convention theme centered on ways the black communities could improve their own lot— by running for office and patronizing black-owned businesses. They were 8,000 strong, delegates, alternates and observers, who convened for two days that early spring week in March. They were elected officials, entertainers, business and religious leaders and civil and human rights activists.

Among them were Coretta Scott King and Malcolm X's widow, Betty Shabazz, along with the singer Isaac Hayes and the poet Nikki Giovanni. Actor and activist Dick Gregory and Congressman John Conyers of Michigan were among the notable convention participants.

"This convention signals the end of hip-pocket politics," said Richard G. Hatcher, mayor of Gary, who co-chaired the event with Congressman Charles C. Diggs of Michigan, told convention-goers in a speech on the opening day. "We ain't in nobody's hip pocket no more."

Photos, like this one by Gary Settle of *The Times*, of men and women wearing big, round, beautiful Afros and suits and turtlenecks, holding signs representing their respective states—Utah, Mississippi, Florida—painted a picture of determined black pride. Yet they went mostly unpublished. Stories about the convention in *The New York Times* also spoke of a group brimming with conviction and idealism, united in letting the country, and those who represent it, know they meant to be taken seriously. Some conventioneers wanted to take even bolder action, calling for sustained national political activism.

There at a lectern was the Reverend Jesse L. Jackson, telling the crowd, "We must form a black political party," according to an account of his remarks in a *Times* story about the first day of the convention. He suggested it be called the Black Liberation Party, saying, "Without the option of a black political party, we are doomed to remain in the hip pocket of the Democratic Party and in the rumble seat of the Republican Party."

—DANA CANEDY

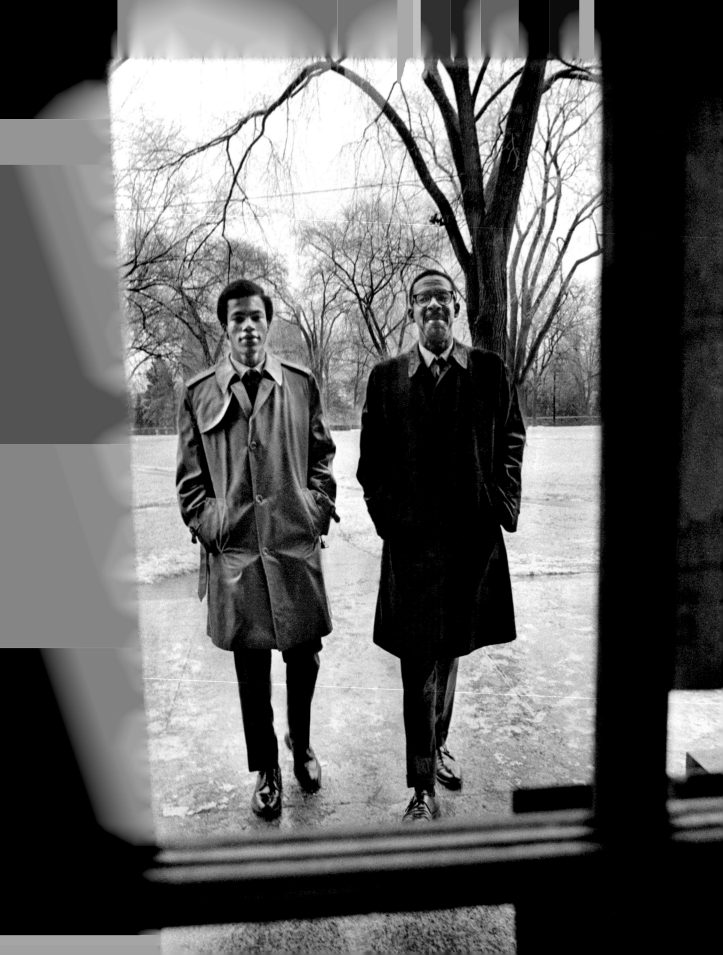

MONETA SLEET JR.: A KEEN EYE AND A HUMAN TOUCH

"I wasn't there as an objective reporter," Moneta Sleet Jr. once said about being a photographer. It was a quote that appeared in his *New York Times* obituary, which ran on October 2, 1996. "I had something to say and was trying to show one side of it. We didn't have any problems finding the other side."

Indeed not. For his images of Martin Luther King Jr.'s funeral, including King's five-year-old daughter, Bernice, resting her head in her mother's lap, Moneta Sleet became the first African-American journalist to win a Pulitzer Prize and an inspiration to countless journalists, including this one.

A native of Owensboro, Kentucky, Sleet earned a master's degree in journalism from New York University and worked for various black publications before landing a staff photographer position at *Ebony* magazine. It was a job that would take him on the road away from his family in New York to photograph a wide range of subjects: musicians (Billie Holiday, Stevie Wonder), athletes (Muhammad Ali), international figures (Haile Selassie and Jomo Kenyatta) and civil rights leaders in the South, including—and especially—King.

"He was just Dad to us," Gregory M. Sleet, Moneta's eldest son and one of four children of Sleet and his wife, Juanita, recalled in an interview. Whenever he was home, the family would always have dinner together, with their father taking those moments to talk about his work and what was happening in the world. Gregory Sleet, the first African-American United States judge in Delaware, recalled how his parents would also have guests over to their house on occasion. "The adults would have dinner, and then I would be invited into the living room to watch as my father shared his work on the slide projector." Then from time to time he would share his slides of his work with just the family.

There were two indelible moments for Gregory growing up. The first was when his father took him to cover Jackie Robinson's induction into the Baseball Hall of Fame in 1962. "I was a great baseball fan and I played baseball, and wow. I got to go and watch."

The other memorable moment was the day Moneta Sleet piled his family in the car for a trip to the airport. This wasn't unusual for a man who constantly traveled, but this time was different, Gregory recalled. "He told my mom to take the wheel and park the car, and he had me come along with him."

When they arrived at a double door marked VIP and entered, Gregory began to recognize people he had seen on television. This was the day that his dad, on assignment for *Ebony*, was to travel with King to Norway to receive the 1964 Nobel Peace Prize.

All of a sudden, he recalled, the crowded room began parting. "My dad came through the crowd with Dr. King walking next to him. Dr. King walks straight to me and shook my hand and looked directly at me, and I have no idea what he said."

Years later, when he was practicing law, Gregory received an envelope from his father. Inside was a photograph of him, his father, and King taken that day at the airport, along with a program from the Nobel ceremony. On the back of the program, King inscribed "To Gregory, for whom I wish a great future and whose father I admire very much. Martin Luther King."

While touring Wesleyan University in Connecticut in 1969, Gregory and his father were photographed by Eddie Hausner of *The New York Times* to illustrate an article about the diversity on the Wesleyan campus.

Whatever the reason, the fact that the photograph was not published carries more than a hint of irony: The very reason Gregory was considering Wesleyan was for its campus activism—and his father knew it.

—Sandra M. Stevenson

LOUIS GOSSETT JR. AND THE POWER OF DIVERSITY

The Zulu and the Zayda was a musical about an old Jewish grandfather, a *zayda*, and young African man. It was set in Johannesburg and billed as a comedy, which might have only been possible because when it opened on Broadway in 1965 it featured a versatile black actor who grew up in a Jewish neighborhood of Brooklyn and knew some Yiddish: Louis Gossett Jr.

He was twenty-nine years old when this photo was taken in 1966 by Sam Falk of *The Times* in the actor's dressing room at the Cort Theatre, for an article about his upbringing and his performance. More than fifty years later, he said that seeing the unpublished photo brought him back, not just to the play about two very different men trying to make sense of an unjust world, but also to memories of a very special time in the life of New York and America.

"It was the time of Ali, and Malcolm X, the Chicago Seven, the Black Panthers," he said in an interview. "People started to wake up. It was a beautiful movement, because people believed that we all were equal."

"This was also the same time as the folk movement down in the Greenwich Village," he added. "Peter, Paul and Mary and those people, and the best-known people of the folk era, ending of course in Woodstock. Everybody came. Judy Collins, Bob Dylan—Bobby Zimmerman at the time. So we rubbed elbows. It was a time for compassion."

The New York of Gossett's youth had prepared him for inhabiting a variety of roles. He grew up around Coney Island in an area that was predominantly Jewish but filled with kids from all kinds of backgrounds and families who looked after everyone. When hunger called, he said, "I'd go next door and get the gefilte fish, or I'd go next door and get the lasagna, the corned beef and cabbage."

The food, in many ways, set in motion a cycle of support. He ended up on Broadway as a teenager because of a teacher who encouraged him to audition for the play *Take a Giant Step*. He was president of his class in junior high and high school because his charisma mattered more than the color of his skin, and he thrived in the world of New York's cultural scene because, he said, "I was raised by history makers."

"I didn't know it at the time, but they were," he said. "Lena Horne, Josephine Baker, Adam Clayton Powell, Malcolm X. They all took care of this new kid on the block. I was treated very well. I was taken good care of."

Since then, he has been known to return the favor. He won an Oscar in 1983 for his performance in *An Officer and a Gentleman*, and though he said he always felt more comfortable in New York than he did in Hollywood, he has long been known for doling out kindness to all, from the camera loader on a movie set up to the most esteemed colleague.

HIS YOUTH PREPARED HIM FOR A VARIETY OF ROLES

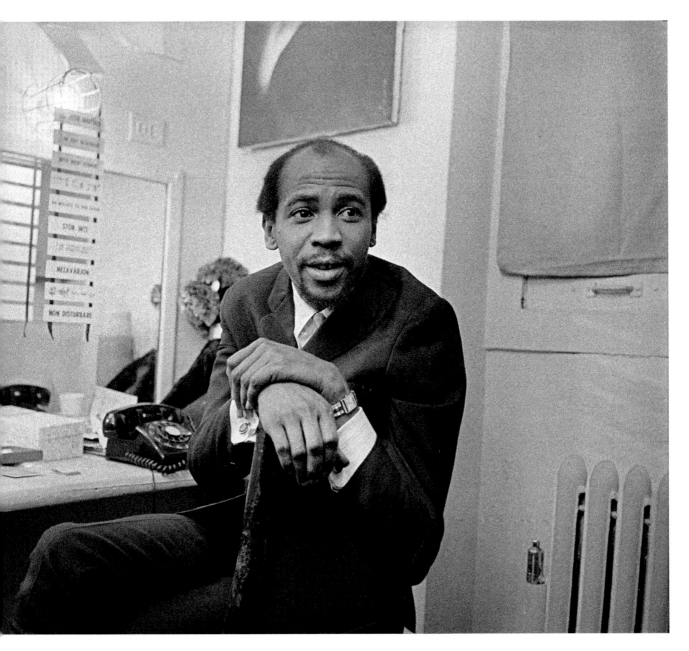

Now when he looks out at the young actors and directors and writers coming up, Gossett sees hope in the middle of an ongoing struggle. He said he believes that history and culture will be on the side of diverse, tolerant communities like the one where he grew up, that there's no denying that "the people who call the shots better are the ones who have more life experience."

"We are a diverse country whether people like it or not," he said. "The next frontier is happening as we speak. It is for people of any nationality, any color, to call the shots, to the benefit of us all."

—DAMIEN CAVE AND JOSHUA BARONE

FROM STUDENT TO TEACHER, IN A TIME OF CHANGE

"Princeton's two elementary schools were integrated 16 years ago," *The Times* reported on June 21, 1964. "Thus began a three-act racial drama—first, a period of Negro hopes; next, Negro frustration and disillusionment; and then, a limited degree of fulfillment."

An article in *The Times Magazine* assessed the school system's progress in integration. While offering a caveat that still resonates, noting that in the search for equality "good schooling is not enough," the article mostly trumpeted Princeton, New Jersey, as a model for struggling integration efforts in schools across the country.

Was that positive assessment correct?

When we published this image online, unearthing it from the outtakes for that magazine story, today's *Times* readers wanted to know what happened next. As is often the case when we look into the past, they wanted an update. We didn't even have the names of the subjects, and so we did what journalists often do: We started reporting and we asked for help. We asked if anyone knew either child. Then one of those children—the little girl—found us.

Evelyn Turner Counts was seven years old when Sam Falk took this picture of her second-grade class in 1964. The image, from a classroom at Nassau Street Elementary School, one of the first integrated elementary schools in Princeton, never made it into print back then. But after we published it online, Counts, a retired teacher, counselor, and coach who worked in Princeton's public schools for thirty-four years, saw it on Facebook and contacted us.

She told us she immediately recognized herself. "I looked and I said, 'Oh my gosh, that's me!'" she said, adding: "It totally blew me away. All of a sudden it all came back."

Evelyn Counts, in a photo on the following page taken by Chang W. Lee, told us her story:

"It was second grade. Second grade was when I had this marvelous African-American teacher. You can see the joy in my face. She was one of the people who made me think that teaching might be my career. That's the power of a role model who says you can do whatever you want to do, you can be whatever you want to be.

"It was an interesting school. There were lots and lots of Caucasians, lots of kids who had a lot, who knew a lot, who did a lot. It was Princeton. But it was second grade. Kids were kids. You played with everybody. You would go to a birthday party, and everybody in the class

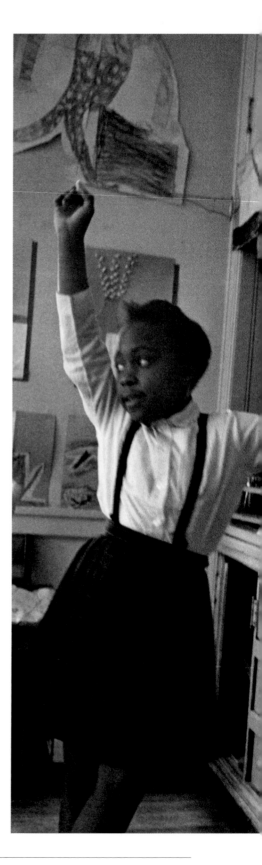

was there, and there would be this huge house. My whole house could fit into the living room.

"By fourth grade, things were beginning to change. People are older. People say less kind things. Yes, we were black, but now people were pointing it out to us. Did we have slurs? There was some of that, yes, from both sides. It didn't bother me personally. But I do remember friends who would cry. I do remember friends who would get into fights. In fourth grade, you find out where you are in the pecking order.

"My neighborhood, they would call it the ghetto, but it was a golden ghetto. It was the area not too far from the university where blacks originally came and lived and could easily get to work at the university. It was a front porch community. My mother was a homemaker. My father worked for the government, at a warehouse depot, shipping government supplies. There were teachers in my neighborhood. There were policemen in my neighborhood. There were working people who were in the service industries, a little bit of everything. They knew who you were; you knew who they were. It was a true neighborhood.

"Since then gentrification has taken place. That is very painful for me. I want people to know: 'Hey, you're not just living in this house. You're living in a place that's golden.' I want them to know something about the history.

"I've always been able to interact with a wide variety of people very easily. Was that solely as a result of the integration? Well, my parents were very outgoing. So I'm going to give integration part of the credit for that. I'm certainly going to give my parents credit, too.

"Perhaps the most important thing that made a difference for me as a student was the people, the teachers that I had, who took a little extra time. They were black and white teachers. The teacher who put a star above any vocabulary word that I used that was extraordinary. It made us all love words. Or the teacher who asked, 'Are you having a hard time today?' It was the caring, the kindness, the extra little bit of thoughtfulness. I think that's what made the difference for me."

—DAMIEN CAVE AND RACHEL L. SWARNS

FLAVOR FLAV AT THE GARDEN

The Times was slow to appreciate the full influence and artistry of hip-hop, but Public Enemy never escaped notice. In his review of their debut album in 1987, Jon Pareles praised their subversive sociopolitical approach and the seriousness of their appeal.

Even when rapping about themselves, he wrote, "They make it clear that they're also speaking for an embattled black underclass." A few years later, despite controversies over whether some of their lyrics were anti-Semitic and misogynist, Pareles called Public Enemy "New York's most important rap group."

Michelle V. Agins—one of *The Times*'s best nightlife and music photographers—wasn't as much of a fan. She described photographing the band in 1992 at Madison Square Garden as mostly a hassle, with security intense in response to the band's confrontational lyrics and provocative stage show.

On that night, January 3, 1992, the props included a malt liquor bottle with a skeleton inside; and a figure in Ku Klux Klan robes, which was placed in a noose and hanged as the band performed "Can't Truss It," its popular single about slavery and exploitation.

Still, Agins managed to get this shot, which fully captured the mood and the moment: Flavor Flav performing in a larger-than-life outfit with a guard in front and sandbags behind. The image that ran with the Pareles review was more predictable: a close-up of Chuck D.

—Damien Cave

A HARLEM POWER BROKER, PROUDLY PARADING HIS HERITAGE

It's September 20, 1970, or Afro-American Day, as that Sunday was known. Basil A. Paterson, a smooth and savvy kingmaker of Harlem Democratic politics, and his wife, Portia, are among the marchers along Seventh Avenue in this previously unpublished photograph taken by William E. Sauro of *The New York Times*.

Paterson, who was then running for lieutenant governor, is flashing a big smile as well as a Black

Power salute. The salute was often seen as an expression of anger as well as pride, but Basil Paterson's son, David, said he's sure there was no anger in his father's heart that day.

"I saw my dad angry only a few times, most notably on the night of the assassination of Martin Luther King," recalled David Paterson, a former governor of New York State who was sixteen when the parade picture was taken. To his father, the salute stood for pride in one's heritage, the way Irish-Americans celebrate their roots on St. Patrick's Day and Italian-Americans mark Columbus Day, David Paterson said. To be sure, Basil Paterson understood that the salute was a way to connect with young

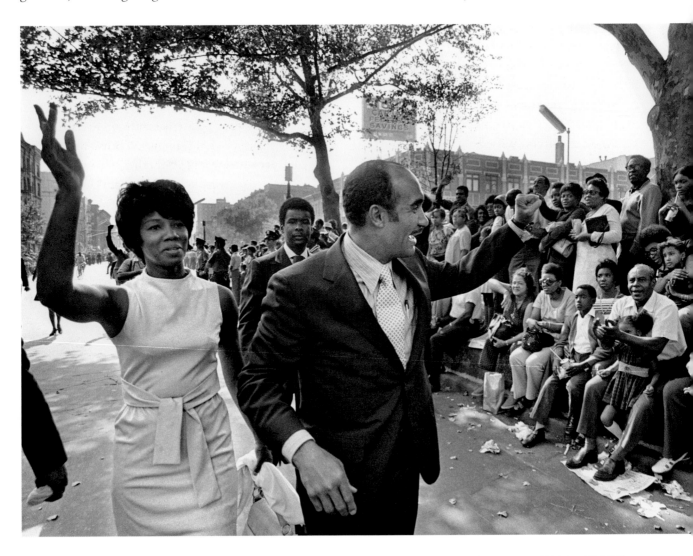

African-Americans, his son recalled, emphasizing that "at no point did he advocate for prejudice" of any kind.

Not that Basil Paterson didn't understand prejudice. During his Army service in World War II, he thought white American soldiers in Europe treated German prisoners of war better than they did their own fellow black soldiers, David Paterson said.

That Sunday parade in 1970 marked a transition of sorts: Adam Clayton Powell, the longtime congressman from Harlem, was the honorary grand marshal. On the reviewing stand, he was photographed chatting amiably with State Assemblyman Charles B. Rangel, who had recently defeated him in the Democratic Congressional primary and would win election to the United States House of Representatives in November.

But Basil Paterson lost that November, as the Democratic candidate for governor, Arthur J. Goldberg, was beaten decisively by incumbent governor Nelson A. Rockefeller and his lieutenant governor, Malcolm Wilson.

When Basil Paterson died at eighty-seven in April 2014, it was recalled that he had been a lawyer, labor negotiator, federal mediator, state senator, New York's secretary of state and deputy mayor—as well as the Empire State's first black major-party candidate for lieutenant governor. He was perhaps more famous as one of the "Gang of Four" political power brokers in Manhattan, the others being Rangel, the dean of New York State's congressional delegation; David N. Dinkins, who became the city's first black mayor; and Percy E. Sutton, a civil rights leader and longtime Manhattan borough president, who died in 2009.

Despite the smiles and cheerfulness that prevailed at that Afro-American Day parade, 1970 was not a happy year, David Paterson recalled. On May 4, four white students were shot dead by Ohio National Guardsmen in an antiwar protest at Kent State University. The following week, two black students were shot and killed by police at Jackson State College in Mississippi in riots that erupted amid a false rumor that Fayette mayor Charles Evers and his wife, Nannie, had been assassinated.

THAT SUNDAY PARADE IN 1970 MARKED A TRANSITION OF SORTS

Six weeks after the Harlem parade, President Richard M. Nixon was greeted by rock-throwing, insult-shouting demonstrators in Anaheim, California, while campaigning on behalf of incumbent senator George Murphy (who would be defeated). The disturbances prompted Governor Ronald Reagan to call up the National Guard.

While Basil Paterson was not, fundamentally, an angry man, his son said, he understood the political forces that anger could unleash. Surely, David Paterson said, his father would have sensed the rise of Donald Trump. "I wish I could have a séance and talk to him," the son said.

—David Stout

DAISY BATES'S STEELY RESOLVE

They were harrowing times for a nation at a racial crossroads. Daisy Bates was at the center of it.

She was as tough and strategic as she was refined. And she would dedicate her life to civil rights advocacy that helped define and change America. Bates, pictured here in 1957, led the fight that year to admit nine black students to Central High School in Little Rock, Arkansas. As the chairman of the Arkansas chapter of the National Association for the Advancement of Colored People, she was central to the litigation that led nine black students to integrate Central High, under the protection of federal troops. The case followed the 1954 Supreme Court decision in *Brown v. Board of Education*, which declared school segregation unconstitutional.

Bates and her family paid a heavy price for taking up the cause of desegregation, but she kept her focus steadfast on the students throughout those trying times. Indeed she maintained her steely resolve even when rocks were thrown through her window, when a burning cross was placed on the roof of her family's home and when local officials had her arrested. She was charged with violating a recently enacted city ordinance giving local officials the authority to review records of certain organizations. The ordinance was enacted specifically to seize N.A.A.C.P. records.

The officials ordered the arrest of all officers of the local organization after they refused to comply with an order to turn over the organization's membership and financial records. The only officers were Bates and the Reverend J. C. Crenshaw, the group's president. The city said the N.A.A.C.P. was an extremist group and that thus it needed to know who the members were. Bates and the organization's lawyers argued unsuccessfully that providing the records would hamper the group's ability to raise money and recruit new members because the membership information would be made public.

One of Bates's lawyers was Thurgood Marshall, then special counsel for the N.A.A.C.P. He released a statement shortly after she was jailed and posted a $300 bond, saying, "The action by the city counsel is another instance of efforts of the state of Arkansas to use judicial process to thwart the Constitution of the United States of America."

In these two photographs, taken by George Tames of *The New York Times*, Bates confers in her living room with other members of the N.A.A.C.P. team to plan strategy before turning herself in to the authorities, and with attorney George Howard awaiting the start of her hearing in a Little Rock courtroom. Neither appeared in *The Times*. Instead, the paper published a wire photo of her being fingerprinted. Bates ultimately paid a $25 fine. She never released the N.A.A.C.P. documents.

SHE WAS AS TOUGH AND STRATEGIC AS SHE WAS REFINED

In her foreword to Bates's 1962 book, *The Long Shadow of Little Rock*, Eleanor Roosevelt wrote, "I have paid her homage in my thoughts many times and I want to tell her again how remarkable I think she was through these horrible years."

When Daisy Bates died in 1999 at the age of eighty-four, President Clinton called her a heroine whose death "will leave a vacuum in the civil rights community, the State of Arkansas and our country."

—DANA CANEDY

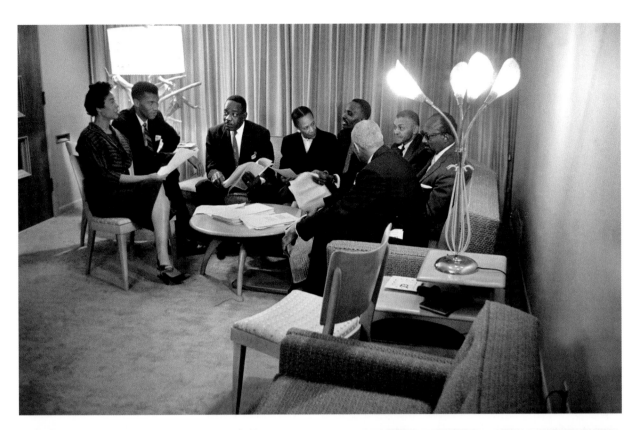

SOLVING A JACKIE ROBINSON MYSTERY

It was 1949, the year Jackie Robinson would bat .342 for the Brooklyn Dodgers and receive the National League's Most Valuable Player Award, just thirty one months after becoming the first player to break the color barrier in decades.

But on February 14, before the season started, before the crowds poured into Ebbets Field, Robinson spoke to the Sociology Society at City College in New York.

We tried to figure out why.

This photograph, taken by an unnamed *Times* staffer, documents the moment with the students leaning forward to hear him speak. But what was he discussing? The photo caption offers only a hint, saying that Robinson was speaking about "his work with Harlem boys' groups."

We knew that Robinson coached children at the YMCA in Harlem a year earlier, to help, as he put it, "keep them off the streets." And it is easy to imagine how his successes and struggles would have resonated with African-American boys and teenagers at a time when racial discrimination was rife. "I had to fight hard against loneliness, abuse and the knowledge that any mistake I made would be magnified because I was the only black man out there," Robinson wrote in his memoir, *I Never Had It Made: An Autobiography of Jackie Robinson*, describing those early years with the Dodgers.

I HAD TO FIGHT HARD AGAINST LONELINESS

Several readers responded to our query, which was published in *The Times* in 2016. Among them was Werner Rothschild of Boynton Beach, Florida, who was there when Robinson visited City College. (In this photograph, Rothschild is the young man seated in the third row, second from the left, next to a student with his chin in his hand.)

Rothschild was a member of the Sociology Society. He was the one who went to the YMCA in Harlem to invite Robinson to speak.

"He said, 'I'd be delighted,'" Rothschild recalled. "He was a real gentleman, just wonderful."

Other readers pointed us to City College's undergraduate newspaper, *The Campus*, which published an article about Robinson's speech on February 18, 1949.

The article quoted Robinson, who told the members of the Sociology Society about his work with underprivileged children at the YMCA. "I've learned more from the kids than they've learned from me," he said.

—RACHEL L. SWARNS

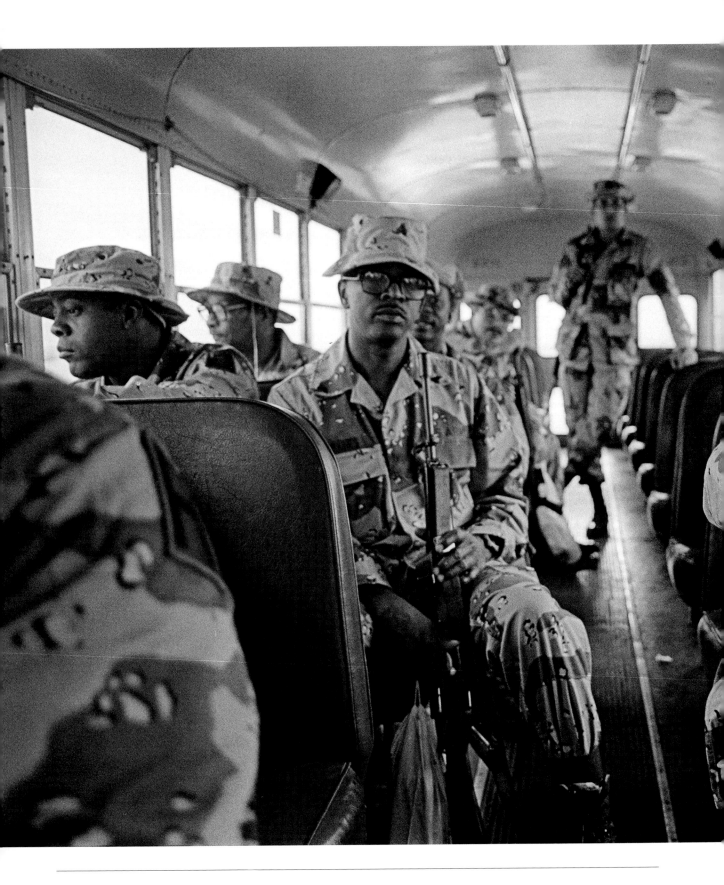

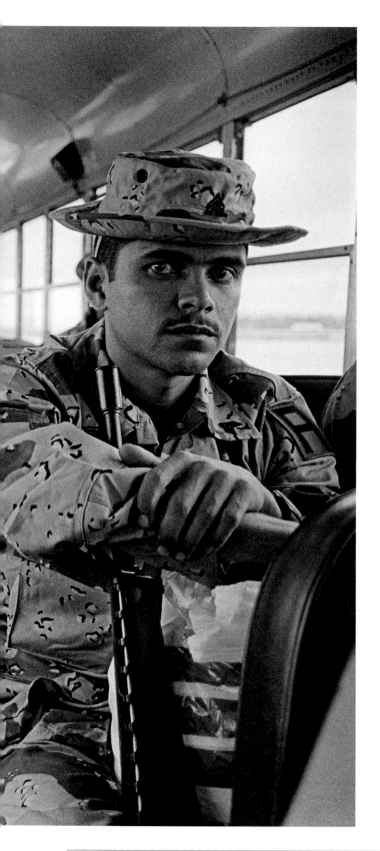

THE HARLEM HELL-FIGHTERS, CARRYING ON A VALIANT TRADITION

The Harlem Hellfighters were an all-black National Guard unit that bravely fought the Germans in France and Flanders in World War I and were the first unit to cross the Rhine into Germany. For their actions, they received the French Croix de Guerre, a medal awarded to soldiers from allied countries for their bravery in combat. They were assigned to the French Army, trained to use French weapons and wore French helmets, the symbol they later adopted as their official patch.

Their name, or most of it, was bestowed by the enemy—it was the Germans who referred to them as "Hell Fighters." And for more than seventy percent of the unit, Harlem was home. They were the only African-American combat unit serving in what was a racially segregated army. Their bravery was unmatched. They stayed in the trenches for 191 days, longer than any American unit, and suffered 1,400 casualties. Despite their accomplishments, the regiment was led mostly by white officers. The first African-American officer to lead them into battle was James Reese Europe, a composer and bandleader whom Eubie Blake later called "the Martin Luther King of music." The Hellfighters' motto was "God Damn Let's Go!" They never lost a prisoner and never gave back captured ground.

When Iraq's occupation of Kuwait in 1990 brought international condemnation and a decision by the United States to send troops into action, my first thought was about the New Yorkers who would be heading to war and how I could find a way to join them to work on a photo essay documenting their involvement and experiences. I knew that so many people of color fought and died for our country over the years, and I wanted to make sure their stories were represented. As a boy, I heard stories about

the Harlem Hellfighters, now a highly decorated
National Guard transportation unit. I knew it rep-
resented the diversity of New York City. It included
African-Americans, Puerto Ricans and Irish men
and women—a true cross section of the city. They
were a reserve group made up of people who by day
were police officers, sanitation workers, paramedics,
construction workers. Before setting off with them,
I received a crash course on gas attacks and training
for other types of terrorist attacks. To this day I still
secure my hotel rooms with the methods I learned
back then.

Because we were going to Saudi Arabia as our
host country, we were asked to remove all our reli-
gious jewelry. No saints, crosses, or stars allowed.
Everyone complied. On the first day in the desert,
the group was given the job of filling sand bags.
In the raging heat, the men began to take off their
shirts. I had never seen so many religious tattoos!
Their arms, chests and backs were covered in tattoos
of Jesus, the Virgin Mary and other saints. The order
stated no religious jewelry but could do nothing
about their tattoos.

It was amazing to see this group of middle-aged
soldiers, a part of Operation Desert Storm, patrolling
the perimeters near the border of Iraq at night, set-
ting up their tents and cots, then returning to their
duties in the morning. While waiting to go into
action they played dominoes in the camp and made
nervous jokes. I felt like I never left my neighbor-
hood in New York. People were speaking Spanish,
English and some Arabic words. The only thing
missing was the food and street sounds.

The day I realized I was covering the history of
people of color serving their country was the day I
made the image of the Harlem Hellfighters working
in the desert of Saudi Arabia.

—ANGEL FRANCO

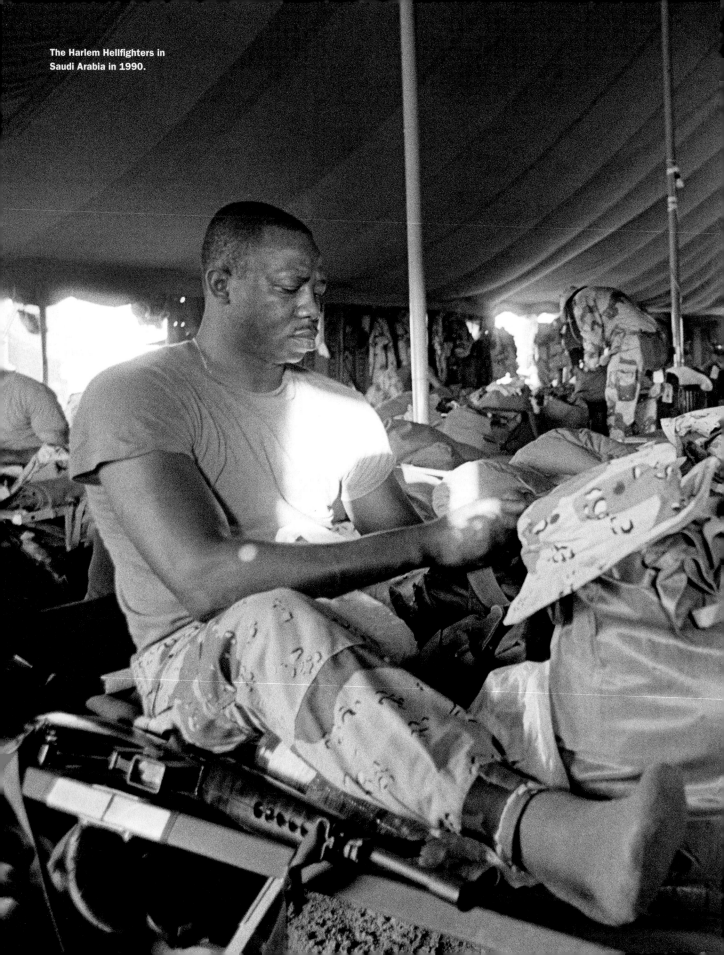

The Harlem Hellfighters in
Saudi Arabia in 1990.

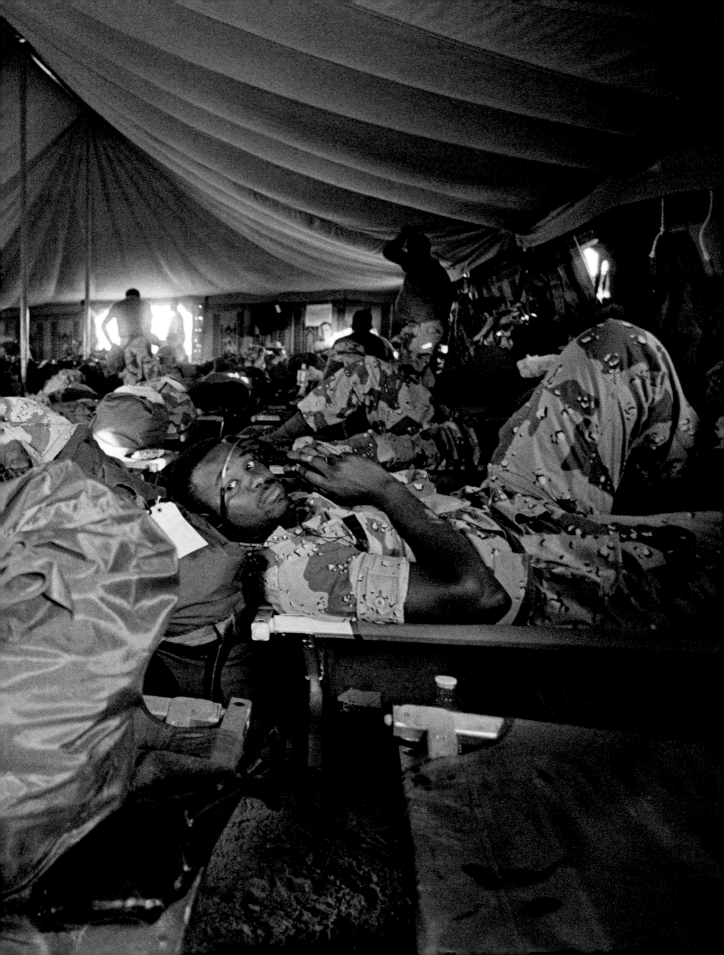

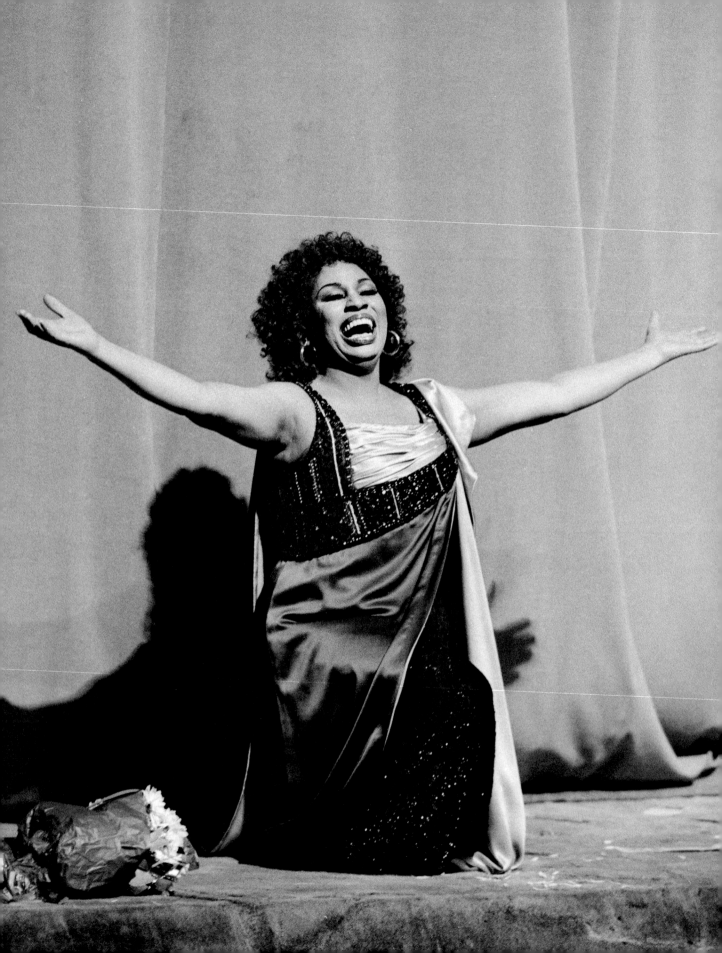

LEONTYNE PRICE SAYS GOODBYE

Leontyne Price was ending her groundbreaking career at the Metropolitan Opera in *Aida*, and *The Times* culture department understood that it was a big deal. It was 1985, early in my career at the paper, and I hadn't gone to more than two or three operas.

My editors wanted a picture in every edition of the paper. Doing so was far more complicated than it is now. The film had to be physically delivered to a darkroom. It needed to be developed, edited, and printed. Every one of these steps took time, and the first deadline was less than an hour after the opera began. So for the very early edition of the paper, I was allowed to shoot from the wings of the stage. That way, I could hand my film to a messenger as soon as I shot it, and he rushed it back to the paper, thirty-three blocks south, where it was processed and published. That picture had to hold the space for the photo of the event they really wanted to capture: Price getting her endless ovation at the end of the opera.

At intermission, I was given a seat on the aisle in the auditorium. It was about fifteen rows back from the stage. I was told that I should run down the aisle and stand at the lip of the stage as soon as the opera was over. The press person instructing me warned that Price had hundreds of fans who had all brought flowers, and that if I let them get ahead of me on that run down the aisle, I would never even see her take a bow. Since I was not really an opera student, I asked how would I know that the end had arrived. I was told that the conductor would never go past eleven p.m. since that would result in overtime pay for the entire orchestra. We set our watches. The final scene featuring Price and her lover dying together in a tomb began. I kept looking at my watch. At twenty seconds before eleven the music seemed to stop.

There was a moment of silence. It felt like an eternity to me. I leapt from my seat and started to run down the aisle with the whole auditorium still in total silence. Did I go too soon? Was I making a fool of myself? I was totally terrified but still making my way down the aisle. I was almost halfway down the aisle when finally the entire auditorium burst into applause. Never have I been so relieved.

After all that, the photo that was selected was of Price with conductor James Levine and another cast member, not the one shown here.

—SARA KRULWICH

AT TWENTY SECONDS BEFORE ELEVEN THE MUSIC SEEMED TO STOP

SHARPTON ON THE STUMP

In this August 15, 1983, photograph, the impeccably dressed Reverend Al Sharpton shakes his index finger at an assembly of younger people brandishing signs and milling about. Sharpton, clad in a three-piece suit and with dark sunglasses accentuating his wavy mane, is clearly the focus of this crowd, but it would still be some time before his face became familiar to readers of *The New York Times* and an emblem of the modern civil rights movement.

Sharpton had called a gathering in front of the Concord Baptist Church in Bedford-Stuyvesant, Brooklyn, to urge residents of black neighborhoods to support Jesse Jackson in his long-shot bid for the Democratic presidential nomination in 1984, but *The Times*, despite sending photographer Don Hogan Charles to record the event, did not run a photo of it. In a telephone conversation, Sharpton recalled that at the time the black political establishment was firmly behind former vice president Walter Mondale because they thought a black, leftist candidate was untenable.

"It was still a far-fetched dream," he said. "Everybody respected Jesse, but some said, 'You're throwing your vote away'" by supporting him.

Sharpton and Jackson had known each other for decades by the time the picture was taken. Sharpton, who began preaching when he was still a child and became an activist soon after, had been youth director of Jackson's Operation Breadbasket. Sharpton had also been the youth director for Shirley Chisholm in 1972 when she became the first black woman to run for a major party's presidential nomination.

Jackson's run was more successful than Chisholm's, marking the next step forward in the incremental march of civil rights. He ran in the primaries on a liberal platform, appealing to what he called a "Rainbow Coalition" comprising many different groups. He finished third in the primaries, losing the nomination to Mondale, who made

history by choosing Geraldine Ferraro as his vice presidential candidate, the first woman to be nominated for the position by a major party.

Jackson gave a rousing speech at the Democratic National Convention that July in San Francisco, calling for action to help the poor in the face of Ronald Reagan's economic policies. It contained the refrain "Our time has come," and ended: "Give me your tired, give me your poor, your huddled masses who yearn to breathe free and come November, there will be a change because our time has come."

The sentiment was premature: Mondale lost the election to Ronald Reagan that November.

Sharpton said that Jackson's bid was not a quixotic historical footnote but rather a learning opportunity that taught him to tone down the language and rhetoric of his protests, "to balance your shock value with making a good, sound argument," so that he could convert a wider group of people.

"I think the Jackson campaign and the energy it generated became the birth of a new movement that got results over time," Sharpton said.

Sharpton would become a national figure in that movement, but not before drawing widespread attention as an outspoken adviser to Tawana Brawley, a black fifteen-year-old who accused four white men of abducting and raping her in 1987 and leaving her wrapped in a trash bag, smeared with feces and scrawled with racial slurs.

Sharpton played a significant part in the case, which highlighted a grave national division in the perception of police and justice in minority communities versus that in white America. He publicly accused an assistant district attorney and a state trooper with committing the crime, called New York governor Mario M. Cuomo a racist, and compared having Brawley speak with state attorney general Robert Abrams to asking a Holocaust survivor to converse with Hitler.

After reviewing thousands of pages of testimony and 180 witnesses, in 1988 a grand jury determined

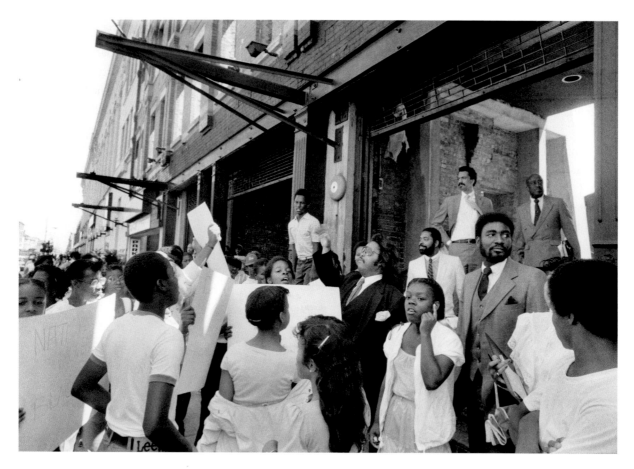

that the case was a hoax. Sharpton, Brawley and her lawyers, C. Vernon Mason and Alton H. Maddox Jr., later lost a defamation lawsuit filed by Steven Pagones, the assistant district attorney they had publicly named.

"Whatever happened, you're dealing with a minor who was missing four days," Sharpton unapologetically told *The New York Times* about the case in 2013. "So it's clear that something wrong happened." Surprisingly, it was not until December 1987, when that case was making headlines, that *The Times* published a photograph of Sharpton for the first time.

After the Brawley affair, Sharpton tempered his public persona, becoming known for pursuing civil rights goals through his National Action Network and high-profile protests after the deaths of Amadou Diallo, Michael Brown, and Trayvon Martin, among others.

"I think that in some ways we made tremendous strides" since those early days campaigning for Jackson, Sharpton said, citing the increase in police body cameras and black executives, and changing racial profiling laws and stop-and-frisk policies.

But, he added, black Americans still face innumerable challenges. "In many ways things have remained the same. We're doubly unemployed, we have the worst health care and the worst reputation. You have to keep fighting."

Sharpton said he took heart from Nelson Mandela, who once told him that "real revolutions are a process, they're not a one-time event" and that "real revolutionaries have to serve for decades and sometimes never live to see the end goal achieved. You have to be a long-distance runner for history rather than a sprinter to make tomorrow's paper."

—Daniel E. Slotnik

SIDNEY POITIER'S WALK ON THE WILDISH SIDE

By the fall of 1967, Sidney Poitier was in the middle of being the biggest movie star in America. *To Sir, With Love* and *In the Heat of the Night* had opened in the spring and summer. *Guess Who's Coming to Dinner* was scheduled for December.

And in the fall he was shooting a romance with Abbey Lincoln called *For Love of Ivy*, about two obnoxious white kids (Beau Bridges and Lauri Peters) who

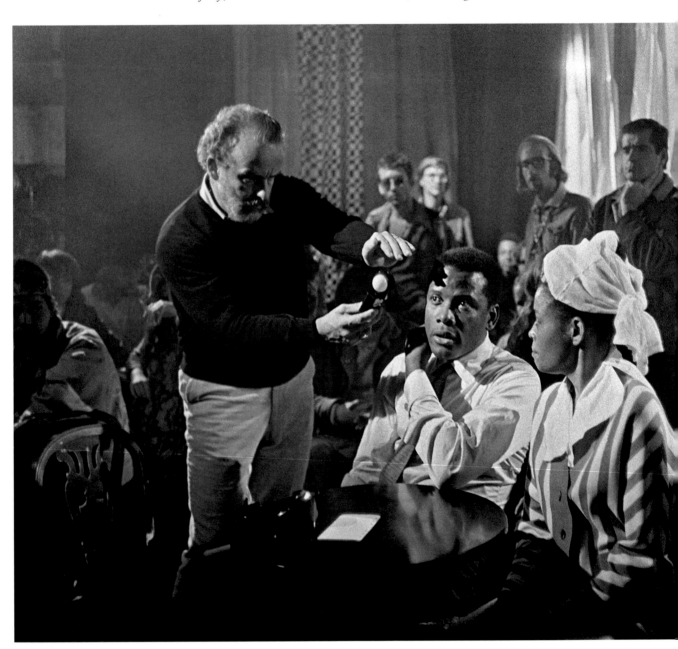

blackmail a black businessman (Poitier) to date their housekeeper, Ivy (Lincoln), so she won't leave the family to live on her own.

Whatever scene is being photographed here in the image doesn't appear in the movie.

The New York Times article that ran without this photo by Ernie Sisto, or any photo, tried to wring some comedy out of hippie wrangling. (It also had to explain to readers that "busted" means arrested.)

The gist of that sequence—Poitier and Lincoln cavorting with doped-up scenesters—does make the final cut, only her dress is red and his jacket never comes off.

Nonetheless, his being there at all is a little absurd, since Poitier's business here in *For Love of Ivy* is an illegal gambling operation, and he's set up to be an establishment square. But he'd been in the movies for more than a decade and a half at that point and was playing with his tidy, no-fuss image. The country was just getting to see him slap down racism as Virgil Tibbs in *The Heat of the Night*, which is as close to black radicalism as he'd come at that point.

Ivy was a walk on the wildish side.

He makes her eat at a Japanese restaurant where the women dress like geishas and feed him with chopsticks (a little kink). They go to a Manhattan club to see some Dada play that he says has been going on for seven months (it's just a gang of people lying around as if they're waiting to get the call to come join the Manson family). Afterward, they dance with those hippies.

That stuff is all pretty embarrassing. But the story was Poitier's idea. He wanted to do something with this movie as head-turning as what he was doing with Virgil Tibbs.

Take Ivy's status as a domestic—or her rejection of it in order to make a life for herself. That feels like a critical metaphor for the history of movies: She tries to leave, and her white employers fear that they won't know who they are without her, that they won't be able to function.

Poitier wanted to show a high-functioning black business world (it was criminal, but it was also classy; I mean, he wore a tuxedo and maintained a fancy white clientele). He wanted to show black romance, too. There's a long sequence between Poitier and Lincoln, the jazz artist who died at 80 in 2010, that culminates with them together in bed.

He was forty at that point, and he'd never been sexier. He'd actually never even gotten to *be* sexy in a movie—and certainly not with a black woman. So you look at that photo now and maybe see a pair of American stars just being beautiful together—just! But back then, the idea of these two making love would have been this close to starting a revolution.

—Wesley Morris

AFTER DETROIT EXPLODED

The photographs here highlight a part of the story but it was difficult to truly capture the anger and despair that led to the Detroit riots that erupted in the dawn hours of July 23, 1967. When the unrest was finally contained after several days of fires, shootings and looting, what became known as the Twelfth Street Riot would be one of the most violent in this country's history.

Tensions between African-American residents of the inner city and the overwhelmingly white local police department had been mounting throughout the summer. The rift reached a boiling point that morning, when officers raided a makeshift after-hours' social club in the heart of the city and arrested more than eighty people. Despite the hour, a crowd gathered outside and steadily grew. Tempers flared, and the rioting that ensued was so intense that 7,000 National Guardsmen, plus Army troops, were called in to help restore order. By then, forty-three people were dead and more than a thousand injured. Still thousands more were arrested as looters ran amok, buildings were destroyed and entire blocks burned. The photographs on these pages of the aftermath show National Guardsmen inside the club—which normally housed a printing company—and a devastated street scene a week after the riots. Both were taken by Sam Falk of *The Times* but were not published.

The city never fully recovered from that ugly chapter in its history. There were nearly four dozen riots and more than a hundred smaller cases of civil unrest in the United States in 1967, but Detroit's were the deadliest, according to *The Times*. A presidential commission later attributed most of the deaths in the Twelfth Street Riot to police officers and National Guardsmen who, in the commission's view, had gone out of control.

—DANA CANEDY

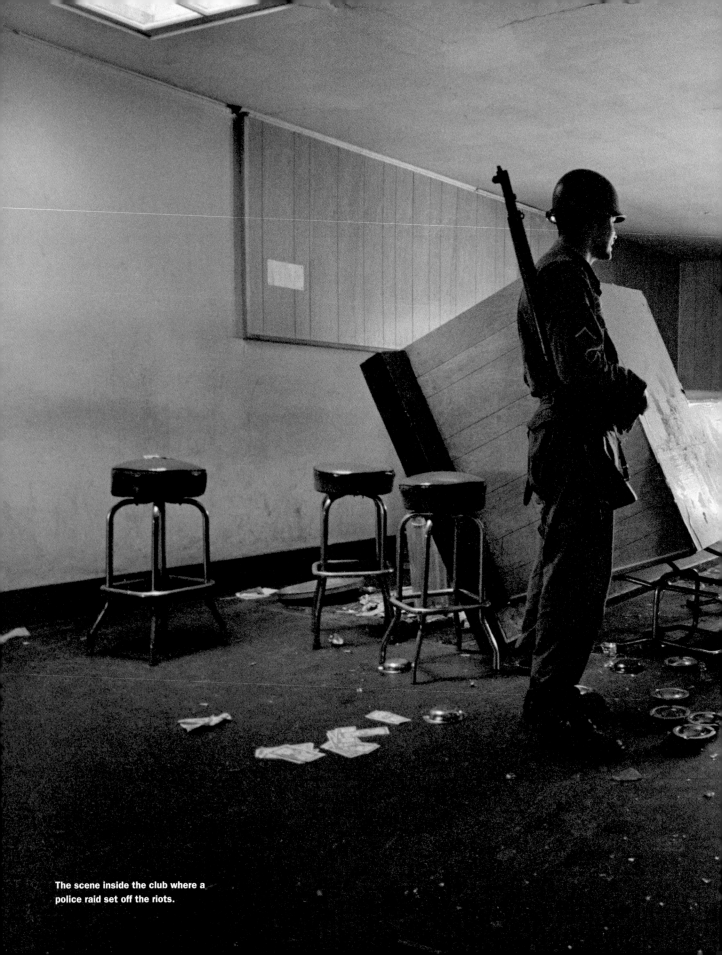

The scene inside the club where a
police raid set off the riots.

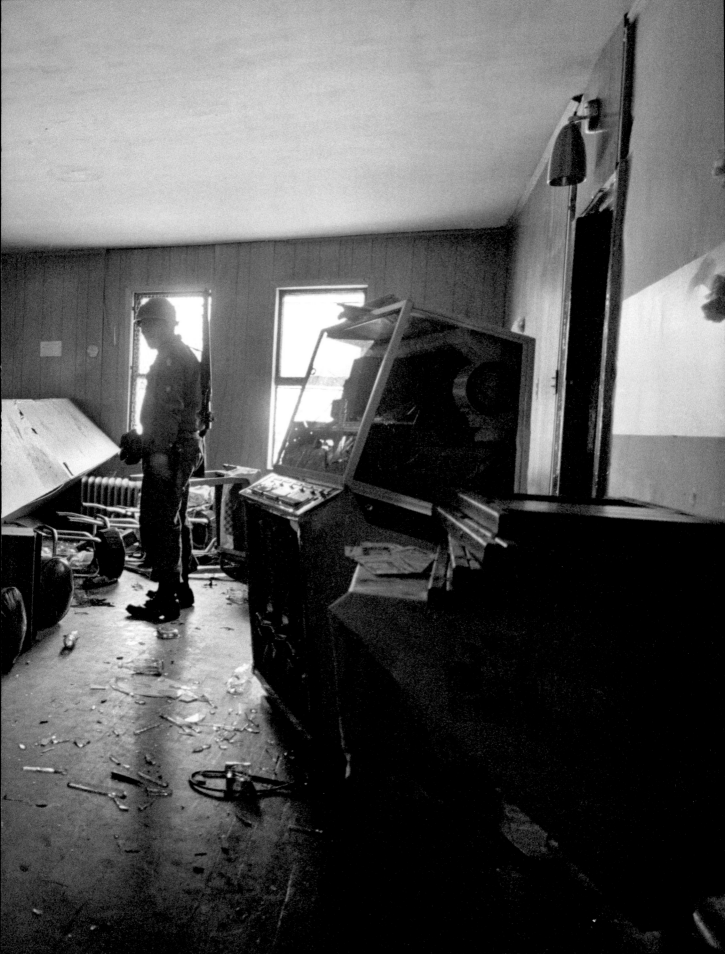

ART IN THE REJECTS: A PHOTO LEFT BEHIND AND MARKED "DESTROY"

The photograph here was taken during a multiday photo shoot by photographer Sam Falk. He was in Detroit just two weeks after the devastating riots that overwhelmed the city in 1967. Falk shot nearly forty rolls of film while documenting the destruction, but one particular roll caught my eye first. A yellowing sleeve of negatives marked with the words "double exposed" and "destroy" was defiantly left with the rest of the film to be discovered fifty years later.

The film, run through the camera twice, was likely a mistake by Falk, who actually had properly exposed frames from the same scenes. The picture is of Viola Mitchell and her four children, who sought emergency housing at the Wayne County Emergency Shelter after the family was left homeless when their apartment was destroyed in the fires.

A HAUNTING AND BEAUTIFUL IMAGE WAS SLATED FOR THE TRASH

Attempts to locate Mitchell were unsuccessful, and her children were never named in the story or in Falk's original caption notes.

The overlaying exposure shows the Bambu Show Bar, which in its prime years of the late 1950s featured Thelonious Monk and John Coltrane, among others.

The bar was located on Twelfth Street, known as "The Strip" or "Sin Street" at the time. Lionel Hampton once described it as a "street where you could get anything." But it was unattributed quotes by local residents in a *Times* article by J. Anthony Lukas that made it clear what it was like to live nearby during the '60s.

"Anything […] pot, horse, numbers, hookers, young girls, young boys. You can get just about anything on Twelfth Street too. It's a street where a black man with a little money in his pocket can go to try and forget he's black."

Another said: "Twelfth Street ain't no slum. Everybody 'round here's got a little money. They ain't got enough though, and that's where the trouble starts."

This haunting and beautiful image was slated for the trash. Yet it tells a story of devastation, hope, struggle, music, poverty, and life in Detroit as well as any *New York Times* story from that era. Double-exposed, maybe, but a work of art for sure.

—DARCY EVELEIGH

THE DUKE AND THE JAZZMOBILE

Sometimes *The Times* misses something—a story in its own backyard, a moment captured by a photographer that just never makes the paper. Maybe it's that there was no room because of too much news. Or maybe the film didn't get sent or developed in time for deadline. Or maybe an editor just didn't see it as all that important.

For whatever reason, this photo by John Sotomayor never made the cut. *The Boston Globe* published a similar image as a free-standing photo, known as a floater, without a story. *The Times* did not write a story, nor publish a photo.

This many years later, we can't know why. But what we can do now is appreciate the elegant swagger and style of the great Edward Kennedy Ellington, better known as Duke. It's hard not to admire his easy presence as he walks offstage after playing at an outdoor concert on a street in Harlem on Sunday, September 6, 1970. It's even harder not to admire the joy he brought to his fans. The man in glasses smiling and clapping with a cigarette in his mouth; the woman screaming and snapping a photo near the back—Sir Duke, American's most important composer, according to jazz historian Ralph J. Gleason, reigned supreme.

—DAMIEN CAVE

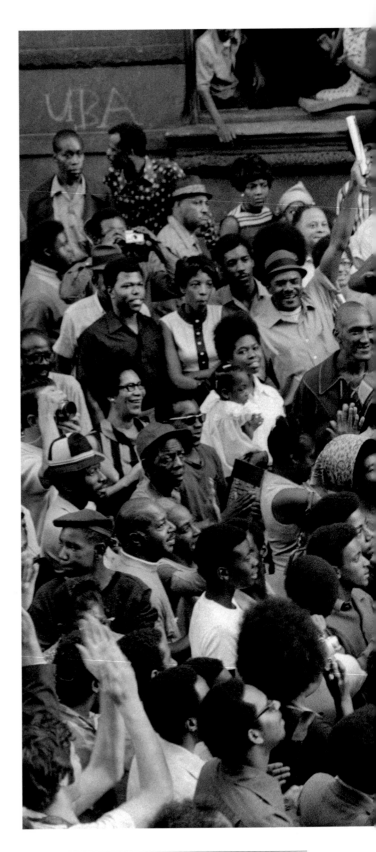

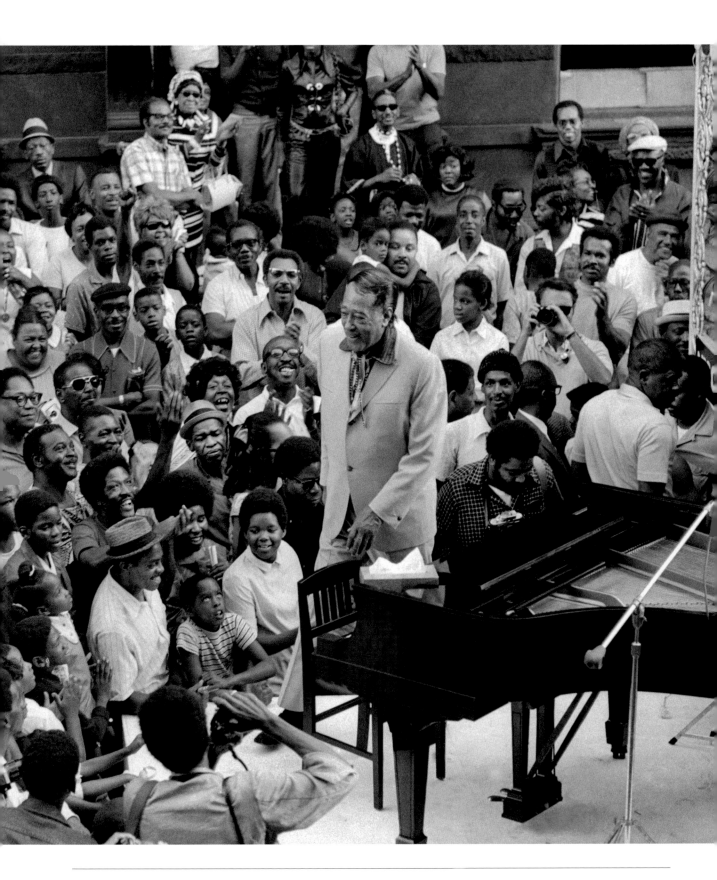

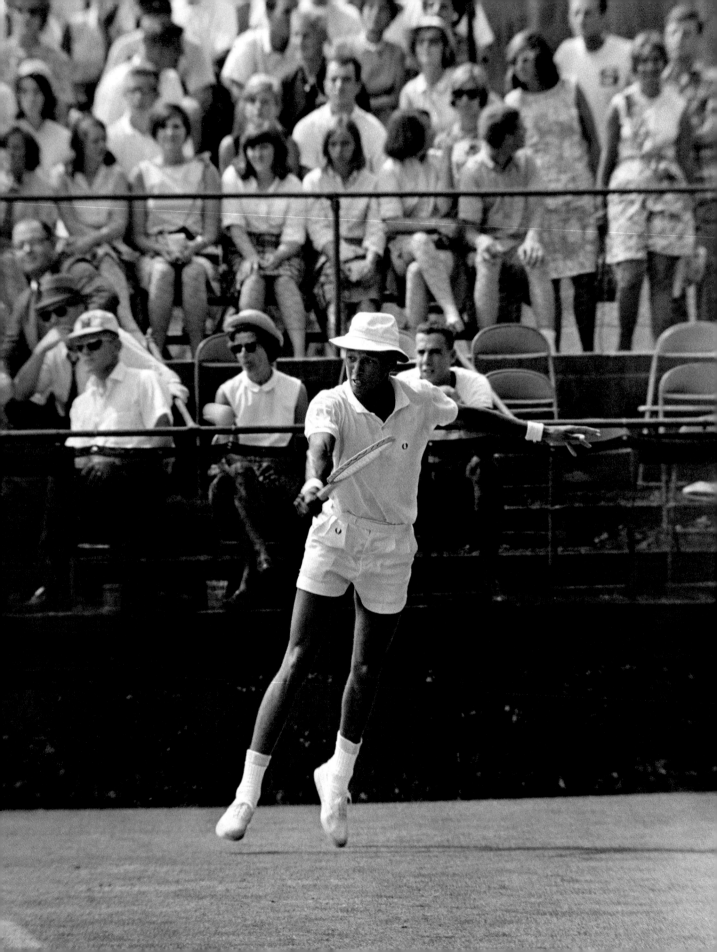

ARTHUR ASHE AND A VICTORY UNSEEN

The twenty-one-year-old upstart toppled the tournament's top-seeded tennis player in a stunning upset on July 30, 1964. We published two photographs of Dennis Ralston, ranked No. 2 in the nation at the time, who walked off the court in defeat. But we didn't run a single photograph of the winner: a young African-American player named Arthur Ashe, shown here, as he played in the quarter-finals of the Eastern Grass Court Championships in South Orange, New Jersey.

Ashe would ultimately become the first black man to win Wimbledon and the United States and Australian Opens. On that day in 1964, he was ranked sixth in the nation and had yet to win a national title. Perhaps that was why we didn't run this photograph. Or perhaps it was because the shots of Ralston were more dramatic, showing him falling to the ground and recovering after missing a return shot. Or perhaps it was hard then for our editors to imagine that the unexpected victory of a promising black player was more than just a lucky break.

Whatever the reason, our photographer, Neal Boenzi, caught Ashe in his element: He is airborne, his arms outstretched, one toe barely touching the ground. After the match, Ashe played down his win, saying that Ralston was tired after playing in several recent tournaments. His opponent thought otherwise. What accounted for Ashe's victory? "Great shots," Ralston said.

—RACHEL L. SWARNS

WE DIDN'T RUN A PHOTOGRAPH OF THE WINNER

Ashe Upsets Ralston and Gains Semi-Finals of Eastern Grass Court Tennis

DAVID DINKINS WATCHES HIMSELF MAKE HISTORY

Chester Higgins Jr., who was there to photograph it, describes the moment in 1989 when David N. Dinkins was just discovering he would win the Democratic nomination, paving the way for him to become New York City's first black mayor.

In the New York City Democratic mayoral primary race against Ed Koch, David Dinkins was always the underdog. Without the support of the city's powerful political establishment, Borough President Dinkins of Manhattan ran a steady and flawless campaign by strengthening his weaknesses, reaching out to all constituents and exploiting the missteps of the Koch administration.

Starting from the beginning of the campaign, I put much effort into gaining the trust of the candidate and his staff so as to obtain access to private moments. As a result, I was the only media photographer allowed to witness Dinkins at the crucial moment when the final primary results were tallied and Mayor Koch conceded.

Having observed that his personal style was more cerebral than emotional, I wasn't at all surprised to watch his family resonate with the emotion of victory, even as Dinkins sat calmly in his campaign hotel room on a sofa amid his excited wife, Joyce, left, daughter Donna and son David Jr. and their families.

Seemingly underwhelmed by his victory, Dinkins showed his characteristic calm, much like deep water.

VOICES RAISED HIGH

When looking at the image of strapping black youths gathered in the atrium of an office center in Lower Manhattan, a viewer can almost hear the stirring music rising from their throats. If the photograph had been in color, a viewer would have been able to appreciate their trademark team jacket, emblazoned with the group's name, the Boys Choir of Harlem.

For more than three decades, the Boys Choir was a cherished local institution with a sterling international reputation. The group performed around the world, offering an eclectic repertory. They sang Mozart in Latin, Bach in German and Cole Porter and Stevie Wonder in English.

This photograph was taken by *New York Times* photographer Angel Franco in December 1986. December was traditionally the group's busiest month, the time its members appeared on television Christmas specials and toured the country's premier concert halls.

Under the leadership of Walter J. Turnbull, its founder and artistic director, the group was formed in 1968 in the basement of a Seventh-day Adventist Church in Harlem and officially incorporated in 1975. The group also operated a school. Most of the choir's 150 members came from low-income, single-parent homes with multiple children and had grown up in one of the roughest neighborhoods in New York.

During its years in existence, the choir sang for kings and presidents and was celebrated for a repertoire that ranged from Handel to spirituals to jazz to pop. But in the early twenty-first century, this one-time symbol of bootstrap success in the ghetto fell on hard times due to financial and managerial scandal, sparked by an accusation by one of the choir of sexual abuse by a member of the staff. Turnbull died in 2007, the year of the group's last official performance, and the choir's life ended officially two years later.

—Constance Rosenblum

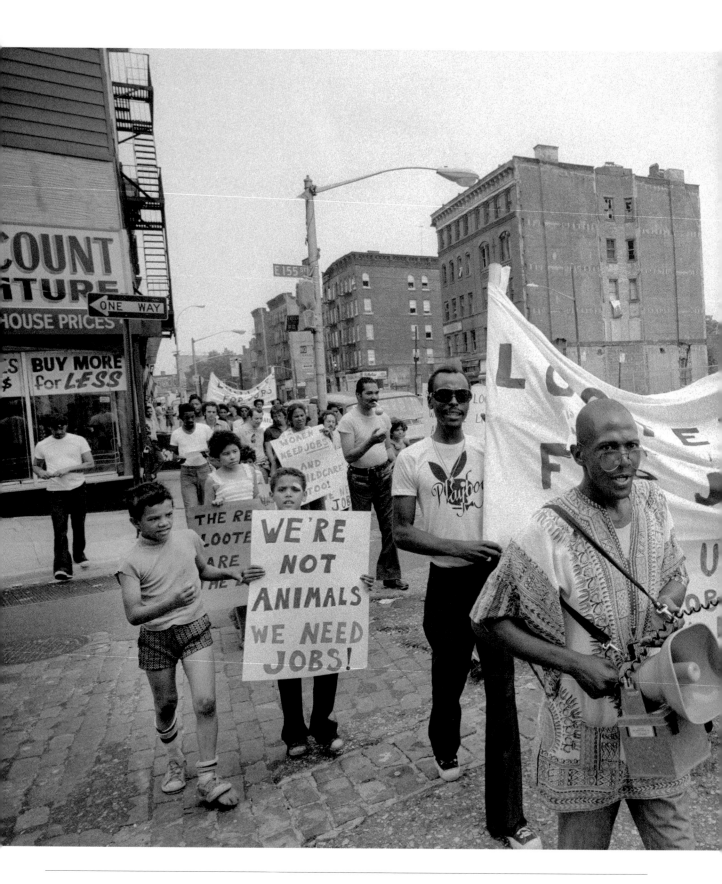

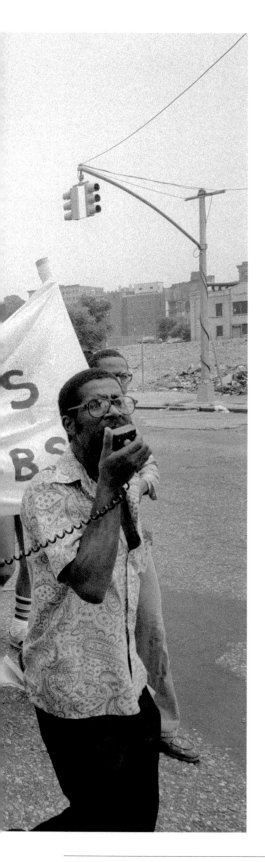

SEEKING JOBS, AND DIGNITY, IN THE SOUTH BRONX

You can look at the desolate Bronx streetscape and think one thing about urban decay. Or you can consider the protesters and begin to understand a more complex history.

The photograph by Tyrone Dukes at left, unpublished until now, appears to have been shot for an article about a program offering 2,000 jobs in the city to clean up debris left from the 1977 blackout that set off widespread looting, rioting and arson fires. The jobs paid $30 a day for up to thirty-three days, *The Times* reported, but there was a catch: "The applicants must not have been looters themselves."

The idea that people wanting cleanup jobs after the blackout had to prove they had not participated in looting might have sounded reasonable to some bureaucrat. And the photograph we ran with the article, showing people signing up, did little to dispel the notion that the program inspired anything but interest and appreciation.

But to many long-suffering residents of places like the South Bronx, East Harlem, or Bushwick, Brooklyn, the proposition was downright offensive.

In the Melrose neighborhood of the South Bronx, where arson and abandonment had already devastated the area, residents were facing a city whose financial straits had left them feeling alone. The idea that they had to prove their moral worth for a job was enough to make them take to the streets, a common sight in a decade when people were unwilling to stay quiet and settle for crumbs. This kind of action—loud and on the streets—helped prompt a grass-roots urban renewal movement there and in other neighborhoods where residents refused to wait for basic city services they deserved.

Almost sixteen years later, Melrose was being rebuilt with new housing and businesses. As they did in the previous era, officials made their plans without really consulting the people who lived there. Once again, residents protested and demanded a seat at the table. This time, officials welcomed them and made them part of the planning process as they designed homes, gardens and other features that gave Melrose a new start.

Today the neighborhood, while still poorer than other parts of the city, is fighting a different kind of problem—gentrification—and activists have landed on a new slogan in their struggle for self-determination: The Bronx is not for sale.

—DAVID GONZALEZ

WALT "CLYDE" FRAZIER MEETS DON HOGAN CHARLES

Even now, it's hard to decide what's more impressive: the Rolls-Royce or those printed pants.

Both belong, of course, to Walt "Clyde" Frazier, one of basketball's greatest stylists on and off the court. Here, it's 1973 and Frazier is posing with Don Hogan Charles, *The New York Times* photographer, but for Clyde, it's the car that really steals the spotlight.

"We was just stylin' and profilin' around the Rolls-Royce," Frazier said in the rhythmic Clyde-speak familiar to Knicks fans everywhere, after being shown the photo for the first time.

He said he bought the car in 1970, after winning his first championship with the New York Knicks. And he definitely deserved it. The Knicks won that year only because Frazier turned in what might be the best game seven performance ever, with thirty-six points, nineteen assists (no, that's not a typo), and seven rebounds.

"The Clydemobile," as the Rolls was known, would go on to be something of a city landmark, traveling on white-walled wheels.

"I was always out and about driving around town, and the Rolls was burgundy and beige," he said. "The sides were burgundy, and the top and hood and trunk was beige. So, I thought it was a slick-looking car."

Frazier was often just as easy to spot. His style—electric in color, matching, often featuring hats and animal prints—has been a trademark for decades. In some ways, he said, it's related to how he was raised in Atlanta, where "you wore your best clothes, because your parents told you you're not only representing your family, but you're representing your race."

Still, as this photo shows, he's up for adding a little extra wattage.

It would be a mistake, though, to see his flamboyance as arrogance. When asked about his accomplishments, Frazier, a longtime television commentator on Knicks games, tends to praise his coaches and his family for teaching him character and respect. Off the court, his colors and cars were bold; in uniform, he was a leader of great composure.

"The greatest thing I've ever done: I played twelve years in the N.B.A., and I never had a technical foul called on me," he said. "You know how that occurred? Because when I was in grade school, high school, college, my coach never allowed me to talk to the ref."

Even now, in Harlem Frazier remains a star who rarely goes anywhere without being recognized. The Rolls is gone, but Clyde said he still feels like an unofficial mayor.

"People stop, blow their horns, wanting to take a picture. It's comical," he said. "I can't really get where I'm going. People are like "Clyde, do you want a picture? Can I give you a ride? Clyde, Clyde, Clyde."

For a guy who was the oldest of nine kids and said he only wanted to be an athlete to help fulfill his mother's dream of a house with a big kitchen, he said it's still a bit overwhelming.

"I haven't played in over thirty-five years," he said. "The adulation and respect that people show me is very humbling."

—Damien Cave and Joshua Barone

EASTER IN HARLEM

Ladies in lovely lavender hats. Young girls in lace and patent leather. Men in pinstripes and even tails. Easter in Harlem has long been its own sort of parade.

Although *The New York Times* annually covers the Easter Sunday parade on Fifth Avenue, it has only occasionally photographed the day that is captured in the pictures on the page opposite and on the next four pages.

Yet Harlem, with its historic black churches and restaurants, draws busloads of tourists from around the world seeking to experience worship services and soul food suppers that occur every Sunday. But they are never more alluring than on Easter Sunday, when Harlem is at its most splendid.

Indeed, Easter Sunday in Harlem, as elsewhere, is primarily a day of worship and reflection. But make no mistake, it is also unabashedly about seeing and being seen.

The outfits, bold and original, have historically hinted at emerging fashion trends. Some years the spring colors were muted and the emphasis was on elaborately constructed hats. Some seasons, silk was in; others, it was linen.

One constant, however, is that finding a seat on a pew or an open table at a local restaurant can be as hard as hunting for a dyed egg hidden in Marcus Garvey Park.

—Dana Canedy

BUT MAKE NO MISTAKE, IT IS ALSO UNABASHEDLY ABOUT SEEING AND BEING SEEN

Chester Higgins Jr., 1977

Chester Higgins Jr., 1977

Chester Higgins Jr., 1977

GORDON PARKS AT HOME

Gordon Parks, the first black photographer for *Life* magazine and one of the most acclaimed photographers of the twentieth century, worked as a Pullman porter in the mid-1930s, making beds, shining shoes and carrying other people's luggage on long-distance railroad cars. Just a few years later, he made his iconic "American Gothic," an image of government worker Ella Watson whose mop and broom symbolized the oppression of working-class black Americans.

Using a camera as his self-proclaimed "weapon of choice," Parks went on to document in the pages of *Life* the effects of race and class in America. He chronicled African-American experiences from an extended family living under segregation in the Jim Crow South to Malcolm X, Martin Luther King Jr. and the Black Panthers. He covered a wide range of other assignments—and was also a gifted fashion photographer with a keen eye for elegance.

Parks traveled the world and treated everyone he photographed with dignity and respect. But he provided particular insight to the experience of

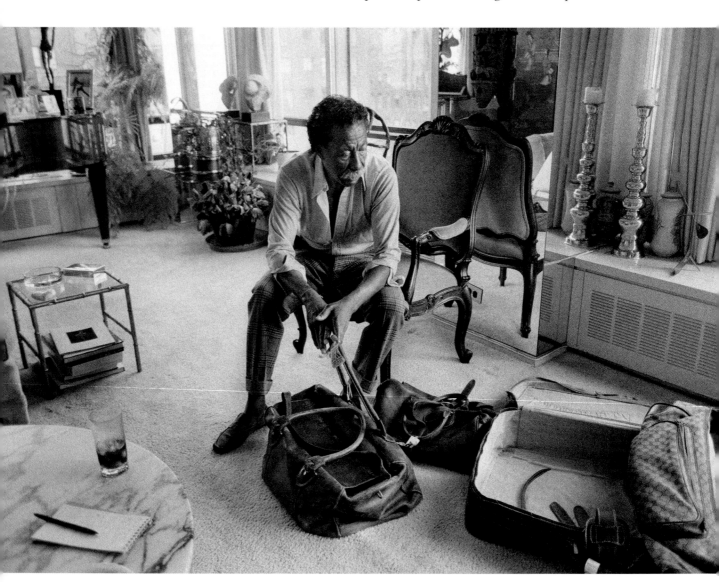

African-Americans by presenting them as real people rather than as anonymous symbols of poverty or racism, which had been typical of mainstream media outlets.

In 1969, Parks wrote and directed *The Learning Tree*, a semiautobiographical coming-of-age film based on his 1964 novel about a young black man in rural Kansas in the 1920s and 1930s. *The Learning Tree* was the first Hollywood film directed by an African-American and in 1989 was selected for inclusion in the National Film Registry by the Library of Congress. Two years later, Parks directed *Shaft*, a highly successful commercial film that introduced Hollywood to the black action hero. The movie won both Grammy and Academy Awards and was also selected for inclusion in the National Film Registry. Parks, who died in 2006, also wrote three memoirs and several novels.

Born in the segregated city of Fort Scott, Kansas, in 1912, Parks grew up poor, the fifteenth child of a tenant farmer, Jackson Parks, and his wife, Sarah, a maid.

In 1976, he was living in a high-rise apartment on Manhattan's Upper East Side. It was there that recently-hired *Times* staff photographer Chester Higgins Jr. was sent to shoot a picture of Parks, and his luggage, to accompany an article describing how famous New Yorkers approached packing while traveling.

"Visiting Gordon at home meant walking into a combination museum and a working library," Higgins wrote in a remembrance of Parks in 2006. "All of the walls were covered with large photographs. The bookshelves were full of his many novels, translated into various languages; his dining table was crowded with stacks of papers here and there; his coffee table filled with his picture books and the piano, near a window, with music sheets with his freshly written notes. Every end table held piles of medals and awards. The entire space, with light flooding in through wrap-around floor to ceiling windows, had a commanding view of the East River."

For some reason, this photograph was never used. But the fluffy feature assignment was not the first time that Higgins had visited the apartment. As a young freelancer a few years earlier, he had sought out Parks for advice on how to succeed in magazines and newspapers as an African-American photographer.

Higgins said he learned "the possibility of doing what I wanted to do because Gordon did it so well."

"Gordon told me that it is important to become well-rounded in all of the finer things in life and art," Higgins said not long ago. "Go to good theater, read good books. Take it all in."

The story ran under the headline "The Art of Packing: It's Lost on Some" and included tips from Nan Kempner, Eileen and Jerry Ford, Mike Wallace and other New York celebrities. In it, the reader learns that Parks's Gucci bags were made in Italy to his own specifications and that he always packed a tennis racket, as well as his suits, shirts, ties, shoes, writing materials, manuscripts and business papers. In winter, we are told, there's an additional bag for ski clothes.

A man who once carried the bags of white passengers as a porter was now gracing the pages of *The Times* with custom-made luggage that he brought around the world.

—JAMES ESTRIN

NINA SIMONE ENDURES ANDY STROUD

Nina Simone has always been unforgettable, known for her strength and independence as a singer and as an outspoken black woman who left the United States in the early 1970s because she said she couldn't tolerate a racial situation that she called "worse than ever."

But it was a long and difficult road to idol status. While strong on stage and in recordings, in her autobiography, *I Put a Spell on You*, Simone revealed herself to be vulnerable and sensitive. As her career took off in the late 1950s, early '60s, she didn't have a manager. She didn't have time to step back and think, averaging five shows a week for more than a year.

Then she met Andrew Stroud, the man pointing, demanding, in this photo. He was a New York City police detective who always carried a gun, and initially she said he made her feel safe. "He had a strong and solid air about him," she wrote, "that made you think 'Well, maybe . . . '"

They married in 1961, and he became her manager. This photo was taken by Sam Falk in New York in 1965. A few years later, their marriage fell apart, leading to accusations of abuse lodged against Stroud; their daughter, Lisa, also later said her mother appeared to be bipolar and could also be abusive.

Simone lamented the loss, noting that she wanted more from Stroud that he had been prepared to give, even though he was thoroughly involved in every aspect of her life. "Andy was wrapped around me like a snake," she wrote, "and there was no part of what I did that he didn't know about or influence."

It was clearly a complicated relationship. She would eventually call it suffocating. This photo seems to show a bit of what that meant. She wrote at one point: "Sitting in my dressing room with my back to the door I knew the moment Andy came in even if I couldn't see him, because I felt his personality around me."

—DAMIEN CAVE

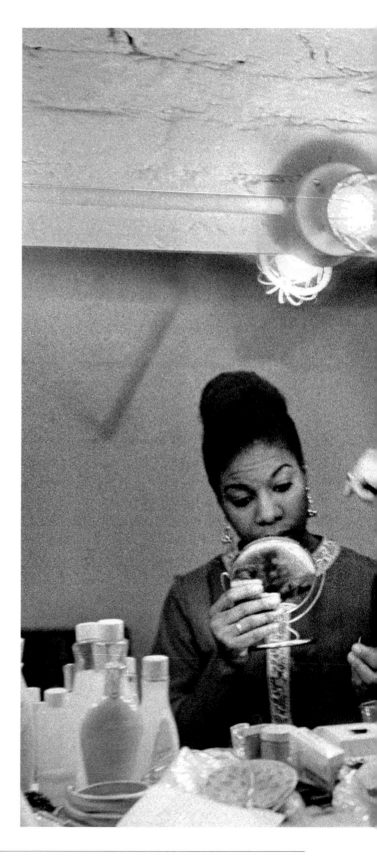

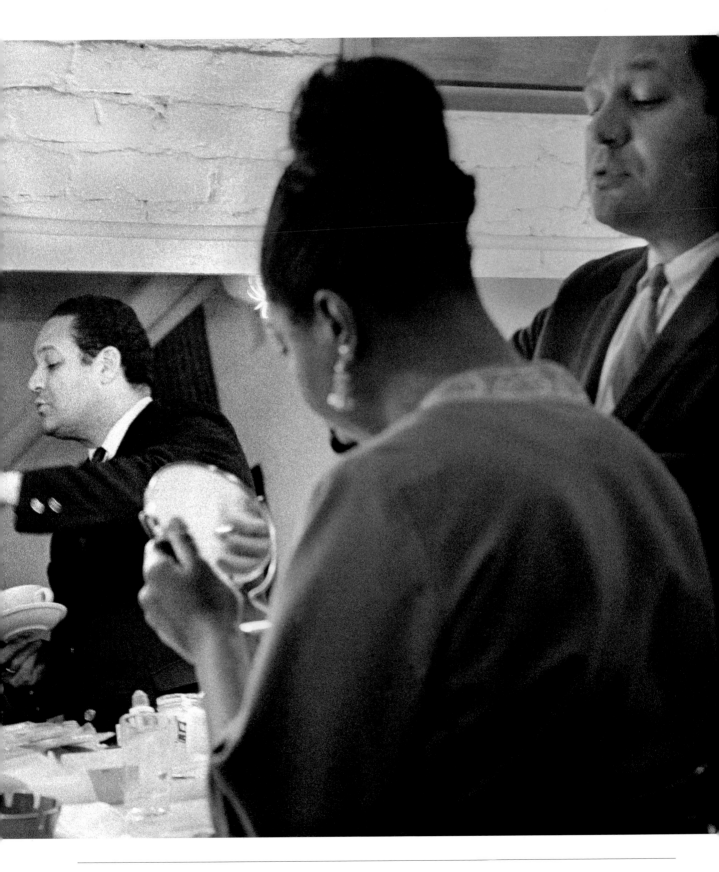

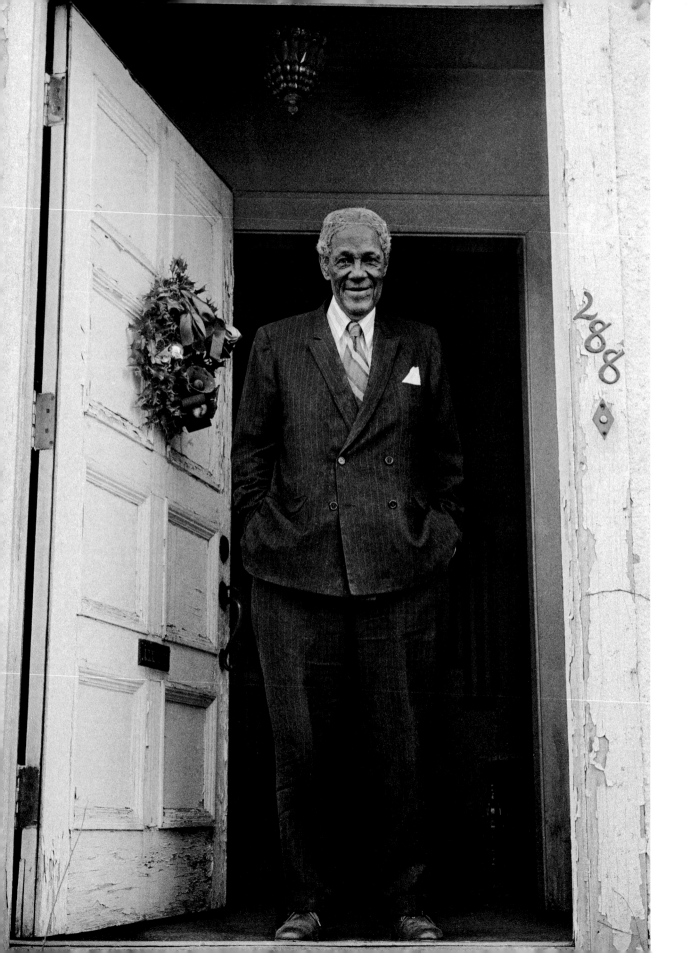

FRITZ POLLARD IN THE DOORWAY

Sometimes history lives in the house at the corner. That was the case for the neighbors of Fritz Pollard, who was well into his eighties when this picture was taken in the doorway of his home in New Rochelle, New York, in 1978.

Who was that older gentleman, so quiet and regal? Frederick Douglass Pollard, known as Fritz, was a football pioneer. He was the first black player to play in the Rose Bowl; the first black halfback to become an All-American at Brown University in 1916.

His professional career was groundbreaking. He joined the Akron Pros in 1919 in a league that became the N.F.L. in 1920, when Pollard led them to the title, on a team that also featured Paul Robeson. Together, Pollard said, they made up half the black players in the league. And neither was welcomed.

"Akron was a factory town and they had some prejudiced people there," Pollard told *The Times*, with characteristic understatement. In fact, the fans regularly shouted racist insults. He had to get dressed for the games at the team owner's cigar store or in his car. At only five feet nine inches and 165 pounds, he had to roll over and cock his feet, ready to kick opposing players thinking of piling on.

Still, despite all that, he became known as a leader with ideas about how to play and win. In 1921, he was Akron's best player and the team's head coach—the first black head coach in the league. He then coached the Pros of Hammond, Indiana, from 1923 through 1925 before returning to Akron.

Some of this was described in *The Times* profile for which this photograph was taken; and again when he died at the age of ninety-two. At the time, Pollard was still a footnote (he was only inducted into the Pro Hall of Fame in 2005), and the images that accompanied *The Times*'s stories were more traditional newspaper headshots, with Pollard inside his home.

Now, the grace and calm in this portrait by Joyce Dopkeen somehow seem more appropriate, and more revealing.

—Damien Cave

WHO WAS THE OLDER GENTLEMAN, SO QUIET AND REGAL?

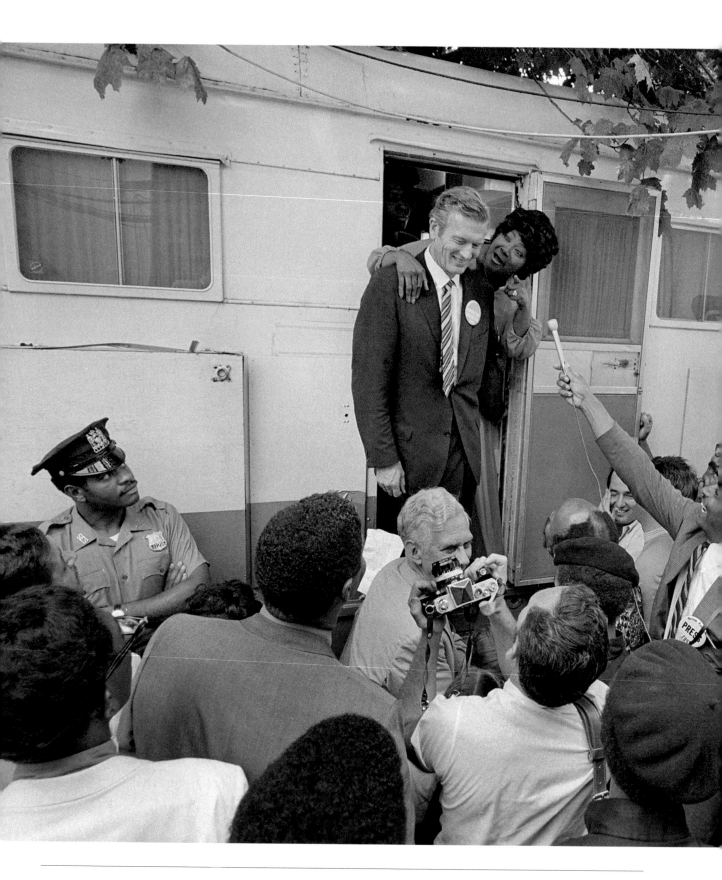

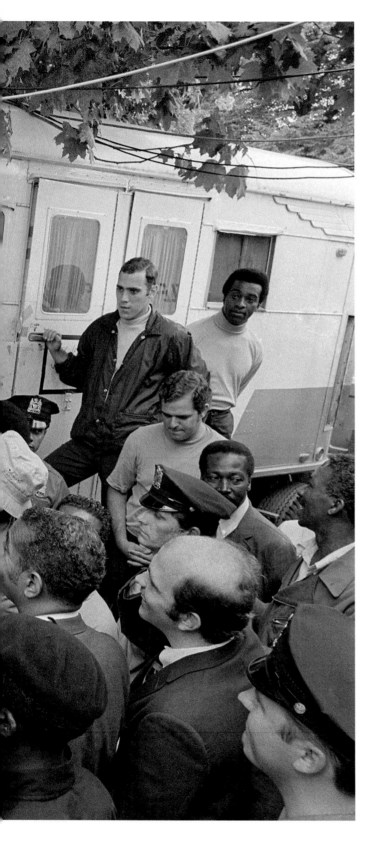

THE GOSPEL SINGER AND THE MAYOR

Photo editing is always more art than science, and the text and importance of an article shape the decisions about which images are published. Often, that makes sense. Sometimes, though, that means great photos like this one remain hidden for decades.

In this case, the photo of the gospel singer Mahalia Jackson and New York City Mayor John V. Lindsay was taken by Donal F. Holway of *The Times* for an article that ran on page thirty-two of the paper on July 14, 1969, under the headline "15,000 Attend 'Gospel Festival' in Rain in Harlem Park." And that headline seemed to guide the photo editing because the published photo that day focused primarily on one thing: the size of the crowd.

As a result, readers missed out on learning about a fascinating political encounter. At the time, Lindsay was seeking reelection and struggling, after labor strikes and intense racial tensions that followed the assassination of the Reverend Dr. Martin Luther King Jr. in 1968.

He joined Jackson in her trailer at the event because he was seeking her endorsement. For the online version of the project that led to this book, we asked readers what they saw in this image. They assumed that the white politician was helping the black woman, but in fact it was the opposite: He was the one who needed her.

After the meeting, they left the trailer together, and he was smiling for a good reason. She happily announced to fans and reporters, "We're really going to go for him."

The unpublished photo of Jackson and Lindsay showed chemistry. It captured an important moment. There was a story behind the scenes as an opportunistic mayor sought votes with help from a black celebrity.

And yet, the image sat in our archives for decades without seeing the light of day.

—DAMIEN CAVE

HELPING BLACK VOICES BE RAISED ONSTAGE

Michael Schultz, seated, staff director of the legendary Negro Ensemble Company, and the playwright Douglas Turner Ward, the company's founder and artistic director, were captured by *New York Times* photographer Eddie Hausner in December 1971 as they discussed the set design of *The Sty of the Blind Pig*, at the St. Mark's Playhouse on lower Second Avenue, the company's longtime home.

Of the play, about the bitter yet loving relationship between a mother and a daughter set in Chicago in the early 1960s, *New York Times* theater critic Clive Barnes wrote, "What the playwright is trying to show here is a picture of America at a time of enormous change and the way those changes affect black America."

The company was founded in 1967, an era in which, as *Times* critic Mel Gussow noted in the article for which this photograph was taken, "blacks were called Negroes and 'Negro theater' was still something of a cultural oddity." Black playwrights and performers struggled, generally without success, to make their voices heard, and realistic theatrical depictions of black life were virtually nonexistent. By 1971, Gussow wrote in the same article, the Negro Ensemble Company had emerged as "one of the cornerstones of the flourishing black theater movement, a movement it has nurtured with its talents."

THE COMPANY WAS RUN BY AND FOR BLACK PEOPLE

Run by and for black people, the company presented plays that dealt with often ignored aspects of the black experience. Many of the more than 200 works it produced were critically acclaimed and represented some of the most important theatrical work of the time. In the 1972–73 season, it presented Joseph A. Walker's drama *The River Niger*, about the struggles of a black family from Harlem in the 1970s, which was the first N.E.C. production to move to Broadway, where it went on to win the Tony Award for best play. In 1981 the company presented Charles Fuller's *A Soldier's Play*, the gripping tale of the travails of a black soldier, which won the Pulitzer Prize for drama.

—Constance Rosenblum

A CURBSIDE SERMON FROM REVEREND WYATT TEE WALKER

The Reverend Wyatt Tee Walker served as chief of staff for the Reverend Dr. Martin Luther King Jr. from 1960 to 1964 and spent nearly four decades as the pastor of Canaan Baptist Church of Christ in Harlem. In this photo by Michael Evans, from April 5, 1970, he is taking his message to the streets. Although it perfectly captures the urgency of his fight against drug dealers and addiction, our article the next day did not include this photo, or any other. Damien Cave spoke to Walker about the unpublished image and the role of the faith community.

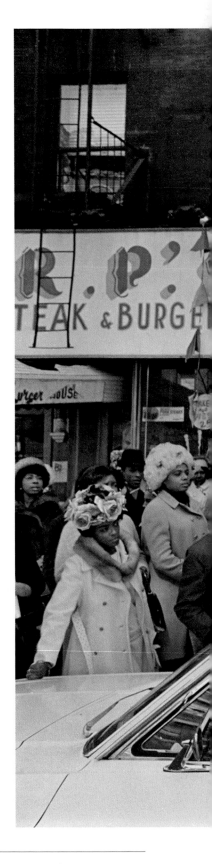

I was at the height of my prime, at 116th Street in Harlem, and we had a big problem with drug trafficking and our kids. They'd be recruited for drugs, then come to the community centers under the auspices of the church.

That picture was taken when I was talking to the parents of the children.

It was an ongoing movement—some several months. I guess we had a couple hundred people that day. It was after the morning service at the church. I spoke for thirty, forty-five minutes, not too long because people wanted to get to dinner.

We worked with different faiths, different groups. It was mouth to mouth in the community. We wanted our children to have a choice that was better than drugs.

They were the people I recruited to fight the drug trafficking. It was so rampant.

That's why Frank Lucas—you remember that movie, *American Gangster?*—put a hit out on me, because I was effectively thwarting the drug traffic.

I had been threatened before. It didn't bother me. I was convinced that God would take care of me.

The police, I think they were overwhelmed. The 28th Precinct, where our church was situated, was one of the worst drug centers in New York City. You couldn't buy aspirin, but you could buy any kind of drug.

There was some talk that the police were involved in the drug traffic. I can't say that myself, but people said the police were being paid by the drug traffickers.

We just felt they weren't doing anything about it. I guess we felt abandoned. Our children were at risk. That's why we were so mobilized.

That photo, now, it reminds me of the times that I did things over and beyond what was good sense.

They were always warning me that it was dangerous, but that didn't stop me. I had been involved in the struggle in the Deep South, so I was accustomed to dangerous situations. It was tough to frighten me because I was so convinced that God would take care of me.

My basic faith was in the Lord. We were doing the right thing at the right time.

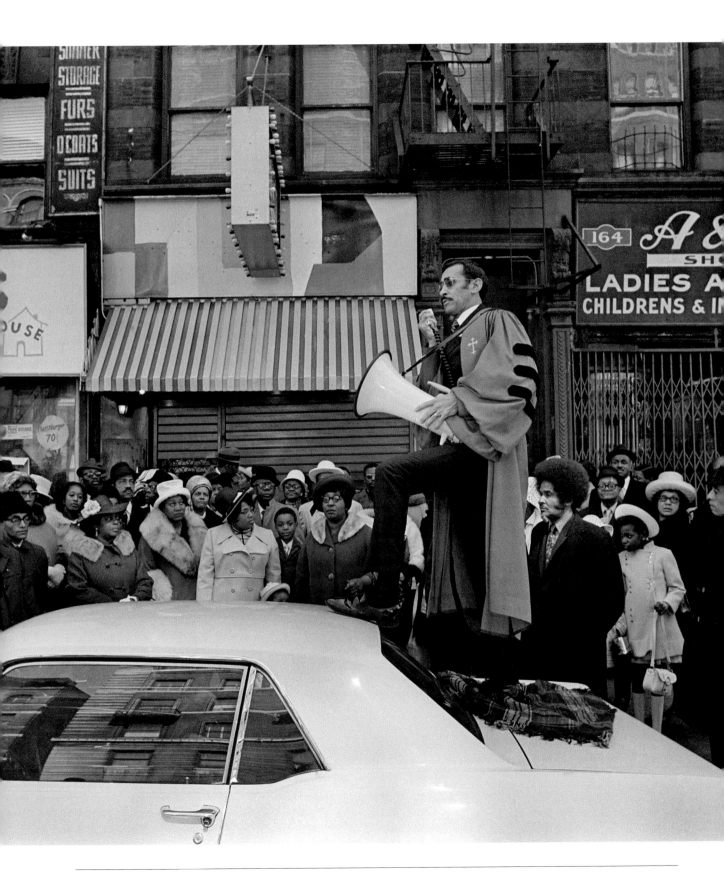

A CRIME SCENE TURNS INTO A MEMORIAL TO MARTIN LUTHER KING JR.

Less than two weeks before George Tames took this photograph in 1968, the hotel balcony he captured was full of life. The Reverend Dr. Martin Luther King Jr. was making plans for dinner and discussing music for a coming meeting, requesting "Take My Hand, Precious Lord."

Then came gunfire. King fell. He was pronounced dead an hour later.

Absence is a story that's never easy to tell, in word or image. News photography in particular thrives on drama, and so it is hardly a surprise that the most memorable images of King's death come from just after he was shot in Memphis on the evening of April 4, 1968.

Now, though, this one takes on more meaning. Like the civil rights museum that now occupies the old Lorraine Motel where he was shot, a small and intimate memorial in its own right, the image demands contemplation.

Pit-of-the-stomach grief, for King and for the country, is hard to avoid if you move between this image and the one of King lying on his back and dying, which has come to define the event.

Returning to *The Times*'s coverage of the day means experiencing other forms of remembrance: images of King praying, and in prison; photographs of mourners and relatives.

A single picture on April 5 showed the motel, with two police officers blocking the door of King's room. It was still a crime scene then, with "dismay, anger and foreboding" expressed by leaders across the country, a *Times* headline reported.

By the next day, the mood had darkened. The front page seemed to shout: "Army Troops in Capital as Negroes Riot; Guard Sent into Chicago, Detroit, Boston; Johnson Asks a Joint Session of Congress."

The time for quiet sorrow either had passed, or would need to be postponed.

Tames found his own way to make it happen. He was twenty-three years into his *Times* career by that point, a regular on Capitol Hill (he died in 1994 at the age of seventy-five) best known for the portrait of President John F. Kennedy, showing him as a silhouette, leaning on his desk in the Oval Office and appearing burdened by the weight of his job.

But after King died, Tames made his way to Memphis. He shot his photo of the balcony eleven days after the assassination.

As the country continued to shudder, facing racial unrest, and uncertainty about whether the civil rights bill would pass, Tames found a quiet moment of nonviolence and mourning. He saw absence. Loss. Contemplation.

Snap. He got it. Maybe not for the front page, but for history.

No one outside his circle saw it. Until now.

—Damien Cave

EPILOGUE: CONTINUING KING'S MISSION

It was May 12, 1968, just one month after a bullet silenced the Reverend Dr. Martin Luther King Jr., and thousands of people were pouring into the streets.

Coretta Scott King, King's widow, had called on Americans to join her in "a campaign of conscience" to uplift the poor. A picture from a news agency, which accompanied *The Times* article about her campaign, captured the scene from a distance, offering a wide view of the crowd in the nation's capital.

Our staff photographer Don Hogan Charles took a different approach. He got close. He zoomed in. He focused on the individuals, not the multitudes, who gathered for the Newark leg of the demonstration. His image, not published at the time, invites us to linger and to examine the faces.

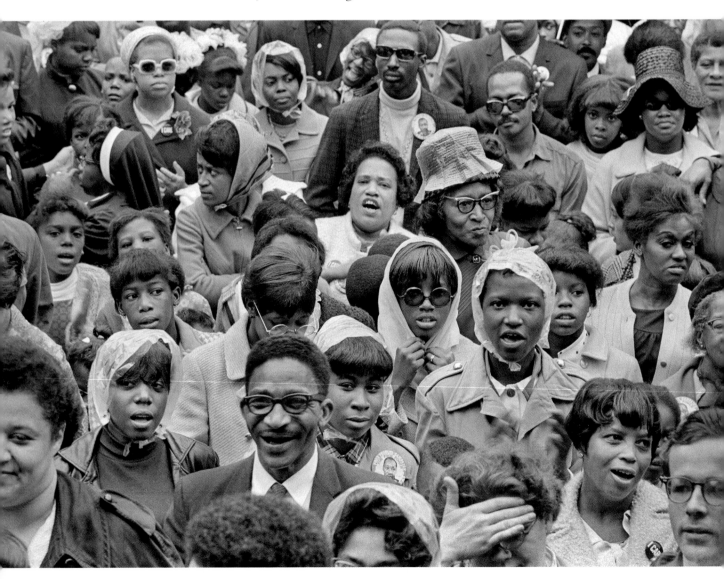

Some seem hopeful, introspective, and serene. Some look joyful and expectant. They are mostly women. (Coretta King had called on "black women, white women, brown women and red women" to prod Congress to increase spending on poverty programs.) But there are men and children, too, people with lives and stories of their own, who decided to try to make a difference that day.

The rare collection of photographs in this book captures dozens of powerful unpublished moments like this one. And we hope that these images will continue to inspire conversations about history and its resonance in our modern-day lives.

Reflecting on history allows us to reminisce about where we've been. But it also helps us to understand the present, offering an at times painful reminder of how far we have yet to go.

REFLECTING ON HISTORY HELPS US TO UNDERSTAND THE PRESENT

Among those hopeful faces in that crowd in Newark, there were also expressions of doubt, uncertainty, and anger, feelings that reverberate in the protests of our time, over income inequality, racism on college campuses, and the killings of unarmed African-Americans by the police. Voters elected the nation's first African-American president in 2008, a milestone in our history. But many Americans say the struggle for racial justice is far from over.

We remain keenly aware that this collection is incomplete. A vast trove of photographs remains unpublished in our archives. Many important people and moments in black history were never photographed by our staff photographers, partly because the staff was small and partly because we emphasized words over pictures. We also know that the gaps probably reflect the racial biases of some of our editors at the time.

But there is opportunity in that absence. Just as we have begun unearthing these photographs, many archives, museums, and ordinary people are also bringing new images and documents to light, illuminating events, communities, and individuals who were long forgotten.

The search to recover lost chapters in the African-American story is vital, thrilling, and ongoing. So as you peruse these final pages, we hope that you will see this collection as we do: as a beginning.

—RACHEL L. SWARNS

PHOTOGRAPHERS

Michelle V. Agins
Allyn Baum
Neal Boenzi *(1)*
Arthur Brower *(2)*
Patrick A. Burns
Don Hogan Charles *(3)*
Suzanne DeChillo
Joyce Dopkeen
Tyrone Dukes *(4)*
James Estrin
Michael Evans *(5)*
Sam Falk *(6)*
Angel Franco *(7)*
Carl T. Gossett Jr.
Eddie Hausner *(8)*
Chester Higgins Jr. *(9)*

Donal F. Holway
Thomas A. Johnson *(10)*
Sara Krulwich *(11)*
Chang W. Lee
Meyer Liebowitz
Jack Manning *(12)*
Keith Meyers
Larry C. Morris
Ozier Muhammad *(13)*
John Orris
Librado Romero *(14)*
William E. Sauro *(15)*
Gary Settle *(16)*
Barton Silverman *(17)*
Ernie Sisto *(18)*
Claude Sitton *(19)*

John Sotomayor
George Tames *(20)*
Robert T. Walker *(21)*
Ruby Washington
Jim Wilson *(22)*
Marilynn K. Yee

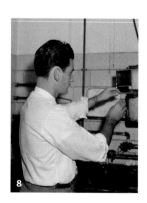

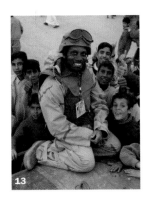

CONTRIBUTORS

Joshua Barone
Suzanne DeChillo
James Estrin
Jim Farber
David Gonzalez
Angel Franco

Nikole Hannah-Jones
Chester Higgins Jr.
Sara Krulwich
Vincent Mallozzi
Wesley Morris
Ozier Muhammad

Ben Ratliff
Librado Romero
Constance Rosenblum
Giovanni Russonello
Jay Schreiber
Sandra M. Stevenson

Daniel E. Slotnik
David Stout
Anthony Tommasini
Jim Wilson
Earl Wilson

ACKNOWLEDGMENTS

Our thanks first to *The New York Times* photographers for the incredible breadth of talent on display in this book. The men and women who took these pictures did so with heart and believed in the power of great imagery. It is long overdue that this work receives the attention and recognition it deserves.

Thanks also to Alexander Spangher, data scientist and Daniel Simpson, former manager of diversity at *The Times* who first asked the question "Is there something in *The New York Times* archives that would be of interest to African-American readers?"

To Arthur Sulzberger Jr., *Times* publisher, Dean Baquet, executive editor, and Janet Elder, deputy managing editor, for giving Dana Canedy and me the green light to embark on the project.

To national editor Marc Lacey for mentoring and guiding us through the early stages of the idea. It was Marc's suggestion to add Rachel Swarns and Damien Cave to the team, which elevated the series to a new level. The project probably would have been just a slide show without Marc's contributions.

To Aaron Krolik, interactive news developer, for building a fantastic digital presentation and assisting us in producing the series for the web.

To *The Times* image support group, who brought artistry to the technical craft of digital restoration and preservation. In the process of this project and others they continue to diligently catalog history for future generations. William O'Donnell led the team of Sonny Figueroa, Alessandra Montalto, Patricia Wall and James Nieves, who also contributed visual ideas and searched the archives with as much passion and interest as the writers.

To Jeff Roth, *The Times* archivist, for his guidance and assistance in research. This was hard. You made it fun.

To Carla Murphy, our research assistant, for laying the groundwork with our living subjects. Carla convinced nearly everyone she spoke to that this was an important opportunity to finally have their story told. Her impeccable notes and detailed fact sheets were the backbone of nearly everything we wrote.

To the subjects depicted in this book who so willingly shared their experiences. Each time one of you agreed to speak with us there was a flurry of giddy excitement that kept the energy level high and encouraged us to keep going.

To copy editor Chris Plourde, for his meticulous attention to detail during the initial presentation of this series.

To *Times* researcher Susan Beachy for helping us uncover the Grady O'Cummings erroneous obituary.

To our contributing writers, whose enthusiasm was contagious. This was a true collaboration of friends and colleagues who were passionate about an idea and enjoyed every second of producing it.

To Lisa Tenaglia and J.P. Leventhal at Black Dog & Leventhal, thank you for believing in this book from the start. Lisa, you kept us organized, on track and focused. We imagine it is difficult dealing with one author. You had four. You are a saint.

To Melanie Gold, the managing editor for the book at Black Dog, for coordinating and arranging everything behind the scenes, allowing us to focus on the big picture.

To Elizabeth Van Itallie, interior book designer, and Amanda Kain, cover designer, you both got it instantly! The results are beautiful and we love it.

Finally, to Alex Ward the director of book development at *The Times*. Your guidance and contributions to this book are enormous. The authors and team at Black Dog are all very aware the project would have come to a screeching halt without your influence as editor, writer, talent finder, negotiator, mentor and visionary. We are truly grateful for your belief in us.

—DARCY EVELEIGH

INDEX

Note: Content contained in photos is indicated by italic.